About French Poetry
from DADA to "TEL QUEL"
Text and Theory

About French Poetry
from DADA to "TEL QUEL"
Text and Theory

Edited by Mary Ann Caws

Wayne State University Press
Detroit, 1974

Library of Congress Cataloging in Publication Data

Caws, Mary Ann.
 About French poetry from Dada to "Tel quel"; text and theory.

 Includes bibliographical references.
 1. French poetry—20th century—Addresses, essays, lectures. 2. Surrealism—
France. I. Title.
PQ443.C28 841'.9'1209 74-10962
ISBN 0-8143-1520-8

Acknowledgment is made to the publishers for permission to quote from sources protected by
copyright.
Association des Amis de Benjamin Péret: Selections from his works.
Éditions Gallimard:
 "Arbre," from *Les Calligrammes* (1917), in Guillaume Apollinaire, *Oeuvres poétiques* (1956).
 "Invocation de la momie," Antonin Artaud, *Oeuvres complètes*, volume 1 (1956).
 "L'Enclume des forces," from Antonin Artaud, *L'Art et la mort, Oeuvres complètes*, volume 1
 (1956).
 "Quatre Fascinants," from René Char, *Commune Présence* (1964).
 "Un feu distinct m'habite . . . ," and other selections from Paul Valéry, *Oeuvres complètes*, 2
 volumes, Éditions de la Pléiade (1962).
 Selections from Henri Michaux, *Paix dans les brisements*, in *Moments* (1973).
Éditions du Seuil:
 "Texte 2," from Denis Roche, *Le Mécrit* (1972).
Éditions Seghers:
 "Avant que la nuit . . . ," part 2, from Tristan Tzara, *L'Antitête*, in the collection *Poètes
 d'Aujourd'hui* (1952).
Mercure de France:
 "O de ton aile de terre et d'ombre éveille-nous," from Yves Bonnefoy, *Pierre écrite* (1965).
 "Ruine de la chair," from Pierre Reverdy, *Main d'oeuvre* (1949).
Société Nouvelle des Éditions Jean-Jacques Pauvert:
 Prose poems 22 and 29 from André Breton, *Poisson soluble*, in *Manifestes du Surréalisme*
 (1962).

A number of these essays were originally conceived as a tribute to Herbert Gershman, a scholar in the field of surrealism (1926–71), on the part of his friends; they are dedicated to his memory.

Contents

VI. RHETORIC AND READING

Foreword

By Henri Peyre

A few surly spirits may feel chagrined that a movement which, in 1922, had frightened sedate pontiffs of literature, incurred the scorn of professors and the sarcasm of journalists, should now be so fervently explored by historians, estheticians, and critics. Surrealism, that icono-clast among literary groups, which once delighted in flinging insults at the idols of the 1900–1920 middle class, Anatole France, Loti, Barrès, is, in its turn, in danger of being treated like "an exquisite corpse." Courses on varied aspects of surrealist activity and on its poets are now popular in the colleges of the New World. Pamphlets, esoteric magazines, and books once issued in limited printings, which encountered untold obstacles and seldom won enough donors and readers, today fetch high prices and are bid for by scores of American libraries. In its heroic early decade, orthodox surrealism could brand Dali as a traitor avid for dollars and as an exhibitionist, and later expel Max Ernst for having accepted the prize of the Venice Biennale. In 1974, surrealist paintings and art objects, some of them of indifferent merit, are reverently displayed in a Paris museum which is an adjunct of the Louvre itself. Decoration, tapestries, publicity posters, children's drawings, our very dreams and our love ritual bear the imprint of surrealist imagination. High school pupils cheerfully write comments on Aragon, Eluard, Desnos, Char, and other poets once deemed hopelessly obscure or revoltingly eccentric. "Everything ends at the Sorbonne," as Valéry put it ruefully: he, whose career met with its supreme consecration at the French Academy and in the august Collège de France, remarked also

that what astonishes us most in the revolutionary innovators of yesterday is their lack of boldness.

Our Sorbonne colleagues have not yet, in fact, embalmed or dissected the surrealists who once terrified or puzzled them. American and Australian professors have stepped in first. Respectfully—the phrase of Tacitus holds true, "major e longinquo reverentia"—but critically also and relentlessly, they have multiplied inquiries, exegeses, and syntheses and turned the exploration of surrealism into a preserve of their own. Europeans at first resented that insolence of New World upstarts who fearlessly threw light on poems, manifestoes, and films which they had taken to be either hoaxes or riddles. They do so no longer. They are grateful to us today, proud to be invited to our symposia on modern movements and generous enough to ask their American colleagues in return to lecture in Paris: they even consent to decipher their English prose. Poets who had long been ignored, maligned, or appreciated by a very few in their own land, Reverdy, Jacob, Desnos, Ponge, Bonnefoy, are now close to becoming classics in American colleges. The Romantic poets of France had failed to win an audience outside their own country in their lifetime: it had taken a few decades for Baudelaire and the early symbolists to cease being mocked as decadent, morbid, or mystifying. The surrealists, more truly revolutionary than either, have more speedily won the favor of university teachers and of their students in America.

No one today can intelligently discuss or even understand surrealist poetry, fiction, film, without the interpretive work done in this country by Anna Balakian, Michel Beaujour, Mary Ann Caws, J. H. Matthews, and several others. Nowhere have the arcana of surrealist history, esthetics, and philosophy been more lucidly exposed than in the articles and the two books of the late Herbert Gershman, to whose memory this volume is inscribed as a tribute of esteem from his colleagues. LeRoy Breunig has done as much as any French scholar to elucidate Apollinaire's poetry and prose and to sketch the parallels between cubist painting and the poetry of the first twenty years of our century. René Char has, on several occasions, expressed his gratitude to the American professors who have converted a number of their students to the appreciation of his poetry. André Breton himself, whose peremptoriness was long dreaded by the academics of his own country, and by not a few of his one-time followers, more than once voiced his benevolent curiosity for those of us who lectured and wrote on his

works in American colleges; he seldom refused to answer their honest questions. If he was disappointed by the very slight impact of surrealism on English and American poetry, he had every reason to be gratified by the careful interest that American scholars and critics showed to his every pronouncement. When he returned to Paris after his years of voluntary exile in New York, he grew indignant at the glib remarks of several of his compatriots, then swayed by the vogue of existentialism, to the effect that surrealism was by then dead and might as well be buried in silence. In its essence, he replied haughtily, the movement had existed long before him; it would long outlive him. He found comfort in the assurances that some of us brought to him that the interest in surrealist doctrine and achievement was keener than ever on this side of the Atlantic. That interest was not the macabre eagerness of Ph.D. candidates, anxious to dig into a new quarry for thesis topics and intent upon establishing sources, influences, parallels, so as to spare themselves the risk of offering a value judgment. It was rather, as with the contributors to the present volume, a passionate determination to understand and to illuminate the works of Dadaist, surrealist, and para-surrealist writers and artists. In an essay entitled "Flagrant Délit" (1949), in which he flayed the perpetrators of a forgery which claimed to have discovered a lost poem by Rimbaud, Breton had expressed himself in these noble terms, to which intelligent academic critics may ungrudgingly subscribe:

Any speculation around a work remains barren, if it fails to give us anything of what is truly essential: namely, the secret of the power of attraction radiated by that work. That is precisely what M. Sartre did not at all understand when he felt impelled to offer us his "Baudelaire." The virtue of a work is only very secondarily present in the more or less erudite exegeses to which it is subjected: it lies, above all, in the passionate communion which, in ever growing numbers, young minds spontaneously achieve with it. . . . Knowledge properly speaking, or at least thorough knowledge, has a scant share in those untested pleasures which bring with them, in those who experience them, that gift of themselves. At the start, it is not an affair of understanding, but of loving.[1]

Love, indeed, appears more and more as the central motto of surrealism. Its most valid claim on our half-century lies in its revaluation of love as the central force in poetry. When much else has faded and

some theoretical generalizations sound hollow, Breton's two volumes of lyrical prose in honor of love, *L'Amour fou* and *Arcane 17*, will long survive, as will the love poems of Eluard, Aragon, Desnos, and Char. Vainly had Mallarmé and Valéry, in their impatience with a theme upon which the romantics and Baudelaire had composed too many moving variations, sworn to banish love from poetry. With the surrealists, it conquered all, immodestly at times and with no fear whatever of ridicule. "We shall reduce art to its simplest expression, which is love," was one of Breton's youthful assertions, to which he always remained true. Not since the medieval courts of love and the exalted, if monotonous, hymns of the troubadours had there been heard in the West such litanies to love (and to desire, for the surrealists openly advocated the sacralization of the flesh) as are sung in that poetry. Female champions of feminine liberation are not, in our time, easily taken in by the surrealist crusade of "earthly salvation through woman" which Breton revived. They claim the role which is their due in politics, in everyday prosaic affairs, and in all the walks of life. They should, however, admit that the hyper-romantic eulogies to the Eternal Feminine of the French surrealists never aimed at treating them like sex objects. To see them as goddesses was not to deny them a political and an intellectual role in society. At a time when many of us regret that they did not assert their demands more loudly to correct the harm done by male politicians and by militaries, Breton's impassioned plea, at the end of *Arcane 17*, might well be heeded. He expressed his amazement at the passiveness with which womankind tolerated Hitler in Germany, and elsewhere the headlong rush into war in all the so-called civilized countries:

I have always been amazed that woman's voice did not then make itself heard, that she should not have thought of taking the fullest possible advantage, an immense advantage, of the two irresistible and priceless modulations which her voice possesses: one to talk lovingly to man, the other to summon to herself the wholehearted trust of the child.

If surrealism has much to say today to the women of America which would be timely, just as relevant would be its message and its example to the youth revolted by a senseless war, then brought to a sense of despair in the face of the apparent utter futility of their protests. Their movement, the surrealists never ceased asserting it,

originated in an anguished revulsion at the slaughter of World War I and in their disgust with the literature which then connived at the massacre and celebrated it in patriotic propaganda. Against what was tantamount to accepting the suicide of the West and the final discredit of rationalism, the surrealists advocated a new birth for modern man: "the total recuperation of our psychic force through a vertiginous descent into ourselves," as the second surrealist manifesto ambitiously proclaimed. Years before the marshalling of nuclear energy for the destruction of foe and probably of friend and of ourselves, the founders of that literary movement anticipated Einstein's warning, which they endorsed, that mankind's salvation could only lie in informing the peoples that solely a new mode of thinking could enable mankind to survive and perhaps to progress. Breton has been compared to a pope, and apparently he did not resent the unflattering parallel. Humility set apart, his qualities were even more those of a saint. The question he asked repeatedly, especially in 1947 in "Comète surréaliste," [2] was the one which Péguy had asked, and lent to his heroine and inspirer Joan of Arc: "How to save man?" Breton had then just passed the half-century mark, beyond which most men despair of the future. Undaunted, obsessed by the urgency of the task to be defined and performed, he offered a triple program to his movement: to work for the liberation of man, for the integral cleansing ("désencroûtement") of our way of life, and to remake human understanding altogether.

The word "revolution," in French especially, has become a trite and almost discredited one among us. The surrealists abused it, as did and does every literary movement emanating from Paris, and now every teenager's magazine. One of the most entertaining books ever written on a movement which relished black humor, but seldom consented to turn its laughter at its own august seriousness, *Révolutionnaires sans Révolution*,[3] recently recalled how frustrating was the short-lived attempt to link surrealism with communism. A political or even a social revolution is probably just as unthinkable today in Nixon's America as it is in France. The survivors of surrealism, and their epigoni, cause little fear and trembling to the French of the 1970s. They do not even cherish the ambition of aging Sartre: to end up as a martyr. Their way of being revolutionaries lies through poetry and language, and leads toward a reconstruction of our sensibility. "Today's poet," pronounced Benjamin Péret in 1943, "has no other resource but to be revolutionary, or else to cease being a poet." And the revolutionary, for the surrealists, is he who

plunges deeper into the unknown, transcends the constricting hurdles erected by reason and by tradition, and sets out on an arduous climb to a Keatsian "top of sovereignty." "Each artist must, alone, take up in his turn the pursuit of the golden fleece," Breton prescribed. The editor and the contributors to this volume, artists in their critical appraisals, are Argonauts also.

NOTES

1. André Breton, "Flagrant Délit," in *La Clé des champs*, Paris, Sagittaire, 1953, p. 137.
2. Also included in *La Clé des champs*, p. 102.
3. By André Thirion, Paris, Laffont, 1972.

Preface

On the assumption that a wide spectrum of views runs the least risk of falsifying the object examined and has, even, the greatest chance of illuminating it, these essays are intended to exemplify a number of differing attitudes and approaches to the poetic text. Each critic was invited to choose a particular text or group of texts in his field of specialization: the result is a clear divergence of tendencies—the phenomenological and the psychoanalytic, the scientific and the surrealist, the linguistic and structural and the impressionistic, the closely analytic and the comparative and synthetic. The correspondence of the essays is complementary and not homogeneous; the focus toward which all the lines direct themselves is that of the poetic theory of the text and the nature of the poem itself as it appears in contemporary French literature.

That the genres poetry and prose can no longer be distinctly separated is now recognized; the character of the poetic text discussed here is as various as the perspectives taken to observe it. The range of form stretches from discussions of the Dada and the cubist esthetics to the conjunction in its grammatical and conceptual double role in a surrealist poet, from the oratorical narration of *Nadja* and the automatic texts of *Le Poisson soluble* to the sonnets of Valéry and the *proêmes* of Ponge, from the construct and the destruct in Apollinaire to the *Mécrit* of Denis Roche. When there is a doubling of essays on the same poet, as on Apollinaire, Artaud, and Breton, the commentaries are meant both to reflect on one another and to show the diverse facets of the same textual corpus, as they are spotlighted at differing moments by differing techniques.

No better introduction to the spirit and the purpose of this whole assemblage could be given than the one provided by the first essay, on the mode of juxtaposition. And if certain recurring terms,

names, quotations, and referents are noted, such as might lead a reader to believe that these essays stretching from art to art, from simultaneity to surface and sub-text, form a deliberately posed frame, they might equally well be structures of which another view would alter the whole. The essential perspective here will be the reader's.

The word "about" in the title is to be taken in its two senses: this volume is or revolves about its subject, and it is meant to wander in a space not precisely delimited, except by that revolution—a space various, as the attitudes and directions are various.

The essays are arranged by approach rather than by chronology, so that the general and the comparative precede the analytic and the linguistic. But the categories are not to be seen as tight, nor as finally separating.

Except for the poems of Paul Valéry, which appear in French only, the original and a translation are given of *what is seen as poetry* and of passages which call attention to themselves for their style.

The unfailing generosity of each of the contributors, and their willingness to commit themselves to a project requiring such collaborative patience, made this volume possible.

<div align="right">Mary Ann Caws</div>

1 Mode

The Mode of Juxtaposition*

Roger Shattuck

As suggestive as it is unspecific, the word "juxtaposition" has turned into a handy device for begging critical questions in modern art. The term generally implies some form of modern innovation, yet the technique of juxtaposition has always played an important role in the arts. A glance at Hieronymus Bosch (proverbs and all) or into Rabelais's topsy-turvy narrative tells the tale. The important consideration is that juxtaposition, the setting of one element beside another without supplying the connection, was widely suppressed in the arts at the time of the Renaissance. Within the coherence provided by likeness and perspective in painting (or melody and harmony in music; unity of action or argument in literature), any unexplained or unmotivated element came as distasteful jolt. With our century, the situation has reversed itself again. Art in which the transitions between parts keep the whole in place has yielded to a mode of juxtaposition that implies alternative arrangements. Our earlier attitudes and expectations can no longer relate the parts and make them stick. Thus we have taken refuge in saying that they are "assembled."

* In October 1961, the Museum of Modern Art mounted a large exhibit called "The Art of Assemblage." William C. Seitz, the curator who had organized the exhibit, arranged a symposium on the same topic. He presided over a panel consisting of Lawrence Alloway, Marcel Duchamp, Richard Huelsenbeck, Robert Rauschenberg, and Roger Shattuck. Duchamp read the precise, illuminating, and now famous text called "Readymades." I had been asked to prepare a twenty-minute text, of which I read only a few paragraphs. R.S.

Juxtaposition, an absence of style in the traditional sense of one part leading coherently into another, assumes two distinguishable forms. On the one hand similar closely related elements can be brought together. Cubism and futurism did so in crossing different angles and moments of a single scene. This fragmentation of visual unity did not at the start introduce any theme totally alien to the composition. The painted bottles and pipes as well as scraps of newspaper and playing card belong to an enlarged perceptual unity. The new mode violated above all two conventions: the immobility of the observer and the singleness of the time in which he observes. German Dada and French surrealism, on the other hand, often juxtaposed fragments of the world that display no apparent relation to one another unless one detours through the underground channels of chance and unconscious association. They put practically anything in the picture. Without undue straining, one might suggest that the juxtaposition of homogeneous elements as in cubism corresponds to a new classic style; the juxtaposition of heterogeneous elements as in Dada and surrealism corresponds to a new romantic style. In both, the jolt administered to normal modes of vision becomes not the exception but the rule. The abruptness and fragmentary nature of much modern art at first offends us by appearing to bear no relation either to the appearance of the world or to the ordering capacities of the human mind. In the best of its works, on the other hand, we discover that we have been snatched away to a new vantage point inside the most primitive or sophisticated processes of seeing and imagining. Max Ernst could pick up images from anywhere and find an exciting combination for them. The mode of juxtaposition offers new resources for paying attention to what has always been there.

The present context of an exhibit devoted to collages, frottages, readymades, poubelles, junk art, object boxes, and exquisite cadavers demands considerable refinement in the catchall mode of juxtaposition. We need, I believe, a further distinction of kinds based on effect rather than on composition. The fur-lined teacup, the lumps of marble sugar in a cage, the corpse in the baby stroller—such items illustrate the association of elements that cancel each other out and return us spiritually and esthetically to zero. Once their negative esthetic is grasped, they offer no further development or extension of significance, and their impact as artistic tricks or monstrosities exists in retrospect. Like jokes, they work at full strength only the first time. Later tellings

lack zest. Zero-point juxtaposition is essentially self-consuming, a reversion to dead level after an initial shock. Another form of juxtaposition brings together two components whose conflict does not cancel out but persists. The cubists and, more erratically, the surrealists achieved this tension. Schwitters's best poubelles carry a stability of design that overshadows the evanescence of the materials. For all his fun and fancy, Arp left lasting marks in the universe. In the first category the shock takes place only once per customer: the prepared effect happens, and in happening blows the fuse as in a short circuit. There are no new fuses, only new effects. Scandal cannot be repeated. The second category of juxtaposition on the other hand brings as close together as possible without ignition elements that create a large difference in potential. We react not to a brief bright spark that jumps the gap and thus destroys the whole rig, but to the field of forces sustained by the association.

Dada prolonged longer than anyone would have thought possible the short circuit that was generated out of Zurich, Berlin, and New York, and finally had its day in Paris between 1919 and 1922. The spirit of Dada, one hopes, will be ever with us. Dada itself is a mummy. What characterized the historical movement was its gleeful destructiveness and its emphasis on spectator participation. The perfect gallery-goer was the person who handled everything, broke what impressed him most, and used the urinal on display. The permanence of art was sacrificed for the excitement of a performance that would shatter or repulse.

It is this aspect of cultural fireworks that cannot be recaptured; yet we can at least ask for rigorous distinctions. To set side by side works which shorted out years ago and works whose tension of forces will not lessen with the years damages both the historic interest of the former and the esthetic values of the latter. As the Smithsonian Institution in Washington houses airplanes that no longer fly, we may soon need a repository for works of art that lived for a day and have lost their spark. It would be a museum without art.

One further word about juxtaposition. The frame of a painting both marks and veils the unsettling passage from art to life, from painting to reality. A few artists—de Chirico, Dali, Picasso, Ernst, above all Magritte—have explored the great compositional and metaphysical problem posed by every work of assemblage: why is a painting more than a frame-up? Does it have to be more than a frame-up?

The frame, the conventional rectangular window of a painting, lays out a universe within which the multiple relationships are self-sufficient and fill the space to the edges. Confronting such a work, even if it portrays a bloody massacre or the ecstasy of a saint or sinner, one is not personally importuned to react. Its architectural balance and dramatic isolation establish the proper distance between life and art, set off by the frame. Baroque and rococo bridge the interval only in a few moments of enthusiasm. It was the surrealist René Magritte who exploited the frame and accompanying title to define and defy the entire classic tradition of representation. He produced a series of miniatures in which he depicts common objects with meticulous accuracy—a pipe for example. He then labels it with equal meticulousness: "This is not a pipe." Of course he's right. His picture portrays an absence, specifically of a pipe. Magritte also takes the next step over the precipice by painting a briefcase and labelling it, "The Sky." Why not?

What happened then when Picasso or Braque or Picabia took an ordinary object and stuck it—that is the most accurate verb—stuck it in the middle of a composition? Anyone who looks alertly at such a work knows that the frame has been wrenched out of alignment, turned ninety degrees, and extended to enclose him, the bystander, who innocently reads the torn newspaper or squints into the pasted mirror. To an even greater degree, the readymade seizes upon you or me, the spectator, as one of the elements to be juxtaposed with it in a new plane. We are *assembled into* the frameless work that frames us. The "work" is no longer a separate entity with internal relationships on which we can comment from afar. It comes to life as a machine to importune us, to disturb relationships outside itself, and to project its field of force around and beyond us, victims and interlopers. We have in a very real sense been framed.

There is one last step to take. Insofar as this exhibit is successful, it is a frame-up. It has in fact not gone far enough. The revolving door through which we entered the building could have been engineered with a wobbling pivot, trick mirrors, and recorded sound. There could have been objects to pass from hand to hand and things to break or set up in new positions. An exhibit of and on assemblage? Answer: turn the audience into an assembly line. But we would in the process turn the Museum of Modern Art not into a factory but into the Smithsonian. Therefore we keep our hands off and allow ourselves to be importuned from a distance. That way, I fear we shall not be taken in.

2 Opposition and Juxtaposition

From Dada to Cubism

apollinaire's "arbre"

LeRoy C. Breunig

Arbre

(I)

Tu chantes avec les autres tandis que les phonographes galopent
Où sont les aveugles où s'en sont-ils allés
La seule feuille que j'aie cueillie s'est changée en plusieurs mirages
Ne m'abandonnez pas parmi cette foule de femmes au marché
5 Ispahan s'est fait un ciel de carreaux émaillés de bleu
Et je remonte avec vous une route aux environs de Lyon

(II)

Je n'ai pas oublié le son de la clochette d'un marchand de coco
 d'autrefois
J'entends déjà le son aigre de cette voix à venir
Du camarade qui se promènera avec toi en Europe
10 Tout en restant en Amérique

(III)

Un enfant
Un veau dépouillé pendu à l'étal
Un enfant

Et cette banlieue de sable autour d'une pauvre ville au fond de l'est
15 Un douanier se tenait là comme un ange
A la porte d'un misérable paradis
Et ce voyageur épileptique écumait dans la salle d'attente des
 premières

(IV)

Engoulevent Blaireau
Et la Taupe-Ariane
20 Nous avions loué deux coupés dans le transsibérien
Tour à tour nous dormions le voyageur en bijouterie et moi
Mais celui qui veillait ne cachait point un revolver armé

(V)

Tu t'es promené à Leipzig avec une femme mince déguisée en
 homme
Intelligence car voilà ce que c'est qu'une femme intelligente
25 Et il ne faudrait pas oublier les légendes
Dame-Abonde dans un tramway la nuit au fond d'un quartier désert
Je voyais une chasse tandis que je montais
Et l'ascenseur s'arrêtait à chaque étage

(VI)

Entre les pierres
30 Entre les vêtements multicolores de la vitrine
Entre les charbons ardents du marchand de marrons
Entre deux vaisseaux norvégiens amarrés à Rouen
Il y a ton image

(VII)

Elle pousse entre les bouleaux de la Finlande

(VIII)

35 Ce beau nègre en acier

(IX)

La plus grande tristesse
C'est quand tu reçus une carte postale de La Corogne

(X)

Le vent vient du couchant
Le métal des caroubiers
40 Tout est plus triste qu'autrefois

Tous les dieux terrestres vieillissent
L'universe se plaint par ta voix
Et des êtres nouveaux surgissent
Trois par trois[1]

Tree

(I)

You sing with the others while the phonographs gallop
Where are the blind where have they gone
The only leaf I picked has changed into several mirages
Don't leave me in this crowd of women at the market
5 Ispahan has made itself a sky of blue enameled tiles
And I come back with you on a road near Lyon

(II)

I haven't forgotten the sound of the little bell of a licorice-water
 vendor of long ago
I already hear the shrill sound of that voice to come
Of the comrade who will stroll with you in Europe
10 While remaining in America

(III)

A child
A skinned calf hanging in the butcher's shop
A child
And those outskirts of sand around a poor town deep in the east
15 A customs officer stood there like an angel
At the gate of a wretched paradise
And that epileptic traveler was foaming at the mouth in the
 first-class waiting room

(IV)

Nightjar Badger
And the Mole-Ariadne
20 We had rented two compartments on the Transsiberian railway
We took turns sleeping the jewel merchant and I
But the one who stood watch did not hide a loaded revolver

(V)

You strolled in Leipzig with a thin woman disguised as a man
Intelligence because that's what an intelligent woman is

25 And one shouldn't forget the legends
 Dame-Abonde[2] in a streetcar at night deep in a lonely neighborhood
 I saw a hunt as I went up
 And the elevator stopped at every floor

 (VI)
 Amid the stones
30 Amid the many-colored clothes of the shop window
 Amid the burning coals of the chestnut vendor
 Amid two Norwegian vessels moored in Rouen
 There is your picture

 (VII)
 It is growing amid the birch trees of Finland

 (VIII)
35 That handsome negro of steel

 (IX)
 The greatest sadness
 Was when you got a postcard from La Coruña

 (X)
 The wind comes from the west
 The metal of carobs
40 All is sadder than before
 All the earthly gods grow old
 The universe is lamenting through your voice
 And new beings arise
 Three by three

Apollinaire's "Arbre" has a position of honor in the history of Dada. It appeared in the opening pages of the first (and only) issue of the first Dada periodical, *Le Cabaret Voltaire* (June 1916).[3] That the editor, Hugo Ball, should have included a text by the acknowledged leader of the Paris avant-garde is understandable enough. But why "Arbre" in particular? And when we learn that Ball reprinted it without the author's permission and could therefore have appropriated any one of a number of other recently printed poems of Apollinaire, we become all the more curious.

There may, of course, have been practical considerations.

"Arbre" first appeared in the little-known Paris magazine *Le Gay Sçavoir* in March 1913, whereas Apollinaire's own periodical *Les Soirées de Paris*, which contained such modernist pieces as "Lundi rue Christine" (1913), "Le Musicien de Saint-Merry," "Rotsoge," "Le Souvenir du Douanier," "Lettre-Océan," and "Ideogrammes lyriques" (1914), was probably too well known in Zurich.[4] On the other hand it is unlikely that Ball was acquainted with *Lacerba* (Florence) where the little poems entitled "Banalités" and "Quelconqueries" appeared in 1914, and it was not in fact until 1919 that the Paris Dadaists reprinted them in *Littérature*.

But even allowing for such external factors, one still wonders why it should have been "Arbre" rather than, for example, "Les Fenêtres" (*Poème et Drame*, January 1913); "Liens" (*Montjoie*, April 1913); "Montparnasse" (*Vers et Prose*, October–December 1913); or "Un Fantôme de nuées" (*Les Ecrits Français*, December 1913).

The answer would seem to be simple. Of all of Apollinaire's poems scattered in the avant-garde magazines during the period from the publication of *Alcools* (March 1913) to the outbreak of the war—Apollinaire's "heroic period" as Tristan Tzara called it[5]—"Arbre" presumably appealed to the young group in Zurich as the closest to Dada.

The temptation is strong therefore to classify "Arbre" as a kind of poem-manifesto or at least as a proto-Dada text. This means, in effect, that we examine it as an effort to create a language which will destroy language or as an example of the use of language as non-communication. In 1916, Hugo Ball, who as Michel Sanouillet points out was largely responsible for enunciating the ideological foundations of Dada,[6] wrote that "language as a social organ can be destroyed without the creative process suffering thereby. Indeed it seems that the creative powers stand to gain. . . . Spit out words. . . . Reach an incomprehensible, inaccessible sphere." [7]

"Arbre" seen in this light becomes a typically Dada exercise in incoherence. The title first of all seems totally gratuitous; whatever the subject of the poem it is obviously not about a tree. "Arbre" thus seems to announce the type of absurdly irrelevant titles which will head the Dada or Dada-type of work from Picabia's *Unique Eunuque* down to Ionesco's *Cantatrice chauve*.

The main impression of the first stanza is not only the incongruity of the content among the six lines but of their structure as

well: two declarative sentences (11. 1 and 6) in the present tense; two in the past (11. 3 and 5); an interrogative (1. 2) and an imperative (1. 4); and the absence of any connectives among them except the "Et" of the last line which joins two patently unrelated statements. The tone of illogicality is in fact set from the opening line since "tandis que," although it can, of course, be used as a synonym for "pendant que," suggests nonetheless an adversative ("alors que") which creates a false contradiction between the verbs "chantes" and "galopent."

Add to this the confusion in the personal pronouns. The shift from "Tu" (1. 1) to "vous" (1. 6) implies not so much a change in the person addressed as a variety of speakers, and one is not sure if the "je" (1. 3), the "me" (1. 4), and the "je" (1. 6) refer to a single voice. Perhaps the six lines are spoken by six different voices.

In the second stanza the repetition of "son" (11. 7 and 8) and the contrast between "autrefois" and "à venir" set up a tenuously logical link which is then destroyed by the adynaton (e.g., "barefoot boy with shoes on") of lines 9 and 10.

In addition to the more obvious devices of non-communication in the third stanza such as the brief notations of lines 11 to 13 (like those in 11. 18–20) and the same illogical use of "Et" (11. 14 and 17), the reader who knows his Apollinaire will recognize a model for a device that was to become dear to both Dada and the surrealists: the private allusion or *gag intime,* meant for the habitués of the Spiegelgasse in Zurich or later the Certa in Paris but inaccessible to the bourgeois public. Rose Sélavy's "marchand du sel," a phonetic anagram of Marcel Duchamp, is the classic example. It may be a little far-fetched to assume with Margaret Davies that the calf in line 12 is necessarily Marc Chagall's,[8] but there is little doubt about the allusion in line 15 to the Douanier Rousseau, whom Apollinaire compares to an angel in two other poems.[9] Even more clear-cut are the lines 20–23, which read like a paraphrase of Cendrars in *La Prose du Transsibérien et de la petite Jeanne de France:*

Et je partis moi aussi pour accompagner le voyageur en bijouterie qui
 se rendit à Kharbine
Nous avions deux coupés dans l'express et 34 coffres de joaillerie de
 Pforzheim . . .
Je couchais sur les coffres et j'étais tout heureux de pouvoir jouer avec
 le browning nickelé qu'il m'avait aussi donné[10]

(And I left too in order to go with the jewel merchant who was on his
 way to Harbin
We had two compartments in the express and 34 boxes of jewelry
 from Pforzheim . . .
I slept on the boxes and I was very happy to be able to play with the
 nickel-plated Browning that he had also given me.)

How could the good citizens of Zurich possibly know that the
"moi" in line 21 of "Arbre" was Blaise Cendrars? And even if they did
what connection could there be with the rest of the poem?

The next stanza piles up more strips of *non-sequiturs* with the
same confusion of pronouns and the irrational use of connectives. The
presence of the conjunction "car" (1. 24) seems to announce a logical
explanation of "intelligence," yet not only does the repetition of this
word in its adjectival form blot out the clarification but the noun form
itself is left hanging. Even if one rereads line 23 and fills in the ellipsis,
deducing that a woman is intelligent because she disguises herself as a
man, there is no explanation of why this should be so.

Thanks to the repetition of "entre" with its objects and the
simple statement of line 33, we at last come to a block of the poem
possessing its own coherence. Even here, however, the random
selection of the objects, the lack of identity of "ton," and the
disconnection between the sentiment expressed and the rest of the
poem add up to a failure in communication.

In the one-line section (1. 35) the demonstrative adjective "Ce"
creates an illusion of continuity where there is none. Lines 36 through
39 contain more unrelated statements and we reach the concluding five
lines where for the first time in the poem there is a rhyme scheme (a b a
b a). The rhymes strengthen the coherence of a fairly straightforward
poetic statement which conveys a feeling of sadness because the old
gods are giving way to the new "beings." Nothing, however, has
prepared us for this conclusion, and the final line is itself an enigma.

Such an analysis of "Arbre" amounts to a kind of Dada
explication de texte, in line with the remark of Georges Charensol in
1920 when calling Tzara a "true Dada" he adds: "He gets a real
pleasure out of putting words together which, once they are joined, lose
their meaning." [11] By stressing all the elements that are destructive of

language and contribute to the meaninglessness of the poem, we have made a Dada text out of it.

The moment, however, that we examine more closely the history of Dada in the spring of 1916 we begin to ask whether such a classification is not perhaps too simplistic. In June, when *Le Cabaret Voltaire* appeared, the group had been calling itself "Dada" for more than three months but its nihilistic, anti-esthetic stand was still far from clear. In mid-March a "French Soirée" in the cabaret had featured verses by Max Jacob, André Salmon, and Jules Laforgue along with the performance of a Saint-Saëns sonata. It was not until the following August that Hugo Ball made his attack on language, from which we have quoted. Meanwhile a remark of his on June 4 clarifies his intentions in publishing *Le Cabaret Voltaire* when he notes that it is "the first synthesis of the modernist tendencies in art and literature. The contributions here represent elements of Expressionism, Futurism, and Cubism." [12] And indeed the contributors include among others Cendrars, Kandinsky, Marinetti, Modigliani, and Picasso.

For Hugo Ball then "Arbre" was a "cubist" poem. Its position on the right-hand page (p. 11) opposite a cubist nude of Picasso (p. 10) undoubtedly confirms the editor's intention. Later on the Dadaists were to speak with the utmost scorn of "le cubisme littéraire," but at this stage, as the latest avant-garde movement, it still remained the object of their admiration. Looking back in 1923 upon the basic difference between his own movement on the one hand and cubism and futurism on the other, Tzara wrote that "these latter two tendencies were based above all on a notion of technical or intellectual perfection, whereas dadaism was never based on any theory and was only a protest." [13]

In other words, a cubist poem is a construct, which makes a Dada text, if we may use the word, a "destruct." As the movement closest to it in time and style, cubism (along with futurism) provided Dada with some of its principal devices: the deletion of punctuation; typographical innovations; the use of little or no meter and rhyme; the disintegration of the regular stanzaic form; the widespread use of ellipsis or more specifically the suppression of connectives and transitional locutions in order to create an effect of discontinuity; enumerations of single words; brief notations and autonomous statements of a more or less heterogeneous nature; syntactical shifts from one type of sentence to another, from one pronoun to another. All these devices are to be found, for example, in Tzara's *Vingt-cinq poèmes*, published in

1918. True, one finds as well a heavy dose of solecisms, of "bruitisme," borrowed entirely from the futurists, and of incongruities within each line or phrase; but by and large the cubist and Dada styles are similar enough to allow us to situate individual texts of either style along a single spectrum, according to their degree of incoherence and non-communicability.

We can apply this gauge, for example, to the principal pieces of Apollinaire in 1913–14 which Hugo Ball might have chosen: "Liens," "Les Fenêtres," "Lundi rue Christine," "Le Musicien de Saint-Merry," "Un Fantôme de nuées," and "A travers l'Europe" (originally called "Rotsoge"), all of which incidentally figure in the opening section, entitled "Ondes" of *Calligrammes*. To these we should add "Zone," the opening poem of *Alcools* (composed in 1912) simply because it is generally considered the cubist poem par excellence.

If by "cubist" we mean more precisely a poem based not on a linear structure unfolding in time but rather upon the simultaneity of all the diverse elements—comparable to the multiplicity of perspectives in a cubist painting and hence justifying stylistically the "cubist" label— then "Zone," in spite of its flashbacks and the presence of some of the devices we just enumerated, is not strictly speaking a cubist poem (and even less Dada) since its structure corresponds to the one-day period—morning to morning—in which the action unrolls. In this respect it resembles "La Chanson du mal-aimé" (*Alcools*) whereas "Le Voyageur" (*Alcools*) comes much closer to the cubist structure of 1913. "Liens," the liminary poem of *Calligrammes*, is more cubist not only because of the lack of localization but because of what seems to be a haphazard enumeration of disparate elements (ropes, sounds of bells, centuries, rails, rain, cables, bridges, rays of light) until we realize—perhaps too quickly—that they all cohere as forms of "liens" or ties. The ease with which the reader grasps the unity of the poem makes it perhaps the least Dada of the group.

"Lundi rue Christine" on the other hand seems to be the most Dada of all. Here presumably is a perfect example of the totally gratuitous juxtaposition of incongruities. The moment we sense, however, that these are snippets of conversations in a café and that the poet is reduced to the role of a recorder in the middle of it all, the Dada credo of protest and destruction withers away and we are left with what could be the jottings in the notebook of a nineteenth-century realist.

The very specific localization and the narrative framework

exclude both "Un Fantôme de nuées" and "Le Musicien de Saint-Merry" from a cubist-Dada classification even though toward the middle of "Le Musicien" a series of completely arbitrary notations introduced by such adverbial locutions as "Puis ailleurs," "A ce moment," "Ailleurs," "Au même instant" seeks to give a sense of ubiquity to the action through the device of simultaneity.

This leaves "Les Fenêtres" and "A travers l'Europe." The heterogeneity and incongruity of their lines place both poems alongside "Arbre"—with a slight edge perhaps in favor of "A travers l'Europe"—as the most Dada of the batch. There exists, however, an external factor which gives the two poems a kind of coherence which the lines alone do not necessarily possess. For each is a modernist form of the nineteenth-century "transposition de l'art" as practised by Gautier and Baudelaire. "Les Fenêtres" seeks to evoke through verbal equivalents the style of Delaunay and "A travers l'Europe" that of Chagall. Each poem in fact prefaced the catalog of two different exhibitions by these painters in Germany shortly before the war.

"Arbre" has no such support and comes closest on the spectrum to the ultra-violet of a Dada text. The more or less successful efforts to search for coherence from within nonetheless stamp it as a cubist poem. Both Margaret Davies in a brief commentary and Philippe Renaud in a more detailed exegesis have made the attempt.[14] "Arbre" was also the subject of a group analysis during a colloquium in Cologne (1964) on the principles and methods of contemporary structural analysis.[15] A variety of brief and perceptive individual insights dotted the discussion but perhaps because of the sheer number of participants—twenty-two—nothing approaching a "collective interpretation" actually emerged.

For Miss Davies the coherence lies, as in "Zone," in the tension between the poet's self-imposed effort to espouse the modern age "catching after the images of the external world" and the more natural nostalgia for the past. "Within the kaleidoscope of the present in Rouen, in Finland, behind the brave new robot of a brave, new world—'ce beau nègre en acier'—is the sadness of the lost love of the past."

In the beginning of his analysis M. Renaud tries to impose the unity from outside by stating categorically: " 'Arbre' refers as clearly to Cendrars as 'Les Fenêtres' to Delaunay and 'A travers l'Europe' to Chagall" (p. 333). Taking his cue from the "Nous" in line 20, M. Renaud suggests that many of the other recollections in the poem are

not Apollinaire's at all but Cendrars's and that the work is a kind of "poème-conversation" between the two. This rather ingenious theory does not take into account the allusions to Chagall and Rousseau in lines 12 and 15 nor the evidence, which Apollinaire intentionally displayed, that the other two poems are directly inspired by the painters. Fortunately M. Renaud confesses that the Cendrars question is secondary, and in the remaining pages seeks the coherence from within, finding in it much the same ambivalent sentiment that Miss Davies had noted:

The subject of "Arbre" seems to lie in the contrast between what is disappearing and what is beginning to exist in the modern sensibility. . . . One would say that in "Arbre" Apollinaire has given word to disquiet and sadness, a new feeling of strangeness taking hold of him at the idea of the modernism which was besieging him through the voice of his friends, the works of certain contemporaries, and the very spirit of the age.[16]

M. Renaud substantiates this interpretation by pointing out how a pattern of antitheses emerges which reinforces the underlying opposition between old and new: contrasting pairs of place names; images connoting the human or vegetable as against the mineral, the horizontal versus the vertical, death against rebirth, and the self against the non-self. From such patterns M. Renaud deduces—in line with our own notion of a cubist text—that there is no psychological or temporal progression but that all the elements are simultaneously present in the mind.[17]

Later on, however, he seems to forget this deduction when he tries to connect the opening lines, imagining through free association a sequence that runs from "chantes" in line 1 to "aveugles" in line 2 (since blind men often sing, whether street beggars or Homers); from "aveugles" through "feuille" in line 3 to the implied image of a tree of knowledge (since the blind are often seers), a tree which, however, refuses to bestow any oracles but only "mirages"; and from "mirages" in turn to the related sense of abandonment expressed in line 4.

When Shakespeare puts a series of disconnected lines into the mouth of Lear it is perfectly legitimate for the reader to piece together the sequence as in the following passage (which for the sake of the argument we have fragmented typographically as though they were "cubist" lines):

> Look, look, a mouse!
> Peace, peace;
> This piece of toasted cheese will do't.
> There's my gauntlet;
> I'll prove it on a giant.
> Bring up the brown bills.
> O, well-flown, bird!
> I' the clout, i' the clout:
> Hewgh!
>
> [act 4, sc. 6]

Despite their obscurity these are not cubist or Dada lines. Lear is mad and the reader, playing the role of amateur psychiatrist, discerns the underlying continuity of thought which proceeds both "psychologically and temporally" as M. Renaud would say through word play (peace to piece, bills as weapons to bills of birds, etc.) and free association. There is no simultaneity here, whereas in "Arbre" it becomes fruitless to posit a sequence which would lead from line to line. M. Renaud apparently realized this because after line 4 he gave up the effort. What possible sequence is there between a crowd of women in a market place and the blue tiled "sky" of Ispahan and from there to a road outside of Lyon? [18]

The coherence in "Arbre" derives primarily from the echoing of lines at a distance, from what Max Jacob has called "leur appel mutuel et constant." [19] And M. Renaud is at his best when he reveals these connections, as we have seen. It is on this basis that we suggest two other unifying themes which in no way contradict the old-versus-new motif discerned by Miss Davies and M. Renaud. On the contrary, they complement and enrich it.

The first is the theme of enclosure announced by the artificial sky of Ispahan (1. 5). The repetition of "dans" in lines 17, 20, and 26 sets up a pattern suggesting that man-made structures—the waiting-room, the small railway compartment (a *coupé* has only one bench), the streetcar—confine modern man. And when we add to this the prepositional phrases introduced by "au fond de" (11. 14, 26) and "entre" (11. 29–34) and the images of the customs officer confined to his post (11. 15–16); of Ariadne (1. 19) in her labyrinth (who, if by chiasmus she may be associated with the winged nightjar,[20] finds a closer affinity with both the burrowing badger and the mole); of the Leipzig woman in her men's clothing; of the poet in the elevator,[21] we begin to feel an oppressive sensation of isolation and claustrophobia.

The poet struggles against this sensation by the counter-theme of ubiquity and multiplicity. M. Renaud has already demonstrated the complex "chassé-croisé" of the shifting personal pronouns which create an effect of several interlocutors. The statement which enunciates the metamorphosis of the singular into the plural is the ambiguous line 3, perhaps the best-known line in the poem.[22] Apollinaire may have intended it in part as a private statement since no one was more aware than he of the protean qualities of the leaf image which runs throughout his poetry (leaf to hand to flame to heart, etc.). In any case the word "mirage" connotes in his vocabulary the work of art or the activity of the creative imagination, the falsehood that tells the truth;[23] and the change from "seule" to "plusieurs" announces both the content and the form of the poem: the expansion of the self beyond the confinement of its oneness and the whole kaleidoscope of images and statements that this expansion produces, the poem itself in its multiplicity. This line also clarifies the title since unlike all the man-made products of modern technology which tend to subjugate man, the leaf-producing tree is the finest example of natural creation and by extension the symbol of the poet.[24]

But just as the initial espousal of the modern (1. 1) is modulated into nostalgia for the past in the Davies and Renaud interpretations, so does the search for ubiquity end up in the same failure that Apollinaire will describe at the end of "Merveille de la guerre":

Je lègue à l'avenir l'histoire de Guillaume Apollinaire
Qui fut à la guerre et sut être partout
Dans les villes heureuses de l'arrière
Dans tout le reste de l'univers
Dans ceux qui meurent en piétinant dans le barbelé
Dans les femmes dans les canons dans les chevaux
Au zénith au nadir aux 4 points cardinaux
Et dans l'unique ardeur de cette veillée d'armes

Et ce serait sans doute bien plus beau
Si je pouvais supposer que toutes ces choses dans lesquelles je suis
 partout
Pouvaient m'occuper aussi
Mais dans ce sens il n'y a rien de fait
Car si je suis partout à cette heure il n'y a cependant que moi qui suis
 en moi[25]

(I will to the future the story of Guillaume Apollinaire
Who was in the war and managed to be everywhere
In the happy cities behind the lines
In all the rest of the universe
In those who die trampling in the barbed wire
In the women in the cannons in the horses
At the zenith at the nadir at the four points of the compass
And in the single ardor of this armed vigil

And it would doubtless be even more beautiful
If I could suppose that all these things in which I am everywhere
Could also be in me
But in this sense there is nothing accomplished
For if I am everywhere right now there is still only I who am in me)

The opposition between the "univers" and the "moi" in these lines we find in "Arbre," line 42. For if on the one hand the poet addressing himself seems to be praising his voice as the mouthpiece of the universe, on the other hand and more plausibly within the context he is pointing up the contrast between the universe as the symbol of limitless expansion in time and place and his own single voice in its isolation, its insignificance. The mirages of line 3, which represent the projections of the multi-faceted self in the universe, vanish and nothing is left but the "seule feuille."

The generally dejected mood of the poem derives not only from the pattern of confinement which we have noted but from the disparity between the device of simultaneity which the reader customarily associates with the dynamics of modernism—witness the pairing of the terms "simultaneità" and "modernolatria" in the title of Pär Bergman's work on Italian futurism and French cubism[26]—and the oppressive substance of almost all these free-wheeling images. Thus is created an impression of dissonance between structure and subject matter. The very freedom of the form seems to mock at the feeling of bondage implicit in the content. This disparity, far from detracting from the lyric impact of the poet's ambivalent feelings, actually enhances it.

If the reader accepts these efforts to bestow coherence upon "Arbre" he will conclude with Hugo Ball that it is a cubist work. But to label a poem "cubist" is hardly the same as calling a sonnet a sonnet. Jean Paulhan has summed up the essence of cubist painting with the

one word "négligence" or carelessness.[27] We shall not argue the accuracy of this characterization of the works of Picasso, Braque, Gris, and others, but it certainly seems to apply to many of the texts of Apollinaire, Jacob, Reverdy, Salmon, and the practitioners of "le cubisme littéraire." When spontaneity, chance, and experimentation attend the birth of such poetry one can hardly expect it to fit into a rigorous mold. Individual lines can be interchanged or even removed without spoiling the total effect. Tzara went too far in speaking of "le perfectionnement." [28] The more modest word "considered" in Babette Deutsch's definition is closer to the mark: "cubist poetry. Heterogeneous images and statements, presented in a seemingly disordered but considered fashion, so that together they build a coherent work." [29]

In other words, a cubist poem will always have Dada elements in it, those that create the "heterogeneous," "disordered" impression for the reader, all the opaque elements which belong to Hugo Ball's "incomprehensible, inaccessible sphere." Dada in this sense does not designate a historical movement (1916–1922) nor does it necessarily designate the reality of the style of Tzara, Picabia, Ribemont-Dessaignes, and the other full-fledged members of the group. It refers rather to a particular stage in the reading of the poem, the initial stage of meaninglessness or what the participants in the Cologne colloquium called, apropos of "Arbre," "Dunkelheit" as against "Vieldeutigkeit." If upon successive readings the poem resists all efforts to discover its coherence, it remains Dada; it is a "destruct." If the apparently disconnected fragments gradually communicate a convergence of diverse but interrelated meanings, it becomes cubist; it is a construct. Without using the labels, Max Jacob summed up the distinction between the two schools, styles, and stages when he wrote to Tzara in 1916: "La décomposition agrandit l'art mais la recomposition le fortifie" ("To take art apart makes it greater, but to put it together again makes it stronger").[30]

NOTES

1. *Calligrammes*, 1917.
2. A good fairy in French fairy tales.
3. It is the first poem after the liminary piece "Poème simultan [sic] L'Amiral cherche une maison à louer" of Tzara, Huelsenbeck, and Janco.

4. A reference to it in a letter he wrote to August Hofmann on June 2, 1916 ("I read an article on Reger in the *Soirées de Paris*") confirms that Ball was familiar with the magazine (Hugo Ball, *Briefe 1911–1927*, Cologne, Benziger Verlag, 1957, p. 56).

5. In a conversation with Margaret Davies. See her *Apollinaire*, London, Oliver and Boyd, 1964, p. 225.

6. See *Dada à Paris*. Paris, Pauvert, 1965, p. 18.

7. "Die Sprache als soziales Organ kann zerstört sein, ohne dass der Gestaltungsprozess zu leiden braucht. Ja es scheint, dass die schöpferischen Kräfte sogar gewinnen. . . . Worte ausspeien. . . . Eine unverständliche, uneinnehmbare Sphäre erreichen." Hugo Ball, *Die Flucht aus der Zeit*, Lucerne, Verlage Josef Stocker, 1946, p. 107.

8. Davies, *Apollinaire*, p. 226.

9. "Souvenir du Douanier" (p. 357) and "Inscription pour le tombeau du peintre Henri Rousseau Douanier (p. 660) in Apollinaire, *Oeuvres poétiques*. Ed. de la Pléiade, Paris, Gallimard, 1956.

10. From Blaise Cendrars, *La Prose du Transsibérien et de la petite Jeanne de France*, Paris, Ed. des Hommes Nouveaux, 1913.

11. "Manifestation Dada," *Comoedia*, 29 mars 1920, as quoted by Sanouillet, *Dada à Paris*, p. 169.

12. Hugo Ball, *Briefe*, p. 91.

13. "Tristan Tzara va cultiver ses vices," *Le Journal du peuple*, 14 avril 1923, as quoted by Sanouillet, *Dada à Paris*, p. 323.

14. Davies, *Apollinaire*, pp. 226–27; Philippe Renaud, *Lecture d'Apollinaire*, Lausanne, Editions L'Age d'Homme, pp. 331–45.

15. "Gemeinsame Interpretation von Apollinaire's *Arbre*" [by H. R. Jauss, Siegfried Kracauer, Rainer Warning, Wolfgang Iser, Herbert Dieckmann, Hartfelder, Dimitrij Tschizewskij, Buddemeier, Wolfgang Preisendanz, Ulf Schramm, Neumeister, Dieter Gerhardt, Beyer, M. H. Abrams, W. D. Stempel, Jurij Striedter, Dieter Henrich, Jacob Taubes, Max Imdahl, Clemens Heselhaus, K. H. Stierle, Hans Blumenberg] in *Immanente Ästetik, ästhetische Reflexion. Lyrik als Paradigma der Moderne*, Kolloquium Köln, 1964, ed. W. Iser, Munich, Fink, 1966, pp. 464–84.

16. Renaud, *Lecture d'Apollinaire*, pp. 340–41. Cf. the similar interpretation of Siegfried Kracauer in the "Gemeinsame Interpretation von Apollinaire's 'Arbre'," p. 475.

17. The "cubist" technique is stressed by Mssrs. Iser, Beyer, and Jauss in the "Gemeinsame Interpretation," pp. 467, 471, 477.

18. Renaud, *Lecture d'Apollinaire*, p. 341. More faithful to the principle of simultaneity, Wolfgang Preisendanz detects the connection at a distance between the blind of line 2 and the badger and the mole of lines 18–19. "Gemeinsame Interpretation," p. 475.

19. *Art poétique*, Paris, Emile-Paul, 1922, p. 66.

20. The airy sound of the Greek maiden's name (cf. *aria* and Ariel) may be associated with that of the nightjar which in French literally means "swallows the wind" (O.F. *engouler* + *vent*).

21. Jurij Striedter sees in the horizontal lines 29–32, each with its initial "Entre," a typographical imitation of the floors which the elevator climbs. "Gemeinsame Interpretation," p. 472.

22. The surrealist Marcel Jean prints it in the front of the catalog of a recent exhibition of his in London (Obelisk Gallery, May 1972).

23. Cf. for example in *Les Mamelles de Tirésias*:

> Car le théâtre ne doit pas être un art en trompe-l'œil
> Il est juste que le dramaturge se serve
> De tous les mirages qu'il a à sa disposition. . . .
>
> [*Œuvres poétiques*, p. 882]

(For the theater must not be an art of trompe-l'oeil
The playwright should use
All the mirages he has at hand.)

24. The metaphor of the poet as tree is often called up or at least enhanced by the double meaning of *feuille* (leaf and page). Cf. Victor Hugo's view of himself as a tree in the dedication of *La Légende des siècles*:

> Livre, qu'un vent t'emporte
> En France, où je suis né.
> L'arbre déraciné
> Donne sa feuille morte.

(Book, let the wind carry you away
To France, where I was born
The uprooted tree
Yields its dead leaf.)

Cf. also the analogy of poet and tree in Rilke, as pointed out by Wolfgang Preisendanz. "Gemeinsame Interpretation," p. 475.

25. Apollinaire, *Oeuvres poétiques*, p. 272.

26. Pär Bergman, *"Modernolatria" et "Simultaneità,"* Upsala, Studia litterarum Upsaliensia, 1962.

27. "La Peinture cubiste ou l'espace d'avant les raisons," *La Nouvelle Revue Française*, avril 1953, p. 603.

28. See above, p. 32.

29. Babette Deutsch, *Poetry Handbook: A Dictionary of Terms*, New York, Funk & Wagnalls, 1962, p. 42.

30. Letter of February 26 published by Sanouillet in *Dada à Paris*, p. 556.

Breton in the Light of Apollinaire

Anna Balakian

In the course of my recent studies of André Breton,[1] I had the opportunity to reappraise his connections with Apollinaire, and although the contact has long been recognized,[2] I think that there is still room for scrutiny and reflection in respect to the problematic character of the imprint on the personality and work of Breton. The meeting of these two poets had the character of a surrealist image: it was indeed the juxtaposition of two distant realities, and the disparity between the given factors of their lives and characters produced a spark typically demonstrative of the surrealist metaphor.

It is easy to conjecture that there would not have been a movement designated as "surréalisme" if Apollinaire had not propitiously used the word and named the wheel as the first surrealist object—a designation that actually is quite contestable. Rather, I would suggest that if Apollinaire had never used that particular word the reality of his contact at a particular moment with the destiny of André Breton would have set off in any case that rocket that propelled poetry out of the contextual framework of a millennium. Without that meeting, the future of French poetry would no doubt have found its Nemesis in the clutches of the absurd, or be expressed in direct ideological or introspective pronouncements as it did in so many other countries.

The facts of the momentous encounter are simple and unmysterious. Besides the accounts given by Breton and in the references and reminiscences of many of his contemporaries, we have the letters of both poets, now available thanks to Michel Sanouillet, Marguerite

Bonnet, and Michel Décaudin.[3] When these letters are juxtaposed, the correspondence reveals its purpose and result as a direct and open dialog.

Breton, a young medical student in spite of himself, met Apollinaire, a poet and soldier, in 1916. He had been reading Apollinaire's poems since 1913, the year he determined as that of his intellectual awakening. Both were poets and soldiers. The resemblance stops there. Apollinaire was known and had an entourage without having actually launched a literary movement. Breton had begun to write when he addressed himself to the poet whose reputation was already established to tell him of his admiration and also to take the opportunity to send him a few of his poems. One sees in these letters, written with much tact and strategy, a great deal of praise but also the need for response, and particularly an urgent desire to make a good impression on his elder. Breton succeeds in his objective as we can readily see in the responses available in the collected letters. Breton's formula is clever. He always begins with praise, and then he asks him a number of provocative questions. Apollinaire responds immediately to Breton's intentions and realizes, what is more, that Breton is the director of the correspondence: "With a perfect tact," he says, "you direct the object of my answers and the subject of your pleasure" (AS, 24). He congratulates him but although he finds in his admirer a certain degree of talent he can qualify the poems only as "pretty." He begs Breton to visit him at the hospital the very next morning after his trepanation, and he encourages him to continue the correspondence. It is surprising to observe, in placing the two series of letters next to each other, the tone of equality Apollinaire uses in addressing the young writer, and it is still more astonishing to note that Apollinaire had also favors to ask of the twenty-one-year-old poet. It would seem strange for Apollinaire to show more confidence in this young colleague than in a more prestigious and reputed poet or critic. Yet the fact remains that he makes an extraordinary declaration to the youth, who is virtually unknown as a poet and who has given no proof of any ability as a critic: "I know of no one who could speak as well of what I have done as you" (AS, 32). But it is in another letter that the explanation can be seen; here Apollinaire tries to turn Breton away from his admiration for Valéry, of whom he says: "He is too smart not to understand that what is attractive today is a far cry from what he had so much trouble imposing on the masters of his own time" (AS, 35). In other words,

Apollinaire prefers to be admired by the young unknown rather than by a famous author of a declining generation. Apollinaire's tone becomes more and more pressing in the course of the correspondence, and it is Breton who lets the correspondence lapse or its pace lag. There is even a puzzling ambiguity to be noted. Breton tells us in *Entretiens* that he used to visit Apollinaire every day; in Apollinaire's letters there is a gentle reproach that he does not come as often as Apollinaire would have liked. One can be led to believe that at a time of physical and mental tribulation Apollinaire had an urgent and deep need for friendship and found himself in a state of solitude, surprisingly so since he was supposedly in regular contact with a long series of friends of his own generation. The dialog is extraordinary: instead of the young man consoling the wounded soldier, we find the latter trying to transmit his natural grain of effervescence and enthusiasm for life to the young, rather morose, and still very reticent poet: "surmount your disgust, shake off your boredom, . . . Your worries, you see, are not unique in this world. Banish them" (AS, 29). He tries to transmit that certain modern gaiety which he considers more profound and more tragic than the old-fashioned spleen of the Romantics. He wants to communicate to him that laughter which is one of the major traits of his own poetic personality.

At that period in his life there are two forces that attract Breton: the archetype of the circumscribed literary man, of which Valéry was the perfect emblem, and with which he had most affinity by nature and education, and on the other hand the archetype of the rebel who rejects completely the literary context, which was incarnated by his friend Jacques Vaché. A moment came when Breton had to choose a life style, and he saw three roads open before him. One might conjecture that on this decision depended to a great extent the future direction of poetry in France. Despite all the reservations that he had about the qualities of Apollinaire's poetic works, and particularly about his last writings, disappointing to Breton, it is obvious that he chose to identify with Apollinaire, and not because of the latter's theoretical avant-gardism.

As the works of numerous surrealists reappear, making it possible to juxtapose them, studying their succession and continuity, we can see with increasing clarity the lack of uniformity in their literary signatures. Each has his own, and it would be impossible to confuse them except in the case of purely imitative neo-surrealists of succeeding generations. Surrealism's situation in this respect is completely different

from that of the symbolist movement, which had very quickly developed a literary code that created its universality but also eventually brought about the weaknesses of stylization.

The destiny of surrealism was quite different. Breton as the intermediary between conflicting trademarks and personalities crystallized the unifying factor over and above the differences: that particular flair of the new poet that Apollinaire had introduced in his self-designation. Actually, Breton was wrong to say that Apollinaire was the "last poet"; he was really the first of a new series, not because of his theories expressed in "L'esprit nouveau" or in *Les Mamelles de Tirésias* or because of his espousal of any "literary" context, but because of his behavior, his transcendence of all known literary frameworks in the first fifteen or sixteen years of the century, and in spite of the decline noted in his last year of life.

Breton ceased to admire Valéry the day he realized that after twenty years of silence all Valéry had been able to produce was more of the same in the same alexandrines. And Vaché died without having reached any social, moral, or literary fulfillment. Yet, for a brief moment Breton remained so fascinated by this strange friend he lost that he replaced him by Tzara. But as the events of Dada in France show, Breton was psychologically incapable of considering the function of poet under a negative guise. Without the alternative that Apollinaire offered him he might have settled for a refined and affected poetry, purifying a form and a style: but he would not have been inspired to that state of mind which we recognize as "surrealist" beyond the theories of automatism, of the cult of the dream, of the image, of objective chance, and dialectical materialism.

At the bottom of the surrealist psyche we find reflected one in the other the portraits of Merlin and Croniamental. But what survives from all the cumbersome mythology of *L'Enchanteur pourrissant* and *Le Poète assassiné*? First, the fact, recognized by the author, that the poet of the twentieth century is on the defensive, that there will be no place for him in human activities unless he opens up to life, returning now to fundamental forces, making of poetry a human science rather than an esthetic object endowed with a reality independent of the life and person of the author. That is the separation of ways between Apollinaire and the symbolists. It is not after Apollinaire but with him, and because of the way he conducted his life and work, that the problems of poetry emerge from the framework of art and enter into

that of life. And it is precisely this change of direction and attitude that
Breton seized so clearly. Already for Apollinaire art had become a
means and not an end, a means to a better life in this world, an effort to
augment the dimensions and efficacies of our affective and intellectual
resources whether we call them "emotions," "senses," or "imagination,"
all part of the same apparatus of experience and awareness. To be a
poet is to know not only oneself better but others as well:

> Moi qui connais les autres
> Je les connais par les cinq sens et quelques autres
> ["Cortège"]

> (I who know others
> I know them by my five senses and some others)

Again in "Collines" he turns in the direction of knowledge rather than
of esthetic pleasure when he pronounces his famous line on the future
of mankind: "Plus pur, plus vif, et plus savant" ("Purer, more vital, and
more knowing"). The whole fundamental surrealist attitude is there in a
nutshell: the exhortation against artifice, against inertia, against igno-
rance. Let each one find his way! That is why Apollinaire in *Les Peintres
cubistes* does not classify the artists according to esthetic values but
according to criteria which he calls "metaphysical" for lack of a better
word with which to express the desire to change, to amplify, to
surprise—efforts which are part of the field of acquisition and radical
transformation rather than of consolidation and perfection of what
already exists. I think that it is a false distinction to separate on this
score the aspirations of Apollinaire and those of the surrealists.[4] The
antinomy between life and art does not exist for Apollinaire any more
than it exists for Breton because in both instances the two are
intermingled, and one cannot thrive without the other.

In the case of Apollinaire that union of life and art, free but
indissoluble, engaged the writer on dangerous ground. That is why one
of the great themes of Apollinaire, a double-edged theme, was that of
risk and loss, the risk that all adventurers have taken since the time of
the first Lucifer, and which is the common link between characters such
as Icarus, Orpheus, and Christopher Columbus, all of whom Apollinaire
evokes. It is in this context that he coined the expression "pilgrims of
perdition" in the "Poème lu au mariage d'André Salmon." Later he
used the slogan: "Perdre pour trouver." We must remember that as a

child Apollinaire had known the risks of gambling in Monte Carlo where his mother was ever present at the roulette tables. For him the poetry game is a risk beyond any measure where the chances of losing are almost guaranteed. "There is almost nothing in common between myself / And those who are afraid of burns," he said in "Brasier." The only defense against the sense of loss and disappointment in a life engaged in the pursuit of poetry was the power of laughter in the midst of regret and bitterness. That is the only fundamental trait of character of Apollinaire that Breton was not able to acquire. He was to cultivate black humor but not the bonhomie of laughter, and in circumstances which would make Apollinaire laugh Breton would rage with anger, that anger being virtually nonexistent in Apollinaire.

It must be noted that it was easy for Apollinaire to take chances and to break barriers since he belonged to nothing (perhaps with the exception of catholicism): he belonged neither to a country, nor a specific culture, and even his family ties were ambiguous. He was born free with all that the word means in terms of advantage and disadvantage:

> Libre de tous liens
> Donnons-nous la main
>
> ["Liens"]

He belonged to everything and to nothing. Not knowing with what to associate himself, he identified with a series of archetypes: magician, musician, conqueror, treasure hunter, thief, soldier, wandering Jew; he utilized even the character of the Christ as an emblem of the exceptional human being and the martyred revolutionary. He knew that poetry could no longer be cloistered in the Ivory Tower, but he could not find a stable new identification to give definitive designation to the poet. All along his poetic career encompassing eighteen years, this continuous effort can be observed to replace the archetype of the assassinated poet by a new and resurrected presence.

In his last year of life, when his relationship with Breton is most constant, all indications are that Apollinaire has already renounced the poetic adventure; as we can see in "La Jolie Rousse," in "L'Esprit nouveau," and in *Couleur du temps*, he had settled for verbalization, for theoretical demonstration while the existential character of the new poetic fulfillment had been erased from his life. Ironically Breton opted for what Apollinaire *was* rather than for what he had *become*. His

criticism of the mutilated poet's work proves it. What he admires is the pre-war poetry, but he is touched by Apollinaire as a dying poet who suddenly gives astonishing signs of timidity. Breton tells us in *Entretiens*: "I discovered the first two numbers of Dada at Apollinaire's, who frowned upon them, suspecting some of its editors of being in trouble with the military authorities of their country and going as far as to fear that receiving such a publication in the mail might compromise him." [5]

Apollinaire's last poem, "La Jolie Rousse," is indeed not a testament to victory but to gallant defeat, not that of a person who makes his will while he is still in good health and in his prime but of one who knows that he is about to die and that he has lost the wager. Let us take a close look at the 1918 poem. It contains all the vocabulary of war: conquest, domain, frontier, enemy, strife, battle; it also contains the rhetorical tone of provocative declamation. If he makes an inventory of his human activities it is with the tone of finality generally used in enumerating the heroism of soldiers fallen on the battlefield. If there is in his poem the same cry of the moribund as in the "Ballade des pendus" of Villon and if like him Apollinaire places himself before a future tribunal, his guilt is not the sin of ambition or of a gross misdemeanor; it is the sin of timidity. That is why his plea for pity is at the same time a justificatory document, a process by which he transfers his own failures to others who, to hear him speak, have presumably not permitted him to pronounce or reveal all he had in him of the seer and the prophet:

> Mais riez riez de moi
> Hommes de partout surtout gens d'ici
> Car il y a tant de choses que je n'ose vous dire
> Tant de choses que vous ne me laisseriez pas dire
> Ayez pitié de moi

> (But laugh laugh at me
> Men from everywhere especially the people here
> For there are so many things I dare not say to you
> So many things you would not let me say
> Take pity on me)

One could well ask: "But who would not let you say?"

The only triumph in that long complaint is that of the love of the pretty redhead; at last a winner in love after having been the rejected

lover all his life, he makes the image of his bride illuminate the otherwise somber tableau of the last judgment and the solitude of the dying poet. Still, the "I" of the beginning of the poem turns into the "we" of the solidarity of the genus poet, genus of which he wanted to augment the population by declaring that one could be a poet in all kinds of areas—the notion that was to become a central credo of the surrealists.

This strange encounter at the frontiers of a life about to be extinguished and another just beginning makes the impact the more dramatic and crucial. The influence derives from contrast rather than from resemblance. In terms of temperament Apollinaire and Breton had everything to separate them; what the contact did for Breton was to turn him away from his natural bent and cultural conditioning. Breton was the son of the lower middle class, strictly and narrowly brought up; one has but to examine his careful and regular handwriting to see to what extent he had been earmarked for the decorative, embellished, stable forms of the work of art. He was also an only child, accustomed to solitude and to contemplative reading. We have verbal self-portraits where he is pictured alone and withdrawn, sitting on a park bench, involved in his book and his conscience. This portrait bears little resemblance to the spiritual counselor and leader he was to become a few short years later, surrounded by his disciples and creating a much altered picture. In contrast, Apollinaire was the alienated one, without father or country, betraying in his lexicon through expressions such as "exiled," "émigré," and "shipwrecked" his status as a stranger. The problems of Breton and those of Apollinaire were poles apart. The one possessing a legitimate and national background was trying to break away from his inherited bonds; the other was to succeed in his last years in legitimizing himself by enlisting in military service and by relinquishing his natural state of vagabond to accept the idea of marriage and family relationship. And yet Breton, who was to show himself so intransigent toward the chauvinism of a Péguy or the patriotism of a Claudel, understands and accepts with some degree of indulgence Apollinaire's desire to place not his pen but his body in the service of the country to which he wants desperately to belong in spite of his spirit of adventure and iconoclasm.

Apollinaire had been a libertarian without being a subversive because of the ambiguous circumstances of his situation. In borrowing from the dying poet so many qualities foreign to his own nature, Breton

adds the spirit of social subversion which is forbidden to those who are
only elective citizens of a country.

In conclusion the totality of the materials Breton borrowed from
Apollinaire to construct his edifice of surrealism loom impressive and
are structurally integral and essential to its identity. The first of these
affinities is the face turned to the future. As if responding to the cry of
Apollinaire: "Men of tomorrow, remember me," Breton was to take as
his motto: "Once upon a time there will be." He was to adopt the way
of life of the older man: the door of his home open to colleagues, the life
at the café, the collective character of that life which produced a
veritable contagion of talents. Apollinaire had said: "our friendship was
the river which fertilized us." [6] The books and the art objects, his
friendship with artists, the fetiches Breton collected were a continua-
tion of the environment into which Apollinaire, the cosmopolitan who
wanted so much to become a Frenchman had introduced the provincial
Breton who wanted so much to become cosmopolitan. Like Apollinaire,
André Breton became a browser through Paris, making of Paris a
magnetic field and a constant and inexhaustible source of surprises and
mysteries. Having read at Apollinaire's apartment the books of writers
outside of the general run, such as Lautréamont and the Marquis de
Sade, he was to canonize them in his manifestoes. Breton was to assume
a number of the roles that Apollinaire had played before him, especially
those of Lucifer and Merlin. In the case of catholicism as a frame of
reference a marked difference was to emerge; whereas in Apollinaire's
poetry the martyrized figure of Christ has an emblematic significance, in
Breton's writing there is a constant struggle to liberate himself from the
catechism which is entrenched in his linguistic code, and the only
element of his native religion which he willingly utilizes is the
evangelical tone inherent in his surrealist annunciations. Of signal
importance to Breton in this emulation of his model is the positive and
virile character of Apollinaire. Breton was to acquire that violent
tenderness which was characteristic of Apollinaire's love poetry: "The
great force is desire," and make it triumph in the new poetry over the
effete and asexual archetypes of the symbolist coterie and its works, to
which the literary world had for so long become accustomed.

Apollinaire's literary taste offered a strange mingling of the
classical Mediterranean heritage and the Celtic and Nordic myths as
well as those of the Cabala. In rejecting classical humanism Breton was
to plunge even deeper into the hermetic sources evoked by Apollinaire.

Like him he was to learn to conciliate the spirit of occultation which penetrates the dark recesses of meaning with that of open communication which opens the doors of poetry to the four winds.

Finally, if the influence proceeds, as we have noted, from the existential to the literary, in terms of writing it does not stop at form but penetrates the poetic structure. If it is a fact that Breton criticizes the definition of modernism in Apollinaire—concentrated as it seems to be, according to statements of Apollinaire and superficial demonstrations, upon eccentric effects and problems of typography and punctuation— like him Breton keeps silent on questions and principles of esthetics. Like him Breton refrains from taking a position on poetic writing except in regard to the provocative power of words. Like Apollinaire he was to be concerned with verbal immanence rather than with style, and in the area of art criticism, following Apollinaire's example he was to emphasize the attitudes of the artist rather than the means of performance. The absence of an *ars poetica* in Breton derives directly from Apollinaire. Although in his early poetry Apollinaire's verse was often melodious because of assonances, refrains, and repetitions of *jeux de mots* and happy alignments, his line (not to say *verse*) became more and more free not only through the multiplicity of lengths but through the choice of his lexicon. Speaking of Valéry in a letter to Breton he said: "Valéry's demise was caused by a crisis of refinement" (AS, 25). At the beginning of his career Breton, as we have seen, almost fell in the same impasse. The fact that Breton chose "Lundi rue Christine" as one of Apollinaire's best poems is proof of his approval of the contamination of poetic language with the demotic. Apollinaire had developed a language on the one hand learned and on the other hand vulgar; both were attempts to get away from what was considered since time immemorial the pure lexicon of the poetic idiom, which contained a limited number of rimes and whose combinations made it possible to express nuances of meaning only through the diversities of syntax, contrasts and antitheses, hyperboles and litotes. Apollinaire had opened the doors of poetic communication in challenging the thousand-year-old notion of good usage. Breton was to follow in his footsteps and go far beyond, to replace the so-called elegance of his first verse which Apollinaire had called "pretty" by a total disdain, giving words neither the primacy of visual beauty nor the sonorities of the old harmony. There lies for instance the radical difference between Breton and Eluard. Even in his prime as a surrealist poet, Eluard prolongs the

tradition of Racine, whereas the language of Breton, raucous, irregular in its breathing span, rich in its multiplicity of rare words culled from all areas of usage, and possessing multicontextual significations, abandoned at the same time rimed verse and the prose poem, to follow the model of Apollinaire as crystallized in poems such as "Poème lu au mariage d'André Salmon," "Zone," "Cortège," "Les Fenêtres," "Arbre," "Lundi rue Christine," and "Musicien de Saint-Merry." Apollinaire had taught him to let the verse limp—what Breton was to call "the ruptured form," [7] and to develop a process of construction of themes and images, permitting a total liberty of linguistic expression.

Apollinaire was to become the ascending sign of Breton. Together they dissipated the symbolist climate and the decadent spirit that had prevailed in France for some fifty years, and opened the windows to fresh air. Like his friend, Breton was to become the poet of fire and light, emblems of warmth and knowledge.

Breton maintained to the end of his life and in the most agonizing situations that philosophical posture of affirmation: a philosophy of failure desired and accepted, like those furious workers in laboratories who know ahead of time the vulnerable character of their experiments and the dim chance they have of success in their undertaking. In the field of science what is important is the hypothesis and the activity toward the proposed objective. The collective activities of the surrealists were to have that very same scientific orientation: inspired, contagious, obstinate, optimistic, communicating and contaminating those involved, inciting and electrifying individual capacities.

Finally, Breton had the same sense of apostolic transmission of the faith as Apollinaire. Breton wore the colors of Apollinaire; it is not yet certain who will wear his, who will measure up to his stature beyond the conventional evolution of the surrealist manner.

NOTES

1. In critical biography: Anna Balakian, *André Breton: Magus of Surrealism*, Oxford University Press, 1971.

2. In Marguerite Bonnet, "Aux Sources du surréalisme: place d'Apollinaire," *La Revue des Lettres Modernes*, nos. 104-7, 1964(4) (série *Guillaume Apollinaire*, ed. Michel Décaudin, no. 3: *Apollinaire et les Surréalistes*); also my chapter on Apollinaire in *Surrealism: The Road to the Absolute*, New York, Noon Day Press, 1959.

3. Two good collections of letters are available: one in the appendix of Michel Sanouillet's *Dada à Paris*, the other in the journal cited above, note 2; the letters of Apollinaire to Breton are preceded by an introduction by Marguerite Bonnet. Here referred to as AS.

4. For a contrary opinion see Marguerite Bonnet's article, cited above, note 2.

5. Breton, *Entretiens*, Paris, Gallimard, original edition (1952), p. 52.

6. In "Poème lu au mariage d'André Salmon," *Alcools*. Of course the friendship mentioned in Apollinaire's verse refers to his lifelong friend, André Salmon, and not to Breton.

7. Apollinaire refers to Breton's use of the expression presumably in a letter addressed to him by Breton (AS, 23).

Cocteau, Breton, and Ponge

the situation of the self

Neal Oxenhandler

No concept reappears so consistently in contemporary writing about literature as the concept of "self." Critics have been ingenious in distilling the various fractions of the self, the modes of its incarnations, the phases of its interaction with the other, whether an object or another self.[1] The validity of the concept of self, insofar as it is the *fons et origo* of the poetic act, is no more questioned than is the critic's right and ability to speak from a subjective center, a self. Behind the concept lies the entire Graeco-Christian position, with its emphasis on the soul, its doctrine of responsibility, and its promise of immortality, that is, substantive continuity for the self.

Yet although the concept of self has had a destiny possibly more prestigious than any other, it is now under serious attack, perhaps even dying. Philosophy has attacked the egological position and the notion of a substantive self; for example, in Jean-Paul Sartre's *La Transcendance de l'ego* (1936), which aims at discrediting the traditional notion of a substantive ego, more precisely the Husserlian transcendental ego that serves to give coherence to conscious states. Sartre wrote in the preface to this work:

For most philosophers the Ego is an "inhabitant" of consciousness. Some affirm its formal presence at the core of the "Erlebnisse," as an

empty principle of unification. Others—psychologists for the most part—claim to discover its material presence, as the center of our desires and our acts, in each moment of our psychic life. We wish to show here that the Ego is neither formally nor materially *in* conscious-ness: it is outside, *in the world;* it is a worldly being, similar to the Ego of others.[2]

Sartre argues that the transcendental ego is superfluous; intentionality, the directedness of consciousness, is sufficient to account for the unity of mental states. The ego or self is not separate and apart, but plunged into the world. The interaction of self and world constitutes the ego, not as a substantive being but as a confluence of transversal intentional acts, even memory itself being a mere screen on which mental states are projected.

Poetry too shows this same tropism toward a non-egological position, toward first a refinement and then, ultimately, an abandon-ment of the ancient concept of self. This is at stake in the poetic evolution of the three poets I shall consider here—Cocteau, Breton, and Ponge.

Each of these poets, despite his long career, is marked by the stamp of a specific decade or decades: Cocteau is a poet of the twenties, Breton a poet of the thirties and early forties, while Ponge exemplifies the late forties and the fifties. We can read their poems as if they were refractive lenses, each one precisely focussing for us the self-concept of the period.

The exercise begins with Cocteau's deceptively simple poem "L'Hôtel" written in 1925, a poem-snapshot—or better, a movie, depicting perhaps the sights and sounds of the Hôtel Welcome in Villefranche.[3] The poem should be classified with certain "present tense" poems which capture the immediacy of experience, such as "Lundi rue Christine" of Apollinaire. Unique to the poem, however, is its particular use of puns: "mer veille" ("the sea keeps watch") and "merveille" ("marvel"), "rue meurt" ("the street dies") and "rumeur" ("sound"), "île faite en corps noirs" ("island made of black bodies") and "il fait encore noir" ("it is still dark"), "les rats de boue" ("the rats of mud") and "debout" ("standing"); finally, there is the triple use of "sel" to mean salt, saddle, and as a syllable in "aisselles" or armpits. The verbal combinations are created following what Emmanuel Mounier describes as "pseudo-laws," drawn from the "old deforming and

summary apparatus of the laws of association";[4] Cocteau's compulsive speech, in other words, exhibits an old-fashioned associationalism. The interrelations among the images of "L'Hôtel" are not multidimensional.

We know that punning is often a profound poetic device, linking multiple meanings. The disjunction between phonetic and semantic content will, in the best poetry, emphasize the theme of the poem. But there is no such profundity here. Rats whether dying or standing have no poetic charge or energy, while salt, saddle, and armpits are only dimly related. The puns are here, in fact, to serve a somewhat blatant purpose. We recognize Cocteau's tendency to exhibit his wit at the expense of a shaped and felt communication, to present himself—the public relations genius who was also at times a good poet—rather than to allow his personality to be mediated by the metaphors of a poem. We are dealing, in other words, with a form of poetic exhibitionism that defines for us one boundary of the modern view of self.

If language stops, identity fades away. Whatever we are—and, for Cocteau, each individual has a specific "nature"—this disintegrates when language stops. So the poet speaks endlessly in order to maintain the being-status of his threatened self. This self secretes language like an essence and manifests itself primarily as a producer of puns, word-plays, images, aphorisms—language in any form.

The use of language to preserve the self is original; the notion that every individual has a nature—is a poet or a lover or an opiomane or a homosexual—is extremely conventional. While Cocteau is poetically original, he is morally old-fashioned. This is demonstrated by a second poem, "A force de plaisirs," written in 1922. The insoluble dilemma which the poem poses—a conflict between conventional morality and the needs of the self—receives a tentative solution through the appeal to language.

Here, the winged animals help establish the basic moral conflict—between ascent and descent, flying and falling. The first image suggests sexual desire within the body seen as a "hive":

> A force de plaisirs notre bonheur s'abîme.
> Que faites-vous de mal, abeilles de ma vie?
> Votre ruche déserte étant maison de crime,
> Je n'ai plus, d'être heureux, ni l'espoir, ni l'envie.
>
> Sous un tigre royal, la rose aux chairs crispées,
> Meurt de peur; il est vrai que ce tigre a des ailes.

Mais l'ange gardien qui casse nos poupées,
A des ailes aussi comme une demoiselle.[5]

(By excess of pleasures our happiness dwindles.
What evil are you doing, bees of my life?
Your deserted hive is a house of crime,
And I have neither desire nor hope of happiness.

Beneath a royal tiger, the rose with taut flesh,
Dies of fright; it's true that this tiger has wings.
But the guardian angel who breaks our dolls,
Has wings too like a dragon-fly.)

The word "poupées" suggests that we are in a nursery. Perhaps the tiger is not a fierce carnivore at all but a child's stuffed animal. The tiger, at any rate, partakes of the bipolarity or ambivalence of all the images in the poem—a movement that is a frenetic, trapped alternation between opposites, flying and falling as we have seen, but also restraint and indulgence as well as maturity and childhood. We begin by this point to understand that the "pleasures" of which the poem speaks are ineradicable childhood sexual fixations. Together the tiger and the guardian angel represent authoritarian inhibitions to the child's impulse to be true to his nature. Here we have then, in metaphoric form, Cocteau's central moral problem: the conflict between moral convention and one's own nature.

The passage from one winged being to another—from the bees to the tiger to the guardian angel, to the schoolboys whose capes are like the wings of angels leads to one of the central themes of the poem, the determining effect of childhood sexual experiences on the future emotional life of the individual. Love is born with the throwing of the snowball: "La neige est vite marbre aux mains prédestinées / Du marbre au sel Vénus connaît la route blanche" ("Snow quickly becomes marble in predestined hands / From marble to salt Venus knows the white road"). This scene condenses the snowball fight dramatized so vividly in Cocteau's film Le Sang d'un poète. Paradoxically, it is these very winged beings—the bees, the schoolboys—who will impede the ascension of the poet and bear him down into squalor and guilt.

The past participle "clouée" in stanza 6 evokes Christ nailed to the cross. Here, Christ is less a judge of the poet's moral ambivalency than he is a fellow sufferer, a fellow martyr. In his own way, the poet is

crucified by contradictory impulses, for in the last two stanzas we see him contending with his childhood memories; within him the bees still manufacture the honey of sexual desire, longing for the ascension of unambiguous selfhood. He is dragged down by Venus and the snowman who represent the repetitiveness of sexual habits.

The hermetic surface of this avant-garde work, its autonomous verbal manipulation, according to the laws of free association, actually masks a conception of character that might have come out of some nineteenth-century catechism. Character is conceived of as a nucleus of static and competetive states. The metaphor of lightness, which dominates the poem, indicates the unattained reconciliation of these states.

According to Emmanuel Mounier, "The most immediate given of psychological consciousness is not a state, however subtle, however unique, it is an affirmation, seized as such, by itself, first in its exercise, then in its own reflection on its activity."[6] In contrast to Mounier's existentialism, Cocteau proclaims that the self is, precisely, a *state;* and the function of the poem is to demonstrate the vacillating efforts of that state to maintain itself in the midst of a threatening world. Not to affirm, only to maintain, primarily by verbal self-display, by wit and linguistic manipulation. In Cocteau, then, the self appears as a complex of feeling-states maintained by the associative power of language.

For André Breton, who sees consciousness as in the world, whose existence is in the Heideggerian sense a being-in-the-world, the image demonstrates, to paraphrase Merleau-Ponty, how consciousness is glued to things of the senses. The "magnetic field" which Breton evokes to describe the privileged moments of poetic consciousness occurs within the perception of an environing world, a world governed by the laws of objective chance—that magical concatenation of events which makes the life of the surrealist unique and significant. Nevertheless, the main emphasis is on consciousness—on the self. Breton writes:

Let us remember that the idea of Surrealism tends toward the total recuperation of our psychic force by a means which is nothing else than the vertiginous descent into ourselves, the systematic illumination of hidden places and the progressive obscuring of other places, the perpetual strolling into forbidden territory. . . .[7]

Breton, the student of Janet and Freud, the lay psychoanalyst,

the practitioner of dream interpretation and automatic writing was, from the beginning, committed to the notion of depth psychology. The explicit goal of the early period of surrealism was to transcribe the unconscious workings of the mind; and, although this goal widened to include the total liberation of mankind, the commitment to "la descente vertigineuse en nous" was never abandoned. While Cocteau remains in the conscious and semiconscious layers of mind, Breton plunges into the depths. Thus the images of fish and diving-bells in his poems; or the image of night as a kind of interiority; or the image of a breach made in a wall, allowing passage and communication—as if messages from the unconscious might surge through it. The emphasis on seeing the marvelous, as in a volcano in eruption, on perceiving the unknown, points once again to that "vertiginous descent" doubled by an occult premonition of mysterious forces beyond the self.

The complex strategies of surrealist poetry aim in many direc- tions, produce many effects, central to all of which is self-exploration, self-revelation. "Directed hallucination" aims at revealing the dimen- sions of self that border on madness; "the unsettling of sensation" goes beyond pleasure toward sense experience as self-knowledge. Other strategies, such as ambiguity, metamorphosis, and analogy are meant to destroy "the false laws of conventional juxtaposition" to permit the revelation of the true order of the unconscious. It has been suggested that Breton's "basic perception" is that implied in the image of the "vases communicants," the two joined vessels in which dream and reality, chance and daily life, the inner and the outer connect with each other.[8]

In his poem "Un Homme et une femme absolument blancs," from Le Révolver à cheveux blancs (1932), Breton presents a scene of erotic contact between man and woman.[9] Although Breton disparages sexual contact without love, he nevertheless admires the "prostituées merveilleuses" who represent chance, the introduction of the marvelous into life. As the pure force of desire is unadulterated by emotion, the adjective "blancs" in the title may be a synonym for nude, for man and woman are shown to us emotionally naked in the poem.

The prostitutes pass under the street light, displacing a moving plane of light, the "papier mural" referred to, evoking in its turn a house undergoing demolition, a marble seashell and a chain. Sexuality and light, the latter now compared to handfuls of cut hay, are fused in the fire which devours the street where the prostitutes walk. They take

on mythic dimensions; their breasts glow in the night like a sun and their breathing ("le temps de s'abaisser et de s'élever") ("the time to rise and fall") becomes the chronometer of life itself. One of the two concluding images of the poem, that of their breasts like stars on the waves, exalts the feminine principle of the Magna Mater, swelling it to cosmic dimensions and identifying it with the forces of nature. The prostitute takes on the divine character she enjoys in certain oriental religious cults; she is desire incarnate, hence woman in her most universal form. Here, Breton presents the self in its Jungian aspect, as defined by its anima, the female principle filled with life and an imperious power, the mystic projection of the self into its environing world.

But the poem does not end with the poet's immersion in the anima. The final image marks a return to a more detached, more objective kind of observation: "Leurs seins dans lesquels pleure à jamais l'invisible lait bleu" ("Their breasts in which forever weeps the invisible blue milk"), an image of frustrated maternity. The scene ends, the women have walked through the light and are gone, the poem subsides after the expansion and contraction of the self.

So the poem represents a surging up, out of the vessel of the unconscious into that of the conscious, a rising and a subsiding of the mysterious power of sexuality, its stimulation and appeasement *by the act of the poem itself*. Breton calls on the power of poetry to open the unconscious, to reach the deep source of sexual energy and allow its incarnation in the unfolding of the poem. More than the prostitutes it is the poem itself that awakes and appeases desire, that calls into play objective chance; for the words that rise up in the poet's mind are as capriciously liable to attract or repel him as the appearance of the beckoning women.

Almost any poem of Breton's might illustrate the most consistent aspect of his poetry—the way in which language reproduces the psyche in a state of free play; almost any poem could illustrate for us the poem as a literal document of the unconscious at work. But let us look at some lines from Breton's epic "Fata Morgana," published in 1942:

Le lit fonce sur ses rails de miel bleu
Libérant en transparence les animaux de la sculpture médiévale
Il incline prêt à verser au ras des talus de digitales
Et s'éclaire par intermittence d'yeux d'oiseaux de proie

Chargés de tout ce qui émane du gigantesque casque emplumé
 d'Otrante
Le lit fonce sur ses rails de miel bleu.[10]

(The bed hurtles down its rails of blue honey
Freeing in transparency the animals of medieval sculpture
It tilts ready to spill into the slopes of foxglove
And intermittently lights up with eyes of birds of prey
Brimming with everything emitted by the gigantic plumed helmet of
 Otranto
The bed hurtles down its rails of blue honey)

 As in Rimbaud's "Bateau ivre," the basic structure is that of a
dynamic, hallucinating movement past a series of disparate landscapes
which have a mysterious revelatory power. The flowers and plants
convey a sense of biological plenitude, a vibrant and burgeoning life.
The voyage is both concrete and internal. Not only does it reveal
strange landscapes, it also reveals the hidden inner landscape of the self,
that "sublime point" where all contraries are resolved in a fusion best
conveyed through the metaphor, a device more necessary than any
other to the surrealist ontology. For it is the metaphor that conveys best
the sense of mental process; and the surrealist poem is the mind in act
at its most intense, most visionary peak—striving for the "sublime
point."
 The dominant image of the fragment is the bed running on
tracks of blue honey, locus both of sex and sleep, a vehicle which
plunges the poet into a landscape of changing metaphors. This
metaphorically drawn landscape is the self seen as a shifting perceptual
field. The images are diverse and disjunctive—the antiquity of medieval
sculptures and the presence of Morgan la Fée (whose name gives the
poem its title), are juxtaposed with images that must originate in the
poet's own experience, however twisted by imagination and the play of
language. For instance:

 le petit chemin de fer
Qui se love à Cordoba du Mexique pour que nous ne nous lassions pas
 de découvrir
Les gardénias qui embaument dans de jeunes pousses de palmiers
 évidées

(the little train
Which twists to Cordova from Mexico so that we never tire of
 discovering
The gardenias which scent the air in young palm shoots hollowed out)

In its passage through lush landscapes, the train conveys the poem
toward a future discovery which is never made precise. In this portion
of the poem, there is no attainment of the "point suprême," there is no
break-through, no revelation. Instead, the poem loops back on itself, as
certain images are repeated: "les bocaux de poissons rouges" ("the
bowls of goldfish"); "le lit à folles aiguillés" ("the bed's crazy
stitchings"). The poet's consciousness remains glued to things of the
senses.

The dynamic action of the psyche is conveyed in a number of
ways by the poem. First, through the sense of constant movement or
flux: the psyche is always in action, never at rest. Second, through the
use of analogy, juxtaposition, and metaphor: the inner self is not
governed by any *a priori* laws but reveals itself as a constant surging up
of words and images in ever new constellations. Moreover, the very
rhythm itself, a prose rhythm that maintains a definite beat as lines of
varying lengths unfold, is free from the constraints of convention; it
obeys only the promptings of the poet's own inner self. Third, there is
the implicit eroticism of the poem: the deep self is always sexualized,
always polarized by the mutual need of man and woman.

It is clear that "Fata Morgana" represents a deeper plunge into
the self—into the poet's consciousness—than either of the poems by
Cocteau. While Cocteau's "A force de plaisirs" is a poem about
psychological experience, Breton's poem gives us the actual experience
of the psyche in flux. Here, the function of the poem is to demonstrate
through metaphorical language how a tropism of the unconscious draws
us deeper and deeper toward the experience of psychic unification.
Breton then is a poet of interiority and depth. That depth might be a
mere metaphor, even an illusion, is never questioned by Breton or the
surrealists, who continue to place overwhelming emphasis on the
revelation of the self. And this point of view continues until Francis
Ponge begins to discover, around 1942, that the self can be a prison, and
that another kind of adventure awaits those who abandon the study of
man for something in appearance more trivial and more circumscribed
—the study of the object.

The first poem by Ponge I shall consider, "Pluie," is one of the most perfect poems in his volume *Le Parti pris des choses*.[11] The entire volume demonstrates the interaction of the poet's sensitivity with objects and the creation of a material universe of language correlative to those objects. "Pluie" does this with humor, delicacy and a great sense of dedication to the object as the nexus of our most fundamentally human experience. Therefore, when we speak of the poem by Ponge it is important not to conceive of it in terms of a naive realism. We are not dealing with the object, to the exclusion of a human perceiver; rather, the meaning of the poem lies in the way perceiver and object interact.

The aim of a poem by Ponge is not, as in Cocteau, to demonstrate the poet's wit; nor is it, as in Breton, to plumb the depths of the poet's unconscious. There is no exploration of psychic states—such as sadness or boredom—connected with the phenomenon of rain. Insofar as the poet is concerned with presenting a psychic state at all, it is one which arises from the act of description. Nor is perception itself examined as a type of psychic phenomenon, with the aim of discovering its laws and structure. The entire poem is concerned only with the act of description, that is the act of finding a series of verbal equivalents for the phenomenon of rain. While not devoid of metaphor, the description is generally discursive and prosaic, beginning with the observation that "La pluie . . . descend à des allures très diverses" ("The rain . . . comes down at very different speeds").

The phenomenon of rain is conceived as a physical event, occupying time and space, and impinging on the physical environment —the roofs, the gutters, the windows; apart from this specific description, the poem seems to have no other intent. The organizing principle for the description is the diversity of the ways in which the rain manifests itself, with no effort made to develop this as a metaphysical insight or even as a metaphor for the diversity of manifestation as it might typify man's ability to perceive the subtleties of nature. If any metaphorical extension at all is intended, it lies in the celebration of the diversity of nature—a celebration carried off in a low key. And the poem ends in a completely restrained way, by giving us the name of the phenomenon we have just witnessed; "il a plu" ("it has rained"). By uttering this banal expression, the poet makes it clear that we are not to expand or elaborate on the phenomenon, we are not to attribute metaphysical meanings to it or interpret it as the manifestation of some complex psychic state. Nor is it a Baudelairean "correspondance"; the

poem is not designed to lead us to "les transports de l'esprit et les sens" ("transports of the mind and the senses"). Everything in the poem circumscribes and limits the metaphorical possibilities, forcing us to experience the poem in a particular way.

It is that particular way we must clarify. Behind this presentation of rain lies a philosophical position. Ponge is opposed to anthropomorphism, he is opposed to humanism, he is opposed to any position that gives man a privileged status in the universe. Here, he anticipates the position given currency by the anti-humanism of Robbe-Grillet. There is no celebration of human cognitive acts or human emotions; instead, the poet insists that man is on a level with objects, having no secrets or mysteries to raise him ontologically above them. For the new anti-humanists, man's ontological pride has led him into the trap of false values: he is not in the image and likeness of God, he is not a little less than the angels, he is not a soul inhabiting a body. To attribute some supreme value to him is to create a false and distorted metaphysics. For these anti-humanists, man is simply an object, having both the dignity and triviality of objects, whose ontological status he shares.

And yet, the interaction between man and objects fascinates the poet, who rejoices in such simple things as the banal act of opening a door ("Les Plaisirs de la porte").[12] Ponge calls this playful interaction of human perceiver and object, in which each reveals the nature of the other, the "objeu." Verbal precision is needed if the "objeu" is to be adequately reflected. Ponge strives for accuracy, instead of aiming to astonish or overwhelm, as the metaphorical language does in Cocteau and Breton.

The first sentence makes it clear that the pleasure of opening a door, a pleasure whose exact quality the poem is carefully constructed to convey, lies precisely in its banality, its ordinariness—"Les rois ne touchent pas aux portes" ("Kings do not touch doors").

The second stanza culminates in the strongly emotive phrase, "tenir dans ses bras une porte" (to hold a door in one's arms). This emotion is reiterated and emphasized in the next stanza, introduced by the emotive word "le bonheur." The entire line suggests an almost erotic intimacy:

Le bonheur d'empoigner au ventre par son noeud de porcelaine l'un
 de ces hauts obstacles d'une pièce

(The joy of grasping by its knob of porcelain the belly of one of these
 tall obstacles in a room)

Not only is the poem erotic, it is didactic. Ponge is giving us
here, in highly condensed form, a phenomenology of the door. He asks
us to exchange our unthinking reflexes for a new awareness, arising from
the direct and immediate presentation to consciousness of an event that
is normally cancelled out of our mental field by preconception but is
now renewed by poetic language.

This phenomenology of the door involves more than the pleasure
of an opening and a shutting. It leads to what might be called the
essence of the door, the quality which makes it unique. This is the
door's ability to close us off from one experience, one bounded space,
and embark us on another. The last stanza evokes precisely that
moment when a man stands on the threshold, hesitating between past
and future, before he makes his decision and resolutely pulls the door
shut:

> D'une main amicale il la retient encore, avant de
> la repousser décidément et s'enclore—ce dont le
> déclic du ressort puissant mais bien huilé
> agréablement l'assure.
>
> (With a friendly hand he still holds it open, before
> decisively pushing it shut and enclosing himself—
> a fact of which the powerful but well-oiled click
> of the spring agreeably assures him.)

This is not any specific door or any specific individual who passes
through a door, but rather the attempt to communicate the essence of
an experience in a language free from artifice, a language that takes as
its goal a dedication to truth.

Ponge sees his poetic mission as the completion of the task of
Malherbe, La Fontaine, and Mallarmé, poets who preferred truth to
artifice and sought for a rigorous form of consciousness expressed in a
concrete language of logical structure. Ponge wishes to lead us to an
understanding of the object, that entity whose otherness dominates our
life at each moment. And finally, lying beyond the poem, the poet's goal
is to obtain the "objoie"—not ecstasy or delirium, but that simple
pleasure in interaction with the things of this world that man can attain.

In his book, *Le Savon* (1967) Ponge recreates the universe out of soap, which becomes the dominant metaphor for a reordered creation. In this universe, Pontius Pilate, the man with clean hands, becomes the chief hero. For the tragic vision of Sartre and the obsessed vision of Robbe-Grillet, Ponge substitutes a lighthearted evocation of a sudsy world. The submission to objects does not entail a spirit of anguish; the renunciation of man's supreme dignity carries with it no sense of loss.

Selfhood carries with it the burden of consciousness but Ponge renounces even that, at least in its transcendental aspects. He no more fears God than he fears death. Modern literature is often a literature of renunciation (Rimbaud renounces his adulthood and his Christianity; Beckett renounces his reason and the limbs of his body), but never before has the renouncing been done so gaily. Ponge's blithe renunciation of radical subjectivity—the subjectivity of a Kierkegaard or a Heidegger or a Sartre, his gaiety in the assumption of a diminished role, his abandonment of transcendental objectives and his calmness in the face of death—these characteristics mark a new poetics, a poetics that envisages the human condition in a renewed and optimistic spirit.

If we look at the role assigned to consciousness by the three poets I have discussed, we can see a process of evolution which has gone on from the early years of the century up to the present. Cocteau writes out of a naive belief in the stability of the self, a belief which is typical of a still dominant psychology, implying no radical doubt as to who or what man is. Despite the anguish of psychological conflict, it is impossible to see Cocteau as a poet who deeply scrutinizes the self. He is still very much a writer of *la belle époque*, something of a dandy and esthete. He inhabits an ordered world—indeed, he often characterizes it as geometrical—and uses poetry less as a means for questioning the role of self in this world than to achieve the pleasurable epiphany of the esthetic event. Poetry serves to please by its flash and filigree, to amuse by its wit, and, above all, to display the self for the admiration of others.

With André Breton, poet of the thirties and forties, the years of World War II, we find the realization of the old Romantic imperative which ordered the poet to uncover the deepest layers of the self. This seems on the face of it a more serious imperative than any heeded by Cocteau, and, as we know, Breton took his mission with a seriousness that was sometimes pompous. But some thirty years after, it is time to ask whether or not the techniques of surrealism—such as dream transcription, use of objective chance, and automatic writing—actually

led to a deeper revelation of the self. We must heed the view of Merleau-Ponty and Sartre who insisted that the unimpeded flux of the mind, as in stream of consciousness, does not reveal character. Only action and choice within one's life situation can reveal character; in other words, there are no purely linguistic techniques for getting at the self, which cannot be reached directly, but must always be mediated by a form or structure. The efforts of surrealist poetry to solve the great problems of human existence, to provide the total liberation of man, fail even though it succeeds in other ways: it reveals the paradoxes of the self and brings to the surface, from the inner reaches of personality, the various forces that are dynamically at play within the person. If surrealism does not, finally, give us the self *in toto* it is because the self cannot be reached by direct assault. Only indirection, a detour through specified forms and even conventions, can reveal its paradoxical nature.

After the war, there is a flight from self-knowledge, a flight once again from the burden of consciousness. The search for identity is aborted, the dream of total self-knowledge and self-realization is abandoned. All man's transcendental goals are thrown overboard. This includes the urge to know God or to know the innermost reality of another being. The struggle to conquer death by an act of will or imagination, as we find this attempted in Bernanos or Camus, this effort too is given up. The imposition of a transcendental shape on life, indeed the belief that life must be consciously defined, as we find this presented by existentialism, seems both unrealistic and impossible. The great dreams and the great objectives vanish and we are left with Ponge's images of soap, bread, raindrops, a well-oiled door.

We read Ponge in a state of moral and spiritual exhaustion, after the failure of all the great spiritual attempts of the last fifty years. I do not think his metaphysic is ultimately right or that it will endure. But his success in going beyond the self represents a moment of stasis. We should accept his invitation to share the "objoie," even if we can be under no illusion as to the permanency of this moment of peace. The burden of consciousness can never be set down once and for all. The transcendental themes will return once again to poetry, although perhaps mediated by things as small as raindrops or the click of a poet's latch as he draws the poem shut behind him like a door.

NOTES

1. An excellent study which follows this path is Priscilla W. Shaw's *Rilke, Valéry, Yeats: The Domain of the Self*, New Brunswick, Rutgers University Press, 1964.

2. J. P. Sartre, *La Transcendance de l'ego: esquisse d'une description phenoménologique*, ed. Sylvie Le Bon, Paris, J. Vrin, 1965, p. 13 (my trans.).

3. "L'Hôtel" in *Opéra, Oeuvres complètes de Jean Cocteau*, Geneva, Marguerat, 1947, 4:116.

4. *Traité du caractère* in *Oeuvres de Mounier*, Paris, Ed. du Seuil, 1961, 2:14.

5. Stanzas 1 and 2, "A Force de plaisirs," in *Poèmes 1916–1955*, Paris, Gallimard, 1956, pp. 31–33 (my trans.).

6. Mounier, *Oeuvres*, p. 524.

7. "Rappelons que l'idée du surréalisme tend simplement à la récupération totale de notre force psychique par un moyen qui n'est autre que la descente vertigineuse en nous, l'illumination systématique des lieux cachés et l'obscurcissement progressif des autres lieux, la promenade perpétuelle en pleine zone interdite. . . ." *Second Manifeste du surréalisme*, Paris, Simon Kra, 1930, p. 23.

8. Mary Ann Caws, *The Poetry of Dada and Surrealism*, Princeton, Princeton University Press, 1970, p. 78.

9. André Breton, *Poèmes*, Paris, Gallimard, 1948, p. 82.

10. *Ibid.*, p. 159.

11. Francis Ponge, *Le Parti pris des choses*, Paris, Gallimard, 1942, p. 7.

12. *Ibid.*, p. 21.

Yves Bonnefoy and Denis Roche

art and the art of poetry

Sarah N. Lawall

When a writer analyzes the relationship between literature and art, and especially when he seems to find his own ideas expressed independently in another medium, the art he favors may or may not be a key to his own literary techniques. His is a curiosity of the creative imagination that seeks to define itself against the refracted images of other personalities and artistic techniques. The kind of painting or sculpture he admires, the special perspective he usually applies, the kind of connections he will recognize between two media, the influence he chooses to allow on his own work, his role as exponent or disciple of another art form: all blend to form an intricate pattern leading from visual art work to literary production. This relationship must be defined specially in each case. Here we have chosen to look at the relation of art and text in Yves Bonnefoy and Denis Roche, two contemporary poets of different generations who represent, moreover, two quite different attitudes towards artistic expression.[1] Both Bonnefoy and Roche have published their poetry in conjunction with essays on art, and both assert an integral relationship between art and their own creative imagination. Their manner of relating to art differs along lines that reflect separate understandings of the creative process in both art and literature.

Yves Bonnefoy writes scholarly, appreciative art criticism that

emphasizes the separate technical requirements of a different medium.[2] From *Peintures murales de la France gothique* (1954) to *Rome 1630* (1970), he displays a constant sense of the raw materials of art, and their deployment in space, even when he seeks to bring out a work's philosophical implications. Bonnefoy's increasing preoccupation with the ontological significance of art does indeed penetrate his formal analyses, but—rather remarkably—he continues to define this significance in terms of its technical expression. In an essay titled "Baudelaire contre Rubens," [3] he outlines a kind of formal-spiritual dialog in which Baudelaire rejects the implications of Rubens' *formal* vision. Poets and painters are only accidentally (though genuinely) separated by their different media. An essay on techniques of expression in French poetry ("La Poésie française et le principe d'identité") considers both painting and poetry, and elsewhere Bonnefoy compares Morandi to Mallarmé, Mallarmé to Piero della Francesca,[4] and Raoul Ubac to poetry in general.[5] All art, according to Bonnefoy, reveals a "gnostic" quest through the shape of its perceptions: a quest for a hidden knowledge and beatitude that we feel just out of sight, and yet need to locate in the world of our own experience. At times, Bonnefoy describes paintings that represent allegorically this search for divine unity, but usually he sees it implied in details—in the blue of Poussin's "Bacchanale à la joueuse de luth" (AP, 11–12)—or through the implications of canvases by Miró or Ubac, apparently abstract but in reality allusive. Bonnefoy does not confuse the techniques of art and literature, and never uses the slipshod rhetoric that adapts painterly terms for literary criticism, but he sees one role for any form of art: the recovery of a "presence" in reality, and the relation of this presence to man's age-old intuition of a lost paradise. He is especially drawn to works that imply a double level of existence, where (as a recent poem put it) "sign has become place." [6] Artistic form (the *sign*) creates a *place* inhabited by a special *presence*: in Bonnefoy's view, therefore, true art can be neither a simple-minded copying of exterior details, nor an arbitrary formalism that revolves around its own subjectivity.

These themes remain the same throughout Bonnefoy's art criticism. His latest book, *L'Arrière-pays* (1972), is an autobiographical narrative that describes how the poet's "gnostic search" for an intuited "country beyond" evolved along with his artistic sensibility. Bonnefoy follows traces of this "arrière-pays" through the clues given in Italian painting, in early Quattrocento painters and architects, in de Chirico,

and ultimately in baroque art that "rose holding in its hands the mystery—this time fully illuminated—of the assumed, fully accepted *place* of existence." [7] *L'Arrière-pays* emphasizes three main areas of artistic experience: a *presence* in a particular *place*, with overtones of paradise regained; a gnostic quest for being that leads to this same recovered paradise; and an insistence on art as a significant, personal form rather than empty representation or soulless patterns. Bonnefoy's art criticism returns again and again to these ideas, which also govern his poetry.

He insists on the spatial metaphor because he does not want to suggest an abstract idealism separated from earthly experience. "Anxious for transcendence but also for a place where it would be rooted," he dreams in *L'Arrière-pays* of finding, somewhere in southern Tuscany, a hidden room where "the absolute work exists and real country is all around." [8] This image of a special place refers to artistic technique as well as to ontological speculation; it evokes the inexpressible intersection point of visible and invisible reality, but it also leads into a discussion of the spatial techniques that artists use in representing the world. Italian Renaissance painters, according to Bonnefoy, accentuate precise perspective not merely for clarity but to demonstrate how even the most exact representation lacks reality. Baroque art "focuses space by presence" (R, 18), and Bernini creates a *being of place* (*l'être du lieu*) out of techniques suggesting pure absence (AP, 154). Ubac paints the "inner infinity" of a space of essences (RM, 157). In the larger perspective of art history, Bonnefoy sees Mantegna, Piero, Bellini, and Giorgione conjugate together a "place of exchange" which leads from silence to essential reality (AP, 150). Finally, space is fully "assumed" in the forms of baroque art; the *hic et nunc* once devoid of form and meaning at last attains real presence, and "the vacant *here* crystallizes" (AP, 149).

This crystallization of real presence comes only after a long experience and ultimate surpassing of the gnostic search. Bonnefoy calls gnosticism a necessary part of great art, inasmuch as art expresses a human need to be journeying towards some indefinable goal (RM, 17–18). Great art seeks to reproduce the gnostic's intuition of being; Italian painting up to the end of the baroque period subordinated precise representation to ontological evaluation, says Bonnefoy (AP, 77), and in modern times Van Gogh, Monet, Matisse, Derain, and Miró choose forms that reach beneath the "physical appearance of things" to

"bear witness to the power of reality" (M, 6). Insofar as the gnostic search stresses its own subjective vision, however, it risks falling into a dualism of subject and object that effectively destroys the very transcendental unity desired. This distortion of the gnostic search seems to be, in Bonnefoy's eyes, a trap into which much contemporary art has fallen. Such art has become pure form, the play of a subjective consciousness lost among a maze of objects seen only from the outside. The poet's recent art criticism speaks more and more pointedly of the dangers of purely idealized form, even though he continues to appreciate abstract technique when it expresses the impulse of creative imagination.

Bonnefoy's point of view is interesting because he actually does try to discover moral significance in form, and yet does not fall into the familiar trap of favoring moral subjects cast in allegorical or representational techniques. He does not seem personally interested in representational form whether it be the Caravaggio tradition (which "unleashed exteriority" [R, 128]) or a modern neo-realism. Bonnefoy values a form that is personal without being subjective, abstract without being empty, significant without being didactic. His analysis of a work's formal existence is in fact quite Sartrean: in "Baudelaire contre Rubens" and parts of *Rome 1630* both ideas and vocabulary are strongly reminiscent of Sartre's *L'Imaginaire:*

It is true that what the work has touched is no longer, for the Midas who creates it, anything but a moment of the work. . . . the self—now made essence, taken out of the stream of time, and reduced to three-dimensional intelligibility—has been stolen away. . . . What we put together is only our own imagining. [BR, 107]

[Poussin gives us] an operation of the mind. How? By dissociating the data of the senses (form, color) from the object or the scene it represents; then by trying to deploy these data according to their own potentiality—spatial relationships, tensions of chromatic layers—to impregnate them with the abstract relationships controlled by consciousness, to transform them into mental reality—and thus to have *possessed* them. [R, 126]

However, Bonnefoy's understanding of the role played by conscious form is accompanied by a warning that form is only one aspect of reality (R, 18). Form must be allusive, not merely abstract (I, 80), or it will not designate the *lieu d'existence assumé.*

In reiterating that form must carry a charge of implied values, Bonnefoy sets himself openly against the view that art is pure form, or an arbitrary assemblage of socially defined impulses and artifacts. Form is to be used and questioned in the search for larger meanings: Rubens himself "does not hesitate to put in question a formal system. . . . He will ruin a language if there is a fact he has wanted to penetrate" (BR, 81). There is a danger that modern artists will forget this search for essences, and succumb to the temptations of abstract formalism:

For many contemporary "a-formal" ["informels"] painters seem often to forget, in their tortured need for immediate possessions, that they could not actually live without having established some values or discerned some essences. [RM, 148–49]

And I am glad to see some contemporary painters, guided by this presence that transforms the object, understand that the true language is reality itself, with its situations coded, and not these words, techniques, or styles which are never anything but a part. [RM, 153–54]

For Bonnefoy, art as pure form denies art as humanistic expression, and a civilization is successful only if it can evoke its own particular image of man (RM, 155). With such a highly personalized view of art, Bonnefoy rejects both impersonal structuralism and Marxist historicism. He calls Marxist realism "a provincial spirituality," and asserts that "art is not formed by an imagination responding only to the demands of history. It is the slow accretion that simultaneously reveals and protects a secret" (R, 131, 166).

Some of Bonnefoy's most explicit descriptions of art as *essential* form occur in the introduction to his book on Miró. Miró represents for the poet both the craftsman's joy in technical experimentation, and the humanist's desire to see technique reproduce pulses of the creative imagination. Miró's abstract art is a culmination of pure form; it attains a "music of numbers" and "approaches the boundaries of pure calligraphy" (M, 26–7). On the other hand, this formal purity is not devoid of meaning, and brings with it the "discovery of a long-sought feeling of hope" (M, 26); a hope attained because the abstract harmony itself is a harmony of the human imagination. "The materials of the picture . . . are simply one element among others in a creative act where the whole world offers material for the artist's wild imagination" (M, 16). "The whole—sense data, metaphor, or plain words—is caught

in the syntax of stresses, relative intensities, arabesques. These last express the pressure of the imagination on the elements of reality it uses, the insistence of the passionate will, the possessing of the object through the visual act" (M, 18). It is hard to imagine a more extreme phenomenological optimism in art, insisting as it does that the artist can possess and express existence in a syntax of the imagination.

Can one point to any viable relationship between Bonnefoy's art criticism and his poetry? Certainly not to a direct relationship: the poem "Sur une Pietà de Tintoret" from *Pierre écrite* is a rare example, and no more significant than another poem on a musical theme, "A la voix de Kathleen Ferrier," from *Hier Régnant Désert*, or Bonnefoy's earliest work, *Traité du pianiste*. If there is any such relationship, it will appear through a coincidence of aims; what Bonnefoy seeks in the visual arts he seeks to reproduce, by appropriate verbal means, in his poems. Let us take, as a point of comparison, a poem from *Pierre écrite:* "O de ton aile de terre et d'ombre éveille-nous." [9] This poem, the last in a series of six entitled "Le Dialogue d'angoisse et de désir," culminates a meditation on presence and absence, light and darkness, life and death. Its forceful appeal follows a tentative, questioning poem: "Imagine qu'un soir," as Bonnefoy tries to call into being the angel of an earthly revelation:

> O de ton aile de terre et d'ombre éveille-nous,
> Ange vaste comme la terre, et porte-nous
> Ici, au même endroit de la terre mortelle,
> Pour un commencement. Les fruits anciens
> Soient notre faim et notre soif enfin calmées.
> Le feu soit notre feu. Et l'attente se change
> En ce proche destin, cette heure, ce séjour.
>
> Le fer, blé absolu,
> Ayant germé dans la jachère de nos gestes,
> De nos malédictions, de nos mains pures,
> Etant tombé en grains qui ont accueilli l'or
> D'un temps, comme le cercle des astres proches,
> Et bienveillant et nul,
>
> Ici, où nous allons,
> Où nous avons appris l'universel langage,
>
> Ouvre-toi, parle-nous, déchire-toi,

Couronne incendiée, battement clair,
Ambre du coeur solaire.

(O with your wing of earth and shadow, awaken us
Angel, vast as earth, and carry us
Here, to the same place of mortal earth
For a beginning. Let ancient fruits
Be our hunger and our thirst—finally stilled.
Let fire be our fire. And let waiting change
Into this near destiny, this hour, this abode.

The blade of iron, absolute wheat,
Having germinated in the fallow land of our gestures,
Of our curses, of our pure hands,
Having fallen in grains that have taken on the gold
Of a time, like the circle of near-by stars,
Both benevolent and null,

Here, where we are going,
Where we have learned the universal language,

Open yourself, speak to us, rend yourself,
Blazing crown, clear pulsation,
Amber of the solar heart.)

If we take as guiding lines for comparison the three criteria that
governed Bonnefoy's response to art: the image of a special *place*, the
gnostic search, and the emphasis on significant form, then it is easy to
see that the poem responds on all three levels. There is the special
"place" of a new Eden, the gnostic search for an immanent revelation,
and a complex pattern of interrelated references. Before entering into a
discussion of these levels, it may be useful to establish the poem's main
lines for subsequent discussion. Here Bonnefoy uses great imagistic and
verbal subtlety in blending two frames of references: the traditional
biblical story of genesis, fall, and expulsion from Paradise, and the
search for redemption in an earthly context.

Bonnefoy calls first upon an angel of earth and shadow—an
angel made of earth, vast as earth, incarnating man's earthly experi-
ence,[10] and yet also the same archangel Michael in the Christian
tradition who expelled Adam and Eve from Paradise and is to awaken
us on Judgment Day. This angel must awaken us (sleeping as if dead)

and transport us to the same spot as ancient Eden; it is time to begin over again, and to enact a new genesis where man is redeemed from original sin. However, Bonnefoy only implies a Christian apocalypse, and actually emphasizes the earthly nature of the angel and the mortality of this self-same spot where a beginning—of some kind—is to be made. The next sentence can be read in either a biblical or an earthly frame of reference: the fruits of Eden will finally satisfy our hunger and thirst for knowledge, or our hunger and thirst for knowledge, finally satisfied in the earthly revelation, will be identical with the fruit of the Tree of Knowledge. A similar double reading occurs in the next line: the flaming sword expelling man from Paradise is to become familiar, friendly fire, or the earthly fire we know is to be seen as the only real one: the unique, essential flame. Finally, the biblical wait for the millennium is at an end; or alternately, it is a sense of the present moment—the *hic et nunc* of intensely felt existence—that is the key to an earthly revelation.

The first stanza suggests a scene of transformation and new beginning; the second uses a series of involuted images to describe the situation of approaching epiphany. The sword blade, shaped like a hard, unchanging blade of wheat, has finally quickened and germinated in the fallow land of our earthly existence:[11] no prepared garden of Eden, but the space of daily life shaped by our gestures, our curses, and our hands that are pure of original sin and absolute knowledge alike. The blade has scattered into golden grains that look like stars (an image suggested by Hugo's "Le Semeur"?) grains that take their color from an absolute golden moment that is, like the stars, benevolently null. Iron has changed to gold and absolute wheat has changed to golden grains of existence in a dispensation ruled not by biblical theology, but by our own innocent struggles to exist. The sky does not display an hostile angelic sword, but only the friendly appearance of detached, circling stars.[12]

The last two stanzas reinforce the sense of immediacy and repeat the initial appeal, this time in a gathering of suddenly expanded abstract images built upon preceding scenes. The immediate space, the "ici, où nous allons," has taught us a universal language: now the earth angel must be rent asunder to speak this language and appear as the blazing crown and clear pulsation of existence, the solid essence and solar heart of the universe.

There can be no doubt that Bonnefoy evokes a specially

significant space in the poem, whose entire rhetorical thrust is to transmute a single *place* in gradually ascending interpretations. A suggested biblical Garden is first seen as a garden of actual consciousness, then as the locus of our earthly experience, and finally as a transfigured space—an illumination at the center of things. Bonnefoy emphasizes the presence of this epiphany: we are "here," "in the same place," "here, where we are going," expecting the angel "at this hour, in this place." The poet must, in fact, stress this physical location if he is to be concerned (as he says in *L'Arrière-pays*) not just with transcendence but also with the "place" where it is "rooted" in our lives. And yet this physical location is not described in minute detail; Bonnefoy will not make the mistake of "unleashing exteriority," as he said of Caravaggio, and when describing the present moment of existence he subordinates picturesque qualities to a developing, changing use of images rendered as "essential" as possible.[13] The garden in the first stanza is sketched in a few basic details, but the following stanzas introduce a space that is much more difficult to visualize: the fallow land of our gestures, and a *battement clair* as invisibly comprehensible as an image it recalls—Mallarmé's space (in "L'Autre Eventail") shuddering like a great kiss. Throughout, this *locus* of transcendental unity is a single allegorical space that is rooted in, but not limited to, its separate physical evocations. It is a present space with transcendental significance: a space reached at the end of the search.

Bonnefoy speaks of his gnostic tendencies in *L'Arrière-pays*, and "O de ton aile . . ." like many of his other poems, expresses the profound quest for spiritual knowledge. The poem's rhetorical framework is an appeal for revelation: an appeal that verges on command in the last stanza, and rests unanswered now as it will in the later fragments of "Dans le leurre du seuil." Or—to be more exact—the search continues and the final question frames its own answer. Images evolving throughout "O de ton aile . . ." reproduce the same evolution of gnostic search that Bonnefoy has described in relation to art in *L'Arrière-pays*. The first stanza evokes an idealistic vision glimpsed through biblical stories of Paradise, but then goes beyond a faith in traditional theology to conceive of the redemption of everyday existence. The second stanza reinforces the idea of earthly involvement, but also suggests the temptation to seek answers in exterior phenomena (compare *Rome* 82). The last stanza goes beyond the intermediate level to postulate a higher synthesis of both exterior and interior reality. Over

and beyond the image of a transcendental truth to be discovered, Bonnefoy has made the poem's own development represent ascending steps of spiritual inquiry.

The remaining criterion of Bonnefoy's interest in art—emphasis on significant form—is overwhelmingly substantiated in the poet's involved and complex verse. Only a brief analysis can be given here. The form of "O de ton aile . . ." shapes and reinforces the significance previously discussed as both *place* and seeking.[14] Besides the formal developments already noted (a gradual heightening of images and a progression in metaphysical perspective), two other elements are also remarkable for their formal reinforcement of the central effect: the synthetic images of the last stanza, and the large syntactic patterns reiterating the already described gnostic search.

Images in the last stanza are not gratuitous figures of pure form, but clearly synthesize a new vision from preceding images and motifs. This vision would appear puzzling or, worse, the arbitrary product of chance ecstasy if it were to lose its sustaining relationship with earlier lines. The speaker's cry at the end must be elliptic and allusive, for it expresses transfigured reality; but it must not become pure form and lose all ties with earthly experience. The first line of the last stanza appeals directly to both aspects of the earth-angel: "Speak to us" he says, now that the universal language has been learned; "open yourself to us," as he suggests an earthquake-like revelation, and "rend yourself" for us—the rending of a sword blade, perhaps, and an echo of "Ouvre-toi" that also includes Christian overtones of divine sacrifice (compare Musset's pelican, and the "visage sacrificiel" of the first poem in this *Dialogue d'angoisse et de désir*). The crown of the second line recalls the circle of near-by stars, and the fact that the crown is blazing suggests both the stars' cold fire and the divine-human flame of the first stanza's earthly paradise. It is the angel who rules now, who is—or is to wear—this halo of a flame, golden like the ripe grains that have taken their color from a specially transfigured moment. The "battement clair"—a luminous beating of the angel's wings as he comes, or the clear pulsing of space in this transfigured existence—echoes both light images in earlier stanzas and the sense of germination and movement in the space of stars. Finally, the last line combines both levels of vision: the angel's heart (or, angel as heart) beats full of warmth and life, a solar radiation at the exact center of our universe. And yet the angel is not exactly the heart, but rather heart's "amber"—a precious *solidified*

deposit of transcendental light that serves to assert once more the dual quality of earthly experience, and the earthly aspect of an angel whose wing is made of earth and shadow. By synthesizing active images of light and shadow from themes in earlier stanzas, Bonnefoy has capped his poem with an exercise in abstract form sustained by latent significance.

The "pure form" of the poem is developed on another syntactic plane in a way that reinforces the poem's movement from level to level of insight and knowledge. In this analysis, the revelation at the end, combining as it does immediate vision with latent significance, also combines two types of expression that are in sharp contrast between the first and second stanzas. In the first stanza, the basic mode of expression is equivalence—especially the equivalence of noun phrases. There is an initial identification of angel and earth ("aile de terre"), and then an imperative verb of action, followed by another identification of angel and earth ("vaste comme la terre") and another verb of corresponding action. Two adverbial phrases state and repeat an equivalent location ("Ici, au même endroit"), and subsequently a whole series of noun phrases links parallel realities ("Les fruits anciens soient notre faim . . . Le feu soit notre feu . . . ," etc.). As if to strengthen this impression, the last equivalence ("l'attente se change . . .") is marked by a triple transformation and three coexisting noun phrases: "En ce proche destin cette heure, ce séjour." The force of this pattern of simple equivalence is that it establishes an image of dual reality, and prepares the way for a perspective in depth.

The second stanza breaks with this simple equivalent form and follows the progression of successive related images. The open-ended nature of this progression is mirrored in the unfinished grammatical nature of the stanza: whereas the first stanza consisted of four complete sentences, the second stanza is merely a long descriptive clause exploring the situation and laying the metaphysical groundwork for the end. The subject and main verb of the sentence, like the resolution of the imagery, appear only in the synthesis of the last stanza. Beginning with one last equivalence ("Le fer, blé absolu"), Bonnefoy launches into a series of branching definitions that range farther and farther afield, and explore more and more deeply the profound and mysterious duality established in the first stanza. One image implies another, which implies another, while that third image is like another which is defined in terms of a still farther reality which is associated with something else. The

blade is like wheat which has germinated in the fallow land of our gestures; thus far there is no emotional significance to *gestures*, but the next line interprets the fallow land and its gestures as a condition of misery, cursing, and innocence. The parallel images: "De nos malédictions, de nos mains pures" serve to broaden our understanding of the preceding image. A more complicated expression occurs in the next lines: the wheat has ripened and fallen as separate grains, which have taken on a golden color, which is the color (and implied preciousness) of a particular time, which is—pause for a parenthetical comparison with stars—of a certain quality: benevolent and null. Bonnefoy leads us here through a continuous chain of qualifying phrases that look deeper and deeper into our existential situation. At the end of the poem, he returns to the syntactic structure of equivalent phrases: first three parallel imperative verbs, and then three parallel noun phrases. However, these elliptic parallel phrases only succeed insofar as they are underwritten by previous meditation in depth, a meditation whose best example is the branching imagery of the second stanza.

In the three areas we have singled out, then, Bonnefoy manages to find his own poetic medium for conveying the qualities he finds most important in the visual arts. He does not try to re-create painted images—he is no Moussorgsky of the printed page—but he does transpose in his own verbal technique the same elements he likes to identify in painting and architecture. A single attitude governs his idea of form: the belief that art has a mission to express the truth of a heightened consciousness, to reveal the Plotinian One,[15] and to use form so as to charge it with significance. Bonnefoy as an existential poet leans towards a phenomenological optimism in stressing art's grasp and transformation of objective reality. He is far removed from a poetry and criticism that see art as pure form, as a purely subjective expression, or as a pattern arbitrarily defined by the social environment. Bonnefoy would have little sympathy, then, for the theories of Denis Roche.

Roche's taste in art and his theory and practice are, however, not quite what one would expect of a *Tel Quel* poet, as a comparison of his notes on Kandinsky with a recent article on Frank Stella by Jean Claude Lebensztejn will show.[16] The painters he discusses are typically Kandinsky, de Chirico, Tobey, Klee, and Miró;[17] he refers with approval to the art historians Alois Riegl and Wilhelm Worringer, proponents of "abstraction and empathy." If it is difficult to imagine the Roche of *Le Mécrit*, that extremely hermetic text, as an expressionist of any kind, the

explanation is that this expressionism is now floating free from communication. Roche's expression exists as a tantalizing example of creative activity seen from the outside; it can be imitated by a prospective reader in his own creative movement, but no communication arises in this "transfer of energy from poet to reader" (RC, 12). He accepts and develops Kandinsky's work with mixed genres,[18] but rejects the latter's emphasis on emotional significance, on spiritual art, and on the availability of communication.

Roche's attitude towards art is in many ways quite the opposite of Bonnefoy's. He equates separate media, and even tries to adapt techniques from one to another; he stands in a disciple relationship to the lessons of painterly technique; and he tends to proceed from the artists' intentions as stated in theoretical writings even more than from the art work produced. Conversely, Bonnefoy sees art as a means of knowledge while Roche considers it an action to be imitated or sign to be defined with historical coordinates; Bonnefoy finds equivalent qualities in the art he favors but never tries to use art as a technical guide for his own works, while Roche believes in the common creativity-structure of several arts and tries to adapt chosen techniques from one to another genre.

Roche's tastes in art have not, apparently, varied from the day he wrote about the comparative techniques of Kandinsky and Ezra Pound. He does not appropriate right away their lesson in the development of his own poetry, but from the beginning he singles out their special kind of creative rhythm in art, literature, and (to a lesser degree) music. In 1962, Roche published in *Tel Quel* a series of translations from Ezra Pound, followed by an essay "Pour Ezra Pound." The first of the translated pieces is a definition of poetic rhythm as the expression of a personality. Pound speaks of a "rhythm . . . in poetry which corresponds exactly to the emotion or shade of emotion to be expressed. A man's rhythm must be interpretative, it will be, therefore, in the end, his own, uncounterfeiting, uncounterfeitable." [19] Roche pursues the idea of creative rhythm felt equally—and separately—by artist, writer, spectator, and reader:

The removal of the idea . . . by its rejection to infinity in Kandinsky, by its multiplication, its swarming in Pound . . . It would be interesting to study in detail the notion of "demultiplication" implied by the passage from figurative to formless art in Kandinsky, and by the

passage from the "imagist" period to the Cantos in Pound. The rate of speed, not of composition but of perception, is no longer the same. And that is perceptible not only for the painter and the poet, but also for whoever looks or reads. [PP, 18]

This equation of poetry and art continues throughout the essay (much as it does, of course, in Kandinsky). Kandinsky's "theory of efficient contact" influences Pound to create the " 'interactions and mixed tensions' that constitute the energetic value of the Cantos" (PP, 18). Later Pound "writes poems in the same state of mind as the one in which the painter Tobey will execute his *temperas* a few years later (PP, 20). Pound's "tensions and interactions" are the same thing as Tobey's "vibrating space," and "Pound's readers, like amateurs of Tobey or of Kandinsky's first abstract watercolors, are no longer analysts but observers" (PP, 21). Underlying Roche's comparisons is the assumption that once you identify a particular kind of creative rhythm, it will take on equivalent form in different media.

Roche's first major book of poetry, *Récits complets* (1963), stresses both in poems and foreword this personal creative rhythm found in art and literature. Although he quotes Worringer and uses a quasi-mystical vocabulary in which artistic expression is seen as exorcism, Roche does not speak of content here but rather of an independent creative experience that can be provoked in the reader (spectator) by the poem (art work). A group of ten poems in *Récits complets* titled "La poésie est une question de collimateur" (a collimator being a sighting device, as on a telescope) affirms the poet's creative activity: each poem presents a bloc of verse in a very self-aware stream-of-consciousness technique, and takes its title from the time of day during its composition (such time ranging from six to twenty-four minutes). The rhythm of artistic creation exists, for Roche, in a special "demultiplied" ratio to real time; it changes our perception to a slightly different rate of speed whether in the art space of the poem or the art space of painting. Roche's poems in this collection are puzzling yet intelligible exercises in personal perspective; the epigraph from Marcel Duchamp ("Cet angle exprime le coin de l'oeil nécessaire et suffisant") suggests that he finds artistic grace in a special "angle" of vision, an angle also compared to the works of Giorgio de Chirico:

The constant of creation . . . is to the poem what the constant of light is to the painting. I do not see any other way of rendering this change in

speed, this demultiplication of poetic movement, than by referring to Chirico's paintings. [RC, 16]

Once more, Roche is comparing the techniques of poetry and painting. This time, however, he refers to his own work instead of that of Ezra Pound, and uses painterly techniques to explain—or corroborate—his own poems.

The most extensive discussion Roche gives to art and literature comes in *Les Idées centésimales de Miss Elanize* (1964), in the ending section called "Kandinsky à venir." This section consists of a series of ten facing pages, the left-hand and last pages reprinting Roche's earlier notes on a French translation of Kandinsky's *Punkt und Linie zu Flache* (as *Point-Ligne-Surface*) and four right-hand pages presenting poems written in response to four Kandinsky paintings. There seems to be a certain discrepancy here between Roche's poems and the literary-artistic theory he describes and will develop in later work. The prose notes outline a theory of "abstract poetry" based on Kandinsky's theories of abstract painting (no mention of Kandinsky's own poetry); the theory as Roche outlines it foreshadows later poems like the "Dialogues du paradoxe et de la barre à mine" from *Théorie d'ensemble*, certain poems in *Eros énergumène*, or *Le Mécrit*. However, the four poems based on Kandinsky's paintings are still in an earlier style: they present a fairly consecutive pattern of vision that can be read as its own "angle of vision" or as a filtered reflection of the original painting. In the poem titled "Trait blanc," Roche begins with a fairly clear reference to the large white brushstrokes down the center of the canvas:

> Les coups de queue des passages froids
> Vont et viennent des plus froids aux plus
> Foncés . . .
>
> (The tail strokes of cold passages
> Come and go from the coldest to the
> Deepest . . .)

but passes quickly to "mon peintre le cousin / De la rue de Chanaleilles" ("my painter the cousin / of Chanaleilles street") and an ending that may reflect distantly the original painting, but expresses first of all a particular poetic vision:

> Bosquets pâles, régions déminées où trempent
> Les flaques des mélanges jaunes et verts mais

Si pâles que ne s'y mirent jamais les cavaliers
Bleus circonspects de nos appréhensions.

(Pale thickets, sapped regions where soak
Puddles of yellow and green mixtures but
So pale that they never reflect the
Circumspect blue horsemen of our fears).

The vision is tantalizingly oblique; horsemen, thickets, and puddles
have no place in a poem representing an abstract painting, but the
apparently realistic images fade quickly into a kind of metaphor that
could easily represent color patches in *Trait blanc*: especially the
"circumspect blue horsemen of our fears." Even if the poem's
representational images (thickets, horsemen, bathtubs, staircase) were
to represent tones of the original abstract canvas, however, the
difference is so extreme that it focuses attention on Roche's creation
even more than on Kandinsky's *Trait blanc*.[20]

The prose notes of "Kandinsky à venir" depart from the
emphasis on personal, oblique vision to stress an "abstract poetry"
following Kandinsky's own theory in *Point-Ligne-Surface*. Although
Roche still speaks of a painting's "emotional result" on the spectator, he
seems to have moved from a *collimateur* approach to one that is more
coldly calculated:

The painting's emotional result is never the reflection of a passing state
of mind in the painter, but rather the outcome of an infinite
combination of traces, surfaces, and colors, all chosen and coordinated.
[IC, 113]

Roche returns now to Kandinsky, the painter of whom he first spoke in
connection with Ezra Pound, to discover a technique of abstract
painting and poetry that will be valid for himself and valid for
contemporary poetry as well ("Application for contemporary poetry to
be indicated . . ."). These techniques of abstraction are available to
poetry because their shocks, ellipses, and tensions exist like all creative
structures in other media too:

It would be interesting to make a thorough study comparing the
perspectives of musical technique (the abstract technique *par excel-
lence*), of abstract technique in painting as Kandinsky began it, and of
the technique of the abstract poem. [IC, 122]

Here Roche (following Kandinsky) speculates on the possibility of literary form's corresponding to painterly form. "Can the problem of the ellipsis, as it is envisaged in certain poetic destinies, have any correspondence in painting? . . . 'Vertical spirals' inside a poem? Magnetic lines? Surely" (IC, 122–23). The ending passages of "Kandinsky à venir" describe different ways in which written form can imitate abstract painterly form, and the phrases Roche uses here foreshadow the experiments of his later poetry:

Poetic writing like a succession of shock points with the different cleavage points indispensable to Western writing. Perspective lines emerging rather from the complexity of images, and "hardness" resulting from the more or less strong contention of these images.

Greater or lesser tendency of the verse line to openness, following the location of the image or strong word in relation to the middle of the line. . . . [IC, 123]

Roche's later "Dialogues du paradoxe et de la barre à mine" (1968) and *Le Mécrit* (1971) both experiment with quickly changing images, parts of words and phrases, and broken typographical arrangements to provide an even more intricately tense and closed appearance. Roche's theoretical statements ("La Poésie est inadmissible . . ." and the preface to *Le Mécrit*) describe this technique of clashing, interlocking images in a structure whose creative composition becomes more and more remote from the reader's own creative vision. In both theory and practice, these later texts reflect their source in Roche's reading of Kandinsky.

Roche's work after "Kandinsky à venir" speaks little of the visual arts, but Kandinsky's example combines with other influences as the poet struggles more and more to develop a form that he can accept on both philosophical and artistic grounds. It is worth mentioning at this point that Roche seems caught in between his natural "poetic" instincts, which are well documented by the tremendous variety of forms with which he has experimented and by the quantity of his editions and translations of poetry,[21] and the intellectual honesty with which he tries to destroy all forms of esthetic illusion. This intellectual honesty guides the several essays from 1968 to 1971 on poetic theory, and it sets up a situation in which the only literary response seems to be one following Kandinsky's example of abstract expression. The preface

to *Eros énergumène* (1968), titled "Leçons sur la vacance poétique,"
insists that modern poetry must rid itself of moral, sentimental, and
philosophical burdens and "bear constant witness that poetry is a
convention (*of genre*) inside a convention (*of communication*)"—that
"any personal intervention is to be banished" and "any appeal to the
reader made impossible." Roche still cannot rid himself of the
attractions of esthetic form, however, and asks in the same breath how
it is possible to "point out with so much conviction the *success* of such
and such a page?" His answer recalls some of the terms he has used in
describing Kandinsky (along with Pound): by describing the laws that
govern "types of facts with a *pulsating* dominant" in the poem's
rhetorical structure (EE, 12–13).

After *Les Idées centésimales de Miss Elanize*, Roche concen-
trates on destroying traditional ideas of "personalizing, esthetic poetry,"
and explains the workings of a much truer understanding of poetic
form, found in both art and literature. In the preface to his translations
of Pound's *Pisan Cantos*, he compares again Pound's "universe of
tensions and mixed efforts" with Mark Tobey's pictural techniques
(*Cantos*, p. 9), and describes the way a modern reader must read the
new pictural form:

Traditional criticism can approach these new poetic structures only
through a reading that is simultaneous and parallel on these different
planes of invention. . . . Reading the poem takes place in successive
revelations of the text, as if, *unintelligibly*, it would only reveal itself as
evidence of poetic creation. [CP, 20]

This poetry does not try to be "intelligible" in the sense of having
specific meanings attached to each phrase, even though the poet himself
may have attached such meaning. Instead, it seeks to exist as
"references of pure imagination" and as evidence of creative activity.
The appropriate analysis will determine only the *evidence of creation*
deposited by mental patterns in the printed text. The same method of
reading is proposed in *Eros énergumène*, again with comparisons to
Kandinsky. Roche's *poèmes* (the word is evidently ironic, especially in
the light of his essay from *Théorie d'ensemble* the same year, titled "La
Poésie est inadmissible") are to appear as a "disappeared trace," as
material absences of "poetic" functioning. This absence is "made

unmistakably obvious by artifices à la Kandinsky (his words on points, lines, surfaces). . . ." The scansion of this new poetic technique is again a "scansion" of tensions and pulsations: "through all manner of pulsating alternations (pulsation designating the *unit of energy in the poetic*). Certain pages of *Eros* should be studied on this level alone of pulsating rush . . ." (EE, 14, 16). The poem from *Eros énergumène* that probably best expresses this pulsating structure is the "Poème du 29 avril 1962," but its open, somewhat Pound-like lines will soon be abandoned in favor of a much denser expression. In an interview published in English in 1969, Roche advises that his poems "can be taken in two ways: either as a totality or on the contrary, through the very specific analysis of individual poems, which would more likely be a thematic analysis, following the linguistic procedures utilized, of which there are many" (*Poems and Texts*, p. 178). The last two groups of poems Roche has published, the "Dialogues . . ." and *Le Mécrit*, explore this patterning of linguistic procedures much more openly than before; one could say that Roche's practice has finally caught up with his reading of Kandinsky's theory.

The six texts and two reproduced inscriptions of *Le Mécrit* do seem to display "abstract poetry" as Roche has interpreted it, even if the form is tighter and more hermetic than that of the Cantos previously compared with abstract art. Now Roche holds that abstract art, in addition to presenting spirals and tensions of pure imagination, must abandon any pretense at communication between writer and reader. For the evidence of artistic creativity to appear purely in and by itself, it should appear as pure form uncontaminated by any burden of "beauty" or "meaning": "towards which, henceforth assured of our solitude, and without anyone being able to follow us, we proceed" (M, 91). Form appears in *Le Mécrit* as purely as possible: in the reprinting, for example, of Mongolian and Etruscan inscriptions whose appearance looked to Roche like some earlier poems of his own; and in the second "text" with its stylistic peculiarities (see next page).

This text accomplishes its purpose effectively, if that purpose is to tantalize the reader with an obviously calculated composition that still repudiates his attempts to "understand." It is not that the composition lacks any trace of meaning, but that no meaning except the overall play with forms is carried along far enough to substantiate a single interpretation. The play with form, then, *is* the meaning: the

Texte 2.

Sans avoir vu écrit, sans un bas de plus& I	l eût
donné beaucoup pour un pré de plus &n œil&	qui f
ait l'angle' avec la forte tour lance une tE	te au
trait bouffi de colère : imposte& pleure& T	endre
évidemment& fesse à faire ffleur-queue impO	sante
voilà donc 5 lignes à titre de con et d'oeI	l.
les 2 me voient tandis que la ferme était P	lus q
&imposante tandis qu'ici moim aim une portE	ouve.
r te sur l'enceinte je pris les 2 cheveuxd'EL	par l
a bride& m'étonnant qu'en fin de journée l'oE	il et
▮e con soient là m'épiant me voletant autoU	r de.
cette forte tour& pieu retirant quelque coL	isero
du paysage que je hais& ô loir love ô couiL	leuse
le haut de ta jambe vers le con vers toi jE	fais.
enfler une fois de mieux mes 2 pourceaux dE	ffleu
ove/queue &. à l'angle enfilons la forte toU	r.&. =

L

author has left his mark in the arbitrary margin lines, the misplaced vertical line of capitals, the sentences continued over the margin lines, the scattered letter and margin continued below, the occasionally repeated images to tease readers trained in "symbolist" poetry ("forte tour," ll. 3, 12, 16, and the variously spelled "oeil" and "oeillet," ll. 2, 6, and 10–11), the puns ("oeillet," as seen, and "moim aim," l. 8), the pattern of changing substitutions for & (either "et," or "u"—"&n," or

"et"—"oeil&," or "u" plus apostrophe—"plus q&imposante," etc.), the erotic or obscene images, the possibility that this poem reflects the first text of "Eros Elémentaire" in *Eros énergumène*, and finally the amusing intervention of this highly self-conscious author: "voilà donc 5 lignes à titre de con et d'oeI | 1." It would seem that Roche has created the "evidence of creativity" that he desires, to the extent that everything is cut out except a sense of the writer's play with verbal form.

To what extent should one apply any term at all to Roche's particular approach? Following the examples of the art Roche himself uses, it appears that his poetry is a particular development on theories of abstract expression. Roche cites Kandinsky, Klee, Miró, de Chirico (Tobey, but not Rauschenberg; perhaps some day Arp), and quotes writings that define art as a form of spiritual expression. He himself does not emphasize the techniques of abstract expression as anything but a way for the artist to suggest, to another person, the pure presence of a creative mind. There is no real play with technique for itself, paradoxically enough, but only the manipulation of form as evidence of an unreachable subjective expression. This subjectivity may be seen "at work," but the most it can communicate is the impulse to a new creation: a creation of reading, if the catalyst at work is a "poem." Roche has equated all along the techniques of music, painting, and literature, and now he negates the ordinary meanings of words sufficiently to achieve an open, "zero degree" of significant form in literature. Certainly this achievement is the triumph of abstract expressionism in literature; whether or not one uses the term usually applied to Kandinsky, it is true that the attitude stresses personal artistic creation in abstract forms. It also runs counter to the assumptions of a different kind of modern painting, for which Lawrence Alloway's name of "systemic painting" seems most useful here.

The label attached to this poetry—whether "abstract expression-ism" or "systemic painting" or whatever—is less important than the distinctions made between the two. The reason for considering such labels at all is the natural temptation to term Roche a "structuralist" because of his connections with *Tel Quel*: and yet to accept such a label would be misleading for a number of reasons. First of all, it does not represent Roche's real theory of achievement; and second, it would in corollary fashion obscure what probably *is* a *"Tel Quel"* approach to art, at least as implied in the numbers before the movement of June

1971. Such an approach would consider the art work as a nexus of historical forces (seen preferably in an anti-bourgeois ideology), and analyze it for the functional structures with which it creates a given "meaning." Roche's *Le Mécrit* displays the function of negating meaningful (communicative) patterns, but perhaps falls short of the greater functional complexity that could be achieved if meanings also overlapped in layers of syntactic significance.

One example of a possible "structural" approach, applied by a modern critic to a modern "systemic" painter, is Jean Claude Lebensztejn's "Fifty-Seven Steps to *Hyena Stomp*," where both historical[22] and structural criteria are applied to the painting by Frank Stella. Western culture has reified art since the Renaissance, he says in good Marxist fashion, and "it is the coding of the relation between the inside and the outside which becomes modified at the moment of the rise of capitalism and the division of work." [23] Lebensztejn continues with a detailed and cogent analysis to bring out the painting's cumulative effects, reached by manipulating visual techniques. "There are 57 units in the picture, that is, five series repeated cyclically, plus two colors," he begins (p. 66). Lebensztejn works his way through fifty-seven steps in his own fifty-seven paragraphs, showing by implication that Stella accepts the same communicative possibility that Roche denies, and in fact that the painter works with it to force his spectator's consciousness into certain patterns and assumptions. Both the structure of the painting, which Lebensztejn shows calculated to disorient and then guide the spectator, and its implied assumption—that the artist does in fact control his audience's response, and creates gradations in the work by predicting and manipulating that response—differ from Roche's practice and theory. Perhaps there is no "structuralist poetry"—perhaps all poetry is "structuralist" and awaits its prophet, or perhaps no poet has yet tried to manipulate forms of discourse as Stella manipulates forms of perception. Certainly Roche and Bonnefoy do not write about artists like Frank Stella, and their poetry and poetic theory follow an older tradition of painting.

Roche and Bonnefoy have, in fact, a good deal in common in their tastes in art. The older poet shows more historical perspective, but in the modern period neither strays beyond a view of art as self-conscious creative expression: Miró on the one hand, Kandinsky on the other. Both stress form, although for Bonnefoy form is a means of

grasping the object, while for Roche form is only the disciplined language of the subject. Bonnefoy is more likely to speak of a work's texture and three-dimensional reality: he discusses architecture, and Miró's ceramic sculptures, while Roche notices mainly the interplay of points, lines, and surfaces in painting and calligraphy. Both stress subjective form, and either assume or ignore the communicative role of artistic structures. Bonnefoy assumes that communication exists: as spectator, he does not hesitate to interpret the formal lessons of various Italian paintings. Unlike Bonnefoy, Roche frequently speaks about the situation of the reader—but he never analyzes that situation as anything but a new and independent creative experience. Putting aside for the moment the work's ontological evaluation or historical status, and ignoring the fact that most of Bonnefoy's art criticism interprets an earlier age, it remains generally true that for both poets art is form, and form is truth. Form is "truth" for Bonnefoy because it frames our divided consciousness; form is uniquely "truth" for Roche, because—in terms of poetry at least—the form of an individual consciousness is all there is.

NOTES

1. "Bonnefoy is the culmination of poetry with a capital P. . . . one does have the feeling that this poetry represents a type of culmination, and that it will most likely not have any future. . . . And then there is another group, it has been called a group of poets, those who belong to the *Tel Quel* circle. . . ." Denis Roche, interview in *Poems and Texts*, an anthology edited by Serge Gavronsky, New York, October House, 1969, pp. 175–76.
 See also F. C. St. Aubyn, "Yves Bonnefoy: First Existentialist Poet," *Chicago Review* 17, 1 (1964): 118–29.
 2. For Bonnefoy, see:
Traité du pianiste, La Révolution la nuit, 1946.
Peintures murales de la France gothique, Hartmann, 1954.
Hier Régnant Désert, Paris, Mercure de France, 1958.
L'Improbable, Paris, Mercure de France, 1959. [I]
La Seconde Simplicité, Paris, Mercure de France, 1961.
Miró, New York, Viking, 1967; an English translation of the first Italian edition from Silvana Editoriale d'Arte, 1964. [M]
Pierre écrite, Paris, Mercure de France, 1965. The first complete edition, although some poems were published separately in 1958 and 1959.

Un Rêve fait à Mantoue, Paris, Mercure de France, 1967. [RM]

La Poésie française et le principe d'identité, Paris, Maeght, 1967. With two engravings by Ubac, a reprint of the essay published in *Revue d'esthétique*, 18 (1965): 335–54.

Rome 1630, Paris, Flammarion, 1970. [R]

L'Arrière-pays, Geneva, Skira, 1972. [AP]

 3. "Baudelaire contre Rubens," *L'Ephémère*, no. 9 (printemps 1969): 72–112. [BR]

 4. "A l'horizon de Morandi," *L'Ephémère*, no. 5 (printemps 1968): 117–24.

 5. "La poésie, ou la peinture selon la poésie, le projet d'Ubac, c'est cela . . ." (RM, 167).

 Bonnefoy has published several special editions of his own poetry in conjunction with Ubac. Eight poems from *Pierre écrite* appear with lithographs by Ubac in a volume devoted to the artist, published as *Ubac* in the collection "Derrière le miroir" (Paris, Maeght, 1958). An earlier version of the second section of *Pierre écrite* (titled *Pierre écrite*) was published as a separate volume with lithographs by Ubac (Maeght, 1959). Another joint edition appeared in 1967, when Bonnefoy's earlier essay "La Poésie française et le principe d'identité" (reprinted in *Un Rêve à Mantoue*) was also issued separately with two engravings by Ubac.

 6. "Le signe est devenu le lieu." in "Dans le leurre du seuil," *L'Ephémère*, no. 19–20 (hiver-printemps 1972–73): 297. Two sections of this work have been published in *L'Ephémère*: the first in no. 11 (automne 1969): pp. 344–57, and the second in no. 19–20 (the number in which *L'Ephémère* announced its discontinuation): 293–307. Future references are abbreviated to "Dans le leurre . . ." I or II.

 7. "se leva avec dans ses mains le mystère, cette fois en pleine lumière, du lieu d'existence assumé" (AP, 153–54). I have italicized *place* to try to retain the peculiar formulaic nature of the *lieu d'existence* in Bonnefoy's terminology.

 8. "Soucieux d'une transcendance mais aussi d'un lieu où elle aurait sa racine" (AP, 45). "L'oeuvre absolue existe et le vrai pays alentour . . ." (AP, 45, 73). For an extended discussion of place as theatre in Bonnefoy, see Mary Ann Caws, *The Inner Theatre of Recent French Poetry*, Princeton, Princeton University Press, 1972, pp. 141–70.

 9. This poem comes from one of the new sections included in the completed *Pierre écrite* of 1965. There are indeed two later collections of poetry, the fragments of "Dans le leurre du seuil" published in 1969 and 1972, but I have chosen a poem which can be seen, if necessary, in its complete context.

 10. Compare "L'ange, qui est la terre" ("The angel, who is earth") in "Une Voix," *Pierre écrite*, p. 80.

11. Compare the following passage from "Dans le leurre du seuil," I, 356:

> Dans la main de dehors, fermée,
> A commencé à germer
> Le blé des choses du monde.
>
> (In the closed hand, outside,
> Has begun to sprout
> The wheat of earthly things.)

12. This absolute detachment underlying the word "nul" appears incarnated in "Dans le leurre du seuil" (II, 301):

> —Mais de ta foudre d'indifférence tu partages,
> Ciel soudain noir,
> Le pain de notre solitude sur la table
>
> (But you share with your indifferent thunder,
> Sky suddenly black,
> The bread of our solitude on the table)

and as a celestial voice of transcendental refusal (I, 351):

> Demandes-tu,
> Je ne te permets pas de savoir le nom formé par tes lèvres . . .
>
> (Should you ask,
> I do not permit you to know the name formed by your lips . . .)

13. In "La Poésie française et le principe d'identité," Bonnefoy comments that he does not want to describe "*a* salamander," using a wealth of exterior details, but "*the* salamander," and that he will choose a word like "stone" before "brick" because the former participates more easily in a description of essences (*Rêve*, 94–97, 104).

14. I am not concerned here with metrical and alliterative organization, and for an interesting study of musical style in Bonnefoy refer the reader to F. Deloffre, "Versification traditionelle et versification libérée, d'après un recueil d'Yves Bonnefoy," in *Le Vers français au 20e siècle*, ed. Monique Parent, Paris, Klincksieck, 1967, pp. 43–55.

15. The epigraph to *L'Arrière-pays*, in Bonnefoy's own handwriting, is as follows: "J'ai en esprit une phrase de Plotin—à propos de l'Un, me semble-t-il, mais je ne sais plus où ni si je cite correctement: 'Personne n'y marcherait comme sur terre étrangère.' " ("I have in mind a sentence from Plotinus—about the One, it seems to me, but I am no longer sure of that or even if I quote it correctly: 'No one would walk there as if in a strange land.' ")

16. Jean Claude Lebensztejn, "Fifty-Seven Steps to *Hyena Stomp*," *Art News*, September 1972, pp. 60–75.

Works by Roche used here:

"Pour Ezra Pound," *Tel Quel*, no. 11 (automne 1962): 17–24. [PP]

Récits complets, Paris, Seuil, 1963. [RC]

Les Idées centésimales de Miss Elanize, Paris, Seuil, 1964. [IC]

Translation and introduction to Ezra Pound, *Les Cantos pisans*, Paris, Editions de l'Herne, 1965. [CP]

Eros énergumène, Paris, Seuil, 1968. [EE]

"La Poésie est inadmissible . . ." and "Dialogues du paradoxe et de la barre à mine," *Théorie d'ensemble*, ed. Foucault, Barthes, Derrida, et al., Paris, Seuil, 1968, pp. 221–33.

Carnac, Paris, Tchou, 1969.

Anthologie de la poésie française du XVIIe siècle, Tchou, 1969.

"Le Mécrit," *Tel Quel*, no. 46 (été 1971), pp. 91–100, reprinted in *Le Mécrit*, Paris, Seuil, 1972. [M]

Trois pourrissements poétiques, Paris, Editions de l'Herne, 1972.

17. Roche spoke at the 1972 Cérisy décade on Miró's "La Ferme," and announced at the same time his permanent abandonment of poetry. His texts in *Le Mécrit* and the translations in *Trois Pourrissements poétiques* are therefore to be his last contact with "poetry." Later he separated from the *Tel Quel* group.

18. *Carnac*, in 1969 (part of the series "Génies du lieu"), is the best example of Roche's focusing on a given problem of expression from many angles. In *Carnac*, he explores the puzzle of "megalithism" through "archaeology, typology, history, and mythology," as the subtitle tells us. He also uses psychological analysis and linguistic speculation. It is clear from the introduction and conclusion that Roche sees the hidden significance of these great stones as a symbol of the written word, which is equally calculated, expressive, and obtrusively *present*—and ultimately undecipherable.

19. Ezra Pound, *Pavannes and Divisions*, New York, A. A. Knopf, 1918, p. 103. The passage as translated by Roche in "Pour Ezra Pound" is as follows: "rythme . . . qui en poésie correspond exactement à l'émotion ou au degré d'émotion à exprimer. Le rythme d'un homme doit être interprétatif, c'est-à-dire . . . son propre rythme inimitable et qui n'imite rien."

20. It is worth noting as historical curiosity that Roche's reaction to *Trait blanc* in no way recalls Kandinsky's much more directly symbolic associations in "Über die Formfrage." For Kandinsky, man's "conscious or unconscious desire" to find a new "material form" for his inner life evokes a positive, creative white beam. "That is what is positive, what is creative. That is what is good. *The white fructifying beam* . . ." opposed to "what is evil. *The fatal black hand*." "Das ist das Positive, das Schaffende. Das ist das Gute. *Der weisse befruchtende Strahl*." ". . . das Böse. *Die schwarze todbringende*

Hand." Kandinsky, "Über die Formfrage" in *Der Blaue Reiter,* Munich, R. Piper, 1912, reprinted 1965, pp. 132, 136.

21. For example, his translations of selections from Pound's *Pavannes and Divisions,* the *Pisan Cantos,* the *ABC of Reading,* the anthology of seventeenth-century French poetry, and the translations of Olson, Pound, and Cummings in *Trois Pourrissements poétiques.* See also the interview with Gavronsky, in *Poems and Texts,* pp. 175–76, where he discusses his place in the tradition of modern French poetry from a much more "esthetic" point of view than in the interview with Marcelin Pleynet in the same volume.

22. Certainly Roche's later writing can be seen in an historical perspective, a typical *Tel Quel* perspective which he expresses in "La Poésie est inadmissible . . ." Such an approach would interpret his *mécriture* as the pseudo-esthetic expression of a hard-won Marxist consciousness negating culture as mass deception, and as an attempt to avoid personal complicity in society's guilt by exposing, in "literature," the literary structures of deceit. Such an historical interpretation—even if preferred by the poet—does not seem to affect our discussion of Roche's view of the *relationship* between artistic and literary form.

23. Lebensztejn, "Fifty-Seven Steps." Readers of *Tel Quel* will notice that Lebensztejn shares the rhetoric, as well as the ideas, of that journal.

3 Ambiguity and Conjunction

Max Jacob

the poetics of "le cornet à dés"

Renée Rièse Hubert

Critics hailed the preface to *Le Cornet à dés* as the long-awaited manifesto of the prose poem.[1] Aloysius Bertrand's coquetries with the devil, his commentaries on his "fantaisies à la manière de Callot et de Rembrandt" shed light on his own opus, but can by no means serve as a blueprint for *Les Petits poèmes en prose*, *Les Illuminations*, or Mallarmé's prose poems. Max Jacob's preface provides neither a definition of the prose poem nor critical assumptions applicable to other volumes belonging to the genre, but it does warn against the temptation to imitate Baudelaire's or Rimbaud's masterpieces. The would-be imitator of Rimbaud might mistake the showcase for the jewel, whereas the epigone of Baudelaire might write fables or parables. The prose poem, so Jacob suggests, must renounce mimetic qualities rather than invite overt comparison with a recognizable reality: "A work of art is valid in its own right and not because it can be confronted with some aspect of reality."[2] The distance thus created between an outwardly definable subject and the essence of the poem situates the text in relation to the reader: "The work of art is a force that attracts, absorbs the available powers of those who approach it." The poem is not a series of statements suitable for meditation or contemplation, but an autonomous living force acting on the reader who should approach it without

preconceived notions. Jacob's esthetic theories would seem, therefore, to be grounded on two variables: undefinable subject matter and readers who must discard their usual critical responses. But a close reading shows that theoretical remarks expressed in the preface are substantiated by a varied poetics which occurs in the text of the prose poems.[3]

At first glance many poems of Le Cornet à dés strike us by the number of ordinary, simple sentences introduced by: "il y a," "voici," where the third person singular of "to have" and "to be" abounds, and which appear nonpoetic in their language as well as in their lack of suggestive power. In addition to many childlike statements which enumerate things hardly worthy of mention, an accumulation of negative sentences also stresses either the apparently insignificant or objects that seemed to have vanished. For instance, in "Dans la forêt silencieuse," we are informed that night has not yet touched the leaves; then that the brook has become motionless due to lack of water in the stream. By this method, the stage is set for a present which lies between what is no more and what soon no longer can happen; and thus Jacob demystifies nature by ridding it of certain pagan and Christian paraphernalia. Negations need not, however, necessarily take the form of negative grammatical construction. Another device which suggests the absence of usual poetic force is an apparent refusal to conclude by anything more positive than a question mark, thus leaving all the options open. The poem entitled "Gloire, cambriolage ou révolution" is a tightly packed account of dramatic actions which turn even the spectators into actors. By the final: "Etait-ce la gloire, le cambriolage ou la révolution?" the poet rejects any classifications of events whose motivations have remained hidden all along and transmits the responsibility for any such possible interpretations to the reader who may still believe that poetry provides answers or turns secrets into revelations.

In "Les deux publics de l'élite" the first-nighters found a certain speech pronounced by the king on the subject of prostitution too long, while the other public applauded it most heartily. This division and apparently ironic lack of conclusion takes on a negative charge when one recalls that both sides take a position only in regard to his action. For in reality, he pronounces the speech not to uphold ethical and social principles for the sake of the nation, but in order to justify the disgrace of the queen mother and his own marriage to a prostitute. In spite of a

bespectacled servant who rejoices at the apparently revolutionary implication of the king's gesture, we believe that Jacob stresses above all the importance of rhetoric and performance which insist on words for the sake of words, and spectacle for the sake of spectacle. Thus the prostitute persuades the king that the queen mother is not his mother but an usurper (putting thereby into question the ruler's own legitimacy), while the people see in him only a man who makes speeches. The poems entitled "Dans la forêt silencieuse" and "Les deux publics de l'élite" in which Jacob refuses as usual to conclude with a clear-cut dénouement, imply that a literary awareness is induced in the reader simultaneously with the unverifiable belief in its legitimacy.

Many texts in *Le Cornet à dés* may be read as *metapoems*. In "Roman populaire," the value of artistic creation and aspiration is subjected to a levelling process. Jacob tells a tale complicated and sensational, in which a judge falls in love with a relative of the culprit he is pledged to judge, so that he cannot separate legal from personal affairs. Four ambiguous words intensify the confusion: "l'affaire," denoting the lawsuit as well as the affair of the heart; "clé," the key needed to disentangle the mystery and to open a safe; "non-lieu," serving to annul the lawsuits and obliterate an adulterous affair; "contre-façons" ironically combines esthetic concerns with legal fraudulence. Thus the artist by the act of imitation or copying, becomes a criminal committing forgery. Moreover, a fundamental or basic truth appears no more attainable in the domain of esthetics than in the world of justice. Contamination by extraneous matters and practices characterizes both justice and artistic creation.

So, it would appear that *La Cornet à dés*, if read in a certain light, points to tempting and widespread fallacies in literature shared by writers and readers alike. "Rafraîchissons les vieux thèmes" ferociously attacks commercialization in literature and the arts, a subject that had aroused several nineteenth-century writers. In beginning "Rafraîchissons les vieux thèmes" by the expression "Dans un pays," Jacob deliberately establishes distance instead of pointing directly to the honest but misunderstood and impoverished artist. At an art sale, burghers are transformed into butchers and the auction into a beheading, as numerous witnesses ghoulishly participate in the spectacular execution of art. Obviously the scene will remain set for one execution or another, and eager philistines will always be available. One of the practices which repeatedly clouds the issue of literature is the

investigation of the artist's life, biographical details standing in lieu of explanations. Numerous poems point towards the relation between the creation and the creator's life: "Un peu de critique d'art," "La Maison du poète," "Genre biographique." The latter makes a satirical gesture toward the belief that every event in a great man's life is of consequence and that in every moment he manifests his genius in his everyday existence as well as in his creative activities, so that the two are indistinguishable. Jacob humorously suggests the usual misconceptions, clichés, and conditioned responses, not only in "Genre biographique," but also in "Moeurs littéraires." Public expectations as well as artistic aspirations take the form of a curious paradox in the first poem:

il avait fait le portrait de sa concierge en passe-boule, couleur terre-cuite, au moment où celle-ci, les yeux pleins de larmes, plumait un poulet. Le poulet projetait un cou platonique.

(He had traced the likeness of his concierge as an open-mouthed ball target the color of terra cotta, at the moment when, dissolving in tears, she plucked the chicken. The chicken projected a platonic neck.)

Here the author describes himself as remarkably portrayed with a lifelike immediacy, his idealistic and sentimental pretentions exemplified by the platonic neck and the tears. We are then immediately exposed to a merry-go-round of complementary clichés which ultimately produces so dizzying and unsettling an effect that the poem abolishes itself, any possible hypothesis concerning its meaning becoming nonsensical:

Il est remarquable qu'il eût été regretté et regrettable qu'il eût été remarqué.
(It's noteworthy that he should have been regretted and regrettable that he should have been noticed.)

Verbal patterns existing in a void function autonomously. When in the final sentence Jacob informs the reader of his false point of departure:

Le poulet du passe-boule était une oie.
(The chicken of the open-mouthed ball target was a goose.)

it becomes quite clear that language alone remains unassailed, for identity, the very crux of the biographical problem—mirrored in the poem through the idea of portraiture—is under serious suspicion.

In "Ce qui vient par la flûte" the questions of imitation and portraiture predominate once more. A traveller is buried at his request with the photograph of his beloved, which is brought again to the surface by a rat; gnawed at the edges, it nevertheless remains so striking that a horseman (duly warned by his horse rearing at the sight of the fleeing rat), falls in love with the model, that is, with an insufficient and imperfect *imitation or representation of reality*. His love arises from an irrational and irresistible passion divorced from reality, its very power based on falsehood. By its burial and resurrection the photograph suggests the indestructible force of passionate love, at least as a literary theme. Jacob not only alludes to the fallacious dimensions of the literary tradition of passion, but also to the conventions of the old analogy between death and eroticism. The photograph gnawed by the rats, nevertheless, preserves or recreates the neckline, the description: "Une dame decolletée" stressing the erotic depths of the traveller's request, its absurdity rather than its mystery.

Jacob points ironically towards the confusion between illusion and reality, between representation and imitation in the world of artistic creation. "Ce qui vient par la flûte" and "Dans la forêt silencieuse" belong to a group of texts in which various myths are juxtaposed and deflated. In "Jugements des femmes" Dante, Virgil, and Eve gather together in the same hell where the form of the herring barrel and Eve's position "courbée" include by suggestion the many circles of the *Inferno*. Eve retains her edenic nudity together with a medieval Christian halo. She conforms both to Christian and natural requirements when she complains of the stench created by the latest dead to arrive in hell, a barrel full of pickled herring: as a saint, she condemns the materialistic or limited view of death to which, ever since she ate the apple, she is subjected, while in addition, her judgment shows that she possesses down-to-earth practicality popularly attributed to her sex. "Dégénérescence supérieure" parodies a romantic commentary on the Icarus myth: the balloon which climbs higher and higher, moving towards light expresses man's aspiration to embrace the absolute, to defy supernatural forces and any limitations imposed on human potentialities. Jacob clearly alludes to man's desire to enter into a mystic marriage with heaven and his wish to dissolve himself in infinity. In this approximation of the Icarus myth, Jacob provides a reversal though not a fall as a fitting punishment for the sin of hubris. After evoking the sky, Jacob converts distance into proximity and the

balloon becomes an everyday object in the throes of imminent danger; the endless dream boils down to its perfectly mundane physical cause: the drunkenness of the pilots. As the title suggests, the breaking away of the superior man from reality appears no less arbitrary than complete enslavement to it. Jacob also illustrates the absurdity of these alternatives in a poem entitled "Les vrais miracles." A priest in the usual black cassock, floating bat-like above a lake, fails to recognize the miracle he is thus performing; however, his astonishment at the dampness of the clothes proves that his thoughts belong to the mundane rather than the spiritual world. The Ascension is thus reduced to an optical illusion.

Such poems as "1889–1916" and "De la peinture avant toute chose" seem to suggest a secret which the reader must extract with great effort, the former alluding repeatedly to things hidden in the womb or in the earth, to objects kept under glass. Hiding the truth coincides paradoxically with its revelation; danger with protection. "De la peinture avant toute chose," where the poet refuses to provide conclusions, ends with an invitation to the reader's involvement:

Quel parti tirer de cette histoire au point de vue de l'art? ma soeur réclame des crayons et un album au plus vite.

(What is to be gained from this story from the standpoint of art? my sister is clamoring for colored pencils and an album.)

Jacob thereby exposes one of our basic assumptions about the relations of literature to reality: we tend to regard art and literature as a means of extracting the very essence of life. Verlaine's "De la musique avant toute chose" points towards the suggestive as opposed to the tangible, whereas "De la peinture avant toute chose" proposes an opposite attitute, that of appropriation. Such an appropriation for the so-called benefit of art or literature appears all the more ironical since the account which leads up to the question is but a preventive concatenation of melodramatic events. This sequence of high and low points proceeds neither in a linear fashion nor according to the canons of any genre. Painstaking geographical precision makes way for a voyage not traceable on any map. Romantic allusions degenerate into bourgeois and bureaucratic considerations: ritual funeral processions turn into classroom lessons. By these associations, at once haphazard and cliché-ridden, Jacob invalidates the final question: "Quel parti tirer. . . . ?"

In "Tableau de la foire" this procedure is intensified: the poem consists primarily of elements borrowed from various contexts. Jacob reverses a typical Baudelairean situation for echoes of Verlaine and Rimbaud, while a line from "L'Invitation au voyage" serves as a conclusion to the text: "Mon enfant, ma soeur, songe à la douceur . . ." Instead of suggesting distant lands evoked by paintings, Jacob recollects a personal and quite ordinary past. The echoes of Verlaine are mocked in their turn, for in lieu of shadowlike nuances and barren November days, the beloved is made to recall chaotic wanderings in a zoo. Thus certain usual quotations are distorted and separated from their original contents. Verbal illusions give way to stock situations. The fair reminds one of "Le Vieux Saltimbanque," again for the purposes of reversal:

Les forains sont sur la place! Un capitaine étant fort ivre, je le conduisais à l'estaminet, quai des Marronniers, où loin du bruit je le réconfortai . . .

(The strolling players are in the square. As a captain was very drunk, I led him to the pub on the Quai des Marronniers, where, far from all the noise, I comforted him.)

The drunk captain takes the place of the sober Saltimbanque in this lively fair. Contrapuntal effects are achieved by sliding from the vulgarity and everyday context to sadness and consolation. If the poet finally invites the beloved to think about sweetness, he has in mind not the harmony and order stressed by Baudelaire, but a rather phony escape.[4]

La Fontaine becomes the butt of repeated transformations: the long sequence of loosely related paragraphs or single-line sentences entitled "Le Coq et la perle" transform the poet's work into a persistent and often blind search. In the concise "Fable sans moralité," machines have taken the place of animals, the steam engine competing with the car. In this competition, where words inflict victory or defeat, regardless of action, moral lessons lose even the little relevance they have in La Fontaine, where they are frequently no more than a knowing wink to the reader or an ironic attempt to maintain a tradition. "C'est le fond qui manque le moins" parodies La Fontaine in a very different manner. Drastically changing the lesson in responsibility, Jacob replaces from the beginning the large field of "Le Laboureur et ses enfants," which would yield a rich harvest, by a tiny yard, incapable of providing a

single tree. The immediate preoccupation with the results of the harvest
as well as an awareness of the impossibility of any yield whatsoever,
reverse the situation of La Fontaine's fable. Jacob, in spite of the
matter-of-fact tone adopted in the poem, insists on the element of
surprise. The author never answers the questions concerning the
possible growth of the tree, but when his friends dig a hole, his lost
precious stones turn up. The treasure perversely situated in the past is
divorced from any notion of merit or responsibility. Jacob has cleverly
misdirected our attention towards what rises above the earth, the
nonexistent treetop. The unexpected does not, as in La Fontaine, arise
from temporary human limitations, but possesses a haphazard quality
similar to the Absurd. The poetic principle involved, that of chance, is
opposed to any form of systematic exploitation. Such questions as:

Mais si le hêtre grandit, ne sera-t-il pas trop grand et s'il ne grandit pas
est-il besoin de le planter?

(But if the beech should grow, won't it be too big and if it should not,
why bother to plant it?)

prematurely situate any possible development into rigid paralogical
propositions and contexts. The very title, borrowed from La Fontaine,
takes on a distinctly different meaning. *Fond* (not *fonds* as in the fable)
means bottom and not substance. The creative principle—the hidden
subject of the poem—depends on negation as well as on causal
incoherence.

 "Poème déclamatoire" belongs to a significant group of texts
which parody various genres. Jacob combines several allegorical
traditions in a declamatory style: the Parcae, the Furies, the Republic,
Glory and Defeat, suggesting that the declamatory poet inflates any
word that comes to his mind. Perennial patriotic odes are interwoven
with blatantly modern expressions, as though the writer were unaware
of any contradiction. Glory and defeat, Waterloo and the Republic
provide the same pathos. In a procession of ghosts, skeletons and
shadows, the dead rhetorical figures of poets long departed, a breath-
less, chaotic evocation of heroes, destinies, and constellations, the poem
explodes its false rhetoric, until at its conclusion a child emerges: "C'est
la France!" This final identification by unquestioned association ironi-
cally crystallizes all the forces of good and reassures mankind of the
future.

"L'Ombre des statues" might be interpreted as another example of Jacob's uneasiness in regard to literary genres; he suggests the lifelessness of creations which fit too readily into labelled categories. The opening line already establishes a certain connection between "Grand Bazar" and "Tableau de la foire":

Je me souviens du Grand Bazar où je fus employé.

(I remember the Grand Bazar where I had been employed.)

The department store subscribes to the principle of order, but the word "bazar" also suggests an oriental lack of order. The narrator composes with great effort a laudatory funeral speech for the defunct scion of a firm allied to the Grand Bazar, only to find out that the deceased was three weeks old. The disproportion is made to appear all the more darkly humorous: the firm of Fichet manufactures minisafes for doll houses.

Earlier we alluded to Jacob's deliberate attempt to break down the convention whereby mystery is alien to everyday existence and akin to remoteness. He repeatedly turns mythological figures into common-place beings inhabiting familiar landscapes. In that respect "Le Centaure" resembles "Dans la forêt silencieuse" where an encounter with the three Magi was expected. In "Le Centaure," where he parodies "Aube" and "Mystique," the poet evokes once again an intimate encounter with a mythological figure in a familiar context. The centaur's coffee color and serpentlike haunches offer a combination whose paradoxality is greatly increased by the narrator's fearful stock reactions which have little to do with the appearance of the monster, as well as by a rather absurd insistence on the idea of circularity. In the final sentence he thanks the sun for enlightenment and learning, one of the many declamatory endings in *Le Cornet à dés*, all the more ironic here because it is out of keeping with the rest of the poem. This speech explains why the narrator fails to exchange a few words with the centaur running around freely in the forests of Brittany. Here as in many other texts Jacob shifts from intimacy to distance and back again without warning, as though to make fun in advance of esthetic distance, a principle cherished by modern critics.

However, Max Jacob's poetics is not solely an antipoetics, a parody of a tradition or a genre or an unmasking of a fallacy concerning the role of one of the arts. "C'est le fond qui manque le moins" suggests

that systematic work is not the road to literary creation, but also that the artist is constantly and obscurely in search of a perhaps undefinable object. It also indicates a "non-declamatory" anguish on the poet's part because he cannot get at the root of his own creation. In two brief texts of "Le Coq et la perle" he declares more explicitly than elsewhere to what extent creation coincides with mystery. The more mysterious a situation, the more absurdly concrete are the examples chosen in order to express it:

Quand on fait un tableau, à chaque touche, il change tout entier, il tourne comme un cylindre et c'est presque interminable. Quand il cesse de tourner, c'est qu'il est fini. Mon dernier représentait une tour de Babel en chandelles allumées.

(In painting a canvas, each touch changes it completely; it turns like a cylinder, interminably. When the turning stops, the painting is finished. My last one represented a tower of Babel in lighted candles.)

This text alludes to the organic dimensions of creation, its constant and mysterious transformation during the creative process, stressing the impossibility of establishing a relation between the poet's gesture and its effect on the object of his creation. Between the work and the creator the relation is one of reciprocity; and after the initial stages the force of the work in its evolution surpasses the awareness of the artist. The poet may be concerned merely with putting down the next stone, but, whether he thinks about it or not, he often erects a tower of which, at a given moment, the overall vision may escape him. Placing lit candles on the tower of Babel deflates the notion of the completed work, points to the disproportion between aspiration and achievement.

Disproportion recurs in many of Jacob's texts, for instance:

De gros fruits sur un arbre nain, bien trop gros pour lui. Un palais sur le rocher d'une île trop petite. Un art dans une nation bien trop pur pour elle.

(Big fruit on a dwarf tree, far too big for it. A palace on the rock of too tiny an island. In a nation an art far too pure.)

The sequence suggests more and more clearly a menace, for we move from a disproportion, which may be inherent in nature, to one created by man, from a physical disharmony to moral chaos. The accumulation produces the effect of a causal or consequential relationship, and

although the concreteness of the examples provides an obvious humorousness, the text points towards separation rather than contact, alienation rather than communion.

In another short poem taken from "Le Coq et la perle," the statement that men are possessed by a demon points toward the unknown and unknowable in the creator:

Si tu mets ton oreille au tic tac de ton oreille, tu entendras bien en toi quelque chose qui n'est pas toi-même et qui est un ou le démon.

(If you put your ear close to the ticking of your ear, you will clearly hear in yourself something that is not yourself and that is a or the devil.)

Repeatedly Max Jacob raises the problem of identity, with or without its relation to the creator. The necessary limitations of self-recognition tormented Jacob; the poet once again signals the unaccountable which can be the source of creation: that which is not ourselves is still ourselves, when we listen to the ticking of our ear. Not only does the apparently simple action of listening thus become impossible (how can an ear listen to the ticking of an ear?) but the unaccountable reaches a climax through the association of a demon with the mechanical ticking of a watch.

The poem "Jeu sur le mot caste" can be interpreted as an indictment of false social distinction or as a funny attack on the mechanical explanations of problems, whereas in our opinion what matters most in the text is the search for an identity. The poem suggests an ever renewed pattern of hostility and reconciliation, projected along a chain of human beings. Reconciliatory actions are all the more praiseworthy when they occur between two people of different caste. Ultimately one becomes aware that no two human beings belong to the same caste, not even mother and son. Likeness is abolished for the sake of separation. Exclusion and difference are meaningless barriers preventing individuality:

J'ai bu un verre de vin à la table de famille, mais debout, car j'avais frotté le parquet.

(I drank a glass of wine at the family table, but without sitting down, for I had polished the floor.)

Reconciliatory gestures are of no avail, they seem almost to go against the grain of nature, lacking any relation to the authenticity which seems to preoccupy Max Jacob as evidenced by the recurrence of the word "vrai" in several titles: "Les vrais miracles," "Anecdote vraie," "La vraie ruine."

In "Littérature et poésie" Jacob apparently makes a distinction between genres, an issue which he seems to avoid or even to ridicule elsewhere. The distinction centers around the problem of falsehood and authenticity, illusion and reality; it implicitly presumes the dichotomy between literature and reality. In an adaptation of a line from Verlaine, a father says about his son who is praised as a poet:

C'est bien, mais si c'est un littérateur, je lui tordrai le cou.

(That's good, but if he's a man of letters, I'll wring his neck.)

Literature is rhetoric, declamation, words inflated beyond meaning: the boy to whom poetic talent is attributed is a liar who invents recollections of Naples, a city which he has never visited. Moreover, Max Jacob himself begins with an untruth: the water, he says, rises in Brittany so as to cover the roads and the forest. Thus a close parallel is established between the boy and himself without his being explicitly present in the poem. Poetry is therefore an untruth in regard to reality, while literature (which may or may not include poetry) is a misuse or a distribution of language, the very basis of literature. The boy who invents the sights of Naples he has never seen and proposes them as a personal recollection wears a sailor suit because his mind wanders from reality to fantasy. During this "voyage" he experiences an isolation greater and greater, and thus it becomes his lie and his own private world; but this separation, this evocation of lonely streets with never more than a single pedestrian is not based on a romantic psychological predicament, but on the unformulated, yet very tangible law of poetic analogy which bridges all distance.

NOTES

1. *Le Cornet à dés*, Paris, Gallimard, 1945. Cf. Suzanne Bernard, *Le Poème en prose*, Paris, Nizet 1959; S. J. Collier, "Max Jacob and the poème en prose," *Modern Language Review*, 51 (1956): 522–35. For a dissenting view cf.

Annette Thau, "The Aesthetic Reflections of Max Jacob," *French Review*, 45(1971): 800–812.

2. All translations by Judd D. Hubert.

3. I deal with problems of poetics not investigated by: Sydney Lévy, *Une Poétique du jeu: Etude sur le Cornet à dés de Max Jacob*, dissertation, Univ. of Calif. (1970); Gerald Kamber, *Max Jacob and the Poetics of Cubism*, Baltimore, Johns Hopkins, 1971.

4. Toward the end of the poem Jacob alludes to Rimbaud's "Après le déluge" and "Ponts" without in any way abandoning the claptrap booths and vulgar entertainment provided by the fair.

The Esthetics of Ambiguity

reverdy's use of syntactical simultaneity

Eric Sellin

Le vrai lieu est donné par le hasard, mais au vrai lieu le hasard perdra son caractère d'énigme.[1]—Yves Bonnefoy

Among the most important characteristics of the cubist-surrealist esthetic is simultaneity: its driving force, ambiguity, is the hallmark of several poets of the period. Ambiguity has a greater range than simultaneity and may take several forms—for instance, the retroactive mystification of an apparently finite word in a phrase like: "A bird perched in the tree of silence." After some brief remarks on the esthetics of ambiguity, I should like to examine a pure form of syntactic simultaneity particularly as it occurs in the poetry of Pierre Reverdy.

Intentional ambiguity has been exploited by poets from time immemorial—seriously and in jest—and its use by Reverdy has been mentioned specifically by at least one critic,[2] but a further study of these esthetics should be undertaken. The following remarks do not pretend to be more than prolegomena.

In a paper entitled "Creativity and Culture," Morris I. Stein describes the motivational stage of the creative process as follows:

The creative person has a lower threshold, or greater sensitivity, for the gaps or the lack of closure that exist in the environment. The sensitivity to these gaps in any one case may stem largely from forces in the environment or from forces in the individual.

Associated with this sensitivity is the creative individual's capacity to *tolerate ambiguity*. . . . I mean that the individual is capable of existing amidst a state of affairs in which he does not comprehend all that is going on, but he continues to effect resolution despite the present lack of homeostasis.[3]

The assertions of creative artists themselves—even those who are not trained psychologists or philosophers and whose testimony is based solely on a direct intuitive understanding of the creative experience—tend to support the validity of Professor Stein's description of the contradictory situation in which the creative artist is motivated by a need to synthesize or achieve closure while his basic creativity is measurable in terms of his ability to tolerate or to seek the ambiguous, a tolerance and a search essentially antagonistic to the need for closure; and, as a result, the creative experience is at once a self-realizing and a self-destroying process. In the moment of creative production, the artist has achieved the closed in that he has filled a gap or a certain "want," [4] although the ambiguous will never be annihilated altogether, as the product would then be so scientifically explicit as to be devoid of artistic interest.

Of the two modes of thought, scientific and creative, modern poets tend to pursue the ambiguous, or the symbolic. Their pursuit is all the more zealous since the language of science has also become so extreme or polarized in our day, as Marcel Raymond points out:

Thus one is led to observe a real dichotomy between two undertakings and two modes of knowing. This dichotomy is first inscribed in two different languages. That of the poet is necessarily ambiguous, plurivocal, overdetermined (as the psychologists say), because the whole man with all his capabilities and above all by means of his sensations, tries to wed things in their fullest being—whereas the language of the scientist tends to univocality and to the grasping of a truth which will be logically or mathematically demonstrable as well as of a practical

application; a relative truth, however, relative to the intellectual consciousness of the observer and to the profile which this consciousness will have etched in the real.

In its purity, the language of the scientist is composed of rigorously conventional signs, of abstract indicatives. The vital knot of poetic language is the symbol, which, said Goethe, must be understood as a symbol; in other words, the symbol is literally untranslatable, cannot be reduced to an abstract idea. In it are mixed, concentrated, and expressed a subject and an object, a man, who has arrived at a unique point of his destiny, and his universe. But the symbol is doubtless also the most resistant kernel of myth.[5]

I like to consider the cosmic imagery of the modern mystic poets—from the serious surrealists, the Italian hermeticists, and Reverdy, to Bonnefoy, Jean-Claude Renard, and others—an assault on the "resistant core" of the myth, an attempt to construct a mythic world or "lieu" in which "le hasard perdra son caractère d'énigme" (chance will lose its enigmatic character).[6]

The problem of understanding the hypermodern convention in poetry is largely one of definition. The nucleus of the new poetry is a poetic image which is not metaphor as such nor any specific rhetorical device and, furthermore, is not really an image as we generally interpret that word. It is not depiction, parallelism, or analogy, although it may occur within such frameworks; it is rather a glimpse at the universal, a confrontation with an irreducible ambiguity. It does not dazzle us with aptness of comparison between known units but rather enlightens us or at least stuns us by giving us an impulse into the area of the ineffable. Such poetry must, perforce, be *mystic*, and we cannot avoid the word. Let us say at once that most modern poetry which is truly new and not just a variant of the Romantic and Post-Romantic poets is mystic. It is significant that the modern poet is fascinated not by Descartes but by Heraclitus.

For many centuries, Western art and philosophy have been concerned with unity and with the destruction of opposition and paradox. On the other hand, so-called primitive societies, like the Pre-Euclidean, not only accept opposition and paradox as immutable facts of the universe but make those qualities the foundation of their total way of life, their mythos. Consider, for instance, Fang esthetics

which are predicated on an acceptance of opposition and duality and which recognize in duality a vitality-yielding polarity and tension.[7]

The poetic image generally assumes three forms related to metaphor, parallelism, and the frank exploitation of paradox. I shall not dwell here on traditional rhetoric, although ambiguity may be found within the context of simile, or metaphor. I should like, however, to pause briefly on the "polar" image since it, too, forms an important part of Reverdy's esthetics of ambiguity. There is a certain type of image which, when not intentionally contained in a prescribed poetic form, is normally called a *"non sequitur";* but this type of image is, due to the very act of creative, or intentional contiguity of its apparently unrelated elements, one of the most interesting devices at the disposal of the poet. In the use of such images the poet is in the deepest sense a *maker.* If one forgets for the moment its more subtle continuities, the image of the Japanese *haiku* falls into this category. According to tradition, the greater the apparent contradiction between the two parts of the *haiku* and, therefore, the greater the subtlety of the contextual relationship of the two parts, the more the poem is to be admired. This results from the fact that there is a dichotomy in most cultures of the expository or scientific and the suggestive or esthetic and the two different truths they pursue. If this polarity exists—as Marcel Raymond has implied—suggestivity would be an essential ingredient of the ultimate poetic image and the "disparate" or polar image would be at a premium in poetry.

One of the foremost exploiters of the suggestive, disparate image is Pierre Reverdy—significantly a contemplative—who wrote in his notes that the more remote the two elements of the poetic image, the purer the poetry. In one of her articles on Reverdy, Anna Balakian has referred to the theory of polarization held by the recluse of Solesmes and compared the image resulting from the "silent space" to a spark in a gap. It is clear, if we may pursue the comparison, that should the poles of the image be too far removed, no commutation or arc occurs, and the image is absurd or at best intentionally contradictory. It becomes evident, as well, that the charge between the terminals of the image—unlike the unequivocal and quantitative electrical charge in a scientific apparatus—is largely a measure of the personal intervention on the part of the reader, or recipient, of the image. If Reverdy is a difficult poet, it is because at times the "charge" or image fails to occur for us, which does not mean that it does not occur for others who may

receive it with totally different personal acumen, or, indeed, that we might be affected by the image at another time in our lives or perhaps in another state of mind as under the influence of alcohol or drugs. The surrealists concluded that the area known to us of our total receptivity or sensitivity—of which dreams, hallucinations, and normal wakefulness are parts—forms a very small portion of what in fact exists within us, whose delineation has been the object of the quest ennobling the best surrealist art. The surrealists contend that the more profound regions of receptivity provide an area, an atmosphere, in which apparently absurd images make contact, arc into being. It may be that the more contemplative—the oriental artist, the occidental mystic, poets like Reverdy, through their self-examination and their study of nature—penetrate a little further into the collective unconscious and therefore perceive and create valid images whose tension and ambiguous charge is unfortunately inaccessible or even intolerable to the average reader, until his awareness is developed. The toleration of a great degree of ambiguity can be acquired through a contemplative study.

A great deal has been made of Reverdy's theory of the polar image:

The image is a pure creation of the mind. It cannot be born from a comparison, but only from the bringing together of two realities more or less distant from each other.

The more distant and more accurate the relationships between these two realities now brought together, the stronger will be the poetic image, the greater its emotive power and its poetic reality.[8]

This view of poetic imagery has caused Reverdy to be labeled by some critics a "cubist poet," but it seems to me that another area of his poetry which has not been carefully explored provides a more rational relationship to the tenets of cubism; and let us not forget that, as André Billy has said in connection with Apollinaire and Reverdy, "people speak of cubist poetry only through a vague assimilation with painting" (letter to author). I am referring to the creative, intentional, ambiguity in the syntax of the poems. The polar image is usually construed to be a mutually dependent array of two or more referents which function as a poetic image only in their physically simultaneous and thus momentary and motionless manifestation. This no doubt touches slightly on the area of simultaneity so dear to the hearts of the cubists, but more true to the

cubist conception of simultaneity is the progressive and retroactive ambiguity of the syntax in many of the poems. I shall illustrate this phenomenon and demonstrate that it is intentional and not the result of careless writing or a penchant on the part of the writer which he had difficulty in controlling, such as Victor Hugo's urge for the cadences of Romantic trimeter.

Syntax may be defined as the facts of and the rules governing the grammatical relationships within sentences and within and among subdivisions of sentences or fragments. Syntax reflects many currents in language development, some contradictory, such as tendencies toward exactitude of reference and simplification of language; but an abstract goal of syntax is the achievement of greater precision among the parts of the sentence and the elimination of ambiguity. At least these are the lessons one is taught in school. We have been told so often to watch our antecedents and not to write "He put his hat on the chair and sat on it," that the educated reader of poetry is apt to have a rather rigid concept of syntax. He is likely to prefer the direct progression of subject, verb, and object (if that is the way his language "thinks"), and at least strive to have the sentence parse unequivocally in its entirety, regardless of inversions and so forth. Any departure from unequivocal single-interpretation grammar is usually considered slipshod writing and even when intentional it may very well strike its head against someone's low tolerance of ambiguity.

The overall effect of the syntactic ambiguity is to render two or several contextual meanings simultaneously possible for a given passage. One may well try to opt for the logical choice, but often Reverdy makes it difficult to choose and we must accept both or all options as being a collective integral part of the text, a simultaneous meaning being the desired effect. Thus, Reverdy not only exploited ambiguity as a creative ingredient, but was clearly aware of the ambiguity and made extensive use of it throughout his career, especially in the relationship of clauses made equivocal through the suppression of punctuation. The simultaneous existence of two interpretations of a passage of a poem is the one characteristic that makes these poems truly "cubistic" in an analogy with the paintings of the movement known by that name. The polar image entails the side-by-side presentation of disparate things or realities, but the creative ambiguity in the syntax presents simultaneously two or more concurrent movements of reality in the same direction or the opposite direction or even both at once if several

ambiguities overlap in a passage, as is often the case in Reverdy's work. This phenomenon requires of the reader a retroactive revaluation and an awareness of relativity; the ambiguity contains advancing time which is an essential ingredient in the reading of any sentence, but also negates time by directing all arguments for unity to the irreducible condition of simultaneous options, a condition in which as one makes choices in the normal reading progression he must also make simultaneous retroactive tolerances of ambiguity and thus is reading backwards, as it were, at the same time that he reads forward. This simultaneity is not so much akin to the strange juxtaposition of objects in paintings by Dali, Henri Rousseau, or René Magritte—which are rather analogous to Reverdy's polar image—as it is to the paintings by Picasso in which a person is portrayed simultaneously in profile and full or three-quarter face. The artist is negating the passage of time by representing in one aggregate image or passage two aspects which customarily require the passage of time necessary either for the subject to turn his head or for the artist to walk around him. The ambiguity in the syntax, then, is not one of the improbable possible or the conceivable impossible of the unexpected juxtaposition of objects, but the pure ambiguity of time relevance which cannot be solved since it inheres not in the actual image itself or the contents, but in the presentation of the grammar which has no correlative imagery but rather requires tolerance of ambiguity on the highest level of thought, the imageless area in which thought wrestles with the concept of time.

The syntactical ambiguity usually found in Reverdy's poems is

shown in the above scheme as two or more parsings of a passage in which there is an area of incompatibility between blocks A2 and B2. If the syntactical break comes after 2, as in A, then 3 begins a new thought; if the break comes after 1, then 2 and 3 form a unit; and perhaps breaks could also be interpreted after 1 and 2; but when both or all readings are tenable, they cannot be resolved but must exist in a state of suspension in relative ambiguity. A perfect example of this is found in "Trace de Pas" from *Sources du vent* which begins:

> Cinq branches se sont allumées
> Les arbres retiennent leurs langues
> Par la fenêtre
> Une tête encore dépassait
> Une nouvelle étoile allait paraître
> Là-haut
> L'avion rivalisait
> Avec les astres de vitesse . . .[9]

> (Five branches have lit up
> The trees hold back their tongues
> By the window
> A head still stuck out
> A new star was going to appear
> Above
> The airplane competed
> With the stars for quickness . . .)

Lines 5–7 are syntactically ambiguous because of the lack of punctuation and the fact that capital letters begin every line. Superimposed on my schema, the ambiguity is found to be in perfect equipoise, each interpretation being equally logical in content but the straight combination as read linearly in the poem being a *non sequitur* according to normal syntax:

	A		B
1	Une nouvelle étoile allait paraître		Une nouvelle étoile allait paraître.
2	Là-haut.		Là-haut
3	L'avion rivalisait . . .		L'avion rivalisait. . .

There are many examples in Reverdy's poems of this phenomenon which Anthony Rizzuto has termed "the bridge phrase." In his *Style and Theme in Reverdy's Les Ardoises du toit,* Rizzuto stresses this effect briefly. As support for his discussion he cites an early example of "bridge phrase" in "Une Eclaircie":

> Et tout ce qui s'avance
> Et tout ce que je fuis
> Encore
> Je me rappelle
> La rue que le matin inondait de soleil[10]

> (And everything that moves forward
> And everything I flee
> Still
> I remember
> The street that the morning flooded with sunlight)

and correctly notes that one can find some examples of the device in earlier works by other poets, in particular Guillaume Apollinaire. However, he does not discuss the esthetics of this phenomenon nor does he attempt to demonstrate intentionality. The undeniable examples in Apollinaire—such as the line in "Zone" which reads: "Il est neuf heures le gaz est baissé tout bleu vous sortez du dortoir en cachette"—are less skillfully handled than those in Reverdy's poetry. One is not always certain to what extent Apollinaire's syntactical simultaneity is a by-product of his pioneer experimentation with punctuation-free poetry; in most cases the context clearly favors one particular interpretation. In Reverdy's poetry, on the other hand, even the shortest texts may contain several ambiguities, to such a degree that one must attempt to read them in a single breath to reconcile or force together all the variant readings in an ambiguous meld.

Reverdy might, of course, be given the benefit of the doubt about the ambiguities in his poems, and no one would accuse him of incoherence or careless writing, especially since there are very few poems free of this sort of syntactical ambiguity; however, we can demonstrate beyond a doubt that Reverdy did not unwittingly use syntactical ambiguity through an extreme personal tolerance of ambiguity or in a blind, talented manner, but was quite aware of what he was

doing. We have only to see the way in which he makes distinctive use of lower case in some of the poems in order to conclude that the passages he allows to remain ambiguous remain so through his conscious wish. Ambiguity—creative or unintentional—can easily lead to incongruity and the grotesque. In "Ruine de la Chair," all lines begin with capital letters except in several instances where the poet would avoid an ambiguity creating a contrary effect or a ludicrous image (and as much as Reverdy admired the incongruous image, mere comic incongruity is alien to his mentality and banished from his work):

> Prends ta besace
> Voile ta face
> Et pars
> La route blanchit
> Sous la nuit
> Il est tard
> Va-t'en
> que le temps
> passe
> Oublie que tu vécus un jour
> Meurs à ce temps
> Et recommence
> A marcher vers
> le point final de l'univers
> qui se dérobe
> Change ta robe
> Garde ta peau
> Ainsi le vrai se cache sous le faux
> Pas difficile
> pleur inutile
> Ton coeur recule
> Mais bien plus fort
> et miniscule
> La vie te pousse vers la mort
> Tour gigantesque
> humain grotesque
> par un seul soupir dégrafé
> Tous les remords sont effacés
> > Rouet de l'heure

qui file et pleure
 trop longuement
Arrête et cesse ton mouvement
Le désir avide
 tourne dans le vide
 Vers un autre but
 sous le vent perdu[11]

(Take up your kit
Veil your face
And set out
The road whitens
Under the night
It is late
Go on
let the time
pass
Forget that you lived one day
Die to that time
And start over
To walk toward
the final period of the universe
which slips away
Change your dress
Keep your skin
So the true hides under the false
Not difficult
useless tear
Your heart draws back
But far stronger
and miniscule
Life pushes you toward death
Gigantic *tour*°
 Grotesque human
 unhooked by a single sigh
 All remorse is effaced

° *tour* (fem. = tower; masc. = trick). The word is ambiguous: if feminine, the word "human" in the next line is a noun; if masculine, "human" is either an adjective or a noun. The lower case would lead one to favor the adjectival interpretation.

> Spinning wheel of the hour
> which winds and weeps
> too long
> Stop and cease your motion
> Avid desire
> turns in the emptiness
> Towards another end
> under the lost wind)

In this poem there are a number of syntactical ambiguities. In some cases they constitute desiderata, as in lines 4–6:

> La route blanchit
> Sous la nuit
> Il est tard

and the capital letters have, therefore, been retained, but elsewhere in the poem, where the Reverdian ambiguity would have led to a gross distortion of the poem's intent or to a comically grotesque incongruity, the ambiguity has been suppressed by the introduction of lower case at the beginning of lines meant to be subordinate to the preceding line or lines. If we were not thus assisted in our understanding of the syntax, lines 7–9 might be interpreted in the following abruptly whimsical manner:

> Va-t'en!
> Que le temps
> Passe!

and lines 13–16 could be parsed as in my schema B with the following unfortunate proverbial result:

> A marcher vers
> Le point final de l'univers.
> Qui se dérobe
> Change ta robe!

Conversely, the restoration of the capital letter in the beginning of the penultimate line permits us either to subordinate the idea of that line to the line before it:

> Arrête et cesse ton mouvement.
> Le desir avide

<pre>
 tourne dans le vide
 Vers un autre but . . .
</pre>

or to treat the middle section parenthetically and thus subordinate the
last line to the first:

<pre>
 Arrête et cesse ton mouvement—
 Le désir avide
 tourne dans le vide—
 Vers un autre but . . .
</pre>

but not to make "tourne" an imperative, as we could if all letters
beginning the lines were capitals, with the following result:

<pre>
 Arrête et cesse ton mouvement—
 Le désir avide—
 Tourne dans le vide
 Vers un autre but . . .
</pre>

I believe that this demonstration, which could be supported by
many more examples from poems composed both early and late in
Reverdy's career, indicates that Reverdy was very much aware of the
ambivalence of his syntax and considered this ambiguity an important
part of his *ars poetica*. Furthermore, in an objective critical sense, this
ambivalence in the syntax provides a solid argument for classifying
many of Reverdy's poems as "cubistic" in structure even if they remain
surrealistic and mystic in content.

NOTES

1. Yves Bonnefoy, *L'Improbable* (Paris: Mercure de France, 1959),
p. 181.

2. Anthony Rizzuto, *Style and Theme in Reverdy's Les Ardoises du toit*
(University, Alabama: University of Alabama Press, 1971).

3. Morris I. Stein, "Creativity and Culture," in *Explorations in
Creativity*, edited by R. Mooney and T. Razik (New York: Harper & Row,
1967), pp. 110–11.

Some critics suggest that contemporary literature is an extension of the
Romantic movement. It appears to me, however, that literature in the West has,
since the decline of classicism and the creative failure of eighteenth-century
rationalism, been in a period of predominant tolerance of ambiguity of which

Romanticism only constitutes an early manifestation. I must stress that to say this is not the same as to say that we are today still in the Romantic period. The philosophy of surrealism demands great tolerance of ambiguity of its adherents and it is understandable that the surrealists should have felt a certain kinship with the Romantics, which is not to say, however, that they are simply later-day Romanticists. As for surrealism's own influence, most serious works of art of the twentieth century reflect a highly-developed tolerance of ambiguity on the part of the creative artist. For this reason it is difficult to assess the direct influence of the surrealist movement as opposed to the spontaneous presence of a tolerance of ambiguity: thus Yves Bonnefoy shares with the surrealists a high degree of deliberate ambiguity, although he is no longer to be called a surrealist. The same may be said of writers as various as Reverdy, Beckett, and Robbe-Grillet.

4. As Wallace Stevens wrote, "poetry and painting, and the arts in general, are, in their measure, a compensation for what has been lost" (*The Necessary Angel*, New York, Vintage Books, 1965, p. 171). Examples abound of artists' confessions that creativity constitutes for them an irrepressible urge to achieve closure. For example, Artaud told Jacques Rivière that the poems he had sent him were "les lambeaux que j'ai pu regagner sur le néant complet" and the Swedo-Finnish poet Bo Carpelan has described the poet's task as one of "winning, out of two words, one back."

5. Marcel Raymond, *Vérité et poésie: études littéraires*, Neuchâtel, Editions de la Baconnière, 1964, p. 272.

6. Bonnefoy, *L'Improbable*, p. 181.

7. James W. Fernandez, "Principles of Opposition and Vitality in Fang Aesthetics," *Journal of Aesthetics and Art Criticism*, 25,1 (Fall 1966): 53–54.

8. Reverdy, *Le Gant de crin*, Paris, Plon, 1927 (copyright 1926), p. 32.

9. In Reverdy, *Main d'œuvre*, Paris, Mercure de France, 1949, p. 107.

10. Rizzuto, *Style and Theme*, pp. 69–70.

11. *Ibid.*, pp. 488–89. Trans. M.A.C.

Benjamin Péret

marvelous conjunction

J. H. Matthews

Throughout his life, Benjamin Péret was concerned with establishing a basis for poetic communication commensurate with the situation of the contemporary poet. He saw the poet as legitimately occupying a position at the forefront of cultural development, yet guaranteed neither praise nor reward for his effort to combat stupidity and routine.[1] In his view, the present-day writer is a poet only so long as he is a revolutionary, committed to advancing into the unknown (AM, 30).

For the most part, the statements to be found in *La Parole est à Péret* are at the same time assertive and vague. They attest well enough to a distinctive sense of poetic vocation, but offer tangible evidence neither of the nature of that vocation nor of the direction it gives Péret's own poetry. This is hardly surprising, since Péret cared little about theorizing. He preferred leaving the public to deduce from his writings the principles upon which these rest. However, readers are likely to find small consolation in the knowledge that a poet whose reputation within the surrealist movement is unrivalled felt no obligation to explain his motives and ambitions in detail. To them, not the least disconcerting aspect of a Péret poem is that it seems to proceed by *non sequiturs*, rather than advance according to any readily perceptible plan. A

disjunctive principle seems to operate almost everywhere. Thus one often hesitates to refer to the development of a theme, or even to speak of a succession of meaningfully arranged images. Even readers who approach Péret's work with a perfectly open mind may soon have the feeling of being shut out by a poet who apparently cares not at all how readily he communicates with his public.

The disruptive principle underlying his writings is epitomized in Péret's remarkable imagery. The latter betokens such a violent departure from poetic precedent that it may well command the reader's exclusive—and puzzled—attention. To be able to go forward into Péret's poetic universe, however, we need to do more than be able to assimilate the images he favors. We also have to learn how to respond to a distinctive grammatical structure which provides his verse with its characteristic framework. Systematic examination of that framework would certainly offer insights into Péret's poetic concepts and their application. I propose to begin on this occasion with a single feature of grammatical structure, the conjunction, in the hope that observing how conjunctive elements paradoxically serve the disjunctive principle in his poems will help identify the motivating force of Péret's poetry.

Normally, the conjunction serves to unite sense as well as structure. Its designated grammatical role is not simply to join but to impose upon the elements it brings together a link that makes unquestionable sense of their proximity. Underlying the conventional use of conjunctions, therefore, we detect certain rational suppositions regarding the manner and the nature of verbal exchange. These are assumptions which the poems of Benjamin Péret challenge aggressively.

It is really of no account that conjunctions of the type which interest us are absent altogether from Péret's first volume of verse, *Le Passager du transatlantique*, published in 1921 in the "Collection Dada." It matters no more that their presence is not equally noticeable from collection to collection, after 1921. For it is clear that poems grouped under one title tend to fall into structural forms which dispense with conjunctions more readily than others. What is important is not so much how frequently conjunctions occur in Péret's writings as the forceful way our attention is drawn by their use to the distinctive manner in which his poetic imagination functions.

It is no easy matter to select verses illustrative of Péret's handling of conjunctions that will allow us to progress from simple

examples to more complex ones. Of course, it is not hard to pick out
lines which are quite elementary, on the plane of verbal structure; the
following, for instance:

> les chats bondissent parce que leur queue
> s'envole
>
> [*Un Point c'est tout* (1946) (2:185)][2]
> (the cats leap because their tails are
> flying off)

> mais la tempête ment comme une soupe
>
> [*Immortelle Maladie* (1924) (1:63)]
> (but the storm tells lies like a soup)

However, the question of relative simplicity or complexity can be
neither posed nor answered in relation to linguistic sophistication alone.
Conjunctions of the kind represented above have a special value. The
explanatory role reserved for them in conventional usage is subverted in
the antirational realm to which Péret's poetry gives access. Here
phenomena which reason finds unjustifiable exist side by side, or even
engender one another.

Péret once accused the eighteenth century of substituting for
God a terrestrial divinity, reason, which, he said, would soon try to
dominate the world.[3] In protest, he spoke elsewhere of poetry
understood as total liberation of man, calling the poet "an inventor for
whom discovery is but the means of attaining a new discovery," fighting
to bring man "an ever-perfectible knowledge of himself and of the
universe." [4] Our period, he asserted, should abolish all gods, including
reason, and "give man back to man" (PUI, 13). With the assistance of
remarks like these we begin to see Péret's conjunctions in proper
perspective. They serve to reclaim the world from reason. They
regularly mark a lyrical departure from the mundane, in the interest of
imaginative freedom. They become truly liberating agents since,
through their use, Péret denies the reasoning mind the reassurance of
finding his poetic statement totally incoherent while, like the English
Gothic novel, his poem "extracts the marvelous, quivering with passion,
from the far end of the attic to which rationalist thought has relegated
it." [5]

It is interesting to note that, although in his article "La Pensée

est UNE et indivisible," he terms the marvelous "the heart and nervous system of all poetry" (PUI, 10), Péret avoids circumscribing its meaning by further definition. Only when we come to grips with his poems and short stories are we able to infer what significance he attaches to the marvelous. For example, the conjunction "because" is used in his poems in a manner that overturns the principle of cause and effect, as this is generally understood and applied in our rational society. Thus sequence is set on another track and predictability is discredited:

> Et personne ne passera plus sur la route parce que
> les lettres seront des mitrailleuses hystériques
> [*Le Grand Jeu* (1928) (1:121)]

> (And no one will be able to use the road any more because
> the letters will be hysterical machine-guns)

Utilized in this fashion, "because" repudiates its traditional role. Its effect is no longer to enclose the poetic statement within the zone of familiar, habitual reality, but to open upon the unfamiliar and the unforeseen. Instead of being a fence to keep out the marvelous, the conjunction has become a window upon it.

This is the reason why Péret's writings offer explanations which frequently rival the sights and events they are required to justify, or even exceed them in strangeness. In one poem, for instance, a long passage incorporates the following prediction:

> Les grands arbres seront morts
> et les seins suspendus à leurs branches
> se soulèveront régulièrement pour signifier leur sommeil

> (The big trees will be dead
> and the breasts suspended from their branches
> will rise regularly to signify their sleep)

And why should this be so? Péret's explanation brooks no objection from reason:

Tout cela tout cela parce qu'un chien court après sa queue
 et ne la retrouve pas
parce que les pavés sont sortis en rangs pressés et menacent les rivières
parce que les plantes dépérissent dans des scaphandres désaffectés

parce que l'eau ne s'égoutte plus entre les doigts
tout cela enfin parce que tu n'es plus qu'une figurine
découpée dans un billet de banque
 [*Le Grand Jeu* (1:137–38)]

(All because all because a dog is chasing his tail
 and can't find it
because the paving stones are out in serried ranks and threaten the
 rivers
because the plants are withering away in deconsecrated diving-suits
because water no longer drips between fingers
all because finally you are no longer anything but a figurine
 cut out of a bank note)

Our feeling of disorientation is increased as Péret prolongs his explanation in a manner that profits from ambiguity. It is disconcerting enough to find that he combines a number of improbable circumstances to account for the situation his poem foresees. But is it not even more difficult for reasonable thought to cope with the possibility that Péret's first explanatory clause may depend upon the second, which in turn rests upon the third, while the third is the consequence of the fourth? However we interpret what Péret has written, it is clear that he accords "because" a pivotal position in his poetic statement, where its function is never in doubt: it supplies an explanation which heightens the antirational effect of the poem as a whole—instead of reducing or controlling it—so enriching the lyrical content of his verse:

> Et je vous attends avec le sel des spectres
> dans les reflets des eaux volages
> dans les malheurs des acacias
> dans le silence des fentes
> précieuses entre toutes parce qu'elles vous ont souri
> comme sourient les nuages aux miracles
> comme sourient les liquides aux enfants
> comme sourient les traits aux points
> [*Immortelle Maladie* (1:61)]

> (And I await you with the salt of ghosts
> in the reflections of fickle waters
> in the misfortunes of acacias

in the silence of cracks
precious above all because they have smiled at you
as the clouds smile at miracles
and liquids smile at children
as dashes smile at dots)

Like "because," in the poems of Péret the conjunction "for" is a
trap set to snare the unwary into looking for a logic which the poet long
since has put aside. Thus, in the lines below one is at a loss to find a
necessary connection, satisfying to common sense, between what
precedes "for" and what follows it:

Si je vais sur l'océan je charmerai tous les
 poissons et les pêcheurs me maudiront car les
 poissons seront centenaires pour avoir fait
 trois fois le tour du globe
 [*Le Grand Jeu* (1:121)]

(If I go on the ocean I shall charm all the fish
 and the fishermen will curse me for the fish
 will be a hundred years old thanks to having
 been around the globe three times)

The more one reads passages patterned after this one, where the
conjunction dislocates reasonable sequence, the more one is likely to be
persuaded that the essential characteristics of Péret's verse are arbitrari-
ness, inconsequence, and impertinence. In the following lines, for
example, after beginning with a simple statement modelled upon the
silly exercises of teach-yourself language textbooks, Péret proceeds to a
justificatory clause that entices his readers further away from what
reason considers acceptable. Then he makes a final affirmation which
sums up his lack of concern to effect a reconciliation with reason:

Les canards des astres ne sont pas ceux de ma soeur
car ma soeur est noire comme une huître
et de sa voix sortent des taupes
et les taupes de ma soeur gardent leur secret
 [*Dormir dormir dans les pierres* (1926) (1:48–49)]

(The stars' ducks are not my sister's
for my sister is black as an oyster
and from her voice emerge moles
and my sister's moles keep their secret)[6]

Typically, "for" serves primarily to open up reality in Péret's poetry:

car une source coule de mon genou
emportant ma hache vers d'autres continents
[*Le Grand Jeu* (1:226)]

(for a spring flows from my knee
carrying my axe toward other continents)

Under the conditions obtaining in his verse, one may feel tempted to give special stress to the confession he makes in a poem from *Immortelle Maladie*:

car c'est l'inverse que je vois

[1:64]

(for it is the opposite that I see)

In fact, however, one would do better to bear in mind that Péret sees the scale of values which we perceive consciously as "the rational product of absurd and horrible social constraints" (PUI, 11). In other words, what Péret has called "conscious reality" represents a deformation of reality by rational education (PUI, 11). To accuse him of inverting reality, then, is to miss something fundamental. From where Péret stands, the things evoked in his poems are not a deformation of the real but its rectification, thanks to a process aimed at eliminating the effects of the deforming prism of rational education. In *Le Déshonneur des Poètes* he vigorously attacks the idea that poetry is escapism, assuring us that it is "reality itself, its essence and glorification" (DP,72). In his *Anthologie des Mythes* he looks forward to a time when "poetic thought" will have become as natural as seeing and sleeping, and when the marvelous will no longer frighten mankind (AP,28).

Understanding Péret's line of thought, we appreciate why it is that, where "because" and "for" affirm a liberty that common sense is powerless to resist, the conjunction "but" raises no objection to their revelations. On the contrary, for Péret its role is to second the other two in their revolt against rational limitations. Although "but" serves to qualify a preceding statement, as in customary usage, it never has the effect in his writing of reducing the distance between that statement

and reasonable conjecture. Instead, Péret uses "but" so as to attain higher levels of irrational projection. He ends a succession of far-fetched injunctions in a poem from *A Tâtons* with this qualification:

mais ne jamais insulter le facteur pour chasser les souris de la pendule
qui attaqueraient les bronzes d'art à coups de bec
<div align="right">[*A Tâtons* (1947) (2:203)]</div>

(but never insult the mailman to frighten off the clock's mice
which would attack the artistic bronzes by pecking them)

Just as "but" qualifies without confining imaginative freedom, so when used to propose alternatives it helps conduct us further into the world of imagination, rather than leading us back into the everyday world. Thus one poem of *Je sublime* takes us:

au delà de la grande plaine glaciaire où les dinosaures couvent encore
leurs oeufs d'où ne sortiront pas de tulipes d'hématite
mais des caravanes de hérissons au ventre bleu
<div align="right">[*Je sublime* (1936) (2:126)]</div>

(beyond the great glacial plain where the dinosaurs still sit on their eggs
from which will emerge not hematite tulips
but caravans of blue-bellied hedgehogs)

Even when the clause introduced by the conjunction has a higher emotional charge, logical sequence is dislocated just as violently:

droit comme un mât de cocagne dont j'atteindrai le sommet
pour que tu me regardes non comme un kilo de sucre
mais comme une nuit que tu as décousue
<div align="right">[*Je sublime* (2:133)]</div>

(straight as a greasy pole that I'll reach the top of
so that you will look upon me not as a kilo of sugar
but as a night you have ripped open)

One could multiply examples, adding for good measure instances of Péret's use of "in order that," "however," and so on, which contribute to his poems in the same way as the conjunctions considered above. But enough evidence is available already to allow us to sketch a few conclusions.

Whenever Péret's conjunctions are viewed in context, we see two factors governing their use. One of these is the influence exerted by a mode of intuition to which we have heard him allude. The other is desire. Indeed, Péret's major contribution to surrealism in poetry is, perhaps, having made these factors interdependent in his poems. And yet, characteristically, he never once emphatically related desire to intuition in the comments he published about the nature of poetry. Hence to learn something of what desire meant to him, we must turn to two selections he made of other men's writings—his *Anthologie des Mythes, légendes et contes populaires d'Amérique* and his *Anthologie de l'Amour sublime*. As for his concept of poetic intuition, this is reflected most clearly no doubt in his essay "La Pensée est UNE et indivisible."

When we begin with the latter, it does not take long to see why Péret considered poetic intuition supremely important. His starting point was the belief that intuition necessarily must meet antagonism, in a rational society reluctant to admit that poetry is destined to reveal "the future of the world." He argued in fact that, in its most audacious form—"prophetic intuition"—poetic intuition is bound to be the object of a concerted attack, mounted by reason with the purpose of bringing discredit upon it.[7] Taking up the challenge offered by rational thought, in opposition to rationalist education Péret invariably promoted intuition in poems that pay tribute to intuition as "the creator of reason itself."[8]

It is essential to realize that Péret saw no valid distinction between reason and unreason and that this is why thought appeared to him as *indivisible*. His poems stand as testimony to his conviction that there is a unity in thought which rationality is patently incapable of recognizing. Denying that there is any justification for separating poetic thought, as "prelogical thought," from the logical thought supporting rational discourse, Péret's preface to his *Anthologie des Mythes* implies a significant connection between poetic intuition and the unconscious.[9] Thus when in "La Pensée est UNE et indivisible" he places reason second to poetry, he is really elevating the irrational above the "monstrous product" of the Age of Enlightenment and linking poetry with the unconscious, "the source of all knowledge, of all creation" (PUI, 12). When, coincidentally, he speaks of desire as residing in the unconscious,[10] he permits us to glimpse how, in his mind, desire and intuition are interconnected.

Just as he equated poetry with intuition so, we learn from *Le*

Déshonneur des Poètes (p. 72), Péret saw it also as love. This explains why he could talk in his *Anthologie de l'Amour sublime* of the nineteenth century as a period dedicated in France to liberating sensibility by pleading the cause of the marvelous and of love—two aspects, he insisted, of the irrational (AAS, 10). This implication of a close relationship between love and the marvelous in the realm of the irrational is important, since it permitted Péret to lay the foundation of a myth of "sublime love," originating in desire. The relevance of his discussion of love to his use of conjunctions becomes apparent in his emphasis upon the fact that, in sublime love, the marvelous loses the "extraterrestrial supernatural character" with which earlier myths invested it. Here, according to Péret's argument, the marvelous takes its place "within the limits of human existence" (AAS, 20).

Beneath the surface of Péret's essays on love and desire lies a conception of poetry that is never quite given explicit development, perhaps, but to which his poems nevertheless make us sensitive. Here we become responsive to an undercurrent of meaning which, in its turn, helps illuminate his verse, as we listen for example to Péret declare that sublime love takes its origin in primordial aspirations, so effecting a transmutation that produces agreement between body and spirit in "a higher unity"—a fusion which it is the role and justification of desire to bring about (AAS, 20). True, it is not possible to interpret every phrase used by Péret on this occasion at the level of poetic creation. All the same, the role of grammatical structure in fusing elements rearranged at the bidding of non-rational intuition interestingly parallels that of desire, as we find him referring to it. Specifically, thanks to the way he uses conjunctions, Péret makes us witnesses in his poems to the operation of "that desire multiplied by its own satisfaction" (AM, 25), helping us appreciate in them more readily "the complete abandon without which no true love is conceivable" (AAS, 8).

Presenting his *Anthologie de l'Amour sublime*, Péret asked pertinently whether it is only the poet who can experience sublime love. He replied affirmatively to his own question, but insisted that the poet is not to be understood as a writer so much as someone capable of detecting the presence of poetry: "He is not a stranger to poetry who, even placed at ground level, discovers in everything its heavenly aspect" (AAS, 70). As Benjamin Péret never made any secret of his contempt for religious solutions to human problems, his reference to the heavenly aspect of things should lead to no confusion. In his *Anthologie*

de l'Amour sublime, at all events, it marks his profound opposition to the incomplete sense of reality which reason is limited to encompassing. When he speaks of "recognizing poetry," he means glimpsing that enlarged sense of reality called surreality. He is talking, in other words, of being responsive to the dictates of desire, for which sublime love is but one mode of expression. Thus, if we consider the deeper implications of desire, we go with Péret beyond emotional involvement, however passionately communicated. For him, desire undertakes to fill the void inherent in human life with another being—someone with whom it is possible to form "an harmonious whole." Granted divinity by desire, a person of the opposite sex at the same time confers divinity. Hence this "double operation, by its irrational character, participates in the marvelous." [11] It is especially illuminating, then, that in his poems conjunctions consistently show Péret to be deaf to reason's protest. They externalize the non-reasonable which, for Péret, is fundamental to poetry. They tend to undermine the barricade separating the rational from the irrational. Or, to borrow a figure the poet himself has used, they help fill the void inherent in the human condition, as they reduce the distance between physical reality and the realm of desire.

Péret's use of conjunctions bears witness to that "reaching out" by man toward the complete happiness which he expects when he finally ceases to feel torn apart (AAS, 21). This is why they bring to our attention that "double automatic movement, centrifugal and centripetal" (AM, 35), by which desire finds fulfillment in his verse. In this sense, their function is to highlight desire, which his *Anthologie de l'Amour sublime* likens to a mariner's compass (p. 73). If we do not keep the compass in sight, we soon lose our way in Péret's poetic universe. But if we are able to remain attentive to its movements, unpredictable as they may seem to reason, then we enjoy the benefits of a kind of magic which the poet once defined as "the flesh and blood of poetry" (AM, 23).

In 1942, Benjamin Péret looked forward to a time when poets, with the active or passive collaboration of everyone else, will create "exciting marvelous myths" capable of stimulating the whole world to "assault the unknown" (AM, 31). Five years later, André Breton was to comment on the only *"evidence"* he recognized in the world, remarking that it came from the "spontaneous, extra-lucid, insolent relationship" which certain conditions imposed upon things that common sense would deter us from bringing together. Confessing to his fascination

with anything able to break the chain of discursive thought, "illuminating a life of relationships fruitful in a different way," Breton categorically condemned the form of rationalized verbal logic one associates with use of the word "therefore." [12] Expressing contempt for that conjunction, Breton implied a relationship between the *evidence* which earned his approval and dislocation of conventional thought processes. At the same time he helped show why Benjamin Péret, whose use of conjunctions is so peculiarly personal, was, in the estimation of the surrealist leader in France, "among us all the one who threw himself without restraint into the poetic adventure." [13]

NOTES

1. "Pour lui, il n'y a aucun placement de père de famille, mais le risque et l'aventure indéfiniment renouvelés. C'est seulement à ce prix qu'il peut se dire poète et prétendre prendre une place légitime à l'extrême pointe du mouvement culturel, là où il n'y a à recevoir ni louanges ni lauriers, mais à frapper de toutes ses forces pour abattre les barrières sans cesse renaissantes de la sottise et de la routine." *Anthologie des Mythes, légendes et contes populaires d'Amérique*, Paris, Albin Michel, 1960, p. 31 [AM] The passage quoted here is taken from an essay *La Parole est à Péret*, New York, Editions surréalistes, 1943, written in 1942 and incorporated in the preface to the 1960 anthology.

2. Each quotation from Péret's poems is identified by the name of the collection from which it is taken. Original publication of the collection in question is given upon first citation only. Thus *Un Point c'est tout* appeared in a special number of *Les 4 vents*, "L'Evidence poétique" (No. 4, 1946), before coming out in Péret's volume *Feu central*, Paris, Editions K, 1947. All page references are to Benjamin Péret, *Oeuvres complètes*, Paris, Eric Losfeld, vol. 1 (1969) and vol. 2 (1971).

3. "La Pensée est UNE et indivisible," *VVV*, no. 4 (February 1944). [PUI]

4. *Le Déshonneur des Poètes* précédé de *La Parole est à Péret*, Paris, Jean-Jacques Pauvert, 1965, p. 75. [DP]

5. Here he is speaking of the Gothic novel's popularity in France. *Anthologie de l'Amour sublime*, Paris, Albin Michel, 1956, pp. 56–57. [AAS]

6. Readers who find these lines hard to assimilate may wish to try their luck with *taupe* in its other senses: "prostitute" or "wen."

7. "L'intuition poétique par son caractère bouleversant reste donc fatalement l'ennemie car elle risque de faire surgir ce qu'il vaut mieux ne pas voir: l'avenir de ce monde. De là, le discrédit où elle végète sous sa forme la plus audacieuse: l'intuition prophétique" (PUI), 10.

8. "l'éducation rationnaliste . . . dans le meilleur des cas, n'assigne à l'intuition qu'une place de concierge alors qu'elle est en réalité l'ingénieur qui dirige les travaux, le seul savant, le grand inventeur, le créateur de la raison elle-même" (PUI, 13).

9. "Tant qu'on n'aura pas reconnu sans réticences le rôle capital de l'inconscient dans la vie psychique, ses effets sur le conscient et les réactions de celui-ci sur celui-là, on continuera à penser en prêtre, c'est-à-dire en sauvage dualiste à cette réserve près que le sauvage reste un poète tandis que le rationnaliste qui refuse d'admettre l'*unité* de la pensée demeure un obstacle au mouvement culturel" (AM, 13).

10. "l'inconscient, individu cosmique où siège le désir, souverain phénix qui s'engendre indéfiniment de sa propre fin" (PUI, 12).

11. "Le désir se propose de combler le vide, inhérent à la condition humaine, par l'être qui lui permettra de former un tout harmonieux. Jadis c'était la divinité en qui l'homme tentait de s'abîmer pour en acquérir quelque parcelle, désormais c'est d'un être de l'autre sexe qu'il lui faut obtenir la divinité en la lui conférant" (AAS, 61).

12. "Pour moi la seule *évidence* au monde est commandée par le rapport spontané, extra-lucide, insolent qui s'établit, dans certaines conditions, entre telle chose et telle autre, que le sens commun retriendrait de confronter. Aussi vrai que le mot le plus haïssable me paraît être le mot *donc*, avec tout ce qu'il entraîne de vanité et de délectation morose, j'aime éperdûment tout ce qui, rompant d'aventure le fil de la pensée discursive, part soudain en fusée illuminant une vie de relations autrement féconde, dont tout indique que les hommes des premiers âges eurent le secret." "Signe ascendant" (1947) in his *La Clé des champs*, Paris, Les Editions du Sagittaire, 1953, p. 112.

13. André Breton, *Entretiens*, Paris, Gallimard, 1952, p. 68.

4 Implication

Eros and Paul Valéry

Albert Sonnenfeld

Sur le mur, son ombre démente
Où domine un démon majeur,
Parmi l'odorante tourmente
Prodigue un fantôme nageur,
De qui la transe colossale,
Rompant les aplombs de la salle,
Si la folle tarde à hennir,
Mime de noirs enthousiasmes,
Hâte les dieux, presse les spasmes
De s'achever dans l'avenir!

"La Pythie" [1]

 The gigantic shadow of Valéry's demonic Pythoness impatiently mimes the laboriously hesitant convulsions of the fleshly original struggling to give birth to the prophecy of poetry. So too, everywhere in Valéry's verse as in his theoretical pronouncements, there lurks the necessary *ombre démente*, the mad and reckless shade of sexuality. Valéry's ideal persona, Leonardo da Vinci, may well have been the consummate Apollonian, may indeed have said that the fury of love is so ugly that if those who practiced it could see themselves in the act *la natura si perderebbe*. Nonetheless, Valéry's Faust modifies his warning to the disciple ("prenez garde à l'amour") from "cave amorem" to "cave venerem." For it is not the act or the sentiment that counts, it is the drive, the image-producing energy, the primeval demon of lust, be it *libido sentiendi* or *libido sciendi*. Leonardo may be the ideal Apollo

(though Freud has a different view) in that intellectual comedy which had not, prior to Valéry, found its poet and which struck him as inherently more valuable than the *Comédie humaine* or even *La Divine Comédie*. But Valéry himself defines poetry in *Tel Quel* as:

l'essai de représenter, ou de restituer, par les moyens du langage articulé, *ces choses* ou *cette chose*, que tentent obscurément d'exprimer les cris, les larmes, les caresses, les baisers, les soupirs, etc., et que *semblent vouloir exprimer* les *objets*, dans ce qu'ils ont d'apparence de vie, ou de dessein supposé.
 Cette chose n'est pas définissable autrement. Elle est de la nature de cette énergie qui se dépense à répondre à ce qui est. . . . [II, 547]

(the effort to represent or to restitute by means of articulated language, *those things* or *that thing* which cries, tears, caresses, kisses, sighs, and so on, try obscurely to express, and which *objects seem to want to express*, in their lifelike appearance or their apparent design.
 The matter is not otherwise definable. It is of the same nature as the energy which spends itself responding to what is. . . .)

And Valéry's cherished category of *esprit* is defined by *Mon Faust* (*his* Faust, after all):

La prostitution est son affaire, étant le principe même de l'esprit. A qui, à quoi ne se livre-t-il pas, l'esprit? La moindre mouche le débauche. Il s'accouple à tout ce qui vient, et l'abondance de ses produits ne témoigne que de son infâme facilité. Il offre, il s'offre, se pare, se mire, s'expose; et parfois, met son mérite dans la nudité de son exhibition.

(Prostitution, being the real principle of *esprit* (mind, spirit), is its true business. To whom, to what, does it not abandon itself? The least fly debauches it. It couples with everything that comes its way, and the abundance of its products only bears witness to its infamous facility. It offers, offers itself, adorns itself, gazes at itself, exposes itself, and sometimes its greatest merit lies in its bare exhibitionism.)

"Le plus grand poète possible,—c'est le système nerveux," he was to write in *Humanités*. Behind the luminous landscapes lies the penumbra of the forest, before the dawn was dream-filled night ("La confusion morose / Qui me servait de sommeil, / Se dissipe dès la rose / Apparence du soleil."); La Jeune Parque's cerebral gropings on the obscure path to lucidity had their origins in the most visceral energies:

Il eût connu pourtant le plus tendre des nids!
Car toute à la faveur de mes membres unis,
Vierge, je fus dans l'ombre une adorable offrande . . .
Mais le sommeil s'éprit d'une douceur si grande,
Et nouée à moi-même au creux de mes cheveux,
J'ai mollement perdu mon empire nerveux.

It is surprising to me that so many readers still view Paul Valéry only in the light of Monsieur Teste's thought "que l'amour consiste à pouvoir être bêtes ensemble." Valéry's remark in *Tel Quel* that "un romantique qui a appris son art devient un classique" is more than an aphorism; it is a revelation that Valéry, to quote Harry Levin on Flaubert, *lives down* his Romantic origins, that man's life may well, as he himself puts it, be compressed between two literary genres: "On commence par écrire ses désirs et l'on finit par écrire ses Mémoires." Somewhere between desire and memory lies the creation of sublimated desire, the creation of great symbolic poetry:

Un travail se place entre l'*émotion reçue* ou l'intention conçue, et l'achèvement de la *machine* qui la restituera, ou restituera une affection analogue. [II, 564]

(A work is placed between the *emotion received* or the conceived intention and the completion of the *machine* which will restitute it, or an analogous affection.)

Let us look more closely at these origins in desire ("Hier la chair profonde, hier, la chair maîtresse," we read in "La Jeune Parque"). The quest of Narcissus (. . . "Je prétends à l'extrême / Douceur d'être tout à moi-même") is mirrored by certain words that seem to contain faithful reflections of themselves, of their sonorities, that is to say: I am referring, of course, to puns. Like Narcissus and his double in the water become mirror, the pun, before its duplicity is recognized, appears to be a unitary word; we discount the double meaning as frivolous and merely decorative when we recognize it, until the "reflected sound" ceases being an echo to attain equality of intensity. We would wonder, as Narcissus might, whether reflection had become original and vice-versa, were it not for the crucial role of orthography as an anchor in reality for the word. Narcissus may think that his reflection mirrors him faithfully; it is in fact the projection of darker desires, of the heresy of self-love: "Vous n'aimiez que de l'onde, et je suis certitude," the nymph tells him.

The reflection in the water is really more like the demented and exaggerated shade of the Pythoness: it is not light but shadow, and it reveals obscure prophecy.

"La Fileuse," the first of the *Album de vers anciens*, seems at first glance a straightforward and innocent spinning song in which the strands of the spinner's dreamed thoughts entwine metaphorically with the threads of wool in a perfect fusion of the inner and outer worlds:

> Assise, la fileuse au bleu de la croisée
> Où le jardin mélodieux se dodeline;
> Le rouet ancien qui ronfle l'a grisée. [I, 75]

But suddenly one is struck by the reflection of sound—the spinning wheel becomes a man: the entire poem takes on a new symbolic power and in effect seems to adumbrate "La Jeune Parque." The dream substance becomes the confused erotic thought-stream of the agitated adolescent body; the turning of the wheel marks the passage of time from childhood to puberty, as the imagery takes on a troubling and equivocal dimension of sexuality that is even more apparent in the 1891 version of the poem published in *La Conque*:

> Une tige, où le vent vagabond se repose,
> Courbe le salut vain de sa grace étoilée,
> Dédiant, magnifique, au vieux rouet, sa rose.
>
> Le songe se dévide avec une paresse
> Angélique, et sans cesse au fuseau doux, crédule
> La chevelure ondule au gré de la caresse . . .
>
> N'es-tu morte naïve au bord du crépuscule?
> Naïve de jadis, et de lumière ceinte;
> Derrière tant de fleurs l'azur se dissimule! . . .
>
> Ta soeur, la grande rose où sourit une sainte
> Parfume ton front vague au vent de ton haleine,
> Innocente qui crois languir dans l'heure éteinte.
>
> Au bleu de la croisée où tu filais ta laine. [I, 75–76]

I shall have more to say about Valéry's consistently erotic death imagery. Let me give another, equally controversial example of the dark verbal reflections of the pun, one taken from what seems to be *poésie*

pure, "La Dormeuse," that plastic evocation often likened to Giorgione's *Venus.* The last verse seems to accentuate this plasticity: ". . . ta forme veille, et mes yeux sont ouverts"; but suddenly we realize that there is a physicality here, the eyes are green with all that that color symbolizes. And upon rereading the poem, we find the spectator-poet trying to decipher precisely those secret dreams whose passionate urgency gives to the sleeping girl "ce rayonnement d'une *femme endormie*" (my italics); she had, after all, been "ma jeune amie" in the first verse. The play of shadow and luminosity is therefore not merely plastic in effect but the expression of that conflict between outer and inner worlds. So we can finally understand important obscurities and paradoxes:

> Dormeuse, amas doré d'ombres et d'abandons,
> Ton repos redoutable est chargé de tels dons;
> O biche avec langueur longue auprès d'une grappe,
>
> Que malgré l'âme absente, occupée aux enfers,
> Ta forme au ventre pur qu'un bras fluide drape,
> Veille [I, 122]

The absent soul shows us that we are still dealing with the secrets of "La Jeune Parque." Lest this be considered far-fetched, I can follow the lead of Alain and of P. O. Walzer[2] in pointing to the poem "Anne," in the *Album de vers anciens,* as the explicitly erotic prototype of the pure "Dormeuse":

> Anne qui se mélange au drap pâle et délaisse
> Des cheveux endormis sur ses yeux mal ouverts
> Mire ses bras lointains tournés avec mollesse
> Sur la peau sans couleur du ventre découvert.
>
> Elle vide, elle enfle d'ombre sa gorge lente,
> Et comme un souvenir pressant ses propres chairs,
> Une bouche brisée et pleine d'eau brûlante
> Roule le goût immense et le reflet des mers.
>
> Enfin désemparée et libre d'être fraîche,
> La dormeuse déserte aux touffes de couleur
> Flotte sur son lit blême, et d'une lèvre sèche,
> Tette dans la ténèbre un souffle amer de fleur.
>
> .
>
> Au hasard! A jamais, dans le sommeil sans hommes

Pur des tristes éclairs de leurs embrassements,
Elle laisse rouler les grappes et les pommes
Puissantes, qui pendaient aux treilles d'ossements,

Qui riaient, dans leur ambre appelant les vendanges,
Et dont le nombre d'or de riches mouvements
Invoquaient la vigueur et les gestes étranges
Que pour tuer l'amour inventent les amants . . . [I, 89–90]

It is not without interest that the important line "La dormeuse déserte aux touffes de couleur" was, in an earlier version discovered by J.-P. Monod [3] "La dormante putain aux nattes de couleur," perhaps expressing a distillation of a mediocre early sonnet entitled "Le Divin Adultère:

L'Epoux triste médite en sa douleur profonde,
Des larmes ont coulé sur sa tunique d'or
Car l'épouse est rêveuse, et tandis qu'elle dort
Murmure un nom d'amant caressant comme l'onde.

After overhearing his spouse's lament for her godlike oriental lover, and suffering from her rebuff of his sensual prayer to bring back "des jours lointains de volupté," the husband becomes the spectator (and we have an absurd surprise ending):

Puis elle se rendort—et puis il la contemple
Toute pâle, suivant un songe et souriant:
"Jésus! Mon doux Jésus! Ouvrez-moi votre temple!"

Valéry's taste for extravagant word-play is already apparent in the provocatively ambiguous "Ouvrez-moi votre temple."

It may occur to some that this critic is indulging in his own extravagances or obsessions. Let me turn briefly to a more prosaic demonstration based on a common and essential pun: *mer / mère*. The sea is the birthplace of the gods and was so long before Freud, and Valéry makes this mythical pun the basis for his rather Parnassian "Naissance de Vénus":

De sa profonde mère, encor froide et fumante,
Voici qu'au seuil battu de tempêtes, la chair
Amèrement vomie au soleil par la mer,
Se délivre des diamants de la tourmente. [I, 77]

What is interesting here is not the confirmation of the obvious pun but the effect of the pun on our reading of the poem and, more importantly, on Valéry's own choice of imagery which takes on startlingly erotic dimensions, making the choice of Venus (Botticelli notwithstanding) almost a tautology—the birth of the goddess of love is itself an act of love:

> Son sourire se forme, et suit sur ses bras blancs
> Qu'éplore l'orient d'une épaule meurtrie,
> De l'humide Thétis la pure pierrerie,
> Et sa tresse se fraye un frisson sur ses flancs.
>
> Le frais gravier, qu'arrose et fuit sa course agile,
> Croule, creuse rumeur de soif, et le facile
> Sable a bu les baisers de ses bonds puérils;
> Mais de mille regards ou perfides ou vagues,
> Son oeil mobile mêle aux éclairs de périls
> L'eau riante, et la danse infidèle des vagues.

The same pun explains much of the imagery of the Ode "Eté," "roche d'air pur, et toi, ardente ruche, / O mer!" where the poet apostrophizes the

> Tonnes d'odeurs, grands ronds par les races heureuses
> Sur le golfe qui mange et qui monte au soleil,
> Nids purs, écluses d'herbe, ombres des vagues creuses,
> Bercez l'enfant ravie en un poreux sommeil!
>
> Dont les jambes (mais l'une est fraîche et se dénoue
> De la plus rose), les épaules, le sein dur,
> Le bras qui se mélange à l'écumeuse joue
> Brillent abandonnés autour du vase obscur
>
> Où filtrent les grands bruits pleins de bêtes puisées
> Dans les cages de feuille et les mailles de mer . . . [I, 85–86]

Or the poem "Vue" where the blue eye and the salty tear become the sea and sky, and then the mer / mère:

> . . . l'eau debout d'une mer
> Assoupie en son empire
>
> Celle qui sans les ouir

Si la lèvre au vent remue
Se joue à évanouir
Mille mots vains où se mue

Sous l'humide éclair de dents
Le très doux feu du dedans. [I, 84]

I might mention parenthetically at this point the virtually obsessive effect produced by Valéry's eros-haunted imagery in these early poems, especially when the analogy seems not particularly appropriate: the descriptive "Valvins": "aux blancheurs de son flanc que la Seine caresse / Emue"; or "Je vois le vin céleste, et je caresse / Le grain mystérieux de l'extrême hauteur. / Je porte au sein brûlant ma lucide tendresse, / Je joue avec les feux de l'antique inventeur" in "Profusion du Soir."

 I could spend hours cataloging phonetic play in Valéry's verse, from the leering "Je m'ébranlais brûlante et foulais le sol plein, / Liant et déliant mes ombres sous le lin" of "La Jeune Parque," the "Je ne crains pas les épines! / L'éveil est bon, même dur!" of "Aurore"; the "Ose gémir! . . . Il faut, ô souple chair du bois, / Te tordre, te détordre, / Te plaindre sans te rompre, et rendre aux vents la voix / Qu'ils cherchent en désordre! / Flagelle-toi!" of "Au Platane." We would meet a Valéry surprisingly different from our familiar aquaintance, the classifier of the myriad definitions of *esprit*, the maker of aphorisms on civilization and its contents, the Apollonian.

 Interpelle ta chair,

Traverse sans retard ses invincibles trames,
Epuise l'infini de l'effort impuissant,
Et débarrasse-toi d'un désordre de drames
Qu'engendrent sur ton lit les monstres de ton sang!

 The origins of this disorder of blood-drama might be sought in biographical evidence. This has been attempted by Gilberte Aigrisse in *Psychanalyse de Paul Valéry*,[4] with, in my view, typically disastrous results. We know so little, happily, about Valéry's "real" personality that to categorize him according to *complexe d'Oedipe, complexe spectaculaire,* and *complexe de sévrage* is to ignore the factitious and yet representative personality of this impersonal author in his verse, essays, and aphorisms. That is, the Valéry who ultimately matters to us is a character hero of his own works—if some positive relationship between

the "man" and the "fictitious man" confirms a psychocritical insight, so much the better and how pleasantly reassuring for us. But the created reality of life and the created reality of life-in-art are not of equal import. There is a Valéry in the poems, prose, and even (and especially) in the *Cahiers* who is a self-created Valéry, a *creation of words as being* and *not of being as being*. We may therefore look to his own early verse rather than to biographies; even his *Correspondance* is, after all, not the man himself, but the man in words.

I think in this light we must take to heart Malraux's notion that artists do not derive their style from life but from their readings; their choice of whom to emulate betrays their psychological state as creators. In an adolescent poem such as "Splendor," first published in *L'Ermitage* in 1891, the tone is blatantly, almost parodistically, Baudelairean:

> Oh! . . . Sois de marbre! sois d'un métal froid et clair,
> Et, parmi la résine aromale brûlée,
> Brille lointaine et pâle, ô Reine Immaculée!
>
> N'es-tu pas le Calice adorable de Chair
> Où l'artiste—blanc prêtre à la magique phrase—
> Boit à longs traits le vin suprême de l'Extase? [I, 1580]

The irreverent sexualization of liturgical imagery (which for Baudelaire probably had Manichean implications) will become for Valéry the basis for an attitude that leads to word play. The imitation of Parnassian descriptive verse will lead to the sexualization of descriptive imagery, the joining of two areas of physicality leading to a revelation of the secret self of the poet. Here is an extract from the 1889 sonnet "La Mer," where the pun is not stated except in the title:

> Et la houle odorante au large se dilate
> Sinueuse s'allonge et puis se dresse un peu
> Comme un serpent sacré sous l'oeil fixe d'un Dieu
> Le jour baisse. Le flot s'infuse, d'écarlate. [I, 1586]

Male and female, the serpent and sea, are joined as water turns to movement, *la houle*. The Baudelairean and the Parnassian are joined in "une coupable et triste et trop exquise étreinte" of "Viol"—*Bronze du musée secret* (which won eighth prize in a sonnet competition sponsored in 1890 by *La Plume* behind such sonneteers as Marcel Noyer, Bénoni Glador, Jules Labouc, Vigne d'Octon); the poem is deliberately obscene and shocking:

Belle et chaude!—une Femme agace un mince enfant
Ignorant de l'Amour, qui repousse la lèvre
Et les tétins vers lui dardés, brûlants de fièvre
Et les regards chargés d'un désir triomphant . . .

. . . Millénaire! le viol de bronze se consomme!
Le petit inquiet, sous le brasier charnel
Se tord et ne veut pas, horreur! devenir homme . . .

Mais elle le contient! qui d'un geste éternel
Impose la splendeur de ses chairs odieuses
Et lui cherche le sexe avec des mains joyeuses! . . . [I, 1577]

It is revealing, I think, of the struggle in Valéry between night thoughts
and the dawn's appeal: "Existe! . . . Sois enfin toi-même" ("Air de
Sémiramis") that his devotion as disciple of Mallarmé is so intensely
stylistic that the images in "Arion" (published in *La Wallonie*, 1892) are
merely slavish pastiche, revealing nothing of the night of "Baisers, baves
d'amours, basses béatitudes"):

Le luth luit sur le monstre élu pour un tel astre
Plus haut que le sourire adoré des oiseaux
Qu'amuse la beauté des larmes du désastre
A la figure sidérale du héros. [I, 1582]

And so on.

A sonnet written much later than most of the *Album de Vers
anciens* seems to me to sum up admirably the tensions of Valéry's
adolescent and early verse which I have attempted to outline here:

Un feu distinct m'habite, et je vois froidement
La violente vie illuminée entière . . .
Je ne puis plus aimer seulement qu'en dormant
Ses actes gracieux mélangés de lumière.

Mes jours viennent la nuit me rendre des regards;
Après le premier temps de sommeil malheureux,
Quand le malheur lui-même est dans le noir épars
Ils reviennent me vivre et me donner des yeux.

Que si leur joie éclate, un écho qui m'éveille
N'a rejeté qu'un mort sur ma rive de chair,
Et mon rire étranger suspend à mon oreille,

Comme à la vide conque un murmure de mer,
Le doute,—sur le bord d'une extrême merveille,
Si je suis, si je fus, si je dors ou je veille? [I, 81]

A different version of the first stanza in *Les Cahiers* contained the rich
pun "Le *feu* amour m'habite" and the grammatically almost monstrous
"Je n'en puis plus aimer seulement qu'en dormant."

"Le feu amour m'habite." Through a pun, love and death
become synonymous. But beyond the single play on words, we find in
reading Valéry's verse that there is a continuous sequence of confusions
of love and death, so much so that much of his verse takes on a secret
meaning. Eros and Thanatos are, of course, invariably joined in the
Romantic tradition (and in the popular imagination in such expressions
as "la petite mort," etc.). However, Valéry's usage has broader
implications since his neoclassical virtuosic poetry takes on a hermetic
and thoroughly Romantic sense. It becomes a fusion of the two worlds
of literature, Classicism and Romanticism, as of day and night. This is
beautifully illustrated in a stanza added to "Aurore" for the 1920
edition of *Odes* but suppressed in subsequent editions:

Immobile, tête fée,
Ta substance de cristal,
Matière même d'Orphée,
Rayonne le jour total.
Dans la vibrante demeure
Il n'est de souffle qui meure
Sans avoir semé l'amour.
Je suis cette créature
Dont la fatale nature
Est de créer à son tour. [I, 1647]

In the light of the ambiguity of "le feu amour," an apparently chaste
sonnet, "Le bois amical," takes on an equivocal dimension which almost
makes a mockery of the opening line: "Nous avons pensé des choses
pures," for when we read the key tercet:

Et puis, nous sommes morts sur la mousse,
Très loin, tout seuls parmi l'ombre douce
De ce bois intime et murmurant

we realize that the friendly wood was at least for one voice of the equivocation the site of actions which contradicted the pure thoughts:

> Nous marchions comme des fiancés
> Seuls, dans la nuit verte des prairies;
> Nous partagions ce fruit de féeries
> La lune amicale aux insensés.

The same prevarication returns a few pages later in the *Album* in "Narcisse parle"; where the image is expanded and diffused:

> Je me délie en vain de ta présence douce,
> L'heure menteuse est molle aux membres sur la mousse
> Et d'un sombre délice enfle le vent profond.
>
> Adieu, Narcisse . . . Meurs! Voici le crépuscule.
> Au soupir de mon coeur mon apparence ondule,
> La flûte, par l'azur enseveli module
> Des regrets de troupeaux sonores qui s'en vont.
>
> .
>
> La ride me ravisse au souffle qui m'exile
> Et que mon souffle anime une flûte gracile
> Dont le joueur léger me serait indulgent! [I, 83]

Which image is, in turn, explained in a feminine version of the "Narcisse parle," the following poem in the *Album*, "Episode," where a young virgin is combing her tresses in the light of the setting sun; and the reed (as in the myth of Pan and Syrinx) betrays the masculine presence in the mind of the nubile girl; "c'est le dire absurde d'un pipeau, / Flûte dont le coupable aux dents de pierrerie / Tire un futile vent d'ombre et de rêverie / Par l'occulte baiser qu'il risque sous les fleurs." Innocent enough, on the surface, but the erotic equivocation soon becomes unmistakable:

> . . . elle démêle une lourde auréole;
> Et tirant de sa nuque un plaisir qui la tord,
> Ses poings délicieux pressent la touffe d'or
> Dont la lumière coule entre ses doigts limpides!
> . . . Une feuille meurt sur ses épaules humides,
> Une goutte tombe de la flûte sur l'eau,
> Et le pied pur s'épeure comme un bel oiseau
> Ivre d'ombre . . . [I, 84]

That Valéry is entirely and continuously aware of his linguistic ambivalence seems to me to be documented by both the title and the content of the 1921 poem, "La Fausse Morte," which combines affinities with "La Dormeuse" with a peculiarly Petrarchist sequence of verbs and paradoxes to form the credo of "le feu amour":

> Humblement, tendrement, sur le tombeau charmant,
> Sur l'insensible monument,
> Que d'ombres, d'abandons, et d'amour prodiguée,
> Forme ta grâce fatiguée,
> Je meurs, je meurs sur toi, je tombe et je m'abats,
>
> Mais à peine abattu sur le sépulcre bas,
> Dont la close étendue aux cendres me convie,
> Cette morte apparente, en qui revient la vie,
> Frémit, rouvre les yeux, m'illumine et me mord,
> Et m'arrache toujours une nouvelle mort
> Plus précieuse que la vie. [I, 137–38]

Another verbal equivocation common to all of Valéry's verse makes an appearance here, the verb "mordre." Its poetic origins may reside in the "morsure" inflicted by Baudelaire's lover on *Celle qui est trop gaie*. But the most famous example is surely "La Jeune Parque," Valéry's most erotic poem, as Lisa Schroeder has shown, albeit in a most turgid study: "J'y suivais un serpent qui venait de me mordre. / Quel repli de désirs, sa traîne! . . ." The adolescent girl's attempts to reject the serpent and to discover the Eden of daylight will be typical, as we shall shortly see, of the poet's attempt to overcome the convulsive inspiration externalized and mythified in "La Pythie." In a patent obscenity, La Jeune Parque says her unspoken thought: "Cesse de me prêter ce mélange de noeuds." But Valéry himself all too often seems incapable of rejecting the image. In the adumbration of "La Dormeuse," the early poem "Anne," we read:

> Laisse au pâle rayon ta lèvre violée
> Mordre dans un sourire un long germe de pleur,
> Masque d'âme au sommeil à jamais immolée
> Sur qui la paix soudaine a surpris la douleur! [I, 90]

La Pythie, in her writhings of gestation, is "Pâle, profondément mordue" (this is the rhythmic line from which, according to Gide's

Journal, the entire poem was born). And there is, of course, "Ebauche d'un serpent," which entire poem explains and exploits the image of the tempter and his bite:

> "N'écoute l'Etre vieil et pur
> Qui maudit la morsure brève!
> Que si ta bouche fait un rêve,
> Cette soif qui songe à la sève,
> Ce délice à demi futur,
> C'est l'éternité fondante, Eve!" [I, 143]

A simple variant on love's and temptation's bite or itch can be found in "L'Abeille": "Pique du sein la gourde belle, / Sur qui l'Amour meurt ou sommeille." But the best statement of the temptations of the night, of Eros-Thanatos, of *la chair profonde, la chair maîtresse* appears in a speech by Goungoune, that "incube-succube" of the section of Valéry's *Mon Faust* significantly entitled "Lust." She answers the boasts of Bélial and Astaroth:

Moi, je hante et je tente et j'enchante, . . . J'attise, je souffle, j'embrase et j'enlace. . . . Oui, monstres, quand je me forme et me condense en pleine et fraîche fille nue, et me glisse le long d'un jeune homme qui dort, je lui ménage un songe si ardent, un accès si aigu qu'il poursuivra toute sa vie, de femme en femme, sans les joindre, l'être illusoire et le délice trop réel que j'ai distillés de son sang et dégagés de sa candeur. . . . [II, 334]

To which Bélial replies: "Eh bien, descends de ton perchoir, pâle succube! . . . Tu as là un dormeur tout chaud. . . . Viens chatouiller ce tas ronflant de vie humaine . . . (II, 335)."

Like so many poets of his generation, Valéry is obsessed with overcoming or transcending the anarchic inspiration of dark forces by the very act of poetic creation made possible by that inspiration, Joyce called it the movement from kinesis to stasis; Flaubert spent his entire career writing down the turbulent inspiration and temptation of Saint Anthony. And the way to do it was through a new classicism, *eine klassische Dämpfung* in the fullest sense of the word, which tamed the contorted extravagances of the poet's double, La Pythie; the way to tame the beast was by total structuralization or intellectualization. As we read in *L'Idée fixe*:

la plupart des gens, l'immense plupart n'opèrent que . . . timidement,
ne perçoivent dans leur esprit, à partir de ce qui le sollicite, que des
. . . commencements. Ils poursuivent à peine, coordonnent vaguement.
La plupart des pensées de la plupart demeure à jamais à l'état nais-
sant . . . Ils ne savent ou ne peuvent . . . apprivoiser leur Implexe.

.

En tout cas, je suis sûr d'une chose: rien de plus rare que la faculté de
coordonner, d'harmoniser, d'orchestrer un grand nombre de *parties*.
[II, 261]

(most people, the great majority, only go about things timidly, only
perceive in their mind, starting with what engages it, certain begin-
nings. They scarcely pursue any idea, making vague efforts at coordina-
tion. Most of the thoughts of most people remain forever nascent. . . .
They do not know how to or cannot tame their Implex.

.

In any case, I am sure of one thing: nothing rarer than the ability to
coordinate, to harmonize, to orchestrate a great number of *parts*.)

This idea was already hinted at in Leonardo da Vinci's method as
invented by the young Valéry of 1894, in the passage on the *double vie
mentale*. Formulated in a more poetic way in *Mélange*, in the section
"Mythologie:" "l'effort de l'homme qui pense transporter de la rive des
ombres à la rive des choses, les fragments de rêves qui ont quelque
forme par quoi on les puisse saisir, quelque ressemblance ou utilité. Le
vaisseau plein de rêves échoue sur les récifs de la veille. Robinson
s'éfforce d'en ramener quelque chose de prix sur le rivage. Il peine."
Monsieur Teste's niece Emma contemplates writing the "diary of her
body," calling her interior life "MY creation, my most important work."
Valéry was right to tell F. Lefèvre that "La Jeune Parque" was "a
course in physiology," for it is organized, totally structured, static (in
Joyce's sense) while its raw materials are of the very substance which
Auden called "Weeping anarchic Aphrodite." The poet and his persona
are taming their unfettered inspiration:

Oui, je me suis imposé, pour ce poème, des lois, des observances
constantes *qui en constituent le véritable objet*. C'est bien un exercice,
et voulu et repris et travaillé; oeuvre seulement de volonté; et puis
d'une seconde volonté, dont la tâche dure est de masquer la première.
Qui saura me lire, lira une auto-biographie [*sic*] dans la forme. [Lettre à
André Fontainas]

(Yes, for this poem I imposed on myself rules and a constant observing of them *which are its true purpose*. It is really an exercise, willed and resumed, mended and worked over; a work of will alone; and then of a second willing, whose difficult task it is to hide the first. Anyone who knows how to read me will read an autobiography in the form.)

This is what is meant in the last stanza of "La Pythie," that depiction of the wildest furies of poetic inspiration which ends in serenity: "Honneur des Hommes, Saint LANGAGE, / Discours prophétique et paré, / Belles chaînes en qui s'engage, / Le dieu dans la chair égaré, / Illumination, largesse!" The chains are beautiful; they are beauty and form.

Valéry wrote of the crisis of 1892, "je fus contraint d'entreprendre une action très sérieuse contre les Idoles en général." For his productive years, this action was poetry, formal, classical poetry built on formless, Romantic inspiration. Later on, that action was silence; then epigrammatic and ironic pundit-like prose. The detachment, the analytical formularization, as detailed by P. O. Walzer in his article on Eros in *Les Cahiers*,[5] strikes me as pseudo-scientific and unworthy: now it is Valéry himself speaking, not his persona.

Le moyen adopté est une projection par contraction musculaire spasmodique, provoquée par atteinte d'un niveau de sensibilité lui-même *situé* au *plus haut* d'une colonne d'excitations superposées avec fréquence croissante qui s'ajoutent, se renforcent à cause de la permanence des impressions—et qui sont produits par les mouvements comme dans une *magnéto*.

(The means chosen is a projection by spasmodic muscular contraction, caused by the reaching of an affective threshold located at the highest point of a column of stimulations superimposed with increasing frequency which accumulate, reinforced by the permanence of impressions—and are produced by the motions as in a *magneto*.) [XIII, 773]

I much prefer the struggle of sacred language, *Saint Langage*, to fight its way out of the prison of anarchic freedom of silent phantasm into the beautiful chains of form and poetry that paradoxically constitute the true freedom for the wayward flesh of pre-verbal imagination. "Le dieu dans la chair égaré": this god we have discovered in the Narcissistic mirroring of words as equivocations, the duplicity of the pun. It is said

that the first word pronounced by the child Valéry was the word "clef."
I prefer to think that even then, he instinctively uttered his first word in
its plural form.

NOTES

1. All quotations unless otherwise specified from Paul Valéry, *Oeuvres*
(2 vols., Paris, Ed. Pléiade, 1962) I, 130–31.
 2. P. O. Walzer, *Yale French Studies* no. 44, pp. 215–30.
 3. "Regard sur Paul Valéry," quoted I, 1596.
 4. Editions Universitaires, 1964.
 5. See note 2.

5 Reflection

Tristan Tzara

"avant que la nuit ..."

Micheline Tison-Braun

Avant que la nuit . . .

Avant que la nuit ne tombe, à cette minute troublante comme l'air suspendu entre les états liquide et solide, quand tout pense à se cacher la figure de honte, que les bruits même s'envolent, sans courage, pendant quelques instants, quand la sensation qu'un vase va déborder s'implante avec angoisse dans la poitrine de chacun, comme si une nouvelle annonce de mort, d'un atroce suicide, allait nous frapper en pleine poitrine dans la personne d'un être cher, quand cette haine de la vie peut transformer la douleur en une immense gratitude, que des monceaux de cadavres, à moitié putréfiés, des hommes qu'on a connus dans la constante amertume d'une gaîté sans repos—faut-il que la tristesse soit puissante parmi des signes si évidents pour qu'elle emprunte de si étranges aspects—se sont mutilés, déchirés, étranglés avec une joie acharnée de destruction, dans un délire de haine, une telle frénésie, que la joie seule, et la plus vive, seule, peut élever la pureté d'une âme jusqu'à de si tendres altitudes,—avant que la nuit ne tombe, à cette minute qui tremble dans la voix de chacun, sans qu'on le sache, à cette minute qui n'est perceptible qu'à bien peu d'êtres exercés, pour qui l'invisible compte au moins autant que la matière dégradante, comme la souffrance physique est dégradante, et de se savoir esclave de la douleur vous blesse dans l'orgueil d'homme, quand le sort s'amuse à

vous montrer ses crocs d'acier, prêt à mordre, comme à la foire, dans
l'engrenage de ses roues de loterie, mangeur de feu, sa propre création
grouillante de malentendus, sujet sur lequel je reviendrai, sur lequel
tant d'autres sont revenus, sans se retourner comme dans la chanson,
enfin pour ne pas me laisser aller sur la pente amère, avant que la nuit
ne tombe, dis-je, à cette minute qui est une longue aspiration d'air, qui
paraît plus longue dans une poitrine creuse, une longue aspiration pour
pousser un cri qui ne sortira jamais peut-être, tant l'inutilité des choses
s'est figée même dans les intentions de la nature, j'ai songé à t'appeler,
dégoût, toi qui vis caché derrière le sens des choses et des gens, toujours
présent, inondant ce monde de ta gluante imprécation, toi qui n'as
jamais changé, enseveli sous les couches immémoriales des humains
désespoirs, fusant parfois avec la force des orages, et t'étalant orgueil-
leusement devant nos pas hésitants,—dégoût, j'ai songé à t'appeler
d'une voix sans éclat et sans injure, d'une voix qui aurait capté les voix
de tous les hommes sur le parcours infini qu'elles ont de peine, amère
plainte et peine sans retour, à s'en souvenir, de toutes les voix unies dans
un faisceau de haine, je t'appelle, dégoût, à mon secours, pour que la
face hideuse surgie au milieu de ce monde puisse dénombrer tes
immondes amants et ceux qui s'en détournent, pour que ta face hideuse
puisse partager en camps serrés la masse hybride et indécise, je
t'appelle, sournois dégoût, toi qui ralentis nos mouvements, toi qui
découpes la dure rançon d'au moins la moitié de ce que nos regards ont
recueilli, de ce que nos mains ont touché, de ce que la pensée a essayé
de remplacer ou de chanter, toi qui réduis notre haine et décourages
l'assassin qui est né avec nous, qui a grandi en nous et se débat dans un
cachot entre l'amour et le soleil, en nous,—dégoût, lorsque ta face sera
montée des monstrueuses noirceurs, et qu'elle aura caché toute une
moitié du ciel de sa fétide substance, la réponse s'ouvrira peut-être dans
la parole de chacun, comme la lumière qui ne brillera que du côté de
leur invincible haine.

Before Night . . .

Before night falls, in this instant disturbing like air suspended between
liquid and solid states, when all things think of hiding their face in
shame, when even the sounds take their flight timidly, during a few
moments when the feeling that a vase is going to spill over takes root
with anguish in the breast of everyman, as if a new obituary or atrocious
suicide were to strike us hard in a person whom we love, when this
hatred of life can transform sorrow into immense gratitude, when piles
of the cadavers half-putrefied of men one knew in the constant
bitterness of a restless gaiety—how powerful must sadness be amid such

obvious signs to take on such a strange aspect—mutilated, torn apart, and strangled one another with a relentless joy of destruction in a delirium of hatred, such a frenzy that only the liveliest joy can elevate the purity of a soul to such tender altitudes,—before night falls, in this instant trembling in each man's voice without his knowing it, in this instant perceptible by only a handful of experienced beings, for whom the invisible counts at least as much as degrading matter, as physical suffering is degrading, and knowing yourself a slave to pain wounds you in your human pride, when fate amuses itself by showing you its steel teeth, ready to bite, like the carnival in the meshing of its lottery wheels, fire-eater, its own creation swarming with misunderstandings, a subject to which I shall return, to which so many others have returned without glancing back as in the song, not to let myself go down the bitter slope, before night falls, I say, in this instant which is a long aspiration of air, which seems longer in a hollow breast, a long aspiration to let forth a cry which will never come forth perhaps, so fixed is the uselessness of things in the intentions of nature, I thought of calling upon you, disgust, you who live hidden behind the meanings of things and of people, always present, flooding this world with your sticky imprecation, you who have never changed, buried under the immemorial layers of human despairs, joining sometimes with the strength of storms, and displaying yourself pridefully before our hesitant steps,—disgust, I thought of calling upon you in a voice without splendor and without insult, in a voice which would have captured the voices of all men on the infinite stretch of pain which is their lot, bitter complaint and irrevocable pain, to remember, all the voices united in a bundle of hate, I call on you, disgust, to succor me so that the hideous face, come forth in the center of this world, can count your filthy lovers and those who turn away, so that your hideous face can split into huddled camps the crowd hybrid and indecisive, I call on you, sly disgust, you who slow down our motions, you who slice off the harsh ransom of at least half of what our looks have gathered, of what our hands have touched, of what thought has tried to replace or to sing, you who reduce our hatred and discourage the assassin born with us, who has grown up in us and struggles in a cell between love and sun, in us,—disgust, when your face has risen from the monstrous blackness, and has hidden half of the sky by its fetid substance, the reply will open perhaps in the word of each man, like the light which will only shine on the side of their invincible hatred.

With the first lines, the paradox of time grips us; it does not consist in the fact that time flows, an inexhaustible source, until it stops

for us, but rather in the impossibility of conceiving of this arrest—non-time, non-consciousness, non-being—by our only instrument of knowledge, this consciousness created precisely in order to experience time in its permanence and its flow. In vain the mind knows that the present is not, that it consists only of an imaginary limit traced between the enormous past and this future ceaselessly diminished, for it will always have a stumbling-block in the mystery of the last instant, the one when consciousness ceases to be. There are many ways of not imagining death, many images interposed between consciousness and its inconceivable abolition: the placid numbness of sleep, the bursts of light, the fall, a bogging down, a drift, the black fan suddenly spreading out. All these images, even the most terrifying of them, relieve the mind by evoking events, that is, facts of consciousness. They avoid nothingness. Tzara, however, does not cheat in this text. For he represents nothing here at all, and it is only by means of a syntactic structure that he attaches us to the reality of the moment which will have no successor, the inconceivable:

Avant que la nuit ne tombe, à cette minute où . . .

The suspension marks guard the menace implicit in the incomplete sentence of the title until its recurrence in the text, until this fall of the guillotine's blade, a descent which marks forever its accomplishing. Just as drowned men are supposed to see their entire life once more in a few seconds, here a human drama lies in this unique sentence interminable and unreal, suspended over a future already marked as useless by the triple structure of the expression "avant que." These "befores" which are before nothings are however also "instants when," each of which could cry out, like Caligula, that it is still living. It is this which gives to Tzara's text its extreme importance as a testament, a witness, for contrary to the drowned man upon whom the unconscious imposes its visions mechanically, the poet obeys the living rhythm of an obsession which engulfs him little by little.

More than the lyric progression of sentiments, than the images—rare and immediately covered over—it is the rhythm of the syntax itself which brings back the secret by a natural impulse, like a tide or a lava flow, or like the effort of sick lungs conveying to the lips an unspeakable blood clot. And the confession which is torn by pieces from the depths remains outside of time, or rather time is resumed therein by this single moment, in one single heavy sentence, in one single presence intermina-

ble and illusory. Three temporal clauses, four principal clauses plus one more, tacked on strangely, compose this extraordinary lyrical construction. The three temporal clauses: "before . . ." / "in this instant . . ." / "when . . ." are clearly differentiated, as much by their content as by their decreasing length, and the sentiment of increasing impotence expressed there is finally immobilized on a decree of "nature." The alternately rising and falling rhythm of the clauses and of the profile of images produces a feeling of urgency devoid of hope.

The first temporal clause is frenetic and chatty; it is composed of the involuntary parade of images, and reflection plays little part. It relates to an uncertain state—it is "disturbing" and disturbed, and in addition glacial in feeling, "like air suspended between liquid and solid states." In the inhuman, the drowned man's memory begins to function like a crazed seismograph. Of little consequence the circumstances which provoked this meditation, one of the most remarkable of our time. Of little consequence what pushes the poet toward this night and this grave. Neither a threatening blindness, nor private misfortunes, nor even this night falling over Europe in 1935 can *explain* anything; but perhaps these catalysts were necessary for "approximate man" to bring to light this confession, which is also that of his generation, or a part of it. Everything is included: the anguish of living, the expectancy of unhappiness, which would be a relief from anguish, shame, hatred of life hidden under a false joy, destructive frenzy, all these are expressed in familiar images. Shame, the least perceptible element at this stage, is transferred to objects: nature "hides"; the famous silence of the evening so celebrated by the poets is no more than a retreat "without courage," like that of the Baudelairean bat. Half-secrets pile up. The mask of Dada is easily recognizable in the "constant bitterness of a restless gaiety," and the memory of the group's dissensions, still alive, in the images of corpses torn apart, and mutilated. At the same time, the rhythm of the sentence collapses in a sigh weighed down with self-reflection ("Faut-il que la tristesse soit puissante . . . pour qu'elle emprunte de si étranges aspects"), or it bursts forth in a paroxysm of acute sounds, sharp as claws mutilating and ripping apart, indicating for the first time the theme of purifiying destruction. Then the scene dissolves. The memory of juvenile frenzies fades out, while, in a lower voice, the refrain of night and the tomb picks up again.

The "disturbing" instant has become "the instant trembling imperceptibly," the one which leads to the edge of the confession.

Sensible only to the "experienced" beings, those "seekers of the invisible," the secret murmured only in the sharp sounds of the frenzy, now and from now on far distant, is uncovered in the byways of a subordinate clause like a wood-louse under a stone. "Degrading." Every existence is degrading. And the sentence struggles against this weight of matter and physical suffering, then rises in a Promethean effort to the affirmation of "human pride," the pride of the human wound. But without the certainty of Aeschylus, who dared to summon the gods before a human tribunal, "human pride" stands erect in a metaphysical emptiness and we are spectators at the double collapse of gods and of man. Destiny is no longer a hostile will, but a mechanism all-powerful and ludicrous, halfway between the lottery wheel of the carnival and the threshing machine.

Scarcely has it affronted the "misunderstandings" of fate, whose victim it is and by dint of any other belief, whose creation also, than the thinking reed whose thought comes from nowhere gives itself up to the wind and falls back again into a rhythm of *ritournelle* without return, as in Edith Piaf's song, a vulgarized echo of the refrain "and so many others, and so many others."

One last effort at recapturing. Since the "troubling instant," then the trembling instant, has now become too brief for any thought at all, the living being tries one last expression in a long "aspiration of air," a cry which would be even in its inarticulate form, a witness. A vain effort, but "the uselessness of things" is immobilized "even in the intentions of nature," and the dreamer prey to his nightmare by some obscure fatality, cannot cry out. Or perhaps he no longer desires to do so, overcome as he is by the uselessness of it all, beyond even rebellion; and for the last time, the sentence which began in a burst of revolt has collapsed, invincibly paralyzed forever. Other poems, before and after this, will show another Tzara, one capable of joy. But the Tzara speaking here is the one who "walked in a landscape of the tufts of death" ("Le Rêve expérimental"). We have come full circle, there is no more future; the poem enters an ineluctable present.

Nevertheless the paralyzed shrieking of nightmare is heard once more, unrecognizable, after the series of "before" and "instants when" which served as the grounds of a desperate resolve. What then rises unannounced is an appeal, strange to the reader but apparently familiar to Tzara as the evocation of some accustomed monster. Here again one senses a progression in the urgency of the appeal and the coming to

light of the secret justification: "I thought of calling upon you, disgust, you who. . . ." "Disgust, I thought of calling you. . . ." "I call upon you, disgust, to succor me. . . ." "I call upon you, sly disgust, you who. . . ." And after these four appeals, two of which ("toi qui" . . .) unearth and unmask the beast, a sort of answer is glimpsed in an ambiguous twist of phrasing, perhaps a new sentence, perhaps a simple appendage.

This disgust should not, it seems, be confused with the Sartrean nausea which exudes from things existing, and from man reduced to existence, forgetful of his freedom. Tzara's disgust, so far at least, negates liberty and places the concept of purity in things themselves, in simple things as in *L'Homme approximatif*: "morning of fresh bread, sweet-smelling morning," airborne things: "Joy flying forth like arrows toward the astral regions," in hidden things: mines, gems. It is not from objects that the blemish spreads, but from man. Disgust is "l'imprécation," the "sticky imprecation," living "hidden behind the meaning of things *and of people*," for in a world senseless but for man, all human vision will be impregnated with this self-disgust of man sensitive but degraded, humiliated by his subjection to matter. Thence comes, perhaps, this Dada frenzy for the destruction of all meaning, necessarily human, in order to return to the impossible immediate. Dead henceforth the nostalgia of this forbidden *return* to that which doubtless never existed: a world which was never the creation of men. If, according to the philosophers whose thought, although unknown, was surely sensed by the poets, it is man who gives to things their essence, then this disgust is coeternal with all essence. It has "never changed, buried under the immemorial layers of human despairs."

"Disgust, I thought of calling upon you." The inversion illuminates the presence of the monster, now named. And if Tzara thinks of appealing to it, it is no longer as in the time of Dada where he aroused youth against the gods of Order and of Tedium. All turbulence now muted, "in a voice without splendor and without insult," it is through fraternal compassion that he appeals now; and his words of an endless tenderness make a subtle contrast between the barely distinguishable sounds: *ainte, eine* and the muffled sounds: *our:* "Le parcours infini qu'elles ont de peine, amère plainte et peine sans retour . . . ," the only phrase melodic and free of logical rigor in a text of an exemplary syntax. Then, this music of the soul's interior is suddenly frozen and the fluid phrase is reassembled, as it were, by a feline shifting and gathering

into an unexpected "bundle" of "hatred." The word appears for the
third time: but the "hatred of life" and the "delirium of hatred" which
framed the first "instant when . . ." exploded in a disorganized
agitation, whereas this hatred prolongs the echo of "laments" and of
"pains," of an incantation suddenly become demoniacal.

The expression "I thought" yields from now on to the present: "I
call on you." The appeal is real, and it is a call "for help." The
unspeakable beast, the secret, the sin under the constraints of a magic
invocation, will come forth and provoke the immediate polarization
between those who see and those who do not wish to see the enemy,
"this crowd hybrid and indecisive." Purification by lucidity? successful
psychoanalysis? exorcism? No, for this disgust assimilated throughout
the ages to the substance of man and of the world itself, this disgust at
last unveiled fascinates. Its "hideous face" attracts "filthy lovers," and
the exorcism must change its direction. The last appeal is no longer a
magic invocation but a *habeas corpus*, a summons to appear. "I call
upon you, sly disgust": for there still remains one mask to remove. The
evil—this disgust—hid its action under the appearance of a remedy,
misdirecting the attention, paralyzing the energies. It "sliced off the
harsh ransom" of what our senses grasped, soiling all immediate
perception; it attacked the roots of thought even when the latter tried
to "replace and to sing."

Should one understand by this obscure sentence, so contrary to
ordinary poetic anti-intellectualism, that the enemy of a contented pure
life was not thought, cutting man off from his prereflexive life in its
immediacy, but disgust which corrupted this thought as it did
everything else? Should one imagine that, once delivered from self-con-
tempt, thinking man could rejoin sentient man in his innocence?
Possibly. But what innocence would be thus recovered, if the paralysis
which disgust inflicts on us were to abandon our mind and our
members? And thereupon hangs the revelation which precedes the
finale of this hallucinating Flower of Evil: "You who reduce our hatred
and discourage the assassin born with us, who has grown up in us and
struggles in a cell between love and sun in us. . . ." Is the last word to
be had by the Assassin? "Behold there comes the time of the Assassins."
Assassin / Haschischin, poet violent and *voyant*, "Son of the sun" born
to "accomplish the will of Fire"? The last shred of the secret—has it
been extracted? will the "love and the sun" reduce the Assassin, as the
good anarchists believe, or will they, on the contrary, attach a halo of

beauty and power to its destructive progress? The last lines of the poem contain the answer. But is there a great poem to which the answer is not ambiguous?

The ambiguity is expressed by the very construction of the last lines. Do they form an autonomous sentence, in apposition with "in us"? Is this a piece of the sentence which will cover over the "invincible hatred" or a sword to be brandished?

The only certainty to be had is that the answer, if there is one ("the reply . . . perhaps"), must pass through hatred and violence, the only path whereby disgust is purified. Beyond hatred, one may on occasion discover the wonder of life. However it is not the definitive exorcism of hatred which is promised by the poem, whose last words "invincible hatred" clearly show that the myth of purification by violence which underlies Dada and surrealist thought must not be interpreted in the sense that the optimistic libertarians might wish.

What conclusion(s) can be drawn from these last lines? Perhaps only a dialectic of violence: the "hatred of life" mentioned in the first temporal clause was still just an instinctive Dada violence, the "delirium of hatred" which incited the members of the group to a mutual destruction, whereas at the conclusion of the text, the violence is reflective, lucid. All the paths of retreat blocked by the sight of disgust finally brought to light and obstructing the opposite horizon, it makes way for the stampede of the assassin-magician who manipulates the terrors and the prodigies of Fire. Also the last lines seem to prolong the circular structure of the immense sentence, its coming and going from the night and the tomb to the "invincible hatred," foreseeing nothing for the rebellious beyond the fate of an "intractable criminal on whom prison always closes its gate" (as in Rimbaud's "Mauvais sang"), nothing other than the unquenchable purulence of a disgust from which there occasionally comes forth, like a spurt of fresh blood, a joy or a sorrow not yet contaminated.

Is this poem, occupying a central position in the life of Tzara and the Dada/surrealist movement, to be taken as the last word of both? Probably not. For Tzara himself was to write:

There is such a great joy waiting enclosed in me . . .

And under this same title: "Before night," he was later to celebrate a happiness regained. As for surrealism, we know it results with Breton in

a tragic love of life, with Eluard in the incantation of rhythms and images. This text is not to be taken as a final statement either on Tzara, on Dada, or on surrealism. Nevertheless it fixes, with a terrifying lucidity, one of the most obstinately ignored aspects of our age. No contemporary text approaches it, for no writer, not even Malraux nor Céline, has been able to uncover in such a vitriolic burst of words these tumors of hatred and nervous violence, based on a core of self-disgust, which undercut a civilization with its defenses exhausted.

Still the question remains: how, from this despair and this hatred, can such a text emerge? All beauty supposes a certain distance, a *noli me tangere* erected as a principle between the artist and a suffocating immediacy. If no great work can exist without passion (taken in both senses, as need and suffering), no real work worthy of that name can be only passion. (The most determined partisans of automatic writing always affirmed that they were far from the simply literary.) In the immediate, there is no tragic, only horror. In order to extract from it these unforgettable lines, the artist must surmount the immediate even while giving himself up to it; he must be the man submerged who frees himself, yet knowing his action to be hopeless ("sans espoir se délivre"). The poem itself is his gesture of liberation, is his ascent, now brilliant and now again—as it is here—slow and awkward, toward that unique point of balance which is style, half-way between the unformed and the consciously formed.

This double and necessary motion of sinking and freeing is expressed here by the nuances of rhythm, perfectly adequate to the thought, as we have just seen. Yet it must be understood that this phenomenon is neither simple nor one-directional, that it works rather in both directions; for the rhythm, in spite of its fluidity which makes it to all appearances the most subtle means of expression possible, keeps nonetheless its own logic and its autonomy. One has only to think of the innumerable easy parodies which, since the travesties of Virgil, contrast a pompous rhythm with a ridiculous content. But far more intricate effects can be drawn from such incompatibilities. Consider, for instance, the texts where, within the rigid structures, almost devoid of sense, the rhythm dominates the matter set to that rhythm to such an extent that it alone constitutes the subject of the poem. Thus Tzara's famous: "Capitaine! . . . Prends garde aux yeux bleus" ("Captain! . . . watch out for blue eyes . . ."), where the rhythm of alarm is a perfect match for the incoherence of the context, suggesting a terrified watchman as

he shrieks his warning. "Avant que la nuit . . . ," a strongly rhythmical prose poem, is remarkable by the ambivalence of this rhythm as it responds to the two criteria enunciated above: it engages the passion felt in the immediate, and at the same time abstracts it, transmutes it into the text.

A first reading of the poem makes evident this double use of rhythm on the superficial level. The waves of filth untiringly wash in until the very saturation of despair causes the "face immonde" to emerge as if by a process of crystallization. Thereupon a purifying reversal comes about, for the cumulative structure of the poem carries it forth toward the point where the horizon will perhaps open—toward a new hell, but another one.

Such is the most obvious transmutation worked by the rhythm in the text. But there remains at least one other, more hidden, apparent only on a second reading. As the waves wash one over the other, the regularity and scope of their ebb and tide deflect the attention from the matter toward the rhythm itself, and the hypnotic virtue of these great indefinite surgings calms little by little the useless and degrading resistance. The horde of memories withdraws, the animal fury subsides: only the essence of rebellion and suffering remains, no longer an obstacle to the coming forth of truth. And when horror is finally before him, it is from another shore—saved now at last—that the *poète-récitant*, continuing to proffer his litanies of conjuration in a muffled voice but with increasing intensity, prepares himself and his troops for what will be, perhaps, the breakthrough to freedom.

(Translated by M.A.C.)

The Search for the Place of Poetry

artaud's "invocation de la momie"

Jacques Garelli

What strikes one first in the work of Artaud is the identity felt, thought, repeated, but perhaps also established, between the text as it is read and the mind as it is seen. In this sense, the title of Eluard's "Donner à voir" could be thought of as exactly applying to this work as the common place finally "realized" of the spiritual will to knowledge and self-knowledge in, by, and through the act of linking words one to the other. From the first letters to Jacques Rivière onwards, the identification is felt as a suffering, as a scandal, and even in its imperfections as an irrefutable evidence that the objective faults of the written page do nothing to controvert. In this perspective, the text is presented as "the palpable radiation of a soul." And it is significant that the poem accompanying the postscript of a letter wherein certain literary theses were discussed is entitled: "Cry," a term whose existential weight is manifest. Moreover, in this postscript, Artaud affirms his right to speak by reason of his spiritual suffering, the poem itself manifesting a provisional moment of that suffering which although fugitive has existed nonetheless, and which the reader must re-experience or relive, in and by means of the text, if he means to judge it.

Furthermore, we know that the relationship strongly established, not only between the text and the spirit but between the book and life

is posed in an abrupt and peremptory fashion at the outset of *L'Ombilic des limbes*. It is in the understanding of this strange affirmation that we must take up our place in order to question this text in its smallest details. Now the spirit in act is identified with existence to such an extent that Artaud uses the terms "existence" and "life" without distinguishing between them. If "life is burning the questions," the text-writing itself is none other than the temporal process of this consuming. Thus Artaud can never conceive of the work as detached from life. Each singular work he presents as if it were carved out of the stuff and the living tissue of existence. In that way can the following proposition be understood:

Each of my works, each of my levels within myself, each of the glacial flowerings of my interior soul drivels on me. [01:51] [1]

It is clear in this proposition that the text is treated as one of the levels of existence and that the image[2] of the "glacial flowering of the soul" shows the impossibility of treating the work as a pure essence, the necessity of incorporating it within an existential problematics which poses in its very center the question of the subject, and which implies, on the critical level, an "egology." Now the three following paragraphs insist on the absolute necessity of incorporating the work within the future of a life put in question as it gropes its way along, and of treating the book as a manifestation of existence. First, by stressing the discovery of the existential dimension of the self as it is manifested in the course of its epistolary questionings; second, by refusing all the objectifying conceptions of the mind's activity which are blind to the specificity of its "dimension" of life; and third, by the clearly defined meaning of his inaugural gesture which, according to his expression, "places the book suspended in life," so it will be directly connected with the attacks of the exterior world as well as with the incoherent hesitations of the self as it seeks its own being (01:51). From then on, the identification of the text with the spirit declares itself in a new movement; first by affirming the immersion and in some sense the fusion of the book's pages to take place in the "bain" of the spirit. Against that effort for identity is outlined the categorical refusal to distinguish heterogeneous levels in the life of the spirit and to separate the daily existence from the existence lived by the writer in his relation to words.

It is in that perspective that Artaud attacks the verbal dualism

which places the mind and literature in two heterogeneous areas. From
now on, the book is conceived as the opening of the Self on life, as a
communication between thinking existence and reality inventing itself,
an attitude so novel, thinks Artaud, that it cannot fail to upset the
traditional thought processes. Thus the idea of a topology as an art of
the description of the place opened by, spread out by, the book in the
movement leading to its juncture with reality: "A few of us at the
present time have tried to assault things themselves, creating in
ourselves spaces open to life, spaces which never existed before and
seemed to have no room in space" (01:87).[3] To inspect these new
spaces, created afresh by the unfolding of the text—precisely the task of
a topology—a double danger must be avoided. First, the refusal to
consider the originality, the specificity, the irreducibility of this space
and by a sort of reductive fatality, to conceive of it only with the mental
instruments and the criteria adapted to the space of daily life. This
danger is that of realism. The second, just as dangerous, is the one we
might call essentialist, that of linguistic positivism, which consists of
refusing any system of exchange between language and the world.
Artaud makes very clear the importance he accords to what one might
call the existential dimension or thickness of language and to its opening
on and communication with the world, the refusal to cut off language as
it is spoken from existence as it is lived, to enclose its problematic in a
linguistic ghetto, thus betraying language, spirit, existence, and life. A
rigorous topology must therefore steer its way between the shoals of
reductive realism and reductive essentialism.

For this third path, the notion of "chair" is indispensable; in the
text entitled "Position of the flesh," Artaud stresses the extreme
difficulty of this new knowledge which leads to the working out of a
new method:

But the path of dead stones must be trodden with a slow step, especially
by the man who has lost the *knowledge of words*. It is an indestructible
science which explodes in slow stages. And he who possesses it knows it
not. But the Angels also know it not, for all true knowledge is *obscure*.
The clear Spirit belongs to the realm of matter. [01:190] [4]

It is this third path of knowledge, this obscure knowing of the "flesh,"
this new space to be surveyed that the present essay inscribes under the
name of topology.

Now the flesh is for Artaud an immediate mode of knowing incarnate, at once substance and knowledge whose ambiguity the intellectual dichotomies of subject and object, the for-itself (*pour-soi*) and in-itself (*en-soi*), of spirit and matter cannot grasp. In fact, it is not within the framework of an "ontic" [5] thought that the notion of flesh can be understood but in what Artaud defines as the "Metaphysics of Being" (01:190–91). To speak of knowledge is to speak of evidence. So Artaud affirms an order of the evidence of the body which cannot be reduced to that of logical reason. And it is to that order that the poetic image belongs, as it reveals its lucidity in the flesh of its substance.

In this convergence of vocabulary between the poet and the philosopher is a profound relationship of thought according to which the flesh is that element of Being which does not belong to the reign of objectified things. It is exclusively on the level of the ontology of language that the muffled and hidden life of a text can be perceived, in that space where the opening of sense and the exchange of meanings are covered over by the apparent game of disguise and dispersion. This ontological character of the poetic text as it opens, this dividing line of critical discourse between the reign of the ontic and the ontological, is convincingly described by Eluard:

For the artist as for the least cultivated man, there are neither concrete forms nor abstract forms. There is only communication between what sees and what is seen, an effort of understanding, of relationship, occasionally of determination, of creation. To see is to understand, to judge, to transform, to imagine, to forget or to forget oneself, to be or to disappear.[6]

So the interrogation of the poem should be carried out neither as a study of objectified signs nor as meanings fossilized into a series of objective themes, nor as an intellectual structure to be built abstractly from a global reading of the signifieds of the work and of its signifiers considered as material things to be observed, but rather in the temporal unveiling of the text conceived as an operation which renders visible ("donne à voir") one which, according to its success or its failure, leads the way to *being* or to disappearing.

Invocation de la momie

Ces narines d'os et de peau
par où commencent les ténèbres
de l'absolu, et la peinture de ces lèvres

que tu fermes comme un rideau

Et cet or que te glisse en rêve
la vie qui te dépouille d'os
et les fleurs de ce regard faux
par où tu rejoins la lumière

Momie, et ces mains de fuseaux
pour te retourner les entrailles,
ces mains où l'ombre épouvantable
prend la figure d'un oiseau

Tout cela dont s'orne la mort
comme d'un rite aléatoire,
ce papotage d'ombres, et l'or
où nagent tes entrailles noires

C'est par là que je te rejoins,
par la route calcinée des veines,
et ton or est comme ma peine
le pire et le plus sûr témoin. [01:222]

Invocation of the Mummy
These nostrils of bones and skin
where the shadows of the absolute
begin, and the painting of those lips
which you close like a curtain

And that gold slipped to you in dream
by life which strips you of bones
and the flowers of that false gaze
by which you join the light again

Mummy, and those spindle hands
to turn your entrails inside out
those hands where the frightening shadow
takes the shape of a bird

All that with which death bedecks itself
like a ritual of happenstance,
that banter of shadows, and the gold
where your black entrails swim

By the way of all those things I join you,
by the calcified road of veins,
and your gold is like my sorrow
the worst and surest witness

"A solitary dialog," this poem takes on, by its aridity, the form of an "absolute monolog." [7] But then, who is speaking, of whom or of what, and to whom? Invocation: to invoke, to supplicate by means of the voice. A being of language, the invocation opens a way, a correspondence with the other, originating in the self—even if it were to be a one-way path, it would remain a correspondence. But the mummy is not in this case the receiver of the message, rather the subject of discourse. The strange dialog initiated between "the mummy" of fresh substance that we are and the dead mummy progressively awaking to the consciousness of its being by the work of the word is heard in the long and breathless first sentence of a text we must join to the first, "Correspondance de la Momie":

Cette chair qui ne se touche plus dans la vie,
cette langue qui n'arrive plus à dépasser son écorce,
cette voix qui ne passe plus par les routes du son,
cette main qui a oublié plus que le geste de prendre,
qui n'arrive plus à déterminer l'espace où elle réalisera sa préhension,
cette cervelle enfin où la conception ne se détermine plus dans ses
 lignes,
tout cela qui fait ma momie de chair fraîche donne à dieu une idée du
 vide où la nécessité d'être né m'a placé. [01:223]

(This flesh which is no longer touched in life,
this tongue which no longer extends beyond its outer surface,
this voice which no longer passes by the roads of sound,
this hand which has forgotten more than the gesture of taking,
which will no longer determine where its grasp is realised,
this brain where conceiving no longer decides within its lines,
all that which makes up my mummy of living flesh gives god an idea
 of the emptiness where the necessity of being born has placed
 me.)

A parallel analysis of the two texts shows a similar construction: nothing is known of the beginning series of statements in its grammati-

cal and logical functioning, either in its meaning or its cause, until the
neuter demonstrative: "all that" picks up the totality of what has been
said in order to make of it, in the "Correspondance de la Momie" the
subject of what constitutes "ma momie de chair fraîche," and in
"Invocation à la Momie" the circumstantial complement of manner,
means, instrument, or place, or perhaps all these complements at once,
by means of which a subject saying "I" declares the possibility of
meeting another subject whose singularity has been guessed at in a way
as gradual as it is insistent—that is, by the second person pronoun "tu,"
invoked in the last line of the first quatrain, confirmed as the poem
develops, and then revealed by the title and the initial vocative of the
third quatrain as the mummy to whom the "I" of the last stanza is
speaking even while he claims to be meeting it: ("que je te rejoins"). In
other words, the invocation accomplishes by the temporal use of the
poetic voice a union, or, in the words of Artaud, a "junction" which
modifies the subject of the poem in his being, because from the being
who speaks at the poem's outset he progressively reveals himself as the
mummy to whom he is speaking. Now since the formal process of
constituting and of "junction" is the same in the two texts, the notion of
the "momie" in each must be clarified. In the "Correspondance," the
proposition immediately following the initial statements declares:

Ni ma vie n'est complète, ni ma mort n'est absolument avortée.

(Neither is my life complete, nor my death absolutely aborted.)

Which reveals the mummy as a mixture of life and death, a sort of
composite midway between the fullness of being and the dissolution of
nothingness. The mummy of fresh substance tends toward being at the
same time as it accomplishes the movement which undoes it. Less
evocative of Hegel than preparatory for Beckett, this figure describes
the course of a life which only keeps itself going by self-destruction and
of a death which only manifests itself by an indefinite suspension of the
act which would permit it to attain its final limit.

But on the other hand it is clear that by the term of "flesh"
Artaud means[8] all the ambiguity of the living, which Merleau-Ponty
designated by the same term at the end of his life. He means at once the
origin of opening and of resistance, source of light and of opacity,
wherein the meshing of meanings embodied or incarnate forms an
intersection with the world, so that, by a gesture, the world suddenly
takes on a soul and a body.

Ce sens qui court dans les veines de cette viande mystique dont chaque
 soubresaut est une manière de monde . . .

(This sense coursing through the veins of the mystic flesh [literally:
 meat] whose every motion is a manner of the world. . . .)

The being invoked is thus living and dead, the being of the mummy, of
the invocation, and of the text constructing in its verbal unfolding the
fragile figure of the mummy speaking to itself.

A field of verbal and conceptual presence is spread out in the act
of poetic speech extending from the speaker to the object addressed.
Now this crisscrossing of notions developed in the dynamic of reading is
sufficiently resistant to constitute a being to which, according to the
poet, he is joined. The study of this space itself, by the analysis of its
surfaces and the display of its paths as they are laid out implies the
working method of a *topological approach*. In this instance, the
particularity of this space is constituted by the enunciation as it forms
the being of the person speaking. Here language belongs not to the
order of representation but to that of constitution, since the "I"
constructs itself in its saying. It does not reveal itself; it originates itself.
Before being said, nothing existed. Only by the act supposing the thing
does it come into being.

The difficulty of this text, then, is in its particular portraiture,
alone able to create, transform, accomplish its subject, of which no
model existed; nondescriptive, therefore, and opening the way to
paradox. In this poem, death intrudes its visage in the open field of life,
but only reveals itself as death for the one who names it. Perhaps one
could conceive of the constitution of the mummy according to
the progressive *prise de conscience* by the For-Others (*Pour-Autrui*)
of an existent which would objectify itself in language. Then the
poetic text constituting the route of this coming to consciousness
would be at the same time consciousness of self and one of its modes
of being.

The poem does not try to bring into presence a represented
object, but to make real the movement constituting it. It is the
intentional aim—that is to say the mind as it acts, operative intentional-
ity—which has become poetic matter. The "work" of poetic constitu-
tion, to which this type of verbal creation corresponds, consists
precisely of this realizing and making palpable, audible, and sensible
this intentional consciousness, and not just in representing an object or a

series of objects and facts of which one becomes conscious. The difficulty of the text, the resistance it offers to an unwary reader, the impossibility of treating it according to the traditional systems of ontic explanation, have to do with this uprooting from the ordinary world of the intentional object as it is carried out simultaneously with the work of its transformation.

In this perspective Artaud's untiring declarations that each of his texts manifests the movement of his mind at work should be understood: the self constructing its being in the text by the work of the word. The whole difficulty of the critical enterprise has to do with the nature of this aim. The object of our analysis of Artaud's text is to show the divisions and the junctions of these two components of intentional consciousness.

The intentional objects composing this poem, upon which the work of constitution relies are five:

1) line 1, these nostrils
2) line 3, these lips
3) line 7, this gaze
4) line 9, these hands
5) line 10, the entrails

We are omitting in line 5 "this gold," since as we shall show, it is not a matter of a specified object which exists or has an equivalent in the world.

Starting with these five points of reference, whose realistic component is undeniable and without which the poem would be incomprehensible, the work of constituting the unreal field of transformation and unrealization begins, incommensurable with daily perception. Although the poetic starting point has its place in the perceptive reality from which the poem progressively and forcibly removes itself, this particular type of poetic activity must be understood within the process of transformation into unreal or surreal intentional objects. The poem refers to reality without representing it, designates it without imitating it; constitutes an autonomous world while never ceasing to speak of the real world; creates without relying for its creation on a mute thing pre-existing before the act of verbal utterance.

Scarcely has the first intentional object been named than "these nostrils" are presented not just as a physiological organ perceived and strongly underlined on the realistic level ("these nostrils of bone and skin") but also as a path, a canal, a way which, while it belongs to the

world of the flesh, opens on a beyond which seems to be the reign of absence, of night, of the absolute and of death. The prophetic, rhythmically marked tone of the lines conveys the sense of the irremediable absolute of the universe to which this path leads:

> Ces narines d'os et de peau
> par où commencent les ténèbres
> de l'absolu . . .

If these nostrils in their bodily being open onto the beyond of death, they act as a boundary separating the real world from the "realm of shadows." By his flesh man meets the opening of the absolute. His "metaphysical" dimension is thus constituted by the vision interpreting the intentional object of the nostrils as a magic canal opening directly on to death, introduced and introducing into the reign of the beyond. It is this ambiguous situation which defines the status of "chair" in Artaud's usage.[9] The object originally seen has become "unrealized": the poetic act of Artaud consists very clearly in rendering present and sensible the intentional current envisaging the nostrils as a path toward the shadows of the absolute, not as an organ to be sniffled through, wiped, and so on.

In the following perspective:

> . . . et la peinture de ces lèvres
> que tu fermes comme un rideau

the part of intentionality is still greater than in the first instance, because the reader is uncertain whether the object in question is "these lips" or "the *painting* of these lips." In fact, the chain of the objects visualized in this poem is constituted by the parts of the body, so that it would seem to be the former. But the precise determination, "the *painting* of these lips" seems to belong to the field of the knower since the proposition: "that you close like a curtain" suggests the idea of spectacle that the lips might reveal or close off imperiously.[10] This suggestion creates an oscillation of meaning wherein poetic reverie causes the mind to hesitate between the unreal color of the lips and the spectacle (painting) that they offer in the act of utterance. But if it is the intentional undertaking that makes visible in its hesitation a wavering between color and spectacle, this is because the poem constitutes the unreality of this undertaking verbally, makes the hesitation present in its soul and body. The surreal does not concern the noematic object here:

the lips are lips, nothing more. But the poem becomes surreal insofar as it renders visible intentionality at its noetic level. Contemporary esthetics has never thought of asking what is surreal in the poem: the object or the gaze leveled on it, transforming it by its particular outlook? Plainly the latter, in this case. It is not the thing, which is poetic in itself, but the current of consciousness enveloping it, transforming it and nevertheless leading to it.

However, in the third intentional perspective:

> Et cet or que te glisse en rêve
> la vie qui te dépouille d'os

unreality monopolizes the totality of the intentional field to such a degree that "this gold" which is formally treated as a term of the poetic undertaking cannot be spoken of as an object. It is in itself an element of intentionalizing, not the object on which that aim is trained. We can neither understand this proposition, nor know what it concerns and what its purpose is. But this element is integrated in the general intentional movement of the poem. Here, swept along by its own movement of unrealizing or, if one prefers, transfiguring, the apprehending frees itself from any real object as a resting place; and between the perspective taken on the "lèvres" and on the "regard" accomplishes, as if in emptiness, its route of reverie. In the vain efforts of decoding, in these turnings over of the line in its emptiness, the sentence takes on a density and a weight, imposes itself as an object to be known. The absence of realistic support becomes surreality, the surreal defining itself here as the unreal of the intentional outlook which takes itself as being, intentionality becoming its own object. Whence the opening of the two following lines on a vocative which lends its reality to this movement of invocation:

> et les fleurs de ce regard faux
> par où tu rejoins la lumière
>
> Momie . . .[11]

A perfect symmetry is established between the structure of these two lines and lines 3 and 4 of the first quatrain. In both cases, the hesitation occurs over the precise choice of the intentional perspective: The false gaze or the flowers of that gaze? The flowers seem rather to

belong to the gaze as a means, an instrument, a place and path by which the mummy rejoins the light. Strange association between the essential (work or light) and the realm of the lie, which appears frequently in Artaud, understandable only by a problematics of *constitution*. For what is constituted by language is exactly that which is not "real," what is falsified by language. Thus in "L'Enclume des forces": "A block, an immense false block separates me from my lie. And this block is of any color one wishes" (01:158).

That the flesh is in its ambiguity both nature and intellection is the result of poetic language. The same movement interprets the intentional object as "spindles": an actor-agent suggested by the disturbing figure of the bird as the celebrant of mysterious and cruel funeral rites:

> . . . et ces mains de fuseaux
> pour te retourner les entrailles,
> ces mains où l'ombre épouvantable
> prend la figure d'un oiseau.

These hands at once spindles and bird figure rise up from the intentionality posing them, supposing them.

The constitutive movement of the mummy having been elaborated before the reader by the verbal chain of the poem, Artaud can henceforth declare thetically the junction he operates between this notional being and the self speaking: thus can the last two stanzas be understood:

> Tout cela dont s'orne la mort
>
>
>
> C'est par là que je te rejoins

In this intentional movement logically thematized, and in the series of intentional perspectives presumably of the same order as those discussed above ("ce papotage d'ombres, l'or où nagent tes entrailles, la route calcinée des veines, l'or qui est le plus sûr témoin"), the difference from the preceding perspectives is noticeable. These have only a referential and complementary value, secondary to what was initially postulated, constituted: a reference which folds the poem back on itself, develops and prolongs what was accomplished before. In this sense, the

creative moment of the poem is found in the three first quatrains, the last two unfolding, explicating the initially abrupt creation. At first—in the first moment—the verb constitutes. In the second moment, it logically develops what was postulated, savagely and irrefutably.

(Translated by M.A.C.)

NOTES

1. "Chacune de mes oeuvres, chacun des plans de moi-même, chacune des floraisons glacières de mon âme intérieure bave sur moi." All quotations are taken from Antonin Artaud, *Oeuvres*, vol. 1, Paris, Gallimard, 1956 (cited as 01). [Ed.].

2. It should be noted that Artaud talks in terms of images—as do Reverdy, Breton, and Eluard—and not of metaphors.

3. "Nous sommes quelques-uns à cette époque à avoir voulu attenter aux choses, créer en nous des espaces à la vie, des espaces qui n'étaient pas et ne semblaient pas devoir trouver place dans l'espace."

4. "Mais il faut aller à pas lents sur la route des pierres mortes, surtout pour qui a perdu la *connaissance des mots*. C'est une science indestructible et qui explose par poussées lentes. Et qui la possède ne la connaît pas. Mais les Anges aussi ne la connaissent pas, car toute vraie connaissance est *obscure*. L'Esprit clair appartient à la matière."

5. I have discussed in *La Gravitation poétique* (Paris, Mercure de France, 1966) the celebrated Heideggerian distinction drawn as early as 1927 between Being and a being, the ontological and the ontic, stressing that dividing line of philosophic discourse.

6. "Pour l'artiste comme pour l'homme le plus inculte, il n'y a formes concrètes, ni formes abstraites. Il n'y a que communication entre ce qui voit et ce que est vu, effort de compréhension, de relation—parfois de détermination—de création. Voir, c'est comprendre, juger, transformer, imaginer, oublier ou s'oublier, être ou disparaître." "Je Parle de ce qui est bien," *Donner à Voir*, in *Choix de poèmes*, Paris, Gallimard, 1951, p. 95.

7. It is understood that we do not give to these two terms the sense given them by Lukàcs (*Die Seele und die Formen*, Berlin, Fleischel, 1911) and that Lucien Goldmann takes up in *Le Dieu caché*, Paris, Gallimard, 1959.

8. See also the *Manifeste en langage clair*, 01:238–40.

9. "Chair" designates the carnal being of man as well as the language revealing him as such. This paradox is conceivable if one admits that the noetic aim constituted by language in action reveals the ambiguity of the flesh, an

ambiguity impossible without the consciousness of being as it accomplishes itself through language.

10. The imperative tone of voice brings about the closure, conveying the feeling of the irremediable.

11. The *rejet* plays an important role here.

Prismatic Reflections

michaux's "paix dans les brisements"

Reinhard Kuhn

There is nothing to be said about poems which resound like the never extinguished echo of the echo of the echo.[1] There is nothing to be explained about apparitions which a sorcerer conjures up only to exorcize. The entranced critic finds himself powerless to decode the cryptic messages which Henri Michaux sends from his "far-distant country."[2] Succumbing to the hallucinatory atmosphere which circumscribes this realm, he cannot even explore its relatively accessible provinces and is reduced to a vain attempt at proclaiming his admiration. Thus Michel Beaujour, although he belies his own assertion by the brilliance and specificity of his textual analysis of "Glu et Gli," feels compelled to speak of Michaux's world as a "flaccid and asymbolic universe, traversed by pulsations, about which there is almost nothing to be said."[3] Michaux had foreseen and partially explained the baffled reaction of the critics to his work. In a fable concerning the "reading of the city" he depicts

. . . formerly courageous tillers who themselves now want to find out about the admirably convoluted text, so difficult—perhaps even impossible—to follow and about which everyone is talking. That is what they try to do, however, these opinionated workers, continually walking, lapping up, as they pass by, the diseases of the sewer and the leprous

scales of the facades, rather than the meaning which remains hidden. Drugged with wretchedness and fatigue, they wander in front of the displays, sometimes losing their goal, but never their quest.[4]

Scattered about the landscape of Michaux's far-off domain are the poems, seen by most commentators not as megaliths which could supply us with clues towards the understanding of an ever-vanishing kingdom but as beautiful and sometimes monstrous totems, protected from the graffiti of passing tourists by the awfulness of their inherent magic. It is as if these poems were "poteaux d'angle," [5] strangely biased signposts pointing to nowhere and indicating nothing, or artifacts which the poet has brought into existence at the same time depriving them willfully of all significance: meaningless being. Understandable as such an uncritical attitude may be, it does not lessen the distance which separates us from a foreign universe nor does it serve the reading of Michaux's tantalizing enigmas. And it certainly does not seem to accord with the poet's own stance, unambiguously described in his most recent work and summarized by the phrase: "My first quest: *signs*." [6] These "signs" are not symbols of a static reality or surreality but the images of the creative and destructive processes. They are

> Signes
> non de toit, de tunique ou de palais
> non d'archives et de dictionnaire du savoir
> mais de torsion, de violence, de bousculement
> mais d'envie cinétique [FV, 17]
>
> (Signs
> not of roof, of tunic or of palace
> not of archives or of dictionaries of knowledge
> but of torsion, of violence, of shaking
> but of kinetic desire)

Consequently the actual existence of poems made up of such signs is secondary to their coming into and going out of existence: "it is my pleasure to bring into being, to transform being into appearance, and then to make the appearance vanish." [7] Because the mechanisms of thought are far more marvelous than the thought which they engender, Michaux's goal is to "reveal the complex mechanisms which make of

man first and foremost an operator." [8] The task of the critic should therefore be to reflect upon a reflection upon reflection.

Another factor that serves partially to explain the reluctance on the part of the majority of critics to come to terms with an admittedly difficult but by no means hermetic opus is the apparent impossibility of situating it within an historical framework, be it that of literature or that of Michaux's life. The poet's reticence concerning his own person precludes the possibility of any sort of biographical study or totalization of the type that Sartre has undertaken with Flaubert. On the other hand, it does seem that, by all rights, he should simply be classified among those commonly associated with surrealism. The superficial similarities are so strikingly obvious that they tend to obfuscate some fundamental differences. For example, Michaux, like the erstwhile practitioners of automatic writing, tends to question the role of the poet as unique creator of his own work. "Anyone can write 'Mes Propriétés,' " [9] he said of the work in which he comes closest to defining in allegorical terms his very personal vision of reality. And in his afterword to the recently revised edition of *Plume* he addresses the reader directly with the statement, "Reader, *you are now holding in your hands*, as happens so often, a book which *the author did not make*, although a world participated in its making. But after all, what matter?" (P, 220).

Despite this similarity and many others which provide a natural link between Michaux and the surrealists, the former has always maintained a very distant and guarded attitude towards Breton and his followers. He expressed his reservations in his early essays written for the Belgian periodical, *Le Disque Vert*, of which he was, for a time, codirector. In the article "Surréalisme," devoted mainly to a discussion of *Poisson Soluble*, which had just appeared, Michaux expressly delineates one of the fundamental areas of difference with Breton at the same time as he reveals his ambivalent attitude toward surrealism. Long before Breton elaborated his theory of the marvelous in contradistinction to the mysterious,[10] Michaux had perceived that this was indeed the key and justification of the surrealist enterprise. "With Breton," he writes, "we find ourselves in the absolute marvelous." [11] It is a plateau which Breton could attain through his "absolute non-conformism with reality." But Michaux is disappointed in this "absolute marvelous" (although he admits that it is better than no marvelous at all), because it is a condition which, by its very nature, like the *Paradiso* of Dante and the Hades of Vergil, is characterized by monotony. So he terminates his

essay on a note of guarded approval: "Is there a literary conclusion? Yes: the surrealist marvelous is monotonous, but when there is a choice between the marvelous and whatever else, I do not hesitate. Long live the marvelous! Even if it were only a superficial marvelous." [12] Michaux is in search rather of a marvelous of the depths, a profundity as diverse and transient as the reality to which it gives birth, a marvelous common to all men which he can find only in that momentary eternity of peace amidst the breaking of the waves: "Paix dans les brisements."

The early essays of Michaux, despite their occasional nature and a certain superficiality, are revelatory. They accurately predict that Michaux's work to be will consist of a successful attempt to go beyond surrealism to achieve what so many poets have sought after in vain. The driving erotic force behind the explosive poems of Breton is surpassed in Michaux's works by a multiplicity of forces which are maintained in a state of constantly suspended animation. They thus contain that terrible basic force which Artaud perceived in the plague, the force of the ever-virtual as opposed to the actual. The influence of this equilibrium maintained under pressure on the very texture and dynamics of Michaux's style is apparent. While Breton's poems are orgasmic, those of Michaux are pulsative.

Michaux concluded an article on Freud with one of his very rare presumptuous statements: "Freud only saw a little part. I hope to demonstrate the other part, the big part, in my next work: Dreams, games, literature and madness." [13] He never did write this work. Or did he? It is a title which he might well have given to the book composed thirty-five years later and which he chose instead to call *Paix dans les brisements*.

A long period rich in works had to precede the Work. "Always I had to have recourse *to dissolutions as to a necessary prerequisite*," he writes in *Emergences-Résurgences*, and later on in the same essay he claims that he "insisted on demonstrating the paucity of reality of the concrete world" (ER, 43, 116). But the necessity for creating an inward and an outward void, for encountering nothingness, serves only as a partial explanation of this extended apprenticeship. More to the point may be the inherent contradiction which other creators, most notably Flaubert and Mallarmé, have faced between an uncommunicable imaginary and the exigencies of a form, namely literature, a discourse whose goal is communication. [14] It is the paradox which must be transcended by the writer for whom the inexpressible represents not the

very limits of literature but its unique end. Until Michaux had found the new tools which he needed for the expression of the inexpressible, he chose, in order to avert the dangers of autism, to divert himself with rich but less ambitious projects. In the prose poems contained in *Labyrinthes* and specifically in "La Lettre," which he wrote at a time of deep depression caused by the miseries of the German Occupation, he gave voice to these concerns:

L'union du ciel et de la terre est un poème, mais le poème que nous avons entendu a paralysé notre entendement.[15]

(The union of the sky and of the earth is a poem, but the poem which we have heard has paralyzed our understanding.)

Like Claudel, Michaux had been able to transform universal correspondences into works of poetry. But the poem which he had sensed even in his earliest years stills his creative urge. The preceding passage is introduced by a rhetorical question:

Qui sur notre sol reçoit encore le baiser de la joie jusqu'au fond du
 coeur? [L, 49]

(Who on our earth can still receive the kiss of joy which penetrates the
 heart?)

It is impossible to undertake the great poetic task at a moment in history when joy has been extinguished, when jubilation would seem indecent. And so, in a later epistle, "La lettre dit encore . . . ," he announces a temporary cessation:

Je m'arrête de vous écrire. Non, n'envoyez pas un préparateur des fêtes. Non, il n'est pas temps encore. [L, 54]

(I am going to stop writing you. No, do not send a preparer of feasts. No, it is not yet time.)

The time of the celebrant is not yet at hand, and Saint-John Perse's "fête que l'on fête" [16] has not been prepared.

 In the early fifties Michaux found his "préparateur des fêtes": mescaline. Six years later he dismissed this servant who had become the master of so many of his contemporaries in order to compose *Paix dans les brisements*. This work occupies a place apart in the total production of Michaux because it is the first and only one in which the poet, the

prose writer, and the graphic artist join forces to create what is truly a *Gesammtkunstwerk*. In *Connaissance par les gouffres* prose commentaries follow the poems, which are interspersed among descriptions of drug experiences. In *Emergences-Résurgences* drawings serve as illustrations of the text. But in *Paix dans les brisements* drawings, essays, and the poem form a whole which should be indivisible. It is a four-part work which opens with a series of black-on-white drawings on seven unnumbered double pages.[17] These are followed by a poetic meditation entitled "signification des dessins." The third section, "Au sujet de Paix dans les brisements," serves as a prelude to the poem itself with which the book closes. These arbitrary divisions tend to disappear when one looks at the work as a continuum, within which the parts merge and become indistinguishable, as commentaries, poem, and designs feed upon and nourish each other in a perfect symbiotic relationship. It is within this self-contained and perpetual flow that turbulence is transformed into a form of peace which could be likened to the serenity of a clenched fist.[18] To present this organic structure in material form Michaux had wanted to have the work published as a Chinese scroll, of which the album-like presentation of the original edition is but an imperfect approximation.[19]

The designs themselves seem to be sheets of brief lightning flashes, some connected, some disconnected, sometimes rushing together in a swirling motion to form vortices, sometimes seeming to fly apart in a barely contained explosion which is really an implosion. The initial impression is one of total disorganization. But, as in a seismograph, one senses an underlying organization on the verge of upheaval:

there was disorganization, but in the background always an overtended organization, ready to blow up, but, in the meanwhile, unbelievably actual and doing its job, a tremendous demonstration of the prodigious mental life which cannot come to a halt.

Thus there is an extraordinary tension as if the thin strip of paper covered with signs actually contained an incipient earthquake, a mental eruption which would bring forth a destructive and uncontrollable lava flow of images. The words of the poem fulfill the same function as the images:

Images or words, they are repositories, instantaneous and occasional (fugitive, but, at the very moment, immovable, fastened and as if

invisibly fixed into place), provoked by involuntary evocations which always astonish and which I would like to call "laisses de réflexion."

There is a multiplicity of meanings contained in the definition of words and images as "laisses de réflexion." On the one hand, it could simply signify "reflection leashes" (just as one speaks of "dog leashes"), in which case the images and words serve as checks to control a reflexive thought which, untrammeled, would only reproduce the incomprehensible chaos of drug-inspired visions. They are the instruments of restraint which precariously maintain the tension between the contained and the containing and thus realize that state of virtuality which characterizes so much of Michaux's work. On the other hand, "laisses" also signifies the lines of demarcation left by the high and low tides. This definition supports the original interpretation, for such watermarks indicate the limits—and consequently the limitations—of a force of nature. In a sense they contain the tide. Finally, "laisses" is the technical term for the strophic division in French medieval epic poems. In other words, they represent an artificial device to keep the flow of poetic narration within certain prescribed bounds. Thus, images and words serve a double function: they are the containers of forces and consequently the creators of tension; at the same time they are the signs which record the constant fluctuation of these forces, just as an encephalogram records the ever-changing brain waves. The sign-covered pages could thus be called an eidogram, a transcription of the patterns of the imagination.

Words and images in *Paix dans les brisements* refuse the limitations of their functionality and succeed in transcending their instrumental role. In the relationship which exists between them can be found the very tensions which they create. The lines of the drawings are constantly striving to become words and are sometimes on the verge of breaking through their own matter, in the same way as Michelangelo's "Slave" constantly struggles to emerge from the marble within which he is imprisoned. In the drawings we can almost discern certain expressions rising up through the lines before they are once more submerged. Thus, at one point a word which could possibly be "pétillements" can barely be made out within a convoluted mass of lines. But it is scrawled in such a fashion that the linear aspect of the letters is dominant. For example, the terminal "s," rather than being rounded, is a vertical slash. In similar fashion words in the poem seek to become images:

le multiple me dépèce
malmené
down
pf
pf
pf
des empêche-pensées
sans cesse subitement me subtilisent
tenant ma tête sous foisonnement
intolabel
intolabel
intolabel

(the multiple dismembers me
misled
down
pf
pf
pf
thought-preventers
ceaselessly suddenly steal me
holding my teeming head under
intolabel
intolabel
intolabel)

Here words become what Jarry had called them, "polyhedrals of ideas." [20] The poet is dismembered to become himself multiplicity, misled in a vertiginous descent, as soft and as quiet as eiderdown (it is no doubt this dual connotation of the word "down" as well as its harmonic structure which induced the poet to choose it rather than some French equivalent), a descent which ends with the consonantal sound of a deflating balloon, "pf . . . pf . . . pf," phonemes which at the same time have a slightly derogatory tone, as in the German "pfui." And so a lower level is reached, in which the poet, like a precious metal, undergoes a ceaseless process of refinement. But simultaneously he is turned from himself, actually stolen ("subtiliser" means both "to refine" and "to steal") by the sudden recurrence of subtle distractions, his head submerged in their proliferation. The poet is only saved by the threefold

repetition of "intolabel," a neologism which obviously implies the "intolerable" condition in which he finds himself, at the same time as it more subtly suggests the opiate "belladonna" which could bring sleep and respite, and finally sounds as the tolling of the bell which concludes this movement of the poem. But of equal importance with the ambiguous meaning and the music of alliteration is the typographical layout of the page which depicts in graphic terms the descensional movement and the pictorial quality of the letters. Those which compose "pf," for example, constructed as they are primarily of vertical lines, seem to try to revert to the seismographic designs of the opening drawings. If, in the latter, we saw graphemes struggling to become phonemes, here we see the reverse as phonemes, already deprived of sense, struggle to divest themselves of their oral nature in order to become graphemes. But the breakthrough never occurs, for the words resemble the

> Blanche vermine de broderies trop fines
> qui court partout et ne se rend nulle part,
> trop fine, trop fine
> qui m'étire,
> me mine
> et m'effile

> (White vermin of overly fine embroideries
> running everywhere and going nowhere,
> too fine, too fine
> which stretches me out,
> undermines me
> and undoes me)

Without respite Penelope undoes the work of the preceding day, and the delicate fabric, stretched and weakened, unravels. The tapestry of the drawings is incessantly undone by the thread-like lines which constitute it. There is a constant motion moving nowhere within whose suspended animation we remain imprisoned.

One of the unique features of *Paix dans les brisements* is that this state is only an intermediate one. Preceded by a movement of disintegration, it is followed by one of unification. The disintegration is the direct result of the poet's encounter with infinity, with which the poem opens:

l'espace a toussé sur moi
et voilà que je ne suis plus
les cieux roulent des yeux
des yeux qui ne disent rien et ne savent pas grand-chose
de mille écrasements écrasé
allongé à l'infini
témoin d'infini
infini tout de même
mis à l'infini

(space coughed on me
and so I am no more
the skies roll their eyes
eyes which say nothing and do not know much
a thousand times crushed
stretched out to infinity
witness to infinity
nonetheless infinity
put to infinity)

The first verses are reminiscent of Baudelaire's sonnet "Correspon-
dances." But unlike the "confuses paroles" ("confused words") which
emanate from Nature, Michaux's space emits a coughing so destructive
that the poet is abolished. While the Baudelairean forest looks at man
with "des regards familiers" ("familiar looks"), the sky rolls its eyes, but
even this human gesture is deprived of meaning and evokes a sense of
horror. The phrase "qui ne disent rien" may be translated as "which say
nothing" or "which mean nothing." The vacant eyes have the power
neither of expression nor of knowledge. The poet is tormented, crushed,
and "allongé à l'infini," which could mean "stretched out to infinity" or
"stretched out on infinity" as a victim is stretched out on a rack. And
finally he is "mis à l'infini," "put to infinity" as one is put to death. But
the suffering inflicted upon him does not prevent him from being both
an objective observer ("témoin d'infini") and the object of observation
("infini tout de même").

In one of Baudelaire's "spleen" poems the low and heavy sky
(symbol of a limiting infinite) weighs down upon and contains a
fragmented soul.[21] In similar fashion, the infinite in the opening stanzas
of "Paix dans les brisements" acts as a barrier and holds within bounds a
process of perpetual disintegration. Within these limits there is also

proliferation: "double du double / double de tout redoublement" ("double of the double / double of all redoubling"). On one level the poet is merely a duplication of what is already double; on another level he is the doubling of the very process of duplication. And so the poet becomes a prisoner of the prism:

> prisme
> dans le prisme je me pose, j'ai séjour
> temps de la solennité

> (prism
> within the prism I take my place, my sojourn
> time of solemnity)

The first period, the time of solemnity, is also characterized by a yearning expressed in the cry: "un désir d'union / oh ce désir d'union" ("a desire for union / oh this desire for union"). This longing is to be satisfied in the third part of the poem, at the same time as the poet escapes from the state of mobile inanition. But first, as a preparation for the liberation and consequent uniting, he must bring about a self-identi-fication with time:

> je coule
> sable du sablier de mon temps
> précipitamment s'effondrant
> précipitamment
> comme torrents de montagne

> (I flow
> sand of the sand-glass of my time
> precipitously disintegrating
> precipitously
> like mountain torrents)

Not only is the poet time, but he is what contains time ("le sablier") and what measures it ("le sable"). And a higher order of magnitude is reached as the trickling of the sand becomes the rush of a mountain torrent. In different form, in images rather than in words, this is precisely what we have already seen in the drawings, where the lines are measure, measured, and container of the measured. Like the grains of sand, the minuscule lines form a wild cascade. In the poem the words

which emerge soon after the marriage with time are also a verbal
representation of the lines. They are:

présences multiples
enlace . . . entrelace . . . ce qui entrelace . . .
l'infini est serpent

(multiple presences
entwine . . . intertwine . . . what intertwines
the infinite is serpent)

These verses present a new image—and thus a new form—of time.
They are reminiscent of the words of Valéry's serpent-like Jeune
Parque, "Je me voyais me voir sinueuse et dorée" [22] ("Sinuous and
gilded I saw myself seeing myself"). Like her, the prismatic infinite of
Michaux is self-reflection in which the process of thought becomes the
object of thought.

It is the discovery of these "présences multiples" which triggers
the ascensional phase of the poem in which the poet lets himself be
swept toward ever-higher regions, perhaps even beyond the empyrean,
by

une force
une force d'agrandissement heureux
effarante extension
une force jusqu'au bout du monde
comment calmer les ailes innombrables de la force
qui m'élève
qui m'élève de plus en plus?

(a force
a force of fortunate enlargement
bewildering extension
a force to the end of the world
how to calm the innumerable wings of the force
which lifts me up
which lifts me higher and higher?)

Michaux has always been fascinated with wings, and in *La Vie dans les
plis* he had conceived of headless, even bodiless wings, pure wings
which can rise up beyond serenity toward a region of future felicity

where there reigns a peace beyond peace.[23] The question as to how to calm them does not really call for an answer but suggests the inward tranquility of acceptance. And in fact, simultaneously with the inception of this upward motion, peace is discovered:

> paix
> paix par graine broyée
> je fais la paix
> dans une douceur de soie

> (peace
> peace by ground grain
> I make peace
> in the softness of silk)

This peace is constructed upon the elements of disintegration, for it is achieved by the "ground grain" with its biblical connotations of fruitfulness achieved through destruction: the grains must be crushed between the millstones just as the poet had earlier been dismembered by space. At the same time these potentially fruitful seeds recall the dry grains of sand pouring through the narrow neck of the hour glass. This tranquility of the soul is achieved only slowly and through patience, as is suggested by the expression "par graine broyée" so closely associated with the familiar words "graine par graine" ("grain by grain"). The impossible can be obtained through such patience as Clov, in Beckett's *Endgame*, notes when he meditates upon the grains of sand accumulating one by one until they form a little heap, the impossible heap.[24] Furthermore, this inward harmony can be realized only within the framework of self-reconciliation suggested by the ambiguity of the verse "dans une douceur de soie" ("in the softness of silk") which could be read just as well "dans une douceur de soi" ("in the well-being of the self"). Nor is this word play merely fortuitous. Michaux had carefully prepared the reader for it in an earlier description of a similar but still unresolved condition:

> l'impression suraiguë du malaise de moi
> accompagne l'impression suraiguë de l'aise de moi
> de l'aise vertigineuse
> de l'aise à son extrême

(The piercing impression of the discomfort of the self
accompanies the piercing impression of the comfort of the self
of vertiginous comfort
of comfort at its very limits)

This vertiginous "aise de moi" no longer contaminated by the "malaise de moi" is the "douceur de soi(e)" of inward peace.

Peace within the ascensional movement leads to that spiritual union for which the poet had longed. It is the recompense for the long period of human solitude and loneliness:

m'élevant sans privilèges
tous les feuillages des forêts de la terre
ont le frémissement
à l'unisson duquel je frissonne

(as I rise without privilege
all the foilage of the forests of the earth
tremble
and I tremble in unison)

He has achieved this pantheistic identification of the self with an animistic nature by divesting himself of all of his "privileges," that is to say of those human attributes which distinguished him from non-human natural phenomena, sources of that hostility which originally existed between him and the universe.[25]

This gradual elevation toward the ether, toward "la région où vivre" from which Mallarmé's swan is forever exiled, is momentarily interrupted by the first and only climactic outcry in this work. In fact, this is the only consequential climax in the entire work of Michaux. It is true that the surface tension of his poems is often punctured by brief expressions followed by an exclamation mark, those superficial indications of a moment of crisis. However, they are but the occasional bursting bubbles of an unchanging and ever-simmering fluid and the transformation from liquid to gaseous form is an always reversible one. Prior to *Paix dans les brisements* it is impossible to find a radical and irreversible break which changes not only the direction but the very substance of the poetic enterprise. Here there is true rupture, an emergence followed by an irrevocable resurgence after which nothing will ever be the same again. And so the drama of the moment is accentuated by its very unexpectedness:

sauf!

j'ai brisé la coquille
simple je sors du carcel de mon corps

l'air
l'au-delà est mon protecteur

l'inondation a soulevé mes fardeaux
l'abandon de l'empire de moi m'a étendu infiniment
plus n'ai besoin de mon cadavre
je ne vis plus que de la vie du temple

(saved!

I have broken the shell
simple I emerge from the oil lamp of my body

the air
the beyond is my protector

the inundation has swept away my burdens
the abandonment of the imperium of the self has infinitely
 stretched me
no longer do I need my body
I live only by the life of the temple)

The initial cry of triumph, the jubilant "sauf!", followed by the assertion
that the shell had been broken, reminds one of the ecstasy of Mallarmé's
clown after he had torn a hole through the canvas of his tent. The
parallel is reinforced by the word "carcel." In Spanish it signifies
"prison," and thus the body, like the Mallarmean tent, represents a
place of involuntary confinement from which the poet escapes. In
French it represents a type of oil lamp and hence recalls the sooty
"quinquets" ("torches") of the "Pitre châtié," which also symbolize the
dirty light of reality as opposed to the limpidity of the "azur." In the
case of the clown, purification was represented by the washing-off of
the falsifying but at the same time protective layer of cosmetics. In the
case of the poet, an inundation sweeps away his burdens as the waves
sweep over the decks of a ship; here the very term "inundation" implies
washing off and the word "fardeaux" contains the word "fards"
("cosmetics"). And in both poems there is a willful confusion between

the imagery of water and of air. The essential difference between them
is that the clown is destroyed by his contact with the beyond while the
poet is saved thereby. The clown regrets the "rance nuit de la peau" [26]
("the rancid night of the skin") because he comes to the realization that
his genius was, in fact, the make-up which had been dissolved. For
Michaux there is no regret, no looking backwards. He has divested
himself of his body because he no longer needs it. Without it he
becomes infinite expansion and can live the "life of the temple" to the
exclusion of all else.

The poem "Paix dans les brisements" and the book of the same
title conclude with:

> la pente vers le haut
> vers le haut
> vers toujours plus haut
> la pente
> comment ne l'avais-je pas rencontrée?
> la pente qui aspire
> la merveilleusement simple inarrêtable ascension
>
> (the incline towards the heights
> towards the heights
> towards the ever higher
> the incline
> how had I avoided meeting it?
> the incline which aspires
> the marvelously simple irresistible ascension)

This is not the natural incline which Gide had urged everyone to follow
upwards.[27] It is the supernatural incline of the *via mystica* which once
found can never again be abandoned and which leads to a simple
marvelous far beyond that revealed by the subconscious of the
surrealists. The last two pages of the designs had already given pictorial
expression to this irresistible ascent. The maelstrom of lines, now
primarily horizontal, in the form of elemental birds (that is to say,
birdless wings), seem to be ineluctably drawn in one direction by a
vortex into a vulva-shaped mass of lines. Or, seen in another way, they
sweep out of the darkness, disintegrating into ever fewer and smaller
lines and even dots, as they move inevitably towards the blankness of
the last half of the page. They are tending towards a realm in which

le mal est immolé au bien
l'impur au pur
l'à-côté au droit
le nombre à l'unique
et le nom est immolé au sans nom

(evil is immolated to good
the impure to the pure
the sideways to the straight
the number to the unique
and the name is immolated to the nameless)

In this "région du primordial" reigns the primeval marvelous, the "normal marvelous" (GE, 7), which, with the help of mescaline, Michaux had been able to perceive and which, with the help of his artistic and poetic genius, he was able to express.

In the introduction to the poem Michaux had written:

Le poème mille fois brisé pèse et pousse pour se constituer, pour un immense jour mémorable reconstituer, pour, à travers tout, nous reconstituer.

(The thousand times shattered poem stresses and strains in order to constitute itself, in order to reconstitute an immense and memorable day, through all in order to reconstitute us.)

The symbolists had searched in vain for this reconstruction and their efforts culminated in the brilliant shards of Mallarmé's shattered *Oeuvre*. Michaux's entire work is a thousand times broken poem whose fragments suddenly fall into place in a kaleidoscopic pattern, ever reconstituting themselves within the infinite reflections of the prism of *Paix dans les brisements*.

NOTES

1. "écho de l'écho de l'écho jamais éteint." *Paix dans les brisements*, Paris, Editions Flinker, 1959.

2. "Je vous écris d'un pays lointain," *Plume*, following *Lointain Intérieur*, rev. ed., Paris, Gallimard, 1972, p. 71. [P]

3. "Senns et Nonsens. Glu et gli, et le grand combat" in *Henri Michaux, Les Cahiers de l'Herne*, special no., 1966, p. 135.

4. *Face aux verrous*, rev. ed., Paris, Gallimard, 1967, pp. 41f. [FV]

5. *Poteaux d'angle*, Paris, L'Herne, 1971.

6. *Emergences-Résurgences*, "Les Sentiers de la Création," Geneva, Skira, 1972, p. 114. [ER] In this and all subsequent quotations emphases and capitalizations are those of Michaux.

7. ER, 43. Michaux is here referring to his drawings, but the same remark applies to his writings.

8. *Les Grandes Epreuves de l'esprit et les innombrables petites*, "Le Point du Jour" (Paris, Gallimard, 1966), p. 9. [GE] The profession of this goal is one of the constants in Michaux's work. In writing of his paintings in *Passages* he expresses the same aspirations: "Instead of one vision to the exclusion of others, I would have liked to draw the moments which, end to end, form life, to render visible the interior phrase, the phrase without words, the cord which indefinitely and sinuously unwinds, and, in intimacy, accompanies everything presented both from within and from without." *L'Espace du dedans*, rev. ed., Paris, Gallimard, 1972, p. 308.

9. *La Nuit remue*, rev. ed., Paris, Gallimard, 1967, p. 195.

10. André Breton, "Le merveilleux contre le mystère," in *La Clé des champs*, Paris, Pauvert, 1967, pp. 7–13.

11. *Disque Vert*, 3,1(1925):85.

12. *Ibid.*, p. 86.

13. *Le Disque Vert*, 1924, p. 151.

14. Cf. Sartre, *L'Idiot de la famille*, "Bibliothèque de la Philosophie," Paris, Gallimard, 1971, 2:1972f.

15. *Labyrinthes*, Paris, Robert J. Godet, 1944, pp. 49f. [L]

16. Saint-John Perse, *Oeuvre poétique*, Paris, Gallimard, 1960, 2:130.

17. Except for a very truncated version of the poem published in the anthology of Michaux's works, *L'Espace du dedans*, the only text of *Paix dans les brisements* is the original one referred to in n. 1. [Now repr. in *Moments: Traversées du temps*, Paris, Gallimard, 1973. Ed.]

18. René Char used the expression "A une sérénité crispée" as the title of one section of *Recherche de la base et du sommet*, new enl. ed., Paris, Gallimard, 1965.

19. According to Michaux, during the course of an interview with the author.

20. Alfred Jarry, *Oeuvres Complètes*, "Bibliothèque de la Pléiade," Paris, Gallimard, 1972, 1:173.

21. "Quand le ciel bas et lourd pèse comme un couvercle / Sur l'esprit gémissant en proie aux longs ennuis." Baudelaire, *Oeuvres Complètes*, "Bibliothèque de la Pléiade," Paris, Gallimard, 1966, p. 70.

22. Valéry, *Oeuvres Complètes*, "Bibliothèque de la Pléiade," Paris, Gallimard, 1967, p. 91.

23. "Des ailes sans têtes, sans oiseaux, des ailes pures de tout corps volent vers un ciel solaire . . . trouant son chemin dans l'empyrée comme un obus de future félicité." ("Headless wings, birdless wings, pure wings without bodies fly towards a solar sky . . . piercing a way through the empyrean like a rocket of future felicity.") *La Vie dans les plis*, rev. ed., Paris, Gallimard, 1972, p. 169. A further description of the way which leads towards "peace beyond peace" is found in "Vers la sérénité" in *La Nuit remue*, pp. 90f.

24. Beckett, *Théatre I*, Paris, Editions de Minuit, 1971, p. 144.

25. This is the mystic vision of a poet who, in his youth, had admired Ernest Hello as much as he had Lautréamont. Cf. *Le Disque Vert*, 1925, p. 86.

26. Mallarmé, *Oeuvres Complètes*, "Bibliothèque de la Pléiade," Paris, Gallimard, 1970, p. 31.

27. The originality of Michaux's use of the word "pente" and of Gide's aphorism "Il faut suivre sa pente, en montant" ("One must follow one's incline, but upwards") lies in the fact that "suivre sa pente" normally implies a downward movement.

René Char's "Quatre Fascinants"

James Lawler

With more poignancy than Char's earlier collections, *Le Nu perdu* (1971) is centered on the theme of death. From "Retour amont" to "Contre une maison sèche" the five parts show the presence of suffering and disquiet; nevertheless the poet turns to the imagery of forest, field, house, and of a combat synonymous with aspiration. Resuming a basic equivocalness, the title indicates both time's corrosion and the forces of desire—"verte créance"—which make of loss the condition of action: "We shall pass from imagined death," he declares, "to the reeds of death lived nakedly." [1] In severe language he names a hidden resource, his temper no less resilient than before.

This book serves to underline the scrupulousness with which he has pursued his vein. When we look back over his career we find that it can be interpreted as an attempt to resolve the imperatives of lyricism and didacticism at the heart of surrealist ambitions: *Fureur et Mystère*, *Commune Présence*, and *Le Nu perdu* trace out the path he has followed—responsible, constantly vigilant—to reclaim the world of dream. As he has said elsewhere in other guises and now reiterates: "The question we must ceaselessly ask ourselves: in what place and manner can we give back to our fellow-men their nocturnal dreaming? And, in order to belie the horror that visits them: by means of what supernatural matter, what love millenary and still to be?" [2]

Examined in detail, his work offers, then, a striking continuity. My present aim cannot be to undertake a wide-ranging survey that would illustrate this but merely to suggest, by considering one small

fragment of his writings, what I take to be the integrity of an art that transcends surrealism by virtue of its energy, marrying the concrete and the abstract, the imaginary and the moral. The group of poems I have chosen seems to me a high point in his career. "Quatre Fascinants" was published for the first time in 1950 and later included in three important anthologies of his work.[3] It finally appeared in *Commune Présence* (1964) as part of the fifth section ("L'Amitié se succède") of this admirably composed book. The four short poems constitute, we might say, a bestiary of friendship that expresses Char's "common presence" with familiar creatures of Provence, a tableau embracing fire, water, earth, air; truth, love, fear, death; the massiveness of the bull, the fluency of the trout, the snake's wit, the lark's fervor.

Yet the title also reminds us that Char is not simply depicting beasts, fish and fowl, but consigning his deepest promptings—his own "share of marvel, rebellion, beneficence." [4] The idea of fascination is fundamental in a poetry wherein the harvest becomes an "obsession," the prairie animals an "enchantment." For what Char sees he must come to terms with: he will change it into emblems that bear, splendidly inscribed, the insignia of his hope.

Le Taureau
Il ne fait jamais nuit quand tu meurs,
Cerné de ténèbres qui crient,
Soleil aux deux pointes semblables.

Fauve d'amour, vérité dans l'épée,
Couple qui se poignarde unique parmi tous.[5]

The Bull
It is never night when you die,
Circled by shrieking shadows,
Sun with two like points.

Beast of love, sword's truth,
Murderous duo unique before all.

The first poem, like the last in the sequence, makes use of free verse. It contains two octosyllables, plus lines of nine, ten, and twelve syllables. This apparent irregularity is countervailed by a hexasyllabic measure which imposes its balance (6/3, 6/2, 2/6, 4/6, 6/6). Without a uniform meter, "Le Taureau" thus offers a rhythm recurring and ultimately dominant.

The texture of sound is especially taut. At the opposite pole from mellifluent alliteration, it establishes an interplay of plosives and dentals that conveys high emotional intensity. This is reinforced by the vowel scheme, characterized by the frequency of "i" and open and closed "e" and, on the other hand, by the almost complete absence of nasals. A line such as the final one, exploiting as it does the pattern of consonants and vowels already found in what precedes, creates a vigorous series of correspondences across the caesural pause, translating thereby the drama into a kind of phonetic equivalent.

Char's words are of death and love, sunlight and shadow. In essence direct, they are here developed with such concentration that they take on exceptional weight. Of the two dramatic statements that compose the poem, the second has no main verb so that it approaches the register of an exclamation, while the first gradually builds to a climax, its impact growing from an initial simplicity to the richly dramatic metaphor of line 3. We observe however that, although the two sentences are of different contour and length, they are each made up of three segments that establish a complementarity within the asymmetrical form.

The first line is an expression of complete faith as the use of "jamais" excludes the night and pathos that accompany death. The bull's slaying, felt as an illumination, is raised to the realm of ideas by verbal generality. The mode of address denotes both the poet's communion with the bull and the bull's eternal nature since, like a god, it ritually dies and is forever reborn.

After this confident opening, the second line shows the tension from which illumination is born. In an adjectival phrase that evokes a siege and an obsession, it points to the darkness that is the counterpart of light. The rhythm has changed from the flat rapidity of the first line to a greater deliberateness, which corresponds to the metaphorical emphasis of "cerné" and "ténèbres." The bull is a city invested by the enemy, a hero plagued by fate. "Ténèbres," in particular, introduces a tragic level, confirmed in the relative clause by harsh alliteration and assonance and an auditory image: the shades are so many harpies carrying out cruel torments.

The section closes on an apposition that develops the opening line but places it in sharp contrast to the second. The rhythm gives full accent to "soleil": taking on the resonance of the solar myths, the bull is identified with radiance, warmth, renewal. Yet this is no ordinary scene,

for the transpierced sun is none such as we know but the sign of a glory attained in violence. It translates the union of bull and sword, these two deadly points that meet like predestined lovers.

The three parts of the final section, even more condensed than those of the preceding lines, resume the drama in two abstract phrases, then reformulate it in a striking apposition. The rhythm becomes gradually more assured from the first words which evoke the animal force and presence of love: the bull sacrifices its all to a fatal encounter. The words that follow take up the time-honored image of a corrida as the moment of truth par excellence, placing the abstract term "vérité" alongside "amour" as the twin blade of this confrontation. The asymmetrical disposition of the two phrases imposes a precipitate movement, which is further accentuated by the four occurrences of closed "e" like a single insistent note.

At the beginning of the last line "couple" sums up the duality of "fauve" and "épée," "amour" and "vérité," and the previous "deux pointes semblables." It is an alliance consummated by way of death. The alliteration of "couple" and "qui" echoes that of "qui crient" in line 2 with the same phonetic suggestion of shrillness. Yet from this slaying ("se poignarde" recalls "pointes" semantically and phonetically) emerges the unity, and uniqueness, that are articulated in the last three words. The meeting with death achieves a supreme instant, while its significance is an ideal projection.

Such is this epigram, so brilliantly grasped in sensible terms. It establishes a varied rhythm which possesses a number and direction of its own; it weaves a dynamic sound pattern dependent on internal rhyme, assonance, and alliteration; it contains a structural balance founded on a ternary progression of each of the two sections. But it also calls on our experience of the bullfight, its fury, its color, its enactment of an age-old ritual; and this in turn reaches to some of the most central tensions of our sensibility. The two abstract words in line 4 reveal the allegorical dimension, emphasizing its universal import. In the same way, the last equally abstract phrase ascribes to the drama the value of an emotional absolute, a summit surpassing all others.

Char has thus expressed a transcendent passion for which nothing is more imperative than the gift of self. Into the external world he reads the image of sacrifice, which becomes at one and the same time a poem and a moral lesson spoken under a Mediterranean sky. And these words carry with them the full weight of Char's *oeuvre*, so much

of which might provide a commentary on "Le Taureau." I think for example of certain passages that delineate facets of the same emotional fancy: "Mobile, horrible; exquisite earth and heterogeneous human fate apprehend and qualify each other," he writes in *Partage formel.* "Poetry is drawn from the exalted sum of their shimmering";[6] in *Rougeur des Matinaux*: "Finally, if you destroy, let it be with instruments nuptial";[7] in *Commune Présence*: "Some men have a meaning we lack. Who are they? Their secret pertains to the hiddenmost secret in their lives. They draw near to it. It kills them. But the future that their loving attention has thus awakened divines and creates them. O maze of extreme love!";[8] in *Commune Présence* also, "Homme-oiseau mort et bison mourant," which is a legendary statement of the interrelationship of man and beast, spirit and body, love and death.[9] However "Le Taureau" takes on particular relief because of the extreme economy of its language, its rhythmical and phonetic power and, most especially, the singular conjunction it proposes, in form and theme, of an unfathomable image with the conscious will.

La Truite

Rives qui croulez en parure
Afin d'emplir tout le miroir,
Gravier où balbutie la barque
Que le courant presse et retrousse,
Herbe, herbe toujours étirée,
Herbe, herbe jamais en répit,
Que devient votre créature
Dans les orages transparents
Où son coeur la précipita?[10]

The Trout

River-banks that crumble to fill
The mirror with a ruffled raiment,
Gravel where the stammering boat
Is pulled and tugged by the current,
Grass, grass, that is forever combed,
Grass, grass, that is never at rest,
What is betiding your creature
Amid the transparent tempests
Into which her heart propelled her?

The nine octosyllables are unrhymed, but make use of internal echoes to build a closely knit pattern of sound. The insistence of hard "c," post-vocalic "r," "i," and "ou" introduces the combined sharpness and harmony that mark the poem; while lines 5 and 6, by identical rhythms which serve as a kind of refrain, stress the informing lyricism. The poem is first and foremost a song, a melodic line moving swiftly and as a single substance on its unbroken period and even meter, and composed of four clearly articulated parts: three invocations of two lines each to river banks, gravel, and grass, and a final question that poses an unanswered riddle.

Here we find an unemphatic structure and sense rather than the force of "Le Taureau." A man speaks to natural objects, and his animism is devoid of excess or strain. His voice models itself on the variegated image of the trout, weaving a way amongst eddies of sound and sense, diverse but not diffuse. All is uttered in the present tense until the last verb, which points to a disappearance and a secret action even now taking place. Char uses the imagery of clothing ("parure," "presse," "retrousse," "étirée"), of agitated movement ("croulez," "presse," "jamais en répit," "précipita"), of tenderness ("votre créa-ture," "son coeur") in order to compose the emblem of rigor overcome, of love victorious. "La Truite" is, in modest terms, a beautifully constructed poem, its tone poised, its manner simple.

From the beginning, the visual and emotional are joined. The river with its reflected banks speaks not only to the eye but to the heart, for a magical transformation is taking place on the mirrored surface: clear outline is being reduced to softness, earth and rock to adornment. It is an image that suggests in dramatic terms ("croulez") the details of a natural scene; but the intention that is read into it by the poet is determinedly human. Headlong pursuit is evoked by the adverbial phrase ("Afin de . . ."), a force which thrusts one element towards another.

Again, in lines 3 and 4, the auditory images contained in the repeated alliteration and assonance ("balbutie," "barque"; "que," "courant"; "presse," "retrousse"), and the use of the verb "balbutie" itself, precisely convey the depth of silence in a rural landscape. But this movement is also that of another gentleness, the sinuous caress of water on moored boat.

The third step in the anaphoric development is the most musical as the poet's words espouse their object. The four occurrences of

"herbe" enunciate in sound and sight a humble image drawn to an invisible goal. In the same way, "toujours étirée" and "jamais en répit" are rhythmically balanced, although "toujours" and "jamais" suggest by their polarity the nervous energy that commands the scene. An imperious wind holds sway, transforming grass into the blades of erotic desire.

Now, ending these invocations, the poem puts a question that receives no response but implies an answer. The act of becoming is the mystery of love in which the "coeur" of line 9 constitutes the essential agent. The heart has wrought this sudden and reckless surrender, economically expressed by the past definite tense ("précipita"); the trout has been united with the element that nourishes and enshrines it. Resuming the entire gentleness which the poem composes, the oxymoron of the penultimate line proposes an alliance of passion and clarity that is the hidden key. In addition, as we know, this particular epithet has personal significance for Char, who gave the title "Les Transparents" to one of his poetic scenarios so as to designate the legendary figures of the Provençal countryside—various, immaterial, undying.

Thus "La Truite" brings together a series of details which point to the notion of love. It is ordered with similar plastic skill to that of "Le Taureau," spelling out a formal necessity that controls the single sentence. But the poem leads beyond reason—indeed, it destroys substantial outline—and conveys a meaning of the heart. Tenderness is the interanimating force; it engenders the magic transmutation that nature can suggest to someone such as Char, who voices a change without price. "The storm," he writes, "has two mansions. One occupies a brief space on the horizon; the other can scarcely be contained by a man." [11] It is this other clear storm of the spirit that, uniquely, "La Truite" conjures up for us.

Le Serpent

Prince des contresens, exerce mon amour
A tourner son Seigneur que je hais de n'avoir
Que trouble répression ou fastueux espoir.

Revanche à tes couleurs, débonnaire serpent,
Sous le couvert du bois et en toute maison.
Par le lien qui unit la lumière à la peur,
Tu fais semblant de fuir, ô serpent marginal! [12]

The Snake

Prince of things counter, ply my love
So it foils its Lord whose offering I hate
Of vexed hindrance only, or flaunty hope.

Revenge for your colors, debonnaire snake,
Under cover of wood and in every house.
By the bond that joins daylight and fear,
You pretend to flee, frequenter of margins!

For his meter Char here chooses an elevated vehicle. His seven alexandrines are rhymeless if we exclude the weak homophony of "n'avoir" and "espoir" in lines 2 and 3; yet the caesuras are regularly observed and indicate a decorum that already conveys in part the character of his snake.

The sound pattern complements this measure by creating a sensuous atmosphere. Sibilants are dominant, as befits the subject, but we also note the poet's special delight in assonance: thus, "exerce," "débonnaire," "serpent," "couvert"; "amour," "tourner," "troubler," "couvert," "toute"; "Seigneur," "couleurs," "peur"; "contresens," "revanche," "serpent," "semblant." The result is a structure with considerable depth of resonance and strength of line.

The scheme Char has adopted follows that of the *envois* to prince and protector found in medieval ballads. This is borne out by the tone as the poet addresses himself directly three times to the snake in the three sentences that make up his poem. At the beginning a noble invocation is used, which also carries with it a strain of mock seriousness; on the second occasion the courtly aspect is again allied to the comic ("débonnaire serpent"), the position of the adjective emphasizing the poet's sympathetic indulgence; finally, the last words combine a dignified apostrophe with an epithet that is very much tongue-in-cheek. So, at far remove from both "Le Taureau" and "La Truite," mingling eloquence and a saving smile, "Le Serpent" manages its "low" theme with a fine discrimination. Yet Char plays off the mythical against the natural and opts for the latter in the second half of his poem: instead of the extremes of chastisement and hope, he prefers a middle road; and where the first section makes use of dramatic contrast ("amour," "je hais"; "trouble répression," "fastueux espoir"), the other does not oppose but conjoins ("sous le couvert du bois et en toute maison"; "le lien qui unit la lumière à la peur").

As in the two poems we have already examined, the form is articulated with precision. We find a ternary scheme that first exposes (lines 1 to 3) the help the poet seeks from a legendary presence. His diction is sonorous as he praises the byways of the serpent, its perverse liberty which refuses to pursue the roads of the Lord. The invocation to the "Prince des contresens" is splendid for its mixture of ceremoniousness and humor, which is continued by the imperative "exerce," inhabitual in this context, whose preciosity is muted by the familiar mode of address. Likewise, the manner in which love and hate are linked is a further token of the poet's espousal of indirections in the manner of the serpent. In the third line the language echoes medieval allegory in expressing the arbitrary antagonism within man's destiny as promulgated by the Lord. Alongside the undulations of the snake, God's fiat sounds like melodramatic overkill.

The second section (lines 4 and 5) brings a change. No longer is the poet recalling a legendary struggle; instead, he abandons his personal involvement in order to turn wholly towards the snake and celebrate it. He takes up the vocabulary of chivalry and announces a triumph: the serpent has become a self-assured knight whose colors are the pennant of victory. Yet this is the contrary of the Lord's pompous exhibitionism ("fastueux"). It is discreet, *terre à terre*, finding a hidden path in wood and house, silently present in a diversity of places. The words acquire peculiar relief for being placed after the eloquence of line 4 and of the first section.

A similar kind of verbal contrast is found in the third and final section. Line 6 expresses in abstract language a universal bond in which Apollo does not confront Dionysus, nor sunshine darkness: on the contrary, Char proposes in the likeness of the serpent a symbolic ambiguity as light touches on fear, day's calm on disquietude; and this he transforms in the last line into a familiar and immediate utterance that shows his complicity with an animal in which being and seeming are at odds. The snake is not flight but semblance of flight, for perseverance and courage make its superiority. The final apostrophe "ô serpent marginal" brings together, as I have suggested, the double focus that characterizes the poem, combining respect and humor, distance and familiarity. After the princely vocative Char's epithet pertinently conveys the physical and moral inbetweenness that is the snake's nature, and its lesson. It represents, not a refusal to take sides, but an

impassioned awareness of polarities, a lucidity that steadfastly holds to its own truth while mindful of encompassing anguish.

We find that "Le Serpent" is a witty poem, both suave and amusing, ample yet modest, which discovers a wisdom in its ironic structure, its varied tones, its modern fashioning of a courtly mode. It provides the memorable expression of a vital "marginality" at the heart of Char's work and a mainspring of his ethic: "I who enjoy the privilege," he writes, "of feeling at one and the same time depression and confidence, desertion and courage . . .";[13] and again: "We can only live in the intermediate, precisely on the hermetic dividing-line between shadow and light. But we are borne irresistibly onwards. Our whole being provides help and vertigo for this thrust." [14]

L'Alouette
Extrême braise du ciel et première ardeur du jour,
Elle reste sertie dans l'aurore et chante la terre agitée,
Carillon maître de son haleine et libre de sa route.

Fascinante, on la tue en l'émerveillant.[15]

The Lark
Extreme ember of the sky and first fire of day,
She stays, a jewel set in the dawn, and sings earth's turmoil,
A carillon master of its breath and free to make its way.

Bewitcher, who is killed when struck with wonder.

Nothing appears to be regular about the versification of "L'Alouette," not even a recurring meter which in "Le Taureau," despite the varying length of the verse, constitutes an important structural element. Indeed, it is the freest of the four poems, creating an atmosphere of exuberant spaciousness with its successive lines of fourteen, seventeen, fifteen and eleven syllables. At the end of lines 1 and 3 ("jour," "route"), assonance provides a pause and a balance before the conclusion; but we find no strongly cohesive consonantal system. Here, on the contrary, alliteration is avoided in favor of the insistence of one vowel, open "e," found thirteen times. This becomes a phonetic sostenuto lending eloquent breadth to the diction and supporting the strong rhythms imposed by the caesuras.

The poem comprises two sentences as in "Le Taureau"; as in "Le Taureau" also a lapidary epigram proposes what we may term the

protasis and apodosis of a thought. A ternary rhythm reigns in each part, the first comparatively relaxed, the second tense. In the first section two appositions frame line 2; in like manner the adjective and participial phrase of line 4 frame subject, verb and object. Seemingly disordered, "L'Alouette" presents in reality a marvelous economy of means.

In the first section the language is richly metaphoric. Char introduces the visual imagery of fire, sunset, dawn, of jewel and crown, then passes to the auditory imagery of song and carillon. Only in line 3 do we find abstract concepts with the allusion to mastery ("maître de son haleine") and freedom ("libre de sa route") which the poet ascribes to the lark. The last line, however, isolated from the previous ones, alters the tone with a formulation that is particularly effective because of its generality (the use of "on" underlines the universal nature of the statement) and, of course, because of the way "fascinante" and "émerveillant" complement each other like object and mirror. (A mirror-image—that of the "miroir à alouettes," the lark-mirror or twirl—is implied in the sense as in the shape of the line.)

Clearly, none of the words is unusual in and of itself. Nevertheless we are obliged, by the artistry of rhythm, sound and structure and by the metaphors, to recognize the complexity of suggestion. Thus the first line cannot be read with anything but amplitude: space and time are required to grasp the paradox of this bird that is at once last and first, ember and flame, sunset and dawn. Occurring after the seventh syllable of this fourteen-syllable line, the caesura establishes a symmetrical balance; the open vowels enhance our expectancy; and the set of opposites becomes a luminous spectrum of the imagination.

Light is also evoked in the second line by way of the condensed metaphor of the word "sertie." The lark is a jewel set in the dawn, identified with the sun as the diamond with its crown; it controls its element, hovers like a fixed point in the immensity of air. Continuing to enumerate the bird's qualities, the second hemistich patterns itself by a natural progression on the cumulative coordination of the first line; now, however, a transforming activity is evoked. The lark is the poet who takes for his theme the troubles that beset man and the world, changing them into the song he finds within himself, which is the breath of his desire.

> L'alouette à peine éclairée
> Scintille et crée le souhait qu'elle chante;

Et la terre des affamés
Rampe vers cette vivante.[16]

(The lark, when the sun has barely come
Sparkles and creates the wish it sings;
And the earth of hungry men
Gropes toward this living thing.)

The "blithe spirit" shows that art is man's way of living with death. "We have only one resource with death: to make art before it does." [17]

The auditory image is pursued in the third line, expressing in another guise the restless brilliance suggested by the previous words, designating a music that transcends its maker. But the epithet which follows affirms sovereignty, male independence, as if the lark were a carillon ringing itself, controlling its own measure. Likewise, the next words present the further moral quality of freedom and the notion of mobility that had been excluded until now. The capacity to discover and create the future flourishes paradoxically in the impersonal art of the bells alongside the self-discipline that has just been named. Elsewhere Char will celebrate the same instinctive liberty he associates with birds: "Summer, river, space, hidden lovers, a whole moon of water, the warbler repeats: 'Free, free, free, free . . .' " [18]

Finally, line 4 has exceptional imaginative force by its phonetic and semantic isolation; by the image it offers of a defenseless beauty destroyed; by its syntactical construction which, as we have seen, mirrors the first word in its last. The epithet "fascinante" is a strong one, and gains additional resonance from echoing the general title of the collection of poems; but it is also bound to "émerveillement" which proposes elliptically the image of the twirl used by hunters: the lark is dazzled by the bright reflection and easily caught in the nets. Deceived by those who profit from its naivety, it is drawn to its death. Bitterness is conveyed in the three central words that are placed—ironically "set" like the jewel in a crown—in the midst of marvel and witchery.

This brief poem may be interpreted on many levels. It would for example be possible to refer to Mallarmé's commemorative sonnet for Edgar Allan Poe:

Du sol et de la nue hostiles, ô grief!

(O strife between warring soil and cloud!)

Char, we may say, depicts the struggle between bird and men, aspiration and failure, sky and earth, life and death. He proposes the metaphor of our destiny and the emblem, despite death, of hope ever reborn: "For the dawn, disgrace is the coming day; for twilight, engulfing darkness. Once there were dawn people. At this hour, perhaps, of decline, here we are. But why are we crested like larks?" [19] Other meanings suggest themselves: thus we may think of the relationship between poetry and the world. Proudly free, the poem does not reject troubled earth but turns it into song according to a man's desire. And yet this tenuous bond can be broken when we transfix the words, reduce them to a program, replace the volatile and complex by a formula. The poet warns us: "Free birds cannot be looked at. Let us remain obscure, self-abnegating, near them." [20] This reading opens out onto a properly moral plane that would see the lark as our sense of dignity and love, our ability to hold an upright image which, however, as history shows us every day, can be destroyed by the murderous means we have contrived: "Criminals are they who stop time in man so as to hypnotize him and perforate his soul." [21] These are, I think, valid interpretations; yet so rich is the imaginative power of Char's lines that further glosses would not be hard to find: they radiate from the lark—warm, colorful, exultant in Provençal sunshine—whose flight is ended unworthily.

"L'Alouette" is, then, an epigram of exceptional density which calls on the visual, the auditory and the abstract, inviting us to respond to a "metaphysical" sensibility (using the term as for the seventeenth century English poets), a resolute and broadly rhythmed diction, a language of multivalent signs. I would also again emphasize, as for the three other poems of the group, the superb architectural sense with which the theme is handled. Inside each sentence, as in the form as a whole, a masterly grasp of space is at work. Char shatters, that is to say, elaborates the image—Breton's "unshatterable kernel of night"—composing a visionary ethic so much the more expressive for being found within the limits of the natural scene.

NOTES

1. "Nous passerons de la mort imaginée aux roseaux de la mort vécue nûment" (*Le Nu perdu*, Paris, Gallimard, 1971, p. 125).

2. "La question à se poser sans cesse: par où et comment rendre la nuit du rêve aux hommes? Et pour tromper l'horreur dont ils sont visités: à l'aide de quelle matière surnaturelle, de quel futur et millénaire amour" (ibid., p. 108).

3. Originally published in the *Cahiers du Sud*, No. 300 (1950); then the following year as a separate plaquette entitled *Quatre Fascinants, La Minutieuse*, Paris, S.N.; later included in *La Paroi et la Prairie*, Paris, G.L.M., 1952, *Poèmes et Prose choisis*, Paris, Gallimard, 1957, *La Parole en Archipel*, Gallimard, 1962, and *Commune Présence*, Gallimard, 1964.

4. "Ta part de merveilleux de rébellion de bienfaisance" (*Commune Présence*, p. 6).

5. Ibid., p. 172.

6. "Terre mouvante, horrible, exquise et condition humaine hétérogène se saisissent et se qualifient mutuellement. La poésie se tire de la somme exaltée de leur moire" (*Poèmes et Prose choisis*, p. 222).

7. "Enfin si tu détruis, que ce soit avec des outils nuptiaux" (ibid., p. 242).

8. "Certains êtres ont une signification qui nous manque. Qui sont-ils? Leur secret tient au plus profond du secret même de la vie. Ils s'en approchent. Elle les tue. Mais l'avenir qu'ils ont ainsi éveillé d'un murmure, les devinant, les crée. O dédale de l'extrême amour!" (*Commune Présence*, p. 50).

9. Ibid., p. 200.

10. Ibid., pp. 172–73.

11. "L'orage a deux maisons. L'une occupe une brève place sur l'horizon; l'autre, tout un homme suffit à peine à la contenir" (ibid., p. 209).

12. Ibid., p. 173. The original version of the first section of the poem as published in the *Cahiers du Sud* (No. 300 [1950]: 217) is considerably different:

> Prince des contre-sens [sic], fasses [sic] que mon amour
> En exil analogue à ton bannissement
> Echappe aux [sic] vieux Seigneur que je hais d'avoir pu,
> Après l'avoir troublé, en clair le décevoir.

The identification between serpent and poet is made explicit in a way we do not find in the definitive version; the element of disappointment is spelt out rather heavily; the vocabulary and syntax have less force and economy. Nor shall I attempt to defend the curious subjunctive of the first line.

13. "Moi qui jouis du privilège de sentir tout ensemble accablement et confiance, défection et courage . . ." (ibid., p. 69).

14. "Nous ne pouvons vivre que dans l'entrouvert, exactement sur la ligne hermétique de partage de l'ombre et de la lumière. Mais nous sommes irrésistiblement jetés en avant. Toute notre personne prête aide et vertige à cette poussée" (ibid., p. 266).

15. Ibid., p. 174.

16. Ibid., p. 179.

17. "Nous n'avons qu'une ressource avec la mort: faire de l'art avant elle" (ibid., p. 285).

18. "Eté, rivière, espaces, amants dissimulés, toute une lune d'eau, la fauvette répète: 'Libre, libre, libre, libre . . .'" (*Poèmes et Prose choisis*, p. 166).

19. "Pour l'aurore, la disgrâce c'est le jour qui va venir; pour le crépuscule c'est la nuit qui engloutit. Il se trouva jadis des gens d'aurore. A cette heure de tombée, peut-être, nous voici. Mais pourquoi huppés comme des alouettes?" (*Commune Présence*, p. 267).

20. "Les oiseaux libres ne souffrent pas qu'on les regarde. Demeurons obscurs, renonçons à nous, près d'eux" (*Poèmes et Prose choisis*, p. 286).

21. "Criminels sont ceux qui arrêtent le temps dans l'homme pour l'hypnotiser et perforer son âme" (ibid., p. 260).

6 Rhetoric and Reading

Semantic Incompatibilities in Automatic Writing

Michael Riffaterre

The surrealists' automatic writing texts have baffled critics only because, I believe, they have either resorted to psychological considerations or have relied exclusively on grammatical analysis of the texts. The former were prompted by André Breton's own definition of the device as a dictation by the subconscious, a definition which in practice has led to an impasse. Critics end up making an empiric survey of forms that seem to reflect subconscious mental activities. This, of course, may be of interest in the study of a text's genesis, but it has no relevance to the finished product. It certainly does not explain or even describe the mechanisms of the text, and condemns critics to a repetition of the same psychological generalities, which, correct or not, do not account for the specificity of the poem's form.[1]

A grammatical analysis of automatism would seem more promising, since at least it is relevant, dealing as it does with textual realities. Unfortunately, the syntax of an automatic text is in no way different from that of a non-automatic text.[2]

What *is* different is the automatic text's departure from logic, temporality, and referentiality, that is to say, from the rules of verisimilitude. Although there is nothing ungrammatical about the syntax, the words make sense only within the limits of relatively short groups, and there are semantic incompatibilities between these groups. Or else the semantic consecution of the sentences does not present any problem, but their overall meaning is threatened or checked by smaller

nonsensical groups. Because logical discourse, teleological narrative, normal temporality, and descriptive conformity to an accepted idea of reality are rationalized by the reader as proof of the author's conscious control over his text, departures from these are therefore interpreted as the elimination of this control by subconscious impulses. This is precisely what creates the appearance of automatism (regardless of whether this appearance is obtained naturally or by artifice). I shall call it the *automatism effect*. The presence of this effect in a text places the text in a genre by itself.

Because the automatism effect results from anomalies of meaning, a semantic rather than a grammatical approach is needed to analyze the textual mechanisms of that genre. I shall attempt to apply this approach to two texts from André Breton's *Poisson soluble*.[3]

Poisson soluble is divided into thirty-two sections. Each one of them consists of a story with one or several characters. There is no connection between the story told, or the scene described, and those preceding or following it. There are no references to events that precede or explain any particular episode. The text therefore has the semantic autonomy that characterizes a poem,[4] in this case a prose poem.

Of the two texts I have chosen (sections 29 and 22), one realizes the model of a typical folktale, the other, the model of an equally common sexual fantasy. Each as a whole, as a narrative, is therefore familiar to the reader. It tells a story he has seen under many variants, which imply the existence of a *topos*. The consecutive stages of the narrative are therefore predictable, if not in their detail, at least in their sequence and their semantic structures. This predictability can only underscore the discrepancies that create the automatism effect, which is precisely what happens.

Normally, that is, in a non-automatic text, discourse generated under the restrictions of semantic and morphological association and of rules of grammar, must also conform to the rules and requirements of the narrative.[5] No verbal association is allowed to contradict the narrative or to deflect its progress, except as a parenthesis clearly subordinated like the rest to the overall telling of the story. In these texts, on the contrary, there are incompatibilities between the narrative and the discourse. The words and phrases generated by the lexical actualization of the narrative structure generate in turn associative chains that are aberrant in the overall context. For instance, representa-

tions can be either perceived as nonsense, or rationalized as a mimesis of the supernatural, or of the fantastic, or of oneiric or hallucinatory perceptions. These rationalizations are modalities of the automatism effect. Nor are such aberrant traits only deviations from the narrative. Lexical derivations occur that are incompatible with referentiality when their compatibility with the narrative is restored. This return to the appearance of a "normal" text is then compensated for and the automatism effect maintained by a new restriction on lexical choices: only such sentences as do not yield visualizable representations are then permissible.

The automatism effect within a predictable narrative thus results from two types of deviant lexical derivation: in the first type, lexical sequences make sense (seem referential) but in a way that deviates from the narrative. In the second, they do not deviate from it, but they do not make sense.

The first type is exemplified in the folktale of prose poem 29—a fabulous hunting story. This is a variant of a well-known *topos*. A huntsman encounters a supernatural beast while he is walking or riding through the forest, he fights with the animal or tries to kill it, or else simply confronts it. At once he notices the abnormalities of his prey, and reads these as a sign (sometimes the animal speaks to him, in which case the human voice is the abnormality). The hunter's subsequent acts are the result of this perception. He may submit to guidance by the beast or by something related to the beast; or he may pursue the animal. In either case his action makes him the hero of a quest which leads him through the mysterious forest; he surmounts all sorts of obstacles or taboos, these latter symbolized by physical dangers or his passage into another country.

This sequential pattern is easily verified by a reading of Flaubert's *Légende de Saint Julien l'Hospitalier*, or, among the Romantics, Tieck's *Der blonde Eckbert*, or, in Hugo's *Le Rhin*, the story of the Knight Pécopin and his hundred-year hunt.[6] Little wonder that the surrealists favored this type of story. The hunt and its sylvan locale are a plausible, ready-made link between humanity and the animal world, and also the unknown, the occasion of departure for somewhere beyond. The story symbolizes tenets of surrealism—the belief in *correspondences*, the obsession with the invisible world around us, and especially the quest, with a hero driven by forces unconscious or unexplained.

The sequence cannot be tampered with. Its realization in the text makes it acceptable to the reader, despite the presence of deviant lexical components, and protects these deviations from the reader's negative value judgments (e.g., "empty gratuitousness," "poor verbal play," etc.). Reformulated in more abstract terms, the narrative sequence is composed of the following stages: preface to the story, announcing that it is mysterious; description of the hunter; depiction of the encounter; the hunter becomes hero of the quest; tale of the quest, with the hero moving from sign to sign, following their directions—that is, the two aspects, positive and negative, of an initiatory pilgrim's progress:

Cette année-là, un chasseur fut témoin d'un étrange phénomène, dont la relation antérieure se perd dans le temps et qui défraya la chronique de longs mois. Le jour de l'ouverture cet homme botté de jaune qui s'avançait dans les plaines de Sologne avec deux grands chiens vit apparaître au-dessus de lui une sorte de lyre à gaz peu éclairante qui palpitait sans cesse et dont l'une des ailes seule était aussi longue qu'un iris tandis que l'autre, atrophiée mais beaucoup plus brillante, ressemblait à un auriculaire de femme auquel serait passé un anneau merveilleux. La fleur se détacha alors et retourna se fixer par l'extrémité de sa tige aérienne, qui était l'oeil du chasseur, sur le rhizome du ciel. Puis le doigt, s'approchant de lui, s'offrit à le conduire en un lieu où aucun homme n'avait jamais été. Il y consent et le voici guidé par l'aile gauche de l'oiseau longtemps, longtemps. L'ongle était fait d'une lumière si fine que nul oeil n'eût pu tout-à-fait l'endurer; il laissait derrière lui un sillage de sang en vrille comme une coquille de murex adorable. Le chasseur parvint ainsi sans se retourner à la limite de la terre de France et il s'engagea dans une gorge. De tous côtés c'était l'ombre et l'étourderie du doigt lui donnait à craindre pour sa vie. Les précipices étaient dépassés, puisque de temps à autre une fleur tombait à côté de lui et qu'il ne se donnait pas la peine de la ramasser. Le doigt tournait alors sur lui-même et c'était une étoile rose follement attirante. Le chasseur était un homme d'une vingtaine d'années. Ses chiens rampaient tristement à ses côtés.[7]

(That year a hunter was witness to a strange phenomenon; its previous record is lost in time and it was much talked about for many months. On the day the hunting season opened, this man, who was walking over the plains of Sologne in yellow boots, with two big dogs, saw an apparition over his head, a kind of gas lyre, which gave little

light and kept flickering constantly. And only one of its wings was as long as an iris, whereas the other, atrophied but much more brilliant, looked like a woman's little finger with a magic ring on it. Then the flower fell off and went back to fasten itself by the tip of its aerial stem, which was the eye of the huntsman, to the sky's rhizome. Then the finger came close to him and offered to take him to a place where no man had ever been before. He agrees, and now he is being guided by the left wing of the bird and he follows for a long time, a long time. The fingernail was made of a light so subtle that no eye could quite stand it; it left behind a wake of blood spiralled like a shell of enchanting murex. Thus, without looking back, the hunter reached the end of the land of France and made his way into a gorge. All about him was shadow and the giddiness of the finger made him fear for his life. The precipices had been left behind, for from time to time a flower would fall near him and he did not bother to pick it up. Then the finger was spinning around and it was a pink star madly enticing. The hunter was a man of about twenty years. His dogs crept sadly along beside him).

The first sentence indicates the nature of the story, setting a tone of strangeness or of the supernatural. This function, as we have just seen, conforms to the rules of the narrative—it is the familiar, acceptable component. But from the start the automatism effect is at work also, as is obvious in the second part of the sentence ("dont la relation antérieure se perd dans le temps et qui défraya la chronique de longs mois"). Both "se perd dans le temps" and the second relative clause are clichés frequently found in history books, or newspapers, or in conversations. They constitute a syntactic expansion of the past tense of the verb and of "étrange";[8] in any context they would be standard lexical derivations from a statement about a noteworthy occurrence, miracle, or supernatural event. Here, they stress hyperbolically the witness's reaction to the strangeness of what he once saw. Both are redundant. Furthermore, "se perd dans le temps" and the wealth of "recent" sounding details[9] in the following story seem mutually exclusive. Thus there seems to be no conscious control to weed out repetitions and contradictions.

Then comes the second stage of the narrative: locale of the action, description of the hunter, and his encounter with a supernatural bird or flying monster. The lexical actualization of these necessary narrative components forms two groups clearly separated from each other. One (to the words "vit apparaître au-dessus de lui") is a normal

description which follows the rules of verisimilitude. The huntsman's reality is confirmed by details (boots, dogs) stereotyped in many a text about country life, and by the choice of Sologne, a region famous for hunting. This first group, then, might belong in a conventional, author-controlled narrative. Even the fact that these features underscore, by contrast, the fantastic nature of the apparition could still suggest a well-built network of conscious stylistic artifacts.

The second group, on the contrary—the description of the bird—flouts the rules of the genre, since this beast's monstrousness destroys its credibility, or rather its acceptability. The literary mimesis of a supernatural being is organized by a set of conventional restrictions that make its anomaly acceptable within the conventions of the mimesis: even if we do not believe in the monster, it is still the way a real monster should be or could be. For the representation of a monster to be possible within the rules and aberrations of Nature, it must conform to a system of negations or of substitutions, such as oneness negating twoness for symmetrical parts of the body (e.g., a Cyclopean, one-eyed face instead of a regular two-eyed face), or the transferral of physical characteristics from one species to another (e.g., Spiderman). Here, the beast's monstrosity does not even conform to these acceptable limitations on the fantastic: where the hunting context calls for an animal we get a musical instrument. We cannot even rationalize Breton's lyre as a traditional mythology, metamorphosis (or some kind of hybrid like the chimera or the griffin), or as an animation or animalization. In fairytales there are animated instruments that play by themselves, for example, the Satyr's lyre, in Hugo's *Légende des Siècles*, and Hugo animates elsewhere a bell, and the trumpet of Judgment. But this lyre cannot easily be transformed into a myth by simple semantic reversion from inanimate to animate. It is a *gas* lyre—an artifact, and a commercial or industrial one at that, an object whose uses seem to preclude such flights of fancy as might open into mythmaking or metamorphoses. The *lyre à gaz* was a lyre-shaped fixture that was at one time used to hold gaslights—a rather popular example[10] of the decorator's attempts, in the 1870s, to combine classical form with the latest scientific household conveniences. These dubious alliances involved latent, and perhaps insoluble, formal contradictions that fascinated writers: Mallarmé, for instance, spoke of such fixtures, if not about the *lyre à gaz* itself. It is this formal contradiction that gives the image its effectiveness.

We do not really need to know the referential meaning of the word, because the stylistic distance is enormous between "lyre," a word reserved for antique music in its literal sense and for poetry in its symbolic sense, a word whose very spelling has high-cultural connotations; and "gaz," a word of common usage, scientific at best, but ordinarily quite down-to-earth. Although the referential relationship is similar, there would be no such gap with "electric guitar," since the name of the instrument is formally almost vulgar, as lowbrow as the adjective; nor with "orgue hydraulique," "hydraulic organ," where the Greek form of the adjective makes up for the nondescript ordinariness of its meaning. In "lyre à gaz," the gap cannot be bridged, and it works as an iconic representation of monstrosity. This *lusus naturae* may not be acceptable at the level of the referent or of the signified, but it is quite compelling as a verbal oddity, carrying forward *ad absurdum* the potentialities of word compounds. In the same way, Lewis Carroll derives verbal myths such as "rocking-horsefly" from "horsefly" and "bread and butterfly" from you know what.[11]

It is perfectly possible that as a physical reality the gas lyre held a special interest for Breton, always on the lookout during his forays in the backstreets and fleamarkets of Paris, for unusual or pointless knickknacks which out of context could be turned into absolutes called "objets surréalistes." [12] I suspect, in fact, that the *Poisson soluble* gas lyre was inspired by one described by Huysmans in *Les Soeurs Vatard,* a novel much admired by Breton: this gas lyre dominates an exotic, rather fantastic and pagoda-like nightclub and serves much the same purpose as a neon sign would today.[13] Surrealists were fond of using advertisements or commercial signs as poetic objects (like *Bébé Cadum* in Desnos' *La Liberté ou l'amour!* or the *Lamp Mazda* poster in *Nadja*). But of course, even if my hunch is correct, even if we do have here a word arrived at by the *hasard objectif* method, that bit of information remains irrelevant except insofar as it verifies the impact of this representation upon the imagination. What is relevant is the question of why the gas lyre enters the automatic text just at this point. Clearly because of an interference with *oiseau-lyre,* "lyrebird." [14] Since the context demanded the name of some animal, this compound forms the point of intersection between two chains of semantic association, one dictating a bird, the other a queer one.

Patently the impact of "lyre à gaz," in this context, can never be softened; thus the word becomes a matrix which generates a description

whose basic task will be to orient the text so that every detail confirms
the bizarreness of the bird:

l'une des ailes seule était aussi longue qu'un iris tandis que l'autre,
atrophiée mais beaucoup plus brillante, ressemblait à un auriculaire de
femme auquel serait passé un anneau merveilleux.

A descriptive sentence generated by free association is bound to
be longer than one which has restrictions on its development: for it can
theoretically go on from association to association, as long as any word
of the sequence can be followed, until the lexicon runs out of homologs,
by another that bears a positive or negative relation to it. Any referent
may be represented through selection from among successive pairs of
adjectives or nouns (these pairs actualizing, in most cases, basic
semantic oppositions: (e.g., negative/positive, small/large, etc.). If the
referent comprises, or is in itself, a pair of symmetric components, as is
the case for so many parts of the body, or as here for wings, free
association tends to describe these components by giving, over and over
again, the first pole and then its inversion or binary opposite. This is
what happens in the stereotype pair of friends: Peter is tall and Paul is
short, Peter blond and Paul dark, one lean, one fat; or else Quixote and
Sancho, down to their mounts, skinny horse vs. well fed mule. Normally
this pairing-up of polar opposites applies to pairs whose components can
differ while being functionally comparable. The automatism effect
results from extending this descriptive device to pairs whose compo-
nents are normally identical. Hence, in *Poisson soluble*, a dreamed up
dog who has one blue eye and one yellow eye; or this, "Mes yeux
étaient les fleurs de noisetier, l'oeil droit la fleur mâle, le gauche la fleur
femelle"; or a poet's two mistresses, one "pourpre qui aurait bien voulu
dormir," the other "blanche qui arrivait par le toit comme une
somnambule," etc.[15] Here we have two wings, and since wings can be,
among other things, long or short, one will be long *and* the other will be
short. Which confirms the anomalousness of this particular bird. The
mimesis of the supernatural attaches to the two parallel and contrary
descriptions, modifiers designed to enhance the opposition and the
anomaly: the long wing is long in a strange way (comparing a wing to
the stem of a flower), the short one is pathologically short ("atrophiée").
The exceptional affective overload of such a pejorative description then
sets off a compensatory meliorative description: "mais beaucoup plus
brillante," and so on.

The rest of the paragraph takes the hunter and his hounds to the farthest frontier of the quest, forest or mountain (here the latter), which appears to be a border or gateway to another world. Each detail of his trek simply actualizes the stages and locales of a hazardous journey. In a regular quest narrative, we should have something like this: the fantasy-beast promises the hunter it will lead him into an unknown land. The hunter follows, taking the paths indicated by his guide and comes to a dangerous spot. Fearing for his life, he reproaches the animal, asks it questions, slays it, beholds its resuscitation, etc. Such a tempo demands a frequent recurrence of the beast's name. In a non-automatic narrative, especially one as condensed as this, repetition would entail an unneeded emphasis. The author is therefore supposed to avoid awkwardness (or giving the wrong signal) through variation, using now the name, now a periphrasis or a metonym. Each time, the context would make it clear that the metonym, for instance, is used as a trope, the part for the whole not literally.

The automatism effect is therefore obtained by removing this stylistic motivation, that is, by using the sequence of metonyms as if each of them were taken literally, as if it were the whole character, the whole for the part, a sort of beast in its own right.

At each juncture, the fantastic bird is replaced by another verbal substitute, and each time the metonym undergoes a complete animalization. Since the significant part of the bird is its wing, which concretely actualizes its most essential and defining semantic feature—the ability to fly—"aile" is substituted for "bird," and then "doigt" for "aile," because "doigt" was first a metaphorical transcodage of "aile" (the shorter wing looked like a woman's little finger); and then "ongle," nail, for the whole finger; and then, by implication, for "woman," since that finger is a woman's, and also because "lyre" is a feminine noun in French. Hence the following transformation of the narrative model of the Quest:

le doigt, s'approchant de lui, s'offrit à le conduire en un lieu où aucun homme n'avait jamais été. Il y consent et le voici guidé par l'aile gauche de l'oiseau longtemps, longtemps. L'ongle était fait d'une lumière si fine que nul oeil n'eût pu tout-à-fait l'endurer; il laissait derrière lui un sillage de sang en vrille comme une coquille de murex adorable. Le chasseur parvint ainsi sans se retourner à la limite de la terre de France et il s'engagea dans une gorge. De tous côtés c'était l'ombre et l'étourderie du doigt lui donnait à craindre pour sa vie.

The descriptive details are, of course, quite as certainly determined as the sequence of metonymic substitutions. For the way a substitute is selected and descriptively expanded is regulated every time by its appropriateness to a particular happening in the narrative. This appropriateness is *not* referential, in the sense that we say of a non-automatic text that it fits forms to content, and that its descriptions are true. It is purely functional at the expense of the mimesis. "Aile" is transformed into "doigt" when the bird, represented by its wing, becomes a guide, inasmuch as "doigt," referentially incompatible with wing, is formally and functionally preferable, since "doigt" is linked to clichés about pointing out directions. "Doigt" is transformed into "ongle" when the narrative sequence reaches the point where the miraculous and beneficent nature of the guidance bestowed upon the hero becomes clear: this is revealed in motifs of light. Light shines upon the goal, or shows in what direction it is to be sought. Light indicates the desirability of reaching the goal, or at least of striving toward it, since light and its synonyms are at the meliorative end of the lexical paradigms: for example, a blazing beacon, or a pillar of fire (like those that guided the Hebrews through the desert), or a star (like the star of Bethlehem). All these are positive signs. Now in the descriptive system of "doigt," only the nail may be regarded as a thing of beauty, to judge by fashionable cosmetic practice, or by the literary representations that transmute mere horn into its etymological "onyx," which happens to be a precious stone as well. Witness Mallarmé's "Ses purs ongles très haut dédiant leur onyx." [16] Analogically, then, the nail is described as light, which may be facilitated by the pictorial motif of fingertips turning red and seemingly translucent when held in front of a light. A miraculous light, possibly divine, a light from which men must turn their eyes—such is the light that generates the cliché "lumière si forte que nul oeil ne peut l'endurer." A double interference occurs, however: "doigt" or "ongle," if beautiful, demands adjectives like "fin," and "fin" also happens to be one of the antonyms of "fort" (when speaking of a woman's figure or waist: "fin" in both cases is in the feminine form, "fine"). This, coupled with the rule that excludes the combination of visualizable representations wherever they conflict with the formal sequential relation, generates "si fine que nul oeil n'eût pu tout-à-fait l'endurer (in which "fine" and the *que* clause are semantically incompatible). Later on, the same meliorative constant, significantly, transforms the finger into another variant of the benign beacon, the

star: "Le doigt alors tournait sur lui-même et c'était une étoile rose follement attirante." A pink star because it is positive (in nail code), and "attirante" because we must follow it.[17]

Of course, another guidance-narrative potentiality is the motif of the trail left by a guide who has gone on ahead—broken twigs, white pebbles, and in the most dramatic variant, drops of blood. This most dramatic variant happens to fit the hunt version and its quest symbolism just as well, since blood dripping from a wounded mystic animal is part of both descriptive systems. Hence the second derivation from "ongle": "il laissait derrière lui un sillage de sang en vrille comme une coquille de murex adorable." [18] The sentence, and especially the simile it contains, clearly conform to the meliorative orientation of the "nail" description: clichés emphasize its color, often spoken of as blood visible through its translucent surface (like clichés about skin aglow with health), and this color is a component of its beauty.[19] That generates "murex," the shell from which ancient civilization extracted purple dye, above all because Latin literature has already used the word as a metonym for "crimson" —a positive hyperbole of blood-color at its best. And this image of the shell retroactively generates "en vrille": one of the stereotypes of the meliorative shell description includes admiring remarks about its perfect helix. Undoubtedly the very fact that "sang en vrille" is inconceivable helps to make this selection imperative, under the non-visualization rule. This complex example shows that the devices creating the automatism effect do not impair communication. Despite its formal vagaries and its surface nonsense, the sentence conveys praise for the perfection of this mystic blood, under the successive synonymous forms of "murex" as a simile, of "vrille" as a plus sign in shell code, of "adorable" on the literal level. This semantic repetition can be observed throughout the text, and in all poetic texts in fact: the principle governing the progression of discourse is transcoding.

The second type of deviant lexical derivation creating an automatism effect is that in which the narrative includes sentences at the same time compatible and incomprehensible. These sentences are semantically and syntactically grammatical, but they are unmotivated, and consequently they are either nonsense or contrary to verisimilitude. We are dealing here with a phenomenon of intertextuality: these sentences contain dispersed fragments of a preexistent sequence, they are borrowed from another text which cannot be identified. With a few

exceptions, due mostly to chance, readers are not able to recognize the source, let alone perceive that there is a preexistent sequence.

My example, prose poem 22, is the story of an erotic pursuit through city streets. Any reader familiar with such texts will at once recognize a recurrent surrealist theme: a passerby chances upon a mysterious woman; he tells of his desire for her, and how he follows her through the city by night. Sometimes the chase leads him from streets and squares into parks and gardens, even into the country. Sometimes the unknown woman, still keeping her distance, will shed her clothes as she walks, strip-teasing from block to block: this is what happens in Robert Desnos's *La Liberté ou l'amour!*. Sometimes the climax of the pursuit comes with the sudden exposing of her naked body under her topcoat. Not the end of the chase—for this last sexual enticement is only a new beginning; it confirms that this pursuit symbolizes the never-ending quest for the beyond. Such is the case here. This narrative model is only an expansion of the Romantic and, more particularly, the Baudelairean theme, a chance meeting with an unknown woman on the streets. An exchange of glances is enough to establish a bond between them, to give a promise, perhaps of happiness, of a new life; it acknowledges strange affinities. As I said in my preliminary remarks, what we have here is a common erotic fantasy, and it can be recognized even by a reader unfamiliar with its literary variants. Breton's "Tournesol," and his commentary on it in *L'Amour fou*, most perfectly exemplify this theme—or is at any rate the example most explicit in each episode. The *Poisson soluble* text, on the contrary, emphasizes the presumably symbolic mysteriousness of the narrative, since it never explains matters, and multiplies semantic impasses:

Cette femme, je l'ai connue dans une *vigne immense*, quelques jours avant la vendange et je l'ai suivie un soir autour du mur d'un *couvent*. Elle était *en grand deuil* et je me sentais incapable de résister à ce nid de corbeaux que m'avait figuré l'éclair de son visage, tout-à-l'heure, alors que je tentais derrière elle *l'ascension des vêtements de feuilles rouges* dans lesquels brinballaient des *grelots de nuit*. D'où venait-elle et *que me rappelait cette vigne s'élevant au centre d'une ville*, à l'emplacement du théâtre, pensais-je? Elle ne s'était plus retournée sur moi et, sans le brusque luisant de son mollet qui me montrait par instants la route, j'eusse désespéré de la toucher jamais. Je me disposais pourtant à la rejoindre quand elle fit volte-face et, entrouvrant son manteau, me découvrit sa nudité plus ensorcelante que

les oiseaux. Elle s'était arrêtée et m'éloignait de la main, comme s'il se fût agi pour moi de gagner des cimes inconnues, des neiges trop hautes.[20]

 (This woman, I met her in an immense vineyard, a few days before harvest time. And one evening I followed her around a convent wall. She was in deep mourning. I felt incapable of resisting the crow's nest, of which the lightning of her face was for me the image. This happened while I was trying to climb garments of red leaves with night bells dangling in them. Where did she come from? And what did this vine remind me of, rising up in the middle of the city, where the theater used to be—such were my thoughts. She had stopped looking back at me. Without the sudden glimmer of her leg that now and then showed me the way, I should have despaired of ever touching her. I had made up my mind, however, to catch up with her, when she did an about-face and opened her coat, revealing to me a nudity more bewitching than the birds. She had stopped and was pushing me away with her hand, as if it were a matter of my reaching unknown summits and inaccessible snows.)

 I have italicized the unintelligible details. None can be explained by the incidents of the pursuit. They are quite different from a detail like the glimmer of flesh under the dress, which is perfectly appropriate within the context as a sexual symbol, and as heightening the suspense of an erotic chase. Different also from a detail like the crows: this obviously stems from "en grand deuil"—a derivation made possible by the preexistence in French of both jokes and superstitions associating crows with mourning. The text, functioning as metalanguage ("m'avait figuré"), makes it clear that these crows are the metaphorical vehicle for what would be literally just a predictable story development: the sudden glimpse of her face stirs up a surge of emotion. The crows, then, are a translation into a death-code of a bird-flying metaphor (flying, because these crows are equated with "éclair," and even though "éclair" means "sudden glimpse" rather than "lightning" in context) for élan or inspiration (one thinks of Rimbaud's line: "Million d'oiseaux d'or, ô future vigueur"). The difficulty of the image in this case is entirely due to its being metaphorical and to the fact that, as a metaphor, it has another metaphor (birds other than crows) as a vehicle. These are stylistic shifts, at best transcodings.

 The truly unintelligible details fall into two categories: those which seem at first to present no problem, and are found, only on

second thought, to hide their real meaning. And those that are true semantic impasses.

The vineyard belongs in the first category: it looks like a typical realistic or picturesque detail, that creates the impression we are in the presence of something that does not depend on the plot, nor on the characterization of its personae—in short, a frame of outside reference, a mimesis of reality. It is not, however, as acceptable as the convent, but, rather, disconcerting within the context of an urban locale. The second instance of "vigne" effects an almost imperceptible shift from "vineyard" as a place to "vine" as a high climbing plant. This reduces the possibility of visualization and thereby also reduces the detail to just being a sign. Moreover, the second instance of "vigne" associates it with some elusive memory: the question the narrator asks of himself endows "vigne" with a meaning as yet undisclosed.

The woman's black attire could be—in fact is—interpreted as an erotic commonplace: the text encourages this reading, since the page following dwells upon the contrast between the black, filmy clothing and the color of her flesh. It also suggests that she is easier prey because she is hurt, or lonely, because she is available, a potential object of interested compassion, receptive to an invitation to start living again. But in either case, her mourning implies a whole past of shared emotions, and a sense of loss; it is a sign summing up a previous story, establishing the possibility of a symbolism, or at least a different interpretation of the pursuit, in the form of a question mark.

As for the second category, here we have a total block. Nothing at all is to be made of the *climbing*, the shift from horizontal to vertical—in such a setting, nonsensical. And what of the red-leaf garment? Or the little bells? The only conceivable explanation (that these allude to the cap-bells and wand of a court jester, a conventional symbol of madness) is struck down by "de nuit."

Now it so happens that these details, in this order, were borrowed from Hugo's *Les Misérables*. These details all mark stages in the manhunt during which Hugo's hero, an escaped convict, flees the police with the little orphan girl he has adopted. Both of them elude their pursuers by taking shelter in a convent. Cosette, the child, is "tout en deuil," as the novel insistently declares.[21] The place where they were hiding before the chase began is on the "rue des Vignes-Saint-Marcel," a picturesque name for some outlying section, obviously the memory of a vineyard of the past.[22] What is more significant, when the fugitives are

trapped in a deadend street, the convict first thinks of climbing up the waterspouts on the face of the building. These are elaborately described as resembling vine stalks clinging to the wall.[23] He does finally climb a wall and pulls the little girl up to the top beside him. This epic ascent is referred to repeatedly as a feat possible only for experienced convicts,[24] and we know that such convicts used to wear red uniforms.[25] This is a garish detail hardly to be forgotten, since red prison garb is a thing of the past, and the standard metonymic representation of the convict in nineteenth-century literature is his green cap. And then, behind the wall—this final bizarre detail must be the clincher—the fugitives find the convent garden, and in that garden a gardener (despite the fact that all this happens in the dead of night), and that gardener, being the only man in the nunnery, wears a little bell on his leg like a leper, to warn the nuns of his approach. As if this were not enough, Hugo uses Breton's word several times, "grelot": so rare a lexical occurrence cannot be coincidental.[26]

But it is no coincidence either that the relationship between the two texts is discoverable by a reader. That he is able to connect them would seem odd, despite the fact that the revealing details are so much farther apart in *Les Misérables*, where they are spread over some fifty pages, than they are in *Poisson soluble*. Surely the explanation is not that Hugo's manhunt takes place within the very context of the surrealist pursuit: nocturnal city streets. It is possible for the reader to make the connection and, to begin with, it was possible for Breton's womanhunt sequence to follow—as a line of lesser resistance—a preexistent manhunt sequence, because both sequences actualize the same narrative structure. I could even argue that this structure is closely related to, if not identical with, the structure of the fantastic animal hunt.

Let us now return to the only viewpoint pertinent to our inquiry: the impact of the text upon the reader. First, the unintelligible details create the automatism effect, since the reader's natural reaction is to attribute the incomprehensibility to the author's inability to stem the upsurge of uncontrollable images. Second, these details, being meaningless, are for that reason interpreted as significant on a level different from that of the story. Because he is accustomed to structured communication, where details refer to a significant whole, the reader reads as if these details were fragments of a code, clues to another level of meaning. No decoding is needed. Indeed, decoding would be

impossible. The details taken from Hugo could never serve as a metaphoric code in Breton's text. From the mention of red clothing in Breton, for instance, we cannot deduce the image of a convict which could become a metaphor for the hunted woman. This is, of course, because the details are not structurally significant in Hugo's narrative. They are picturesque. From the convict's red coat to the gardener's warning bell, they are components of the verisimilitude system, and as such they are purely metonymic.

In a conscious, author-controlled imitation of Hugo, they would have been eliminated, since they pertain only to the particular realism of his text and to the motivations of his characters. They could never fit into a new context, for they would threaten its logic and esthetic unity; nor would they be appropriate to new characters. The automatic text, on the contrary, retains these very details: they are not incompatible with the sequence of events defining a chase, because they do not actualize that structure, but merely complete its lexical implementation. They do remain incompatible, as they would in a normal text, with the new network of motivations and verisimilitude factors that goes with the new hunt. Only this time their lack of meaning within the narrative signalizes their meaning as discourse. They are read as hieroglyphs, that is, as the representation of a language whose key is *hidden somewhere else.* Consequently they are the verbal representation, in the automatic text, of precisely the function they performed in its genesis. In Breton's mind they were evidently synecdoches for the whole Hugo chase, its *restes visuels,* visual remnants residing in subconscious memory—a term Breton borrows from Freud.[27] That is also what they look like. Even though the reader cannot explain what they remind him of, they look as if they could, if only he could crack the code. So that the text's grip on the reader is exactly that of subconscious memory itself.

Thus it really does not matter whether automatic texts are genuine or not; their literariness does not reside in their recording of subconscious thought. Their literariness stems from their function as a mimesis of that subconscious. This function they perform by making the reader decode directly at the level of invariants. Because narrative and discourse are incompatible, words are de-semanticized: the "story" (variant) as such does not make sense. Words no longer function as semantic units, but as the lexical implementation, the visible symbol of the structure's invisible presence.

NOTES

1. See, among others, Anna Balakian, *André Breton*, New York 1971, pp. 65 ff.; Claude Vigée, "L'Invention poétique et l'automatisme mental," *Modern Language Notes*, 75 (1960): 143–54; Julien Gracq, "Spectre du Poisson soluble" in M. Eigeldinger, ed., *André Breton*, Neuchâtel, E. la Baconnière 1970, 207–20. And, as a corrective, Jean-Louis Houdebine, "Le concept d'écriture automatique" in *Littérature et idéologie*, special issue, *La Nouvelle Critique*, 39 bis (1970): 178–85.

2. Attempts at a grammatical analysis yield little—e.g., Gerald Mead, "A Syntactic Model in Surrealist Style," *Dada-Surrealism*, 1972 issue, pp. 33–37; also, more ambitious, Per Aage Brandt, "The White-Haired Generator," *Poetics*, 6 (1972): 72–83.

3. Quotations from *Poisson soluble* (1924) are taken from *Manifestes du Surréalisme*, Paris, Pauvert, 1962. The question of genesis of the text will not be considered in this analysis.

4. At least a "lyrical" poem. It can be seen as a fragment of narrative, wherein circumstances previous to the story and long-range motivation are left to the reader's imagination (which facilitates his integrating it into his own personal experience).

5. Each associative sequence is a model which generates the text: as soon as a datum supplied at the outset has let the reader know what to expect, the text proceeds to develop in conformity with the sequence and the expectations. This accounts for the succession of incidents, for their cause-and-effect linkage, and consequently for their verisimilitude. It also accounts for a number of stereotyped phrases which economically actualize the circumstances and events of each narrative stage. On the concept of associative derivation from a datum and of textual over-determination, see my papers, "Modèles de la phrase littéraire," in P. R. Léon, ed., *Problems of Textual Analysis*, Montreal, Didier, 1971, and, with reference to Gracq, "Dynamisme des mots," *L'Herne*, 20 (1973): 152–64.

6. I am concerned here not with the morphology of the tale, which could be arrived at through analysis *à la* Propp or Lévi-Strauss, but rather with the awareness of such a pattern which a reader immersed in a language and its literary forms can actually, empirically acquire. See also the initiatory adventures in Marie de France's *lais:* Jean Frappier, "Remarques sur la structure du lai," in *La Littérature narrative d'imagination* (Colloque de Strasbourg, 1959), Paris, Presses Universitaires, 1961, pp. 22–39. In a gentler variant, Alice herself enters another world by running after the talking rabbit.

7. Pp. 122–23.

8. By expansion I mean transformation of a kernel form into a string of forms, e.g., morpheme into syntagm ("Modèles de la phrase littéraire," pp. 145 ff.).

9. E.g., allusions to the "jour de l'ouverture" and to the custom of hunting in Sologne, two representations which contradict the cliché "lost in time past." They are later annulled by "terre de France," an expression typical of pre-Revolutionary literature, or even of the medieval epic.

10. So popular that *lighting fixture* is one of the secondary but "normal," not even figurative, meanings listed under *lyre* (an entry dated 1873) in Pierre Larousse's first *Grand Dictionnaire*.

11. *Through the Looking-Glass*, chap. 3. Cf. Tenniel's illustrations. There is a difference: starting from "rocking-horse" and "horsefly," the portmanteau word keeps its two components; from "oiseau-lyre" to "lyre à gaz," however, the suffixation is complicated by the aphaeresis of "oiseau" (compensated for by the descriptive context). Tzara's *coeur à gaz* does not involve aphaeresis.

12. We come across the gas lyre in another automatic text, by Breton and Soupault, *Les Champs magnétiques* (1967 reprint, p. 76), where it is called more explicitly "la lyre lampe à gaz des salles d'attente," and where it is set side by side, perhaps significantly, with a "monstrous barometer." Tzara's *Coeur à gaz* (1922) is a similar compound.

13. Huysmans, *Les Soeurs Vatard*, chap. 8 (p. 100): "Aux Folies-Bobino . . . elle admira fort l'entrée. . . . Une femme jaune dansant sur le toit retroussé comme celui d'une pagode et tenant à la main un appareil à gaz, en forme de lyre, la stupéfia." Breton saw in Huysmans a poet rather than a novelist and explicitly referred to the *Soeurs Vatard* description of the neighborhood of the Bobino Follies (*Entretiens 1913–1952*, pp. 11 and 143).

14. The lyrebird appears in person in *Poisson soluble*, pp. 98 and 133. The lyre is animated before, p. 115.

15. Poems 8 (p. 84); 24 (p. 112: "my eyes were hazel blossoms, the right eye being the male flower, the left eye the female"); 31 (p. 126: "one crimson, who would have loved to sleep, the other white, who used to come by way of the roof, like a sleepwalker"). See also poem 17 (pp. 98–99).

16. First line of his "-yx sonnet" ("Her pure nails raising high their offering of onyx"—she is just lifting her hand, mind you). On the nail image in *Poisson*, see Gracq, "Spectre," p. 217.

17. Pink perhaps also because of Rimbaud's "L'étoile a pleuré rose." Later in the text the star-guidance is translated into a code borrowed from Annunciation themes: the star will utter the word "Promettez," at first misunderstood (but is it?) as "Prométhée."

18. This second derivation is incompatible with the first. It is therefore retained, for the same reason that the two wings generate antithetical sequences.

19. Cf. Germain Nouveau, "Les Mains," line 8: "Et le sang de la rose est sous leurs ongles fins." There is even a cliché, now fallen into disuse, about blood under one's nails, to the tip of one's nails, indicating generosity and strength.

20. Poem 22 (p. 107).

21. *Les Misérables*, part 2, bk. 3, chap. 9 and chap. 11 (Bibl. de la Pléiade, pp. 462, 468), and 2.4.3 (pp. 478–79). "Cosette was the Orphan She was no longer covered with rags. She was in mourning, leaving poverty to enter life." The capital letter favors the interpretation of this character as a type, as the semantic structure of a character rather than its verbal realization.

22. *Mis.*, 2.4.1 (p. 469).

23. *Mis.*, 2.5.4 (p. 495).

24. *Mis.*, 2.5.5 (pp. 497, 499).

25. *Mis.*, 2.2.3 (p. 411).

26. *Mis.*, 2.5.8–9 (pp. 505, 508; cf. p. 571). The Hugolian intertext extends to other poems: Cosette's village is named, *Poisson soluble*, p. 129; Jean Valjean is alluded to, p. 131 (cf. *Mis.*, 2.2.3, p. 405 ff.), and metonymically, p. 138 (the lining of his coat, *Mis.*, 2.4.4–5, pp. 482 and 485).

27. Breton, "Situation surréaliste de l'objet" (*Manifestes*, p. 237). Cf. Saussure: "par défaut de mémoire . . . le poète qui ramasse la légende ne recueille pour telle ou telle scène que les *accessoires* au sens le plus propre théâtral; quand les acteurs ont quitté la scène, il reste tel ou tel objet, une fleur sur le plancher, qui reste dans la mémoire" (quoted by Jean Starobinski, *Les Mots sous les mots*, Paris, Gallimard, 1971, p. 18).

The First Person in "Nadja"

Robert Champigny

Life is other than what is written
 André Breton, *Nadja*

You are the Dark One. You are a widower and need to be
comforted. You are also the prince of Aquitaine and your Tower
has just been abolished. Whatever you do, you always speak in the
first person.
 Jean Tardieu, *Problèmes et travaux pratiques*

Nadja begins with the question: "Who am I?" A reading
perspective elicits this translation: how is the first person pronoun used
in *Nadja*?

There is a narrative use: the pronoun designates a spatio-
temporal entity, a process, an individual, more precisely a personified
individual. Call this individual B: I leave out the secondary occurrences
of the first person pronoun in the speeches attributed to Nadja. B is
situated not only within the confines of the meetings with Nadja and
other narrated events, but also as he writes *Nadja* (as such, call him
A.B.): "Manoir d'Ango, Varengeville-sur-Mer, where I am in August
1927" (original edition, p. 26). The last pages are dated December 1927.
The meetings with Nadja take place in the fall of 1926.

Narratives may yield hypothetical examples: this is what hap-
pens in philosophical analyses. In fiction, they posit events axiomati-
cally: they can be neither true nor false. If what is narrated is
interpreted as historical, the narrative may be judged more or less true

and false. I am inclined to view the narrative aspect of *Nadja* as autobiographical, hence historical. The names and details it accumulates regarding events, people, and places provide many links with the outside information I have acquired, verbally or otherwise. Another reader might react differently.[1]

This does not mean that I accept the whole factual aspect of *Nadja* as true. For instance, I doubt the accuracy of the quotations of speeches.[2] To interpret a narrative as historicizing is to receive it as more or less accurate and inaccurate, probable and improbable. These adjectives would be irrelevant if the narrative were considered as fiction, since a fictional character is nothing else than what the narrative makes him to be. In a historical narrative, there is the theoretical possibility of outside verification. In fiction, all that can be checked is the wording.

A narration cannot be taken as totally false, for this would leave no basis for outside verification and the perspective would veer to fiction. I may doubt that André Breton met a woman named Nadja at the time he indicates, but this implies that I posit a man named André Breton who lived and wrote *Nadja* so many years before I read it. On the other hand, it can be neither doubted nor believed that Flaubert ever met the heroine of *Madame Bovary* if this book is held to be fiction.

Historical statements fight against each other and collaborate to furnish the same field of events. Interpreted in this way, a text does not isolate and limit itself as sharply as a work of fiction. If I take *Nadja* to be autobiographical, it will be a document, a testimony, to be added to others and compared with others. And there will be no radical break between the text and the photographs inserted in the book.

But another semantic mode is strongly represented in *Nadja*: the gestural, or dramatic, mode. Thus used, the words do not indicate events: they set poses, develop attitudes. The first person pronoun ties these gestures into a role. Note that, in this respect, the true-or-false question becomes inappropriate, not because a fictional character is described, but because the dramatic mode is not designative.

The syntax and phraseology in *Nadja* are often oratorical, adopting or parodying the traditional devices of French religious preachers, political speakers, or trial lawyers. Take, for instance, this sampling of launching boosters: "Eh bien, je ne trouve pas cela. . . . Je persiste à réclamer. . . . Pour moi, je continuerai à. . . . Certes, j'y reviens encore, rien ne me subjugue tant. . . . Il serait par trop vain d'y

prétendre et je me persuade aisément. . . ." ("I don't agree. . . . I persist in my demand. . . . As for me, I shall continue to. . . . To be sure, excuse me for repeating it, nothing overwhelms me like. . . . It would be only too futile to try and I am easily persuaded. . . .") (pp. 20–21).

The abundance of emotive vocabulary is another dramatic factor. The text even resorts to invective: hypothetical interlocutors are briefly summoned, so as to be called pigs (p. 47) and idiots (p. 178). The frequency of superlatives and augmentatives is also to be noted. For instance:

Thus it is that, with Huysmans, the Huysmans of *En Rade* and *Là-bas*, I find I share ways of appraising anything that may present itself, of choosing with the partiality of despair in the midst of what is, to such an extent that, even though, much to my regret, I have been able to know him only through his writings, he is perhaps, among my friends, the least foreign to me. But then has he not done more than anyone else to carry to its extreme limit this necessary, *vital*, discrimination between the ring, so fragile in appearance, which may mean everything to us, and the vertiginous combination of forces which conspire to make us sink to the bottom? [Pp. 15–16]

The second sentence is adorned with an interro-negative turn of speech. The same oratorical device can be spotted in the neighborhood: "Quel pas ne ferait-il pas faire . . ." (p. 13); "Que ne peut-on, en pareille matière, compter . . ." (p. 15); "Quel gré ne lui sais-je pas . . ." (p. 16). ("What step wouldn't he lead you to take. . . ." "Why can't we count, in such a case. . . ." "What gratitude do I not feel toward him. . . .") The syntax of the passage is also representative of a discourse which accumulates qualifying phrases, subordinate and incidental clauses, not in order to circumscribe an idea more closely, but to make gestures of circumscription. The formulation of ideas is jammed by the oratory, or covered with a sparkling glaze which makes it difficult to extricate something conceptually specific and coherent.

Add to this gestures of concealment, of the I-could-tell-but-won't variety. Thus, allusion is made to a notebook of de Chirico which "I have in my hands" (p. 13). "One prefers not to know" (i.e., not to tell) the motives of some novelists (p. 19). There is a "secret" about the way A.B. knows how to spend "completely idle and very bleak afternoons" (p. 77).

The gestural mode predominates in the first part of the book (to p. 74): it supports and links the scattered anecdotes, allusions, and reflections. It comes to the fore again in the last pages, thanks to the use of the vocative: a new feminine entity is addressed as "you." Besides, it does not disappear in the narrative devoted to Nadja, which is sprinkled with pompous dialogs and monologs, comments and other extraneous details. Thus: "After stopping a few minutes in front of the window of the bookshop of *L'Humanité* and purchasing the latest book of Trotsky, I was walking aimlessly in the direction of the Opera" (p. 77). Such name-dropping serves no purpose in the introduction to the Nadja sequence, except to set the pose of the leftist intellectual.

As far as I am concerned, the gestural aspect does not manage to take hold of the whole text. The outside information which is incorporated in my reading, or rereading, of *Nadja* prevents me from taking it simply as an oratorical monolog. I still posit, as a basis, a historical person, André Breton, writing in 1927. This historical person (A.B.) would, on the one hand, make a historical report about Nadja and himself (BN) and, on the other, perform a dramatic role. He would be a historically situated narrator and also an actor. But the imperialism of the dramatic ego, which takes advantage of the ambiguities of the first person pronoun, spells trouble for this neat distribution. To some extent, the dramatic ego interferes between A.B. and BN.

To this extent, BN becomes part of the role, like a story told by a character in a play; and the true-or-false question becomes in part irrelevant. Does this mean that the perspective of interpretation turns from history to fiction? Not exactly, since the role is still tied to the historical A.B., who composes it for himself. Rather than candidly fictional, BN becomes legendary. By "legend," I mean a variety of myth: a confusion between history (true and false) and fiction (neither true nor false). To this extent, *Nadja* gives a gestural answer to the introductory question, an answer which could be translated into designative style as follows: the first person pronoun refers to a legendary figure.[3]

Here and there, the text provides glimpses of the values it is supposed to stress. The experiences to be treasured are not literary. They occur in daily life. They are not linguistic, except incidentally. They reduce the experiencing subject to the status of a "witness" (p. 24), or "ghost" (p. 7), or medium (in the case of Nadja). If language intervenes after the fact, the disturbing, or creative, factor should be

limited as much as possible: the text should be a factual report. The narrative aspect of *Nadja* conforms to this directive. But the view is often blocked by the orator striking verbal poses in front of the camera. The guided tour becomes a tour of the guide and the facts to be reported a pretext for self-exaltation. Consider the use and abuse of emotive vocabulary: if what is reported is to impress me, a reader, as poignant, moving, prodigious, upsetting, mysterious, marvellous, extraordinary, the text had better not be sprinkled with these very labels. They indicate less than they mask.

In some respects, B is to N as Watson to Sherlock Holmes or Seurel to Meaulnes. But Nadja also functions as a stooge.[4] She confesses B's power over her (p. 103), takes him for a god, believes he is the sun (p. 148). The interventions of the oratorical ego make the following praise, supposedly coming from Nadja, appear comically incongruous: "It is, in my thought, in my language, in my whole way of being, apparently, and this is one of the compliments which have touched me most in all my life, *simplicity*" (pp. 92–93).

Criticizing narratives which conceal historical identities, the orator "persists in demanding the names" (p. 20). But, toward the end, the "you" which the dramatic ego uses as a springboard receives no name. Instead, the second person is given these attributes: "nothing as much as a woman," "a Chimera," and "of course, ideally beautiful" (pp. 209–10; the French for "of course" is in the text). Unusual "fortuitous arrangements" (p. 19), "sudden encounters, petrifying coincidences" (p. 22) have been extolled. But Woman plus Chimera plus Ideal Beauty is a combination of essences, not events. Or rather, since the conjunction is attributed to a person, an idol is set up. Legendary figures are obtained through a confusion between history and fiction, idols through a confusion between temporal and intemporal. The Woman-Chimera-Beauty role is not even unusual: it is a stereotype.[5]

Cracks in the make-up, places where the glaze tends to disappear, allow one to surmise that the oratory is intended to compensate for the inadequacies of experience or of the experiencing subject (in particular, B's inability either to protect N or lose himself with her), intoxicate A.B., as a reader of what he is writing, fascinate or intimidate other readers, according to their dispositions. In a passage about the marvellous, it is asserted that "from the first to the last page of this book, my faith will not have changed" (p. 198). "This book"; elsewhere: "I persuade myself." Professions of faith do not express faith

(except faith in words), but a need of faith which they attempt to satisfy verbally.

This relationship between day-to-day experience and its verbal accommodation is fairly banal. In its way, it points to something fundamental. For, if day-to-day experience satisfied our ethical and esthetic aspirations, there would be neither need nor possibility of language. Words testify to what is lacking in non-verbal experience, even if they state satisfaction. Day-to-day experience can embody values only sporadically, tentatively, temptingly. Besides, values may be in conflict. Thus, there is a conflict between ethical and esthetic directives in B's relation to N.

In *Nadja*, the celebration of values to be sought in casual experience turns to a celebration of the celebrating role. But there is more to be noted than this banal shift in the field of application. The verbal creation might relay the original experience, use it as a material, stylize it, yet remain faithful to the *type* of value which was glimpsed and treasured, missed and messed up. But the way *Nadja* is written involves a shift in the type of value as well as in the field of application.

The occurrences which are alluded to are said to have the appearance of "signals" (p. 23). I understand signalling as a relation holding between events: an event at t_1 signals another at t_2. Scientific laws of nature are rules of signalling. A causal connection may be given this form: an event of type A at t_1 signals an event of type B at t_2. An event signals causally under its general aspect. But what about the signalling radiance of an event under its singular aspect?

Linguistic events are not excluded *a priori*. But the denotative dimension of language is excluded: to denote, to designate, as in a prediction, differs from signalling. Oracles would not count, unless, by "oracle," one means a linguistic event which functions as an omen under the cover of a misleading prediction. An interpretation would thus be proposed for the following sentence: "It may be that life has to be deciphered like a cryptogram" (p. 150). But this remark does not concern oracles in particular. So, instead of a distinction between prediction and omen, a dual signalling could be considered: an event would signal under its general aspect (obvious meaning) and might signal differently under its singular aspect (covert meaning).

In *Nadja*, Breton shows a special interest in the events which make up a single life process, more precisely his own. He says he is concerned about what his "differentiation" consists of (p. 9). To some

extent, a combined application of general rules of signalling can help map out a singular process, whether these rules are scientific or not.[6] But the interest lies in a less negative differentiation, in a coherence, or cohesion, which would grant a positive status to contingency. Signalling under the singular aspect would fulfill the requirement. The connections would produce an impression of destiny. Destiny differs from causality: the singular events are connected without an appeal to induction (generality).

Thus posited, the notion of destiny agrees with "a certain finalism" (p. 155). But the finality involved would exclude orders given by personified entities: the subject, other human persons, or supernatural spirits. For, in this case, the intending event would be a gesture; it would be part of a dramatic stimulus-response dialectic. This is not what "signal" and "finalism," as used in the text, suggest. Besides, if a gesture takes the form of a sentence, the intended event is denoted. "Shut the door!"; "Let there be light!" [7]

The events under consideration must have "the appearance of signals." But they must not be deciphered at the time of their occurrence. Even if it did not apply a general cognitive rule, or cultural stereotype, the interpretation would still be treason, for it would substitute a denotative decision (a prediction) for the experience of a signalling aura. On the other hand, there must be some confirmation: there must be events which appear to have been signalled, for a collection of mysterious signals would not give an impression of destiny. At the time of the signalled event, or later, a deciphering, that is to say, a translation into a designative relation may take place. But, instead of considering the signalling relation as a problem to be solved, as a secret to be disclosed, one may prefer to remain in the light of the atmospheric mystery. The second event is then sensed, rather than thought, as having been signalled by the first. The atmosphere of the first is somehow confirmed in the atmosphere of the second.

Understood in this way, the signalling tie may be labelled poetic, if we agree to extend the scope of poetry beyond what is purely verbal. More precisely, since pure poetry deals with qualities, not events, it would be a spatio-temporal application, or unfolding, of non-verbal, or partly verbal, poetry. The signalling link between events under their singular aspect is a poetic echo.

But a human life lends itself poorly to this perspective. In pain or boredom, we experience the lack of any kind of understanding. Then,

there is a cognitive, practical and ethical aspect. The perspective of applied poetry is esthetic. It aims at a kind of comprehension, not knowledge. More than that: it leaves out activities with deliberate purposes, wavers between the poles of a contemplative stance (the witness, the aesthete) and a reckless involvement which would result in a certain type of madness (how well Nadja, as glimpsed in the book, points to this type of madness is another matter). Finally, other modes of esthetic meaning may interfere: for instance, dramatic dialectic.

What I wish to emphasize is the difference between historical and fictional temporality. The field of a piece of fiction is closed and the interpreter can encompass it as he rereads the text. In historical life, on the contrary, events keep being added and this addition alters the relationships which had been sensed or posited: two days ago C was signalled by A, yesterday by B, today by nothing.

Nadja speaks of "a glass bed with glass sheets, where *who I am* will appear to me sooner or later, carved with a diamond" (p. 20). This glass bed would have to be a deathbed, or a tomb. A.B. would have to be dead, or rather play dead, since he would still have to be a witness in order to read the inscription on the headstone. Day-to-day experience cannot be viewed as a cryptogram, because, among other things, it cannot be an established "text." As I interpret the notion of signal, the metaphor of the cryptogram rather suggests a piece of narrative fiction which would let poetic echoes do the job of cross-reference. The narrative would denote the events; poetic connotation would leave the signalling ties in an atmospheric state.[8]

This is not the linguistic shift effected in *Nadja*. The narrative still clings to history, instead of being frankly fictional. And the tying function is assumed, to a great extent, by the oratorical role which smothers the poetic echoes which might have been sensed through the narrative.[9] Thus, the shift from non-verbal to verbal is accompanied by a switch from a poetic to a dramatic track.

"Who am I?" Metapoetically, this is the wrong question. A search for self-identity, for an identity as a personified unit, is not poetically oriented. A poetic vision dissolves persons into qualities (qualities which happen, not essences). The opposition between person and non-person gives way to an indistinct animism, purposeful individuals to an intentional atmosphere which is not restricted to human individuals.

Practically, for self-preservation, for the preservation of a self,

we need to assert ourselves as persons, things as non-persons; at times, we need to project our selfhood like a carrot in front of our nose. Ethically, we have to decide who is our neighbor, what would constitute a pathetic fallacy: we have to distinguish suffering creatures from the rest. *Nadja* gives no formal answer to the opening question: selfhood is kept dangling ahead. But it composes a dramatic mask, a *persona*, without recognizing it as such: if it were clearly posited as a role to be played, it would not serve its recuperative purpose so well. *Nadja* reacts against Nadja, to the extent that she represents a threat to selfhood.

In a favorable phonetic and semantic context, "who am I" could be turned into a directly poetic unit (instead of a question). It could even be part of the basic combination in a short poem (rather than a poetic narrative) in conjunction with variants such as "who were you," "who were we," which also occur in *Nadja*. Compare Villon: "But where are the snows of yesteryear"; or Apollinaire's *Marie*: "When will the week ever be over." In a prosaic perspective, the questions "When? Where? Who?" call for the intervention of the basic tools of narrative and dramatic prose: spatialization, temporalization, individuation (personified). They ask for a matter-of-fact or mythical answer; thus "in heaven," or, as Nadja is made to say: "I am the Wandering Soul" (p. 92). To convert the questions into poetic phrases, the context must, as a negative condition, avoid furnishing a prosaic answer and even deny its theoretical possibility, so that a prosaic translation would only yield the pseudo-question itself as a pseudo-answer: the snows of yesteryear are now where; the week will be over when; I am who.

It is to be noted that the context in Villon's ballad does not talk about snows or about a particular year, while Apollinaire's poem does not posit a particular week. Besides, snows and weeks are not supposed to be equipped with souls (which discourages a mythical answer). Finally, in ordinary usage, "week" and even "snow" serve at least as much as names of dating tools as of dated processes. In *Nadja*, on the other hand, "Who am I?" remains a prosaic question, because the context does not bar a prosaic answer, either matter-of-fact or mythical. Not only does it allow for the possibility of a solution (problem to be solved, secret to be disclosed, instead of poetic mystery), but it gives a stylistic answer: the first person pronoun refers to a historical person and strings together the gestures of an oratorical *persona*.

In *Le Cimetière marin*, Valéry resorts to the *Ubi sunt* device: "Où sont des morts les phrases familières?" ("Where are the familiar sayings of the dead?"). But, in this instance, the dramatic context hampers the poetic conversion: the dead remain persons, or characters, linked to an oratorical "I," the character of the Poet. To some extent, the oratorical mask in *Nadja* is also that of the Poet.

A poet is not a poetic thing: poetic things do not write poems; they do not experience the need and lack of poetry in this world. And the role of the Poet is not a poem. It is oratory, rather than poetry, which converts the courtyard of the *Manoir d'Ango*, "paved with broken tiles and now covered with real blood!" (p. 74). A species of flower, of the garden or speech variety, might be labelled Real Blood.

NOTES

1. In "Surrealism and the Novel: Breton's *Nadja*," *French Studies*, 20, 4 (October 1966): 366–87, Carlos Lynes shows himself willing to overlook the difference between the perspectives of history and fiction (note 13), also, it seems, between oratory and poetry.

2. In *André Breton*, New York, Oxford University Press, 1971, Anna Balakian questions the authenticity of the words attributed to Nadja.

3. In "Qu'est-ce que *Nadja*?", *Nouvelle Revue Française*, April 1967, Michel Beaujour uses the word *mythe* differently. In the following passage, he appears to be thinking only of already accepted legendary figures: "While skirting myth here and there, as in the metamorphosis of Nadja into Mélusine, *Nadja* never enters it" (pp. 791–92). Mythical confusion does need public cement to achieve stability: the Other is to give it a security. In this respect, it should be stressed that *Nadja* is designed for publication, and publicity. Nadja and Breton become cultural figures in *Guide de Paris mystérieux* (Paris, Tchou, 1966): tourists are invited to behave like pilgrims.

4. In "The *Nadja* file," *Cahiers Dada Surréalisme*, 1 (1966), Roger Shattuck's reaction is that "Nadja emerges not as the subject of the book, but as its victim" (p. 55).

5. An external kind of discordance would appear if the preface to the revised edition, dated 1962, were taken into account. It states that the photographs inserted in the text are designed to eliminate descriptions and alludes to the condemnation of descriptive style in the first *Manifesto*. Yet there are descriptive passages in *Nadja* (thus the description of an engraving, p. 68). Besides, the *Manifesto* even appears to reject narration itself, using, as an

example of futility, the sentence: "The marchioness went out at five." Would the lady be exonerated if she had gone out to buy the latest book of Trotsky? Or was the attack directed against fiction, not against historical narration? For an attempt to reconcile theory and practice, see Albert Chesneau, "La Marquise sortit à cinq heures," *PMLA*, 84 (October 1969): 1644–48.

6. For instance, astrology and other codes of fortune telling. A caricature of oneiromancy is offered by Pierre Dac in the *loufoque* spirit, a kind of nonsense humor which flourished in the weekly *L'Os à moelle* and which owes something to Dada and surrealism (see also Boris Vian). Thus, suppose you dream of a capstan: "If the capstan makes a racket in the cellar, you will be awarded a decoration, but if the capstan addresses you courteously, it will be the opposite." If you dream of an ostrich and "it eats you: asthma or deafness. If you spit out flames and kill it, you will buy a second-hand bicycle. If you have dinner with the ostrich, an uncle of yours will go broke." Stylistically, the surrealist spirit is oriented either toward poetic fiction or *loufoque* comedy. *Nadja* avoids a deliberate shift to fiction: in the eyes of Breton, it would be treason, or a confession of defeat. And against the comic threat, it sets up an oratorical scarecrow.

7. It would be interesting, in this respect, to compare *Nadja* with *The Words*, by Sartre. There is a strong oratorical element in *The Words*. Besides, the child and the grandfather (the section which would correspond to the BN sequence in *Nadja*) are presented as comedians. But, in the Hegelian line, Sartre's conception of history is itself metadramatic: historical ties illustrate a stimulus-response dialectic. Human beings are actors playing roles. As distinct from a purely biophysical evolution, history is made up of their interactions as actors-characters. The "wiles of history" illustrate the device of dramatic irony.

8. Surrealistic images, understood as positing unusual, or fantastic, events, are not identical with such poetic cross-signalling. But they may help it. Logically, a banal event is just as singular as an unusual one: it happens somewhere at a certain time. But its banal aspect tends to hide its singularity. On the other hand, if the image is too violent, or if the device is too systematic, it is not simply the banal aspect of the event which will be eliminated; it is the very nature of what is signified *as* event. *Nadja* alludes briefly to reincarnation (p. 114). In theory at least, the idea of reincarnation suggests a way to ally poetic cross-signalling (one life signals the next, and vice-versa) and a type of surrealistic image (metamorphosis). The reincarnation tie allows identity through discontinuity. One might think that this relaxation of the criteria of individuation would be favorable to a poetic type of vision. It should be recalled, however, that, in any case, fictional individuation is discontinuous. No doubt, the découpage of historical narratives leaves blanks also. But, in the case of a biography, we assume that the blanks could be filled and that the life process was not interrupted. A fictional individual, on the contrary, is only what

is said about him. Even the most realistic narrative fiction thus makes use of reincarnation ties.

9. Renée Rièse Hubert searches for such echoes in "The Coherence of Breton's *Nadja*," *Contemporary Literature*, 10, 2 (Spring 1969): 241–52.

Antonin Artaud

suppression and sub-text

Mary Ann Caws

The following study is based on two hypothetical premises: first, that the inequality in stylistic density of some of the longer so-called "automatic" prose texts of the surrealists may justify (*a*) an initial découpage, in this case the choice of those parts of the text which present, against the neutral background of the rest, passages placed in stylistic relief, composed of salient elements analyzable on the phonetic, syntactic, and semantic levels and (*b*) the subsequent reassembling of those parts into a coherent text; second, that the analysis of certain marked elements of that arranged text may show them to be the visible protrusions on the surface of a generating theme for the "unconsciously" or spontaneously produced images of the automatic text. The markings are of various sorts, more or less obvious, as are the methods by which they were produced, but once they are perceived they can be seen to center about a major image or theme which serves to hold them together in a coherent unity, as an obsession, conscious or unconscious, may generate or connect a series of actions. It is as if the reader had the task of creating the second text by his perception of the missing or suppressed focal point.

Furthermore, certain rules of reading can be formulated, at least tentatively. The following criteria have been found to be operable: (1)

The elements of stress and suggestion in the shortened text must be sufficiently numerous to compose a noticeable and continuous double texture; or, to formulate the rule negatively, dispersion prevents a convincing or ("deep") second reading. (2) The second meaning must be in every case sufficiently distant from the first to establish a definite semantic divergence under the phonetic convergence. (3) The sense of the newly located elements must determine a certain coherence of concepts; that is, once a sufficient number and density of elements has been located, irrelevant second readings should be discarded if their direction is at no point relevant to the direction of the posited sub-text. After the second reading is completed, a new direction may be tried, and so on.

I
L'Enclume des forces

Ce flux, cette nausée, ces lanières, c'est dans ceci que commence le Feu. Le feu de langues. Le feu tissé en torsades de langues, dans le miroitement de la terre qui s'ouvre comme un ventre en gésine, aux entrailles de miel et de sucre. De toute sa blessure obscène il bâille ce ventre mou, mais le feu bâille par-dessus en langues tordues et ardentes qui portent à leur pointe des soupiraux comme de la soif. Ce feu tordu comme des nuages dans l'eau limpide, avec à côté la lumière qui trace une règle et des cils. Et la terre de toutes parts entr'ouverte et montrant d'arides secrets. Des secrets comme des surfaces . . . —La terre est mère sous la glace de feu. . . .

Un cri pour ramasser tout cela et une langue pour m'y pendre.

Tous ces reflux commencent à moi.

Montrez-moi l'insertion de la terre, la charnière de mon esprit, le commencement affreux de mes ongles. Un bloc, un immense bloc faux me sépare de mon mensonge. Et ce bloc est de la couleur qu'on voudra.

Le monde y bave comme la mer rocheuse, et moi avec les reflux de l'amour.

Chiens, avez-vous fini de rouler vos galets sur mon âme. Moi. Moi. Tournez la page des gravats. Moi aussi j'espère le gravier céleste et la plage qui n'a plus de bords. Il faut que ce feu commence à moi. Ce feu et ces langues, et les cavernes de ma gestation. Que les blocs de glace reviennent s'échouer sous mes dents. J'ai le crâne épais, mais l'âme lisse, un coeur de matière échouée. J'ai absence de météores, absence de soufflets enflammés. Je cherche dans mon gosier des noms, et comme le cil vibratile des choses. L'odeur du néant, un relent

d'absurde, le fumier de la mort entière. . . . L'humour léger et raréfié.
Moi aussi je n'attends que le vent. Qu'il s'appelle amour ou misère, il ne
pourra guère m'échouer que sur une plage d'ossements.

The Anvil of Forces

This flux, this nausea, these swaddling bands, it is in these that
the Fire begins. The fire of tongues. The fire woven in torsions of
tongues, in the sparkling of the earth opening like a laboring stomach
with entrails of honey and sugar. With all its obscene wound this soft
stomach yawns open, but fire yawns above it in twisted and burning
tongues which bear vents at their tips as if of thirst. This fire twisted like
clouds in the limpid water, with light at its side tracing a ruler and
eyelashes. And earth everywhere half-open and showing dry secrets.
Secrets like surfaces. . . . Earth is a mother under the ice of fire. . . .
A cry to gather all that and a tongue to hang myself on.

All these ebbings begin with me.
Show me the insertion of the earth, the hinge of my mind, the
atrocious beginning of my nails. A block, an immense false block
separates me from my lie. And this block is of whatever color one
chooses.
The world dribbles on it like the rocky sea and I with the ebbing
of love.
Dogs, have you finished rolling your pebbles across my soul? I. I.
Turn the page of rubble. I too hope for the celestial gravel and the
beach bounded with no more edges. This fire must begin with me. This
fire and these tongues and the caverns of my gestation. Let the blocks of
ice be stranded under my teeth. I have a thick skull but a smooth soul, a
heart of failed matter. I have an absence of meteors, an absence of
bellows afire. I seek in my throat names and the vibrating eyelash of
things. The smell of nothingness, a stench of absurdity, the manure heap
of complete death. Light and rarefied humor. I too I only await the
wind. Let it be called love or misery, it can only strand me on a beach of
bones.

Devices and Suppression

In the prose poem of Artaud considered first, published in *La
Révolution surréaliste* of 1924 and included in *L'Art et la mort* (1926),
generally regarded as an excellent example of automatic writing, I have
eliminated a middle section, data from which will, however, be
included in the notes. The methods by which the text was possibly

produced can be briefly stated as repetition and transformation, methods familiar from many surrealist texts: aural repetition, phonetic suggestion (rhymes, half-rhymes, assonance); the suggestion of images, each by the preceding one, in a chain of which several links can be crossed out, that is, not available in the actual text; embedding on a small scale, or anagrammatic play, where shorter words are contained in longer, more microscopic ideas in larger, etc. These points are determinable and form the basis, with other points of stress (for example, phonetic and syntactic foregrounding or other distinguishing procedures), for the analytic study which has as its goal the discovery of the center toward which the text is directed and about which it turns. The method can be thought of as an extension of the traditional principle according to which rhyme or positioning, for example, mark terms of particular significance.

Découpage and Reassembling

The sections to be discussed are the beginning lines of the text, up to the singular and modest announcement of the subject and of its verbal substitute:

La terre est mère . . .

and the concluding section, beginning with the poet's demand for the poem as a necessary mode of retention and ordering:

Un cri pour ramasser tout cela . . .

with the subsequent assertion of the creative self as the source of the poetic redundance and repetition occasioned by the obsessive/obsessed subject:

Tous ces reflux commencent à moi.

Read together, these passages constitute the second text, which, for reasons that will become obvious, I call a poem.

Echoes and Traces

On the first or phonetic level, this text is built on a group of obsessive echoes which mark the surface with a series of clues as to the subject suppressed; the echoes or rhymes can be seen as the formal equivalent of the "reflux," responding to the initial flux ("ce flux") of gestation. The verbal clues repeat the syllable "-ère" in an irregular

pattern noticeable in its intense accumulation. The engendering of the text thus replies to and is determined by the original obsession with birth from a mother, the natural and therefore obscene starting-point in the flesh (CHAIR/MÈRE), itself bearing the ironic formula [CHÈRE MÈRE]:

lanières
terre
lumière +
terre
entr'ouverte
terre
nerfs
terre
terre
mère
. . .
insertion
charnière
mer +
j'espère +
caverne
matière +
cherche
entière +
misère +
guère +[1]

The stress falls on the conditions of binding (lanières) and nervousness (nerfs) and, after a brief hope (j'espère), the final anguish (caverne, misère). The actual word "mère," while it is the probable determination of all the other rhymes, is first suppressed, then expressed only by its natural substitutes "terre," repeated five times, and "mer"—as the text clearly states, "la terre est mère"—then finally enclosed in another matrix, "m(ati)ère" and its equivalent, "m(is)ère." The deciphering of the word/concept "mère" as the center toward which this series of clues points, as the explanation for the heightened or marked passages, is supported by the many references to gestation and birth: "flux," "nausée," "la terre qui s'ouvre comme un ventre en gésine," "blessure obscène," "baille," "ventre mou," "caves," "creux," "cavernes."[2] But

these appear only at the beginning of the text, together with other phonic traces of obsession, such as the recurring harshness of the sounds *s* and *t* (ce, ces, ceci, c'est, commence, tissé, torsades, terre, tordues, ardenté, pointe, soif, trace, entr'ouverte, secret, surface) and the syntactic foregrounding of the initial presentation (ce, cette, ces, c'est, ceci). The condition is plainly inescapable from the outset; thus the melodramatic presentation, accompanied by the verbal suppression, and by what could be read as the traces of hatred (chien(s)→[chienne], fumier) and of an apparently murderous desire (feu—in the sense of former—éclipse, sang). But like the earth "de toutes parts entr'ouverte" to expose its secrets, the text continues to point to its own matter ("c'est dans ceci"), to expose the mother at its center, "la (lu)m(i)ère qui trace une règle." The hypothesis of a center unexpressed in the literal text is reinforced by such phrases as the "éventail ouvert," the "centre blanc de convulsions," and such images as the spiral of eclipses covering "le même centre" or the "arides secrets."

Outcry and Fiction

Artaud, in the "confusion" of his language, speaks only for the "discrédités des mots et du verbe" (*Bilboquet*, OC, 1:271). The first part of the phrase "un cri pour ramasser tout cela et une langue pour m'y pendre" offers itself as a justification of the syntactic peculiarity of the text, where the frequent and noticeably emphatic non-sentences juxtaposed with complete sentences in almost equal parts (27 to 32) stand in relation to the latter as exclamations to statements, as an outcry to a considered judgment—a further example of syntactic foregrounding. The emotive structure of the text is thus composed of the following exclamations:

Le feu de langues. / Des secrets comme des surfaces. / Force giratoire des astres. / Moi. / Moi. / Ce feu et ces langues, et les cavernes de ma gestation.

The second part of the phrase: "une langue pour m'y pendre" (apart from the possible sub-reference to the CHAIR, where the identification of the phallus with the tongue is implied, an identification clearly made in the texts from Rodez) carries, because of the preceding analogy by juxtaposition: "lanières . . . langue," the verbal reminder of the poet menaced or imprisoned in the confusion of his tongue, suspended from

or depending on its efficacy (as in "la langue bien pendue") and, by the alteration of one consonant, lost therein: "pe[r]dre." [3] To counteract the fear of being swallowed up by the mother tongue, as the baby is swaddled or encased in *langes* (a middle term, suppressed, between "lanières" and "langues"), the self-reference once reduced to its minimum sign, as the component of loss: "*m'y* pe[r]dre," is immediately thereafter reasserted in its fuller forms:

Tous ces reflux commencent à *moi.* / Montrez-*moi* . . . Il faut que ce feu commence à *moi.*

In the initial two-thirds of the text, the *moi*, the to-be-born, was totally absent. In the last third, it appears under various aspects, dramatically omnipresent (17 times), an obsessive demand for the reader's attention. But since the longer forms: "moi," "mes," "mon" are inserted between the initial minimum consciousness already cited ("m'y pe[r]dre") and the final reduction to a phonetic minimum: "m'échouer," the tripled negative reading of the latter verb ("s'échouer," "échouée," "m'échouer") is reinforced, as if the failure ("échouée") and the loss of self thereby were doubly reflected in the "glace," around the two readings of which (mirror/ice)[4] the conclusion of the text revolves.

Artaud would have chosen, as he tells us elsewhere, not to be born of the father-mother, but of his own words. Rejecting the natural and obscene wound of birth, he takes upon himself the responsibility of creation and the artificiality of the meta-text, whose vocabulary represents his concern with placing, juncture, and order ("Montrez-moi l'insertion . . . la charnière . . . le commencement"), with designation ("Je cherche dans mon gosier des noms"), and with the fiction of the poem or the cry, having no reality or specific referent in its utterance ("Un bloc, un immense bloc faux me sépare de mon mensonge. Et ce bloc est de la couleur qu'on voudra").

Moreover, the meta-textual character is repeatedly stressed by the references to a hearer who would, for example, receive the message of the recurring rhymes. The "enclume" of the title prepares the context for two other allusions to the hearing apparatus: the "soufflets enflammés" and the "osselet" [5] suggested by the final "ossements," where the deformation of the final syllable completes the series of rhymes concerned with speech and its failure, conferring on them a retrospective resonance of desperation:

> dents
> *absence* +[6]
> *néant*
> re*lent* +
> attends
> vent
> *ossements*

In fact, the textual determination of "ossement" has a possible origin in the insult hurled toward the matter/mother:

chien[ne]→trou (obscène blessure)→os (sement)

It is also linked by the expression "chair et os" to the CHAIR obsessing the poet who at times identifies it with his outcry, that is, in this case, the poem itself: "Il y a des cris intellectuels, des cris qui proviennent de la *finesse* des moelles. C'est cela, moi, que j'appelle la Chair."

Now the suggestion of image by image is characteristic of the generation of an automatic text;[7] for example, in the production of a double sense for further semantic chains:

Feu/feu miroitement

 soif

 eau ‖ limpide

 ⇓ lumière

 glace/glace

or of sound by sound:

 gravats ————→ gravier

or the combination of these methods:

chiens

 rouler galets

 [plage]→tournez la page des gravats

 gravier céleste

plage qui n'a plus de bords

plage d'ossements

As one looks in a traditional poetic text at the words put into relief by
the end of verse rhymes or by positioning, one should look in a surrealist
text at the passages bearing the traces of these "chain" suggestions, for,
according to the hypothesis stated above, it is probably those *marked*
passages that show the clearest traces of the obsessive images and the
continuing foci which are the cohering and cohesive structures for these
texts, holding their seemingly disconnected parts together.

Thus, in the present text, the last-cited chain ([plage]→page→
plage→plage) is indicative of the progression from optimism in the text
as a passage to be traversed ("tournez la page") and representing an
infinite space ("qui n'a plus de bords"), an optimism leading directly to
the assumption of the tongues of fire by the writer ("il faut que ce feu
commence à moi"), whose birth they will signal ("Ce feu et ces langues,
et les cavernes de ma gestation"), to the juxtaposed denial of that fire by
the "blocs de glace" which return ("reviennent s'échouer sous mes
dents") with their echoing suggestion of failure ("m(ati) ère échouée"),
to the final admission of the bankruptcy of the text stranded in this
"mer rocheuse," as only one more arid secret exposed ("il ne pourra
guère m'échouer que sur une plage d'ossements"). Subsidiary marks of
this deception can be found: the placing in parallel of the soul with the
skull (by the assonance: "crâne . . . âme"), or the rhymed passage:
"Mais les menaces douces de ces orages. Mais les orages," or the
doubling of the morbid by phonemic play:

la m(ort enti)ère→[enterre] = [[en mer]]

To the original and generating force ("Qu'il s'appelle amour ou
m(is)ère"), the self-generating and empty outcry responds, in the form
of an act ordinarily unmentionable, which is, in its own declaration, a
poem:

C'est si l'on veut la connaissance par le vide, une espèce de *cri abaissé*
et qui au lieu qu'il monte descend. Mon esprit *s'est ouvert par le ventre*,
et c'est *par le bas* qu'il entasse une sombre et intraduisible science,
pleine de marées souterraines, d'édifices concaves, d'une agitation
congelée. Qu'on ne prenne pas ceci pour des images. [*B*,274] [8]

One might call it knowledge by way of emptiness, a sort of lowered cry
which descends instead of rising. My spirit has opened through my

stomach, and it is in the lower regions that it amasses a somber and untranslatable science, full of underground tides, concave edifices, of a congealed agitation. Let this not be taken as mere imagery.

Trial and Failure

Thus the elemental and elementary "cri abaissé" (cri a-b-c) descends to an arid fate after the poet's assumption of the creative or *gestative* act.[9] Again the rhymes stress the positive identification of the two elements which are the poem's stated theme: "le feu de langues," a transposition of the biblical referent, the tongues of Pentecostal fire, and it is within the rhymed series that the whole story with its negative outcome can be seen in all its irony ("humour léger et raréfié") underlying the tripled statement of failure. The "-é" sound engenders:

> *ramasser*
> rouler
> tournez
> gravier
> *s'échouer*
> *échouée*
> *soufflets*
> *enflammés*
> gosier
> *fumier*
> léger
> raréfié
> *m'échouer*

In association with the ambiguity of the main sign "feu," that is, in its double connotation of danger and inspiration (here the "soufflets enflammés" replace the classic "anima"), we can now see the counter-theme of a trial by fire. Its outlines sketched only by phonemic suggestion, this final theme is covered over by the textual surface, the semantically readable "glace" which must be shattered to expose the reflection and the fiction, the equal importance "des secrets comme des surfaces." In one of the last sentences we read of a joust between the poet and the text, the trial of his labor:

> J'ai le crâne épais, mais l'âme lisse
> [épée (pal) ·lame lice]

In this reading, the last sentence predicting the arid end of the text takes up once more the figure of the outcry and makes of it a warcry:

guère→[guerre]

Thus the poet sets fire to this feu-text as only a pre-text to poetic matricide or the destruction of the finally avowed matrix.

But the text remains, making of its own attack a fiction and a failure.[10]

II

Décrirai-je le reste de la toile?
(Shall I describe the rest of the canvas?)
L'Art et la mort, I, 149

The knifeblade (lame) which is the soul (l'âme) of the poem just analyzed is hidden within the surface of the collection's title, *L'Art et la mort*, where one can read the phonetic indications (lam) in either sense: "There is a knife which I do not forget" (*Manifeste en langage clair*, I, 239). The potential violence implied in that statement invades and informs the entire apparent system of the poem, thus founded on the double strength of the signifier "fer" whose double meaning of "iron" (or sword) and creation or making is engendered by the following pattern, combining both semantic and phonetic suggestion:

enclume→[fer→faire]

This double-edged sword is to be used against the concepts of mother and of society hidden in their turn within the surface of the title "L'Enclume des forces," where we can decipher the "mère" as well as the "foule."

Closely associated with "L'Enclume des forces" the other poem to be analyzed belongs to *L'Ombilic des limbes* ("The Navel of Limbo"), a title already indicating the site of birth or the center of

rebirth, that which must be severed from the mother as in the umbilical cord. In this case the image serves as the central source of energy for the surface text (T_1) or the text of the body as well as for the second or shortened text (T_2) and for its underlying or sub-text $(S[T_2])$. In the light of the principles laid down above, we can divide the poem into its essential and nonessential parts by choosing from the *materia prima* (here serving as the mother text, from which the second text will be severed) those sentences susceptible of a "deep" reading. As in the first poem discussed, this altered text (T_2) includes the beginning and the conclusion of the initial text, maintaining therefore the original framework.

Une grande *ferv*eur pen*sante et* surpeuplée *portait* mon *moi comme un abîme plein.* Un vent charn*el* et *résonnant soufflait, et le soufre* même *en était dense. Et des* ra*dicelles* infimes peuplaient ce vent *comme un* réseau de *veines,* et leu*r entre*croisement *fulgurait.* . . . Mais, peu à peu, *la m*asse *tour*na *comme une nausée* lim*on*euse *et puis*sante, une espèce d'immen*se influx* de sang végé*tal et tonnant.* . . . Et qu*el*que chose du bec d'une colombe ré*elle tr*oua *la m*asse confuse des états, toute la *pensée profonde à* ce m*om*ent *se stratifiait, se résolvait, devenait* trans*parent et* réduite. L'obs*cur*ité elle-même *devenait* pr*ofuse et* sans obj*et.* Le G*el* entier *gagn*ait la clarté. [I, 51–52]

(A great fervor, thinking and overpopulated, carried me along like a full abyss. A carnal and resounding wind blew and even the sulfur from it was dense. And infinitely small roots peopled this wind like a network of veins, and their crisscrossing shone. . . . But little by little, the mass revolved like a powerful and muddied nausea, a sort of immense influx of vegetal blood. . . . And something like the beak of a real dove pierced the confused and layered mass, all the deep thought at this moment was stratified, resolved, becoming transparent in its reduction. Obscurity itself became profuse and without purpose. Frost won out over clarity.)

In the parts omitted in this altered text, the contrast is unmistakably drawn between a "cotton-like envelope of noise" or again the "complete mental cotton" of thoughtless space and the center of this surrounding vegetal mass, a center defined as a mosaic of sharp forms, a sort of cosmic hammer of a defiguring and defigured heaviness.

The "mental eye" attempts to penetrate the mass but only manages to find on its surface a position more and more precise. Thus the given text (that is, T_1 unaltered) is directly readable as a verbal effort to detach (or give birth to) intelligent sounds from within the enveloping mass of the primary text. This interpretation is supported by the triple reading of the word "éclats": (1) flashes of light, therefore, by extension, that which is presented on the visible surface; (2) sounds sharply detached from the mass by their stress or tone, interpretable or discontinuous against a continuous background; and (3) splinters of wood, separable fragments of the trunk and type of the text.

We can now proceed by four stages toward a decoding of the hidden text:

Reading the Central Indication

A word or occasionally a series of words, marking the deep center of the text, a source-word from which the double sense of the phonemes draws its own meaning, together with the justification of its own semantic duplicity. The action presented here in the preterite form of the verb "trouer" [trou-v-er]—either to make a hole in or, by phonetic suggestion, to find—this piercing through to a layer under the surface is carried out by a "real" dove's beak. But what role has a real dove in a printed text except for that of signal, that is, to point to its irreality: are we to take this as a reminder of Mallarmé or a Lacanian pre-text? The project of the second reading as well as the final goal in all senses is that of penetrating the vegetable mass or the apparent lexical screen to bring into consciousness the second sense. And lest we be tempted by that reality exterior to the text, thinking the beak of the real dove the ideal instrument of poetic penetration, we are quickly dissuaded by the vagueness of the initial description: "quelque chose d'un bec."

Occupying the extreme point at the close of the text (ironically marking the closure with a breakthrough in perception), the "clarté" seems to be overcome by the frost; but in the sub-text it is rather the contrary which occurs, as we will see.

Reading Signs of the Doubled Text

There are numerous manifest as well as hidden indications in the text of the existence of a certain clarity beyond the blurred or cottony noise of the first layer, signs that the text designates itself as text, designs or de-signs itself, transforming its message and changing its direction:

Level 1⁰

surpeuplé overpopulated, that is, one must eliminate certain
 elements

(entrecroisement) ⎤
(réseau) ⎥ indicating the crossroads, the
(mosaique) ⎥ inter-implications of the text
(défiguré)[11] ⎦ readable only with difficulty

bruit comme distillé ⎤ necessary reduction for the
la pénétration du regard vivant ⎥ reading of the message
la pensée profonde . . . réduite ⎦

Level 2⁰

portait ⟶ [portée] the meaning and the destination of this
 self-designating text

soufflait [soufflet] "bellows," see the preceding re-
 marks on the hearing apparatus

radicelles [dit] "says," as the text saying itself in
 secret: the *dit* is embedded

nausée limoneuse ⎡n'oser lis⎤ "not dare to read my," but de-
 ⎣ mon ⎦ formed and truncated, almost illeg-
 ible: the sign pointing to the text

et puissante [et puis?] "so what?," as the importance of
 the reading is instantly questioned

Thus the sign over the reading—both inadmissible and incom-
plete—is affixed. At first taking refuge in the excuse of its own
ungrammaticality, it is then symbolically effaced when the reading is
challenged.

Reading of the Situation

Here the poet defines himself as an actor-participator in the
text,[12] in whose unfolding he is constantly implied. The reading of the
partial sub-text as it is described here will lead to the projected triumph
over this situation. Detaching the sense-laden elements from the altered
text (T_2) by a displacement of the phonemes, we read the following—
keeping to the order laid down in the original text:

santé surpeuplée overpeopled health
témoi (n) commun common witness

me / âme	me / soul
plainte(e)	lament, complaint
raisonnant	reasoning
souffre	suffer
danse	dance (assimilate to "dit" above)
peuplé	peopled
vent commun	common wind°
vain(es) entrecroisements	vain meetings, meshings
l'âme / lame	soul / blade°
tour	tower°
immense sein	enormous breast°
jet	spurt,° gush°
sang végétal étonnant	astonishing vegetal blood
troua / trouva	pierced° / found
TROU	HOLE°
l'âme / lame profonda	soul / blade° deepened °
cure	cure, treatment

The stress falls on the poet's evident scorn for everything touching on the numerous and the physical—"peopled," "vegetal," the recurring images of towers, breasts, and metonymic references (marked °) to the body and its workings, all plainly present once the initial text is pierced—a scorn particularly clear in relation to the reproductive and expelling processes ("parenté réduite," "jet," "rentre"). The coherence of obsession in the text once found marks this admittedly unpleasant reading as irrefutable *in its own terms*. From here on, there is only one step to the final "cure" or abortive process:

el / et le / elle / elle
cure→[curetage]

that abolishing of the project which, once it is recognized, becomes impossible. The obsession brought to light loses its obscure coherence.

Reading the Project
The final step could be marked by any consistent stressing, for example, by a repeated phonetic suggestion. Thus the infinitive form present in the great majority of verbs in this altered text:

faire, porter mon moi, aider	do, carry myself along, help
fulgurer panser (penser)	flash, bandage (think)

se stratifier	to be layered (thus, deep)
t'y fier	have confidence in it (in the project)
devenez parenté réduite	become by reducing the parental
devenez fusée sans objet	become a rocket with no aim
gagner la clarté	gain clarity
gagnée, la clarté	(clarity gained)

The project of refusal and recreation is identical to that of "L'Enclume des forces": to be born (borne, as in "portait mon moi") and also to signify ("portée") in spite of the physical birth, to bear oneself without the need of nature or grammar, through the text. Artaud claims that the "parole intérieure" or interior word formed by each image may, by an effort of the will, penetrate through to the conscious surface once a fissure is produced in the barrier separating the conscious from the unconscious state: "it is a matter of knowing at what moment of its formation the fissure will be produced and if one can be certain that the intervention or manifestation of the will is a cause of disquiet, an occasion for the fissure to take place" (I, 316).[13] The analogy with the *trou* of "trouer" is clear; although rather than the common wind found in the list above, the poetic project is one of multiplicity. But it is precisely there that Artaud discovers his greatest weakness, his "manque" or lacking of determination. The very multiplicity of senses seems proof of his inability to dominate himself, to contain and convince, to continue and to inscribe with certainty:

expression stops because the flow of thought is too violent, because the brain wants to say too many things that it thinks all at the same time, ten thoughts instead of one rush toward the exit, the brain sees as if it were a solid block thought in all its circumstances and sees also all the multiplicity of viewpoints which it could take up and the forms in which it could clothe them, an immense juxtaposition of concepts all seeming more necessary and also more dubious than the rest, these concepts that all the incidents of syntax could never suffice to translate and to expose . . . if the mind could never mechanically decide for one dominant theme over another, it shows its weakness, since nothing was dominant at that particular moment, nothing presented itself with enough strength and enough continuity in the consciousness to be registered there. [I, 319] [14]

His doubt is also that of each reader. The signs pointing back to the interior word can never wholly be deciphered, and the speculative second reading may appear only as one among a number of hypothetical possibilities, even though this reading is backed up by numerous other sub-texts, all restating the same themes, discoverable through the same processes and following the same rules.

In any case it is beneath the forms of the first and apparent reading that we should look, toward another system—at once fissured, speculative, and discontinuous—of a "deep" reading. And this other text, may it not in its turn be the canvas pierced by "something like the beak of a real dove"?

NOTES

1. In this list, as in the two others, the words seen as significant, according to the present reading, are italicized, and the words bearing more than one meaning are starred.

In the part of the text omitted, the rhyme continues: "crinière . . . *lumière* . . . ouvert° . . . derrière . . . derrière . . . derrière . . . cavernes° . . . cavernes° . . . *percer*," etc. The obsessive sequence: animal, hole, birth is obvious here also; otherwise, the reading could not be justified within the whole text, and would therefore be invalidated. That the metaphors of dream and creation or gestation merge is clear from other texts of Artaud. For the sake of consistency, I use only one outside referent: in all supporting quotations here, *Bilboquet* (*Oeuvres complètes*, vol. 1, Paris, Gallimard, 1956). [B] "Mes rêves sont avant tout une liqueur, une sorte d'eau de nausée où je plonge et qui roule de sanglants micas" (*B*,224).

2. Nor is the text without references to actual conception: "derrière cette main d'homme enfin qui imprime son pouce dur et dessine ses tâtonnements." The veiled references to the father ("j'espère") and to the periodic cycles of the mother ("règle[s]"), etc., need no comment beyond this one. Thus does the CHÈRE-MÈRE merge with the CHAIR-MÈRE.

3. See, in this context, Louis Wolfson's *Le Schizo et les langues* (Paris, Gallimard, 1970), where the references to the "enclume," and the other parts of the hearing apparatus, to the distortion of the mother tongue, and so on, as well as the general atmosphere of the text, are reminiscent of Artaud. Here brackets mark the supposition of a letter or letters in the second text and parentheses the omission of a letter from the first text.

4. "Dans cette rupture décisive d'un monde, tous les bruits sont pris dans la glace, le mouvement est pris dans la glace; et l'effort de mon front est

gelé. Mais sous la glace un bruit effrayant traversé de cocons de feu entoure le silence du ventre nu et privé de glace . . ." (B, 244).

5. Whereas, in the "Osselet toxique," the poison is seen as an antidote to the father-mother: "Voici l'étrange lueur des toxiques qui écrase l'espace sinistrement familial" (B, 280).

6. "Mais toute cette chair n'est que commencements et qu'absences, et qu'absences, et qu'absences . . .

absences." [B, 242]
The readings "ab-sens," away from sense, and the emphasis on "lent" in "relent" might be overlooked if it were not for the stress placed on the series by the rhyme, a point worth reiterating.

7. Michael Riffaterre, "La Métaphore filée dans la poésie surréaliste," *Langue française* 3 (1969): 46–60. For examples of the working out of a Dada/surrealist manuscript according to aural suggestion, see my annotation of Tristan Tzara's *Approximate Man and Other Writings*, Detroit, Wayne State University Press, 1973.

8. The underlinings are mine, signalling the bodily and gestative obsession. This act itself will be discussed in part II.

9. It is significant that this passage takes its place "au milieu de ce misère sans nom."

10. This brief sketch ignores, of necessity, many of the complicated determining chains in this text, such as

nausée→[n'oser]
mère→bord[er]
langues ardentes→*soupi*raux
tissé→s(ou)piraux
*ent*r'ouverte→[antre]→cavernes

11. The terms in parentheses occur in the omitted passages. Their suggestion is clear: the difficulty of the mosaic in its fragmentary construction, the defiguration of the initial text, the necessarily reductive and yet vivifying look of the reader.

12. By actor-participator here, I mean to imply also the sense given to the "actant" in current semiotic usage.

13. "C'est-à-dire:
étant entendu que toute idée ou image s'éveillant dans l'inconscient et constituant avec intervention de la volonté une parole intérieure, il s'agit de savoir à quel moment de sa formation la fissure se produira, et si à coup sûr l'intervention ou manifestation de la volonté est une cause de trouble, une occasion de fissure et si la fissure interviendra à cette pensée-ci ou à la suivante." Lettre à Monsieur Soulié de Morant, Feb. 19, 1932.

14. *Ibid.* ". . . la pensée, l'expression s'arrête parce que le jet est trop

violent, que le cerveau veut dire trop de choses qu'il pense toutes en même temps, dix pensées au lieu d'une se précipitent vers la sortie, le cerveau voit d'un bloc la pensée dans toutes ses circonstances et il voit aussi toute la multiplicité des points de vue auxquels il pourrait se placer et des formes dont il pourrait les revêtir, une immense juxtaposition de concepts tous semble-t-il plus nécessaires et aussi plus douteux les uns que les autres que toutes les incidentes de la syntaxe ne suffiraient jamais à traduire et à exposer. . . ." Rather than outside references to Freud, Lacan, Saussure, Starobinski, et al., I prefer to let Artaud's explantion suffice here. Since the surrealist poets were all more sensitive to the aural than the visual, in spite of Breton's scathing references to orchestral sounds, it is no surprise that the poverty of the letter should for them conceal the infinite richness of the underlying images as they determine each other, often by sound. (See note 7.)

On the Determination of the Text

Peter Caws

Y a-t-il tant de choses dans cette toile?
Artaud, "L'Automate personnel"

One of the received dogmas of formalism and New Criticism was that the circumstances of the production of a text, the history and state of mind of its author, his intentions in writing it, etc., must be considered irrelevant to its analysis as a literary object. The critic "may, if he prefers, treat the poem structurally as though it had not been written by a private individual at all." [1] But the knowledge that the text was in fact written by a private individual, if it was, cannot be forgotten, it can at most be "bracketed" in the Husserlian sense. The parallel development of Freudian psychology and structural linguistics has made it inevitable that this question should emerge from the brackets occasionally. Both disciplines throw light on what happens between the subjectivity, conscious or unconscious, of the writer and the objectivity of the text.

This need not, however, mean a reversion to external evidence about the writer's life or upbringing—the necessary indications are contained within the text. Indeed, the direction of the relationship has been reversed altogether. Whereas classical criticism might accumulate facts about the writer in order to illuminate or even to reconstruct the text, recent work tends to accumulate readings of the text; one of the directions in which it can then proceed is towards the illumination or reconstruction of the writer—reconstruction because there can be no

guarantee of identity between the subject or the aspects of a subject thus projected and the real individual who was the "author" of the text. The fallacy of affirming the consequent must be recognized for what it is in criticism as in science. But then there can be no question even in everyday life of knowing the subjectivity of those we "know," and just as the mode of our acquaintance in one context can be visual and aural manifestations, so the mode of our acquaintance in another can be the text itself.[2] The justification for the projection of aspects of the writer as a critical (rather than a historical) activity is that it throws further light on the text. The projection plays the role of a hypothesis whose deductive consequences are broader than its inductive grounds.

To speak first of the contribution of psychoanalysis: In the works that Lacan has called "canonical in the matter of the unconscious" (*The Psychopathology of Everyday Life, The Interpretation of Dreams,* and *Jokes and Their Relation to the Unconscious*) Freud suggests a number of mechanisms that, taken together, yield a plausible account of what might be called the pathological aspects of the production of the text. *The Psychopathology of Everyday Life* is a study of *parapraxes:* the forgetting (repressing) of words, slips of the tongue, misspellings, and the like. From the point of view of this discussion what is interesting is the kind of substitute for the forgotten or correct expression that emerges into the text. The Signorelli case,[3] if Freud's interpretation of it is to be credited, shows that the unconscious indulges in extremely recondite word-play, and that the expressed may bear to the repressed complicated relationships of translation and metonymy. In *The Interpretation of Dreams* the manifest content of the dream is distinguished from its latent content, the latter being metamorphosed into the former by devices of transposition, condensation, and displacement. These mechanisms are largely linguistic, but they cannot be reduced to a formula:

the dream-work carries out a very unusual kind of transcription of the dream-thoughts: it is not a word-for-word or a sign-for-sign translation; nor is it a selection made according to fixed rules—as though one were to reproduce only the consonants in a word and to leave out the vowels; nor is it what might be described as a representative selection—one element being invariably chosen to take the place of several; it is something different and far more complicated.[4]

In themselves these things do not constitute a theory of literary production, and in fact the works in question are mainly anecdotal, although Freud accumulates an impressive number of cases and interprets them with consistent ingenuity. But the elements of such a theory are clearly present. What prevents Freud from arriving at it is that in his preoccupation with the psychic content of his examples he overlooks their striking textuality. In another short essay he almost comes to the point of bringing the resources of the theory of dreams to bear on the poetic text by comparing the imaginative writer to *der Träumer am hellichten Tag*, "the dreamer in broad daylight," [5] but the discussion then turns to day-dreaming in the conventional sense, the projection of romantic wish-fulfillments.

What the extension of Freudian techniques to poetic texts can accomplish is, in one sense, nothing of critical importance that could not be accomplished by other means. It cannot uncover in the text anything that is not there, and everything that is there is in principle accessible to purely linguistic inquiry. But Freud's findings confirm what linguistic evidence independently suggests, namely that the unconscious operates through language mainly at the level of sound, and that the forms of association it practices amount to an exploitation of the sound-properties of language that conscious reflection instinctively rejects as preposterous. The burden of the works of Freud referred to above could be summed up by saying that no parapraxis is accidental, that no remembered dream fragment is insignificant, that no play on words can be confined to the level of the obvious; in the context of the poetic we might add that no reading based on any linguistic feature of the text can possibly be ruled out *a priori* as too implausible or far-fetched. Nothing that the conscious reflection of the reader can conceive can safely be eliminated from the unconscious anticipation of the writer, indeed everything can be attributed to a hypothetical writer projected back from the text, if the intention of the hypothesis is literary rather than historical.

The "writer" in this hypothetical sense, the source of the text as read, is determined by the reader's unconscious as well as by the (historical) writer's, but there can be no question of attempting a partition of unconscious material as between these two components, and the matter is further complicated if the reader has access to criticism, that is, to the readings of one or more third parties with their own unconscious determinations. The distinction, in other words,

between what was written into the text and what is being read into it is in principle untenable. "*Wo es war, soll Ich werden* (where id was, there ego shall be)," says Freud,[6] in a text that has become a touchstone of Lacanian doctrine. But the converse suggests that whatever the ego arrives at has already been laid down in the unconscious. The sentence that immediately follows makes the point clear: "It is a work of culture—not unlike the draining of the Zuider Zee." What linguistic analysis uncovers is unquestionably *there*, however unconscious or unintended it may have been at the moment of the production or the first reading of the text. And it will certainly not be surprising if a great deal of it is "Freudian" in the popular sense of the word, even in the texts of Olympians above reproach. "Ladies and gentlemen," Freud would say, as he probed the infantile sexuality of Goethe or Leonardo da Vinci, "do not be indignant."

It would of course be absurd to pretend that everything in any text (except perhaps in those produced by pure automatism and neither revised nor cut) is wholly determined by unconscious factors. Two other components of determination at least can be distinguished, which might be said to belong to the normal aspects of the production of the text: the conscious intentions of the writer, his "state of mind," and the properties of language itself. The normal activity of writing is not necessarily a transcription of the writer's state of mind, but it is a productive process that originates in this state of mind and issues in the text. The question now is, what are the specifically linguistic constraints that control this process? For purposes of discussion I restrict attention provisionally to texts that are syntagmatic chains whose elements are lexical items in some standard language, even though not every text satisfies this description (some have non-syntagmatic aspects, or contain non-lexical items or items from more than one language) and not everything that satisfies this description may count as a text (cf. Derrida: "A text is a text only if it conceals on the first examination, at the first encounter, the law of its composition and the rule of its game").[7]

The question of linguistic constraint in the production of discourse has generally been treated as a matter of levels—phonemic, monemic, syntactic, semantic, discursive. Thus Jakobson and Halle speak of an "ascending scale of freedom," from no freedom at all (in the combination of distinctive features into phonemes) to virtually unlimited freedom (in the combination of sentences into utterances).[8] There is

of course a sense in which, subject to the psychological constraints already discussed, the speaker or writer can choose to say or write anything he likes. Once embarked on this enterprise, however, he is constrained not only by grammar and intention but also, as soon as he has said or written anything, by the previous elements in the syntagma he is constructing. The productive activity works with sentences or parts of sentences, rather than with individual words or with segments longer than a few sentences at most; there is a limit, more or less confining for different writers, to the size of segment that can as it were fall into place all at once, and as each segment is added it is a function not only of the state of mind of the writer at that point but also of the entire text as it has been constructed up to that point. The text is consciously built up, therefore, with sequential additions of the order of magnitude of the phrase, but it will eventually exhibit features of structure both at the overall level (the resulting text as a whole) and at the level of detail (syntactical agreements, inflections, particles and the like).

Now it seems to follow, from the "ascending scale of freedom," that the writer controls the overall features of his text while phonemic and syntactic considerations control its details. It appears, however, that the scale of freedom may in fact reach a maximum at the level of the phrase and then decline again—that there may be large-scale features of the text that are determined directly by the state of mind without being consciously worked at the level of the phrase. In particular there is reason to believe that the distribution of lexical items and their association with one another constitute such a feature. The absence of conscious deliberation in this case, however, cannot be assimilated to the activity of the Freudian unconscious—the situation is more like one in which some competence has been consciously learned and then drops out of consciousness, as for example in the case of walking or riding a bicycle, when one is no longer aware of the muscular movements that ensure balance. On the other hand it may be precisely this linguistic mechanism that gives the Freudian unconscious access to the text, by feeding into the productive process, along with conscious intentions unconsciously carried out, unconscious intentions as well.

The direct relation between intention or state of mind on the one hand and lexical distribution on the other, while obvious enough in a very rough way—in that for example we would intuitively expect that

a text "about" the desert would contain a greater number of references or allusions to the desert than, say, to the square root of two, and at intervals throughout the text rather than being concentrated in some small part of it—could not have been demonstrated without a great deal of statistical work on texts regarded not primarily as literature at all but simply as ordered aggregates. The "Markov chain" in information theory, for example, was developed on the basis of an analysis of the first 20,000 words of Pushkin's *Eugene Onegin*.[9] For such purposes literary texts offer an admirable resource of empirical material, of a kind that simply does not occur in nature, or at any rate not in such compact or accessible form. It has been pointed out by Chomsky that the analysis of discourse in terms of the pairwise relations between contiguous elements of the syntagmatic chain, which is the basic strategy of information theory, does not do justice to the non-linear nature of syntax, and this of course is true; its usefulness is restricted to non-syntactic features of the text, but lexical distribution is one of these.

The quantitative measure of lexical distribution and vocabulary connectivity is the periodicity or frequency of occurrence of words or groups of words. Periodicity as a large-scale feature of the text used to be thought characteristic only of poetry, in which it was obvious and extrinsic, but Gustav Herdan has shown, in his book *Type-Token Mathematics*, that it is in fact an intrinsic principle of textual production in general, regarded as an expression of conceptual content, so that "once the system of content has been settled in outline not only the main items of the vocabulary needed for expression, but also their relative frequencies are, by and large, determined, the system of content determining how often a particular word will appear in combination with other words. This means" (continues Herdan) "that in the execution of his task in detail the writer is no longer free, since words will have to appear more or less periodically, each with its own period, and thus be 'at the right time in the right place' for unexpected combinations with other words. Words will then act as 'prompters' and suggest ideas to the writer. Thus, although in the strategy of writing the writer is free, he is no longer so in the tactics where he cannot escape the consequences of his own plan of action"[10] It follows from our earlier discussion that an unconscious "plan of action" can be counted upon even if the conscious intention of the writer is not to express a specific conceptual content at all, and in fact it might be tempting to define a poetic text precisely as one in which such a

conceptual intention is lacking, thus leaving the field free for uncon-
scious determination. A view like this might go on to explain that,
whereas when poetry was primarily narrative or didactic it had to resort
to artificial periodicities in order to distinguish itself from prose texts
(which after all would have shared with it the periodicities proper to its
content), now it is able without such devices to exhibit the pure
periodicities of language unburdened by the necessities of communica-
tion. But in order to judge how much weight can be attached to
conjectures like this Herdan's argument must be examined more closely.

Herdan begins from the distinction between "type" and
"token," a distinction originally introduced to resolve a difficulty about
the definition of the *word:* how can "mirage" and "mirage" be at once
the same word in the English language and different words on the
page?—because they are different tokens of the same type. Now clearly
what makes them the same is their standing for the same concept, and
what makes them different is their occurring at different places in the
syntagmatic chain; it therefore becomes natural to associate type with
conceptual reference and token with syntagmatic expression. Herdan
shows, by an analogy to projective geometry, that type and token are
dual to each other, in the sense that any valid proposition of structural
linguistics mentioning the one will also be valid if the other is
substituted for it and vice versa. Hence "if a statement is made it
provides the occasion for another statement, and so on. Language is
thus self-generating, every statement being possibly productive of
another. *Language not only expresses thought, it also creates
thought.*" [11] In the geometrical analogy, points correspond to types and
lines to tokens; and Herdan's further conjecture is that, just as in solid
geometry there are points, lines, and planes, so there will be a linguistic
entity analogous to the plane. This he identifies with the text as an
aggregate of syntagmatic chains, with its associated concept of lexical
distribution.

If the analogy is accepted—in other words if the geometrical
model for linguistics can safely be extended into this higher dimension-
ality—then a new proposition emerges. For in three dimensions the
point is the dual not of the one-dimensional line but of the two-dimen-
sional plane, while the line is dual to itself. This means that type and
text will be directly related to one another and that token will, as it
were, cancel out. A conceptual reference will determine a lexical
distribution, and vice versa, no matter what happens at the level of

syntagmatic expression (the level of the phrase). In four dimensions the dual of the point is the three-dimensional solid, which Herdan pairs with the linguistic notion of content—but the content of the text *as reconstructed by the reader*. In this case token and text both drop out, so that a text successfully used for communication effaces itself and leaves with the reader a conceptual structure like that with which the writer began.

Clearly the interest of criticism lies less in this four-dimensional case than in the three-dimensional one, where the text does not become transparent but presents itself as a surface whose features are to be examined, explicated, and commented upon. It is now clear that one feature of this text, its lexical distribution and hence "vocabulary connectivity" (which follows from the superimposition of different lexical periodicities) is directly determined by the conceptual reference of the individual words (type) that constitute it, at any rate their conceptual reference for the writer. But if the process of writing ends with the text rather than going on to the stage of communication, there arises in a new form the question as to the legitimacy of invoking this conceptual reference as conscious. The problem thus posed as to the status of the text can be approached from a fresh angle if we now ask just what *are* the words that constitute it? If the displacements and condensations referred to earlier—involving word-plays and the whole apparatus of what has come to be called the "paragrammatic" (a special case of parapraxis)—have entered into its determination, it must in fact conceal a second text; and this will have its own patterns of distribution and connectivity. The type-text relation applied in reverse to these features of the second text will then yield a set of conceptual references quite different from those indicated by the surface text.

What is the status of this "second text" (or "sub-text" or perhaps—by contrast to the "manifest text" and by analogy to the case of dreams—"latent text")? Its existence seems problematic, its textuality doubly so, since if detected at all it shows itself only in isolated words and phrases scattered throughout the surface text. It would be extraordinarily difficult to *sustain* a distinct double reading, on the level of sound, through a text of any length without interruptions, indeed examples of more than a few words together are recognized as *tours de force* (like the classic "Gal, amant de la reine").[12] So the second text seems necessarily fragmented and hardly to deserve its name; it is worth noticing that Starobinski's book on Saussure's paragrammatic researches

is called *Les Mots sous les mots* and not *Le Texte sous le texte*.[13] On the other hand, if the fragments could be shown to have the properties of a text in some important respect the application of the term might be justified. But the most obvious properties of texts are syntagmatic continuity and syntactic order, and these are just what the second text tends to lack.

In the light of Herdan's conjectures, however, we are in a position to attribute to the second text one key characteristic of textuality, namely a pattern of lexical distribution (remembering that the same term in the second text is likely to show up under various different disguises in the surface text, and may indeed do so with obsessional frequency). For lexical distribution is quite independent of syntax and of the nature of the interstitial connecting material. On reflection it appears, in fact, that for poetic texts at any rate lexical distribution is a far more important feature than connectedness or grammatical propriety; the notion of the poetic image, for instance, seems to imply disconnectedness, a stress on semantic color rather than on syntactic form. If we think of the remainder of the text as neutral, as merely a carrier for the poetically marked terms, then there seem to be available to the writer two strategies for dealing with it in addition to the obvious one of filling it in as best he can. One is to cut it out altogether; this is a well-known poetic device and accounts for the frequent appearance of poems on the page as schematic or skeletal, full of empty spaces. The other is to borrow it from another text, and this is what the second text does, so that it might be said to be parasitic on the surface text—or rather symbiotic with it, since without the second text the surface text might be merely banal.

One serious difficulty remains. It appears to require close analysis, if not statistical computation, to bring the second text to light, and this makes it seem as if on first reading the surface text should always seem banal, as if its profundity should be accessible only after hard and comparatively technical effort. And yet it is often possible to make an immediate judgment which is vindicated by the subsequent discovery of a second text. Now it is obviously not the case that every poetic effect depends on the existence of a second text; the possibilities inherent in the proper vocabulary of the surface text, in syntactic and other formal characteristics, in content, in the extrinsic periodicities of traditional poetry and in their less apparent metamorphoses, cannot so easily be dismissed. And it obviously is the case that experience with a

particular kind of text increases the degree to which a new text of a similar kind can be penetrated on first reading. Allowing for all this, however, a certain immediacy of literary perception still requires to be explained. Its explanation calls for an inversion of the usual relationships between the conscious and the unconscious.

It must be remembered that everything in the text, even in the second text, is in one sense immediately present, that is, phonetically if not orthographically. It is all directly accessible to consciousness. But our conception of the content of consciousness, where texts are concerned, tends to be colored by our experience of communication, in which as we have seen the text is transparent; the content of the text goes from the writer's conscious intention to the reader's conscious apprehension. (Consider the inevitable question, "What does it mean?") But this raises the old problem of container and thing contained—it does not count as consciousness of the text at all, on the contrary the reader is precisely unconscious of it. The inversion of the sequence conscious intention—unconscious text—conscious apprehension is obviously unconscious intention—conscious text—unconscious apprehension, and this must I think be regarded as the mechanism of the kind of literary perception under discussion. And it has suggestive analogies in perception of other kinds. When for example we perceive any visual quality, say a pure color, we know from scientific evidence that the beginning and end of the process of transmission are quite unlike the content of its conscious representation. Rapid agitations at the colored surface and in the form of electromagnetic radiation, of which we are quite unaware, produce rapid agitations on the retina and in the brain of which we are equally unaware; the result is an undifferentiated perception. The simplicity of perceptual content, in contrast to the complexity of the mechanisms of emission and reception, seems to be achieved in part at any rate by the matching of one complexity to the other.[14]

Reversing the analogy, we might think of the reader's unconscious as matched in relevant respects to the writer's; literary activity then appears as a transmission from one to the other, and the text as the conscious phenomenon of this transmission. The idea of a cultural affinity that would make such a matching plausible hardly needs elaboration; its basis is obviously language, but it must include all sorts of other factors. It has to be recognized, of course, that the writer need not be, as Plato sometimes thought, only the unwitting vehicle of

inspiration,[15] that he may be (and the good writer no doubt often is) quite aware of writing a second text, of exploiting consciously the resources of his unconscious, and that a similar awareness may be cultivated by the critic. But not all readers are critics, and the others may also experience the poetic quality of the text. The view put forward here makes intelligible not only the fact of immediate and non-reflective literary judgment subsequently vindicated, but also the historical development of style, variability in taste, and the relative inaccessibility on first acquaintance of the literature of some foreign cultures. The work of criticism, when it is employed on the products of our own culture, is then not so much to make the text intelligible as to make it visible—not to illuminate the text as though it had been dark (although it may have been obscure) but to show it in its own best light.

NOTES

1. Kenneth Burke, *The Philosophy of Literary Form*, Baton Rouge, Louisiana State University Press, 2nd ed. 1967, p. 73.

2. The most extended example of the inverted relation between text and writer is and will very likely remain Sartre's reinvention of Flaubert (Jean-Paul Sartre, *L'Idiot de la famille*, Paris, Gallimard, 1971–). Sartre makes quite extraordinary assertions about Flaubert, but his justification for them seems to me irreproachable: "It will be asked how I know all this. *Eh bien, j'ai lu Flaubert*" (p. 367). He is not, however, a good example of the critical activity I am discussing, because his interest is primarily in the writer, not in the text. In fact the question with which he begins his book is "What is it possible to know of a man, today?" (p. 7)—but then for him, even in his own case, "man" and "writer" have always been synonymous.

3. Sigmund Freud, *The Standard Edition*, London, Hogarth Press, 1953– , 6:5. Freud himself forgot the name "Signorelli"; the names which suggested themselves to him were "*Botticelli*" and "*Boltraffio*." The chain of relationships by which he explains this includes the equivalence of *Signor* and *Herr*, the fact that he had been talking about *Bos*nia and *Herz*egovina, the fact that the Turks in Bosnia address doctors as "*Herr*" when they wish to make resigned or desperate remarks about death or sexuality, the fact that the news of the death of a patient because of sexual depression had reached him in *Trafoi*.

4. Ibid., 15: 173.

5. Ibid., 9: 149.

6. Ibid., 22: 79.

7. Jacques Derrida, *La Dissémination*, Paris, Seuil, 1972, p. 71.

8. Roman Jakobson and Maurice Halle, *Fundamentals of Language*, 's-Gravenhage, Mouton, 1956, p. 60.

9. Gustav Herdan, *Type-Token Mathematics*, The Hague, Mouton, 1960, p. 141 ff.

10. Ibid., p. 261.

11. Ibid., p. 230.

12. "Gal, amant de la reine, alla—tour magnanime!—galamment de l'arène à la Tour Magne, à Nîmes."

13. Jean Starobinski, *Les Mots sous les mots*, Paris, Gallimard, 1971.

14. Cf. my article "Science, Computers, and the Complexity of Nature," *Philosophy of Science*, 30 (1963): 158–64.

15. Plato, *Ion*.

Afterword

text without a theory, theory without a text

Michel Beaujour

All that matters in surrealism was accurately stated in the first *Manifesto*: surrealism stands *and* falls by automatism. Unfortunately, the practice of automatism was not accompanied by an adequate theory, so that the surrealist manifestoes now seem somewhat antiquated, an insufficiently prehensile tail of Romanticism. The reason, of course, is that the surrealists were reluctant to think about literature as an art, so that they condemned themselves to a misunderstanding of what they were actually doing. *No more work:* the only revolutionary break away from tradition in surrealist thought was extra-literary, and it precluded sustained and cogent thinking about the very texts which were being produced. The surrealists cast away the last vestiges of rhetorical theory along with the old belief that poetic texts result from an elaboration of raw material, the enactment of some set of strategies known as "art" or "craft" in order to shape the finished product. An excessive emphasis on inspiration turned the surrealists into magicians, and their own texts into white rabbits. They saw themselves from the point of view of the magician's audience, a naive audience which is taken in by the magic and ignores the labors of the performer.

This denial of the productive process, although it was insepara-
ble from a rejection of the dominant ideology, which they rightly
diagnosed as mainly geared to production and social exploitation, was
an idealist illusion: it had deplorable ideological consequences since it
opened the door to occultism and mysticism. In any case, it made it
impossible for them to think of automatism in terms other than
medianimic possession and magic trance, rather a crude form of
neoplatonic poetics. Yet, this muddle was a *felix culpa,* since the
surrealists' illusions virtually opened up two new directions for thought,
which on the whole remained unexplored in surrealism proper.

The first one led to a critique of the then dominant concept of
literature as a conscious expression of individual subjectivities. At least
theoretically, in automatism, the product is alien to the ego of the writer
(speaker, "artist"). Automatism taps language rather than the individu-
alized discourse of a conscious mind. The very monotony of automatic
texts, their high commonplace content, their copious amplifications and
their stereotyped syntactic structures display the functioning of a
linguistic-rhetorical machine turned as anonymous and collective as any
operating in pre-literate cultures. But the workings of this "machine"
could not really be understood by the surrealists: their impoverished
theoretical equipment as well as their ideological commitment to
wonder left them unable to think in terms more specific and adequate
than: magic, surprise, humor, revelation, analogy, and image. In this
they shared the common deficiencies which sterilized their French
contemporaries in a period when most writers lacked an elementary
awareness of rhetoric, poetics, and literary theory. Despite these
shortcomings (perhaps thanks to them, since Valéry's uncommon
understanding of poetics led him up a dead end as a poet) the surrealists
reached the threshold of comprehending how language generates texts
over and beyond the limited control of the writer's ego. At any rate,
they did produce texts where these subconscious workings are fore-
grounded to a degree heretofore unknown.

The second area in which the surrealists virtually broke new
ground is contiguous to the first. Just as they came close to reviving the
formulaic and rhetorical devices of pre- and early-literate cultures in
their automatic texts, thus stressing the collective, non-individual
aspects of artistic creation, so the surrealists challenged the cultural
patterns which set the adult, Western individual apart from the rest of

mankind. In extolling the values of unreason, madness, possession, and immaturity they opened up the way for ulterior developments in anthropology and in the broad area of the "sciences of man." It matters little, in the long run, that they were closer in their thinking to Lévy-Bruhl's early prelogical and participatory conception of the primitive than to the hyperlogical one of Lévi-Strauss, since Lévi-Strauss himself owes so much to surrealism. They enabled us to place literature and the arts within the wider perspective of the totality of man's cultural creations; and their denial of the specificity of the arts, awkward as it is at times, was a necessary step in the dialectic which led to a general reassessment of the functions of human artifacts, and of the mental processes which bring them about. Whether surrealism was a symptom of the general mutation of Western anthropology we are now witnessing, or a prime mover in this revolution, remains a moot point: few would deny that, in France at least, most contemporary developments in the sciences of man can be traced back on some level to the radical breakthrough effected by surrealist practices, as they are epitomized in the first *Manifesto*.

"Texts without a theory": this formula may appear a wilful distortion contradicted by the very claims we made for surrealism's impact. Yet, when we compare surrealism to the theoretical activities taking place in Russia at approximately the same time, we must realize that, were it not for the practice of automatism (which could not then be justified by a consistent theory), surrealism and its magical mumbo-jumbo would now seem a terminal impasse of symbolism, for it had come to distrust the mediation of literature and was seeking a more compelling presence of the Word.

I believe that the distance between contemporary American and French thought, which makes attempts at communication such a comedy of errors, can in a large measure be traced back to surrealism or, more accurately, to the fact that surrealism was in all essentials a French phenomenon. English-language writers ignore it, but French thinkers cannot bypass it. Nor do they wish to do so, since it has provided them with such a large store of food for thought. What is at stake is not an explication of surrealist theory, with its glaring inadequacies, so much as an effort to understand and generalize surrealist practices such as: automatism, critical paranoia, the simula-

tion of mental pathologies; or the radical revaluation of Sade, Lautréamont, Brisset, Roussel; and finally the foregrounding of the triad: Marx, Nietzsche, Freud.

Recent French intellectual activity, to many Americans, seems all theory and no text, and they complain that the theory is unintelligible, that is, undistinguishable from "poetic" texts, whose absence they deplore. Texts have been provided by surrealism in such abundance and they are seen in such a novel perspective that understanding this novelty still is the primary task at hand. But the rules of the game of explication, and the very process of theorizing have been challenged, so that the scientific-theoretic discourses themselves now are undermined by the surrealist revolution. Meanwhile, speakers of English are undergoing their own piecemeal and belated surrealist revolution through the muddled manifestoes of the "counter-culture," anti-psychiatry, neo-dadaism, women's lib, etc., which a Frenchman reads with an uncanny feeling of *déjà vu*. As to the American reader, he sees the theoretical paraphernalia of rhetoric, linguistics, logic, poetics, and psychoanalysis, which have invaded French theoretical writings, as a rehash of stale problems.

It may well be that the differences are more significant than the superficial resemblances. "Ideas" do not travel in a vacuum, and our parallel has taken no account of the social, economic, and institutional structures which account for both the sameness and the strangeness in these ideological developments. We can gain but little understanding of the "theory without texts" phenomenon if we forget the conditions which produced so many "texts without a theory" in the era of surrealism. This is a crude dichotomy, a rough heuristic approach to the dialectics of French cultural history. Obviously, Breton, Ernst, Dalí, Artaud, Bataille—and Roussel, should we annex him to surrealism—have left a considerable body of theoretical statements about various aspects of automatism: it is merely claimed that these are all unsatisfactory *as theory* and that these shortcomings are attributable to the impoverishment of the cultural milieu in which these authors worked: they had little or no knowledge of many theoretical discourses, such as linguistics, that have since become common currency in the sciences of man. It is just as obvious that contemporary theorizing tends toward the status of "poetic texts" since they adopt rhetorical devices and word play which were normally excluded from the scientific writings of a more positivistic era. In this they are completing, through other means,

the demolition of practical reason and of an anthropology which used to define man as a productive, adult, rational Westerner: the refusal of *work*, embodied in ambiguous texts and artifacts "magically" produced by surrealist automatism, was the first step in this direction. We are now beginning to understand how such texts, and all kinds of other texts, are generated: this growing knowledge is inseparable from a reassessment of the individual ego's relationship to language, to the body, the unconscious, and to social structures. Text and theory have theoretically become one.

Contributors

Anna Balakian, Professor of French and Comparative Literature, Washington Square College, New York University.
André Breton: Magus of Surrealism and other books on surrealism and on symbolism.

Michel Beaujour, Professor of French literature, Washington Square College, New York University.
Le Jeu de Rabelais and several studies on surrealism and on poetics.

LeRoy C. Breunig, Professor of French Literature and Dean of Faculty, Barnard College.
Guillaume Apollinaire, and other studies on Apollinaire and on cubism.

Mary Ann Caws, Professor of Romance Languages and Comparative Literature, Hunter College and Graduate Division, City University of New York. *The Inner Theatre of Recent French Poetry,* and other works on poetics; translations.

Peter Caws, Professor of Philosophy, Hunter College and Graduate Division, City University of New York.
Science and the Theory of Value and studies in structuralism.

Robert Champigny, Research Professor, Indiana University.
Le Genre poétique, and several other studies on the genres and on stylistics; also collections of poetry.

Jacques Garelli, Professor of French Literature, Washington Square College, New York University.
La Gravitation Poétique, and several volumes of poetry.

Renée Rièse Hubert, Professor of French and Comparative Literature, University of California at Irvine.
Co-author: *Anthologie de la poésie française du vingtième siècle,*

and many studies on poetics and on art; also collections of poetry.

Reinhard Kuhn, Professor of French Literature, Brown University.
The Return to Reality, and studies in the field of symbolism, and of drama.

Sarah N. Lawall, Associate Professor of French and Comparative Literature, University of Massachusetts.
Critics of Consciousness: The Existential Structures of Literature and articles on poetics and on criticism.

James Lawler, Professor of French Literature, University of California at Los Angeles.
The Poet as Analyst and works on symbolism, on Valéry; also translations.

J. H. Matthews, Professor of French and Comparative Literature, Syracuse University.
Surrealist Poetry in France; and many other books on surrealism and on novelists.

Neal Oxenhandler, Professor of French and Comparative Literature, Dartmouth College.
Scandal and Parade: The Theater of Jean Cocteau; studies on Max Jacob, on criticism and film; also a novelist.

Henri Peyre, Sterling Professor of French Literature, emeritus, Yale University; University Professor, Graduate Division of the City University of New York.
Qu'est-ce que le symbolisme? and many other books in a wide range of fields.

Michael Riffaterre, Professor of French Literature, Columbia University.
Essais de stylistique structurale, and many studies in stylistics.

Eric Sellin, Professor of French and Italian Literature, Temple University.
The Dramatic Concepts of Antonin Artaud, and studies in Swedish and Algerian literatures; several volumes of poetry.

Roger Shattuck, Provéditeur Général, Collège de Pataphysique. Commonwealth Professor of French Literature at the University of Virginia, Charlottesville.
The Banquet Years; and studies of Proust, Apollinaire; translations, novels.

Albert Sonnenfeld, Professor of French and Comparative Literature, Princeton University.
L'Oeuvre poétique de Tristan Corbière and studies on poetry, the novel, the use of quotation.
Micheline Tison-Braun, Professor of Romance Languages, Hunter College and Graduate Division, City University of New York.
La Crise de l'Humanisme (two vols.); studies on Sarraute and on surrealism.

Index

The book was designed by Joanne Kinney. The typeface for the text is Caledonia designed by W. A. Dwiggins about 1938; and the display face is Aurora Condensed originally cut by Wagner and Schmidt in 1909.

The text is printed on Nashoba text paper; and the book is bound in Columbia Mills' Llamique cloth over binders boards. Manufactured in the United States of America.